WESTERN PASSAGES

Elevating Western American Art

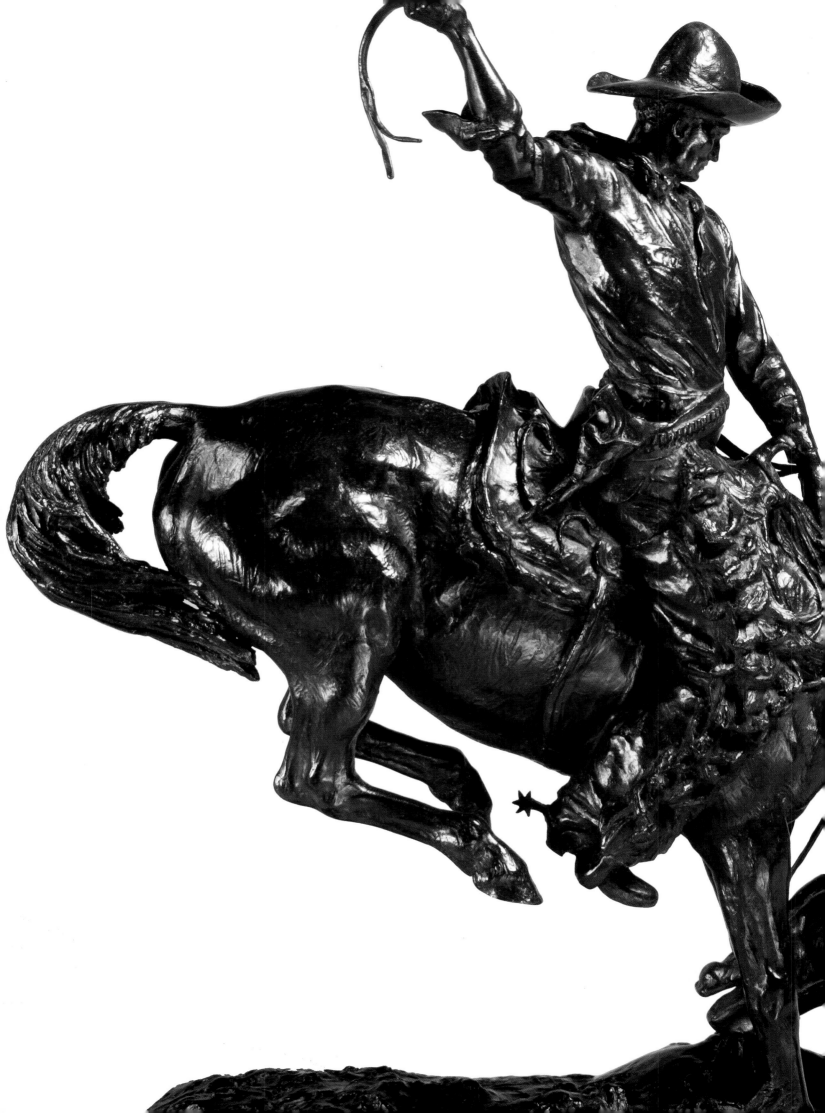

Elevating Western American Art

DEVELOPING *an* INSTITUTE *in the* CULTURAL CAPITAL *of the* ROCKIES

edited by THOMAS BRENT SMITH

introduction by MARLENE CHAMBERS

PETRIE INSTITUTE OF WESTERN AMERICAN ART | DENVER

PETRIE INSTITUTE
OF WESTERN AMERICAN ART
DENVER ART MUSEUM
100 WEST 14TH AVENUE PARKWAY
DENVER, COLORADO 80204-2788

Western Passages is an ongoing series published
by the Petrie Institute of Western American Art,
Denver Art Museum.

EDITING Laura Caruso, Golden, Colorado
DESIGN Carol Haralson, Sedona, Arizona

Library of Congress Control Number: 2011937807
Printed in China
ISBN 978-0-914738-71-8 (paperback)
ISBN 978-0-914738-72-5 (hardback)
Dimensions are given in inches, height preceding width.

Distributed by University of Oklahoma Press
2800 Venture Drive, Norman, OK 73069-8218
1-800-627-7377 www.oupress.com

PHOTOS: PAGE 2: Alexander Phimister Proctor,
Buckaroo, 1915. Bronze, 27 x 20 x 8. Denver Art
Museum, Funds from William Sr. and Dorothy
Harmsen Collection, by exchange, 2005.12; THIS
PAGE: Dietler Galleries of Western American Art,
Hamilton Building, 2006.

Charles Marion
Russell

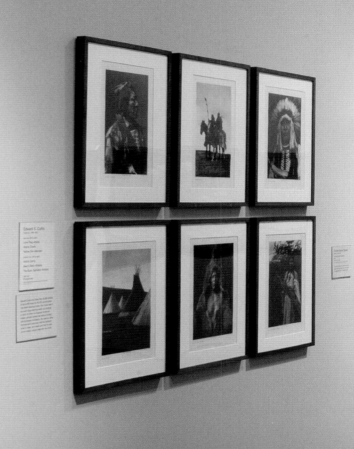

THIS PUBLICATION WAS FUNDED IN PART BY THE ENDOWMENT OF THE

PETRIE INSTITUTE OF WESTERN AMERICAN ART. ADDITIONAL SUPPORT WAS

GENEROUSLY PROVIDED BY THE BARNETT CHARITABLE TRUST, FRIENDS OF

PAINTING AND SCULPTURE AT THE DENVER ART MUSEUM, JUNE STOOL

AND EVELYN WALDRON IN MEMORY OF SYLVAN E. STOOL, M.D.,

AND ANONYMOUS DONORS.

DEDICATED *to all those*
WHO HAVE ENJOYED AND SUPPORTED
WESTERN AMERICAN ART
at THE DENVER ART MUSEUM

Native America

The Power of Art and Artists in Native America

George Catlin, Pohk-hong, The Cutting Scene

MANDAN O-KEE-PA CEREMONY

The Indian Hunter

Charles M. Russell's In the Enemy's Country

Frederic Remington's The Cheyenne

Andy Warhol's The American Indian (Russell Means)

Portraits by James Bama

PLAINS INDIANS DURING AN ERA OF MOVEMENT

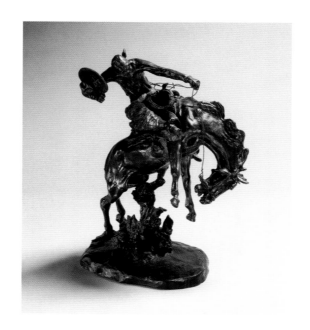

THOMAS BRENT SMITH

Director

Petrie Institute of Western American Art

Charles Marion Russell
The Bronc Twister, date unknown
Bronze, 17¹/₄ x 14¹/₈ x 17³/₈
Denver Art Museum, gift of Sharon Magness,
1998.44

In the final scene of the 1962 John Ford film *The Man Who Shot Liberty Valance,* an unimportant newspaper writer delivers one of the most enduring lines in western film: "This is the West, sir. When the legend becomes fact, print the legend." Legend, fact, and reality all seem to merge in an accelerated way in the American West. It's a characteristic that is as western as any. Ford once stated, "A legend is more interesting than the actual facts." The tradition of legend in the storytelling of the American West, whether it be film, literature, or good old fashioned oral history, is undeniable and at times seemingly unstoppable. In a characteristically western fashion, many legends have grown around the story of western American art and the Denver Art Museum, but rather than simply "print the legend" this anniversary edition of *Western Passages* aims to tell a more full story.

This year, 2011, marks the ten-year anniversary of the Institute of Western American Art at the Denver Art Museum, during which time the new department has enjoyed an unprecedented decade of programming, collecting, and support. Although the institute is a surprisingly young ten years, the history and story of western American art at the Denver Art Museum and in the community of Denver is much richer than one might imagine.

The first part of the three-part history that begins this volume, "Staking a Claim," illuminates important moments that led to the founding of what since 2007 has been called the Petrie Institute of Western American Art. It is an attempt to tell our story, and I praise its author, Marlene Chambers, for her willingness to take on such an onerous project and her steadfast dedication to see to it that the history is told with both truth and fairness. Researching and compiling a history that goes back more than a century and is at times ambiguous is no small feat. Chambers, who was a contributing author to and editor of the 1996 publication *The Denver Art Museum: The First Hundred Years,* was well versed in the history of the museum and was

assisted by Holly Clymore in securing important documents that were specific to the western art story. Chambers's research included interviews with significant staff and current and former trustees, who helped her piece together a cohesive story.

The second and third parts chronicle the Institute's achievements and profile some of the people who have assisted its ascendancy onto the national scene. Particular attention is given to the museum staff's efforts to become the leader in the study of western American art. Also highlighted is the important role the institute's advisory board has played in fulfilling its mission. We are grateful to all those who have served on the board throughout the past decade, including Bob Boswell, Gary Buntmann, Gerri Cohen, Cortlandt Dietler, Ray Duncan, Pat Grant, Chuck Griffith, Bill Hewit, Sarah Hunt, Tom Petrie, Nancy Petry, Henry Roath, and Jim Wallace.

The bulk of the publication consists of essays that highlight and contextualize works in the Denver Art Museum's vast collections. *Elevating Western American Art* includes some thirty essays whose content ranges in style, medium, period, and even museum department, but all share the American West as subject whether it be place, people, history, or experience. Each scholar brings to his or her essay different methodologies. These varying approaches add variety and give readers a glimpse into the dynamic discourse within an encyclopedic art museum. This section illustrates the uniqueness of a western American art department within a comprehensive art museum and how the Denver Art Museum, with its robust holdings, can approach collecting art of its own region within multiple departments, thus further expanding the canon of western American art. Not all of the museum's western works are in the institute's collection; for example, major portions of the American Indian as well as the photography collections are western in nature, and there are important

western works in the Spanish Colonial; Architecture, Design & Graphics; and Modern and Contemporary departments. I thank my colleagues in the museum's curatorial ranks for their enthusiastic response to my request to contribute essays for this publication. Their voices have helped shape this book's content and will undoubtedly prompt some readers to consider certain works as western for the first time.

Ranging from single works to larger topics, additional essays in this publication from leading scholars outside the Denver Art Museum further illuminate and expand on the art of the American West. I thank all of these authors for their willingness to assist in this anniversary edition.

Laura Caruso brought her editing talents to the project and is to be commended for her flexibility and patience while working with so many authors. As always Carol Haralson has delivered a publication design of which any museum would be proud. The Denver Art Museum's photography department, in particular Jeff Wells and Christina Jackson, contributed greatly by supplying photographs of all the works from the museum's collection that appear in this book. Curatorial assistant Nicole Parks has faithfully dedicated herself to all the programs of the institute for more than five years and has been central to the successes of the department. Karen Brooks began a new role as department assistant, taking over for Holly Clymore during this project, and they each worked diligently to shepherd this book to completion.

None of the department's accomplishments over the past decade would have been possible without a dedicated staff. I commend Joan Carpenter Troccoli and Peter H. Hassrick, who both preceded me as director; associate curator Ann Daley; curatorial assistants Mindy Besaw and Nicole Parks; and department assistants Holly Clymore and Karen Brooks. All have contributed greatly to making the institute what it is today. We are

fortunate to have devoted volunteers including Mary Willis, Stacy Skelton, Nancy DeLong, and Tobi Watson, who have given freely of their time for several years.

Major support for this publication was provided by the endowment of the Petrie Institute of Western American Art, to which dozens of individuals in the Denver community have generously donated. We wish to thank Thomas Petrie, Cortlandt Dietler, George and Beth Wood, Al and Gerri Cohen, Joe and Judy Wagner, Intrepid Potash, Inc., the LARRK Foundation, the Anschutz Foundation, Don and Susie Law, Robert Boswell, Pat Grant, the Logan family, the Moran family, Frederic Hamilton, Jim Volker, William and Louise Barrett, Patrick Broe, Nancy Petry, Mick Merelli, Paul Zecchi, Robert and Joan Troccoli, Patricia and Ralph Nagel, Chuck and Barb Griffith, Don Wolf, Tim Travis, Jon Hughes, Stephen Good, Neal and Marie Stanley, Janeen Hogan and Henry Fisk, Peter and Philae Dominick, David Kirk, Kyle Miller, Centennial Holdings, Gerald Middleton, Nick Muller, and a number of anonymous donors. Important additional support was provided by the Barnett Charitable Trust and Friends of Painting and Sculpture at the Denver Art Museum, June Stool and Evelyn Waldron in memory of Sylvan E. Stool, M.D., and anonymous donors, who helped to make this project possible.

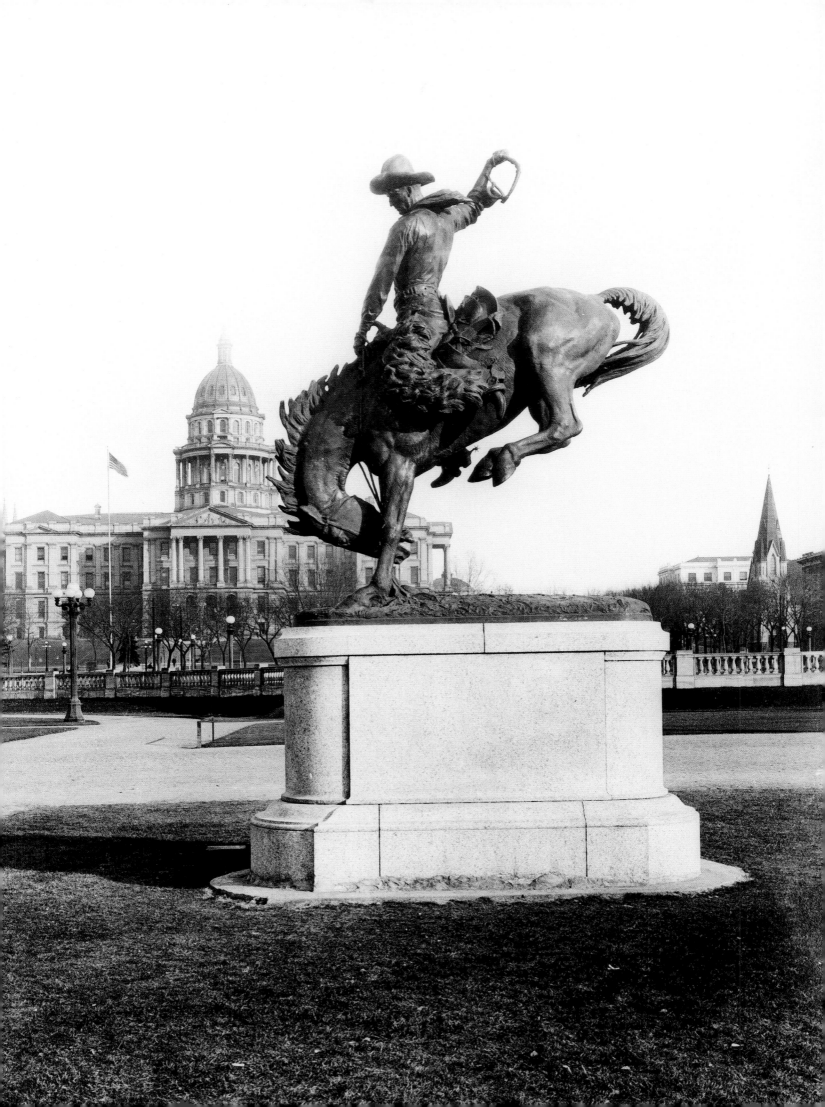

PART ONE
Staking a Claim

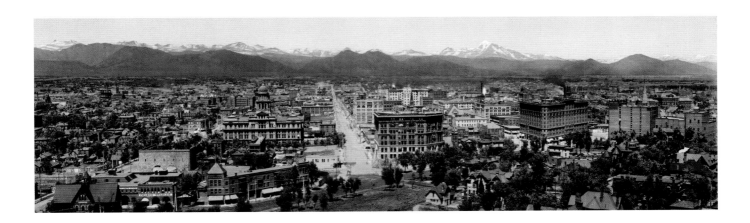

L ong boosting itself as the Queen City of the Plains, Denver took its time in staking a claim as the scholarship capital of western American art. Following in the wake of three great centers bursting at the seams with western art, the Petrie Institute of Western American Art at the Denver Art Museum appears at first glance to have arrived too late on the scene to turn up any nuggets worth assaying. Already busy covering the territory for more than half a century, the Gilcrease Museum in Tulsa (1949), the Amon Carter Museum of American Art in Fort Worth (1961), and the Whitney Gallery of Western Art at the Buffalo Bill Historical Center in Cody (1959) might be expected to have exhausted the lode. But not so. Though it may seem late in

the day, western-themed art has only recently come to be considered worthy of serious scholarly attention, thanks largely to efforts made by these and other major American museums in the last two decades.[1]

Commenting on a 2003 exhibition of Frederic Remington nocturnes organized by the National Gallery of Art, Peter Hassrick, later director of the Petrie Institute, drew attention to this evolution: "I've watched over the past 25 years as Western art has gone from sort of a 'hobby' discipline to one which has enjoyed serious scholarship." Hassrick's observation appeared in a 2003 *Artnews* article that foregrounded the fledgling Institute of Western American Art at the Denver Art Museum as a "scholarly enterprise" and singled out him and then institute director Joan Carpenter Troccoli as "among a number of Western-art experts whose efforts have

fueled serious study . . . of artists such as Remington, Russell, and Catlin."[2] Even so august a historian and self-confessed Cassandra about "the future of western art" as Brian Dippie sees plenty of room for a "younger generation of scholars" and is buoyed by the early promise of the Petrie Institute.[3]

Why, though, did it take Denver so long to make a bid for a leadership role in the study of western American art? After all, Denver is a "western city," according to both former Denver Art Museum director Lewis Sharp and museum board chair Frederic Hamilton in statements justifying the prominent positioning of western art as the first permanent collection that visitors see in the new Hamilton Building that opened in 2006.[4] Part of the answer may lie in the absence of art patrons of great wealth in Denver's early history. Isolated by the routing of the transcontinental

railroad through Wyoming, the city was described by one wag as "too dead to bury" before railroads financed by local citizens connected with the Union Pacific in Cheyenne in 1870, the same year New York's Metropolitan Museum of Art and the Museum of Fine Arts, Boston, were founded.[5]

Recalling his first trip to the West years later in his autobiography, Hudson River school painter Worthington Whittredge described the frontier city in 1866 as a "spruced up mining camp . . . Parts of costly mining machinery lay abandoned by the roadside all along the route to Denver and some pieces of this machinery were still to be seen in Denver."[6] When Whittredge accepted the invitation of Major General John Pope to join him on a "tour of inspection [of] the department of the Missouri," as the eastern portions of the Rockies and New Mexico were then called, there were "no completed railroads . . . across the plains," and the military detachment made the expedition by horseback and mule train:

> Denver was our first stopping place of more than a day or two. There we arrived at an early hour and encamped one mile from the American House, the best hotel in the place. It was a small two-storied building taken up chiefly on the first floor by a bar and a billiard room. Some brick had been used in the structure of this building; the rest of the town consisted of wooden buildings, and they were scattered about without regularity of streets. There were a great many drinking saloons and invariably they had billiard tables attached. One wondered how so many billiard tables ever got to Denver when everything from the east had to be transported across the plains by ox teams, which was very expensive.[7]

Whittredge probably found little changed on his return to Denver in the summer of 1870, this time by railcar and with friends and fellow artists Sanford Gifford and John Kensett in tow.[8]

Alexander Phimister Proctor, Denver's home-grown, nationally prominent turn-of-the-twentieth-century sculptor, draws a similarly gritty picture of the city in his autobiography. Recalling the family's new home as it must have struck him as an eleven-year-old when the family settled there in 1871, he writes:

> [Denver] was not the beautiful city it was later to become. Trappers, cowboys, and dirty-clothed prospectors were familiar sights on the few sagging wooden sidewalks. Huge charcoal wagons with many yokes of oxen filled the streets. Covered wagons were to be seen at any time of day or night. Saloons and gambling halls flourished. Frequently herds of longhorns were driven through town.[9]

But with the coming of the railroad, Denver began to take on a new look as the population escalated from less than 5,000 in 1870 to over 35,000 by 1880, almost 107,000 in 1890, and just under 134,000 by 1900.[10] During these years, the growth of the manufacturing and agricultural services industries gradually replaced the city's unstable gold and silver economies and helped soften the local impact of the 1893 financial panic and the collapse of the silver boom. The few who made fortunes during the boom years found themselves impoverished by the repeal of the Sherman Silver Purchase Act. Those already struggling to make ends meet were often left destitute.[11] Although the cascade of easterners that swelled the frontier city's head-count in the seventies and eighties lost none of their cultural aspirations in the crash, it hardly seemed a propitious time for an ambitious group of artists to take the first steps toward establishing what eventually became a permanent beachhead on the fickle sands of the Denver art scene. Even when money

had been more readily available, many enterprising schemes for enriching the community's visual art offerings through art schools, exhibitions, and museums had flourished and perished.[12]

Who could have imagined that the professional artists who banded together as the Artists' Club on the evening of December 4, 1893, at the studio of Emma Richardson Cherry would evolve into the Denver Art Museum? That evening the artists had their sights set on just one overriding objective—to enlarge opportunities for showing their work and attracting patrons. Although the constitution they approved two weeks later set out a more altruistic purpose—"the advancement of the art interests of Denver"—most of the group's energies remained focused for the next few years on an annual juried exhibition open to Denver artists and others from elsewhere who could be talked into participating. Accurately describing these exhibitions as the group's "real motive" for existence, the press reported that contributions came from "Montana, California, Utah, and Texas and other Western states where good artists are now located."[13]

By the time the group filed articles of incorporation in November 1897, its horizons had expanded to include acquiring an art collection and building a permanent exhibition space. In pursuit of the latter, perhaps more attainable goal, proceeds from the 1900 annual exhibition were earmarked for the building fund and a benefit lecture scheduled. Painter Henry Read, president of the club from 1894 to 1899, argued in the press blitz touting the fundraising lecture that the presence of such a building would fuel the city's economic development.

> To bring to Denver the best class of people, and to interest in Denver the best people of other cities, this form of what we might call solid advertising must be extended. You have no idea of the number of people in the East who are still of the

opinion that Denver is something on the order of an enlarged trading post.[14]

Although the benefit lecture was filled to capacity at fifty cents a head, Denver had to wait a quarter of a century longer before its first permanent exhibition gallery opened in a new fireproof wing of the twenty-two–room Chappell family mansion that had been deeded to the group in 1922 as a center for the creative arts.[15]

Meanwhile, the club failed to act on its 1897 goal of acquiring a collection until 1909, when the entry form for the fifteenth annual exhibition reported that $500 had been set aside to purchase one or more "prize" paintings. From an exhibition that included paintings by J. Alden Weir, William Merritt Chase, Arthur B. Davies, Irving Couse, and Birge Harrison, the selection committee chose to purchase a tonalist work by Frank Vincent DuMond, a popular and influential instructor at New York's Art Students League. By 1916, when the group stopped offering purchase prizes, the collection had grown to fifteen paintings—including ten by eastern artists; one by California painter Hanson Puthuff, a perennial contributor to the annuals; and four purchased from local artists by subscription. It is hardly surprising to find prominent eastern artists among the exhibitors at the club's annual show during these years since many of Denver's early professional artists trained in Europe and the East. As one reviewer of the 1901 exhibition pointed out, "Most of the pictures brought here are sent by their painters as personal favors to the Denver artists."[16] And there is little doubt that the contacts and aesthetic sympathies that such leading lights as Marion Hendrie, Elisabeth Spalding, and Anne Evans acquired during their formal studies and frequent excursions to the East in the late 1890s and early 1900s dominated the exhibition and collecting biases of the Artists' Club for the next two decades.[17] As might be expected, the group's early collection contained no western subjects except member Charles Partridge Adams's *Sunset in the Foothills*, purchased by subscription, and a Puthuff landscape bought as a gift to the club by sustaining member Mrs. Frank L. Woodward.[18]

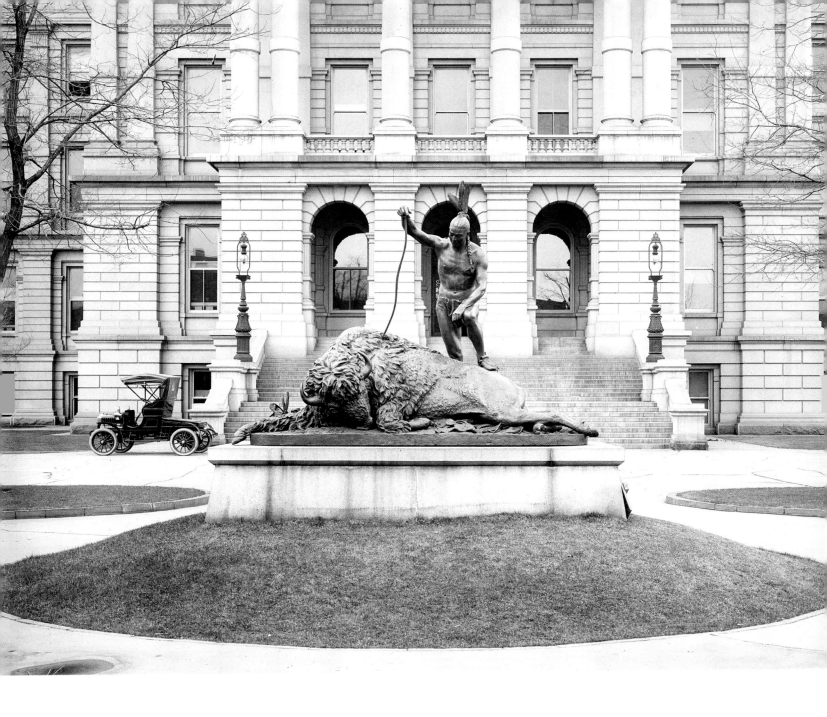

Although the Artists' Club showed little interest in pursuing western images for its painting collection, two monumental sculptural objects with western themes already presided over the Denver landscape by the mid-1910s. The earliest of these, a larger-than-life group depicting a lone Indian with one foot resting atop the carcass of a bison he had just felled, was commissioned by Denver's Fortnightly Club in the boom year of 1892 to represent Colorado at the 1893 World's Columbian Exposition before being retired to the grounds of the state capitol as a "gift from the women of Denver to their state."[19] Under the leadership of club president Eliza Routt, wife of the state's first governor, and Mrs. E. M. Ashley, vice-president of Colorado's Board of Lady Managers for the exposition, clubwomen raised $10,000 to pay sculptor Preston Powers, then head of the University of Denver's School of Fine Arts and son of the nationally famous sculptor Hiram Powers, to realize a bronze version of an abandoned sandstone project undertaken earlier for a group of real estate investors. When club members reviewed the artist's presentation sketch, Mrs. Ashley reportedly proposed that Powers be asked to change the generic features of the Indian to portray Chief Ouray, who had become somewhat of a local hero for his role in negotiating peaceful relations between the Utes and the settlers.

To those present who have lately come to make Colorado their home this may seem an insignificant change, but to the many old-timers who are present, it is an important one, for Ouray, too, was an old-timer. Twenty years ago his face was

as familiar on the streets of Denver as is now the face of our governor.[20]

Powers apparently preferred to follow the example of Augustus Saint-Gaudens's neoclassical *Hiawatha* (1871–72)[21] since the features of the finished figure bear no resemblance to the Ute leader. As an idealized type, the Indian symbolizes an entire civilization and invites viewers to share the response of Albert Bierstadt, who reportedly commended the project as a "perpetuation in bronze of a dual departing race."[22] A sentimental quatrain inscribed on the granite base drives home this reading of the artist's intention: "The mountain eagle from his snow-locked peaks / For the wild hunter and the bison seeks, / In the chang'd world below; and find[s] alone / Their graven semblance, in the eternal stone."

John Greenleaf Whittier, whose portrait bust Powers modeled for the Haverhill, Massachusetts, library in 1874, is the author of the poem and credited for the sculpture's title, *The Closing Era.*[23]

Powers's sculpture was not universally admired, however. A tongue-in-cheek article in the *Denver Republican* of May 21, 1897, traces the wanderings undertaken during the previous fall and winter months by "Mr. Indian and His Buffalo" before coming to rest in their present location on the east lawn of the building, a spot where "they can be seen only from Grant avenue and the windows of the Capitol building which face that way." According to the newspaper account, the sculpture made its first appearance at the Colfax entrance in the fall of 1896.

Everybody who saw the group said it was "out of sight." So it was, as soon as the Board of Capitol Managers managed to have it hauled into the basement of the building. There it remained, mouldering in verdigris, [when] a renascence of Indian and buffalo art set in about three months ago. Then the coat of verdigris was scoured off . . . (By the way Mr. Powers' redskin is lemon yellow): and an arrangement entered into to find an outdoor site for the pair of poor wild things.

Continuing in this vein, the author describes various stops the sculpture made in its tour of the capitol grounds as the superintendent of the capitol building and the Board of Managers sought to negotiate a site acceptable to the committee of forty "women who bought the bronze . . . in a moment of public spirit." The incident that prompted the article, tarred the Indian as a cigar store prop, and led to the sculpture's banishment to its current site is described in gleeful detail:

Somebody had tied an improvised lariat on the protruding hind leg of the buffalo, which looked a natural enough ornament. And Lo! the poor Indian, still more degraded by whatever vandal had lassooed [*sic*] the buffalo, held in his upraised hand a bunch of particularly long, stout, and ill-smelling Pittsburg[h] stogies.[24]

The second of these two early works of public art, the *Pioneer Monument,* is a sculptural fountain unveiled in 1911 on a small triangular lot at Colfax and Broadway, where it is now penned in and dwarfed by urban ugliness. In 1907, after being turned down by Saint-Gaudens, who called the suggested fee inadequate, the

Preston Powers
The Closing Era, ca. 1893
Photograph of statue, State capitol grounds, Denver, 1898
Photo by Louis Charles McClure
Denver Public Library

Frederick William MacMonnies
Presentation drawing for Pioneer Monument, 1907
Watercolor on paper, 46 x 42
Denver Public Library

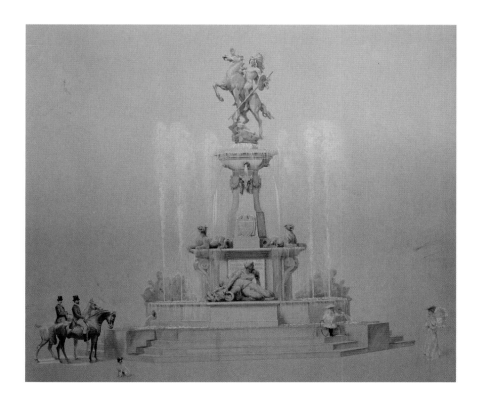

monument committee of the Denver Real Estate Exchange offered the French-based American expatriate Frederick William MacMonnies $70,000 for a suitable monument to honor "Our Western Pioneers."[25] The preliminary sketch MacMonnies sent John S. Flower, chairman of the Public Improvement Committee, proposed a tiered granite fountain adorned on the lower level with bronze figures representing typical pioneers and topped at the apex of the central shaft by a war-bonneted Indian carrying a shield and spear and mounted on a rearing horse. When Flower objected that it would not do to place an Indian in a position of eminence on a monument intended to commemorate the settlers, MacMonnies shot back that the figure was not "the hero of the occasion," but only a finial. Flower countered with results from an opinion poll soundly rejecting the original design. The controversy ended when the sculptor decided to visit Denver to correct what he finally realized was a flawed conception of the West.[26] After being wined and dined by

his hosts for two weeks and agreeing to substitute a likeness of Kit Carson for the Indian at the fountain's pinnacle, MacMonnies returned to France armed with photographs and articles of Carson's clothing and personal gear borrowed from the Colorado Historical Society.[27]

He continued to revise and refine the fountain's design for two years in accord with ongoing advice from his Denver patrons and was finally ready to ship the completed bronzes to Denver in 1911, the same year he exhibited at the Paris Salon green-tinted plaster versions of the four primary groups—a mounted Kit Carson, gesturing onward, and three seated groups representing a pioneer mother and child, a trapper, and a prospector. As described in the *Century Illustrated Monthly Magazine,* "the sculptor's aim was to sum up the sentiment of the whole western movement, "The Call of the West"— "Westward Ho."[28]

MacMonnies's trip to Denver in 1907 bore unexpected fruit. On an automobile tour of the city, he was

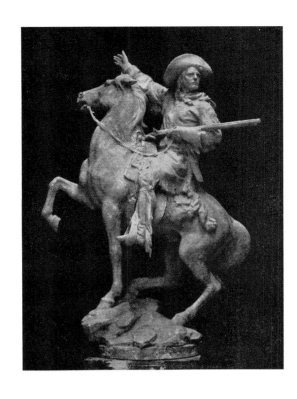

Unveiling of *Pioneer Monument,* probably 1911.
Photo by J. H. Langar
Denver Public Library

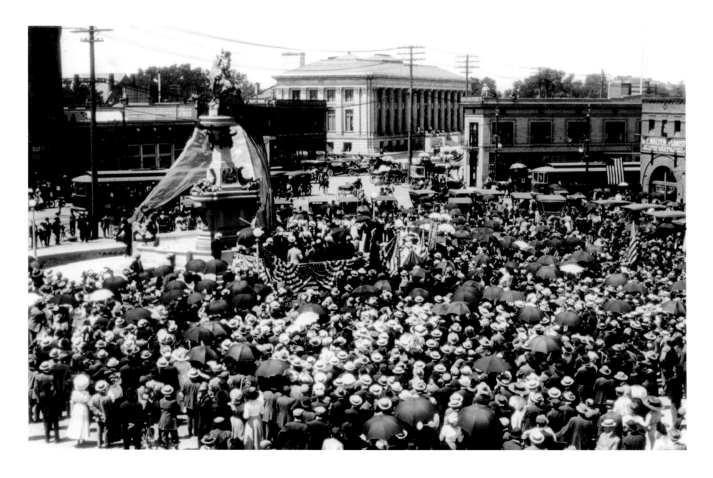

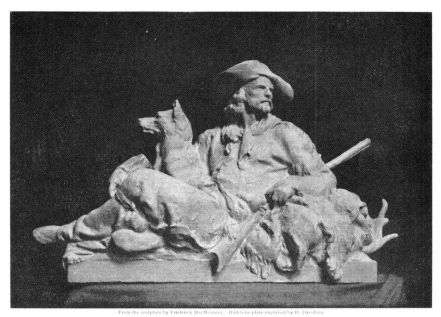

From the sculpture by Frederick MacMonnies. Half-tone plate engraved by H. Davidson
THE HUNTER

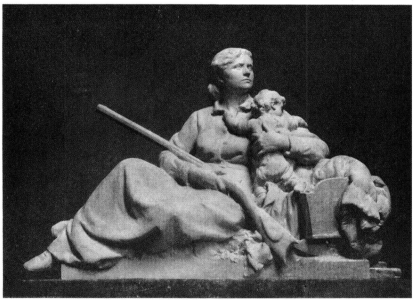

From the sculpture by Frederick MacMonnies. Half-tone plate engraved by H. Davidson
THE PIONEER MOTHER

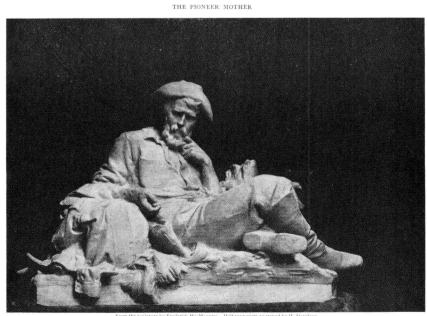

From the sculpture by Frederick MacMonnies. Half-tone plate engraved by H. Davidson
THE PROSPECTOR

reportedly inspired by the sight of "vistas of wide, clean streets, . . . splendid residences and the well balanced architecture of . . . [the] business section" to draw up a plan for a civic center that became the prototype for the succession of plans that followed.[29] By then, efforts to realize Mayor Robert W. Speer's dream for a civic center of grouped public buildings that could offer a "governmental, spatial, and spiritual" focus for city life had been underway since late 1904, when Denver's new Art Commission first recommended a master plan. Charles Mulford Robinson, author of the bible for the City Beautiful movement in America, was hired to draw up a plan that was shelved after a prerequisite bond proposal met defeat at the polls in 1906. Although the city administration approved in January 1908 a plan that the Art Commission itself came up with based on MacMonnies's cruciform design, disputes about tax districts and property assessments, as well as Speer's defeat in the election of 1911, delayed progress. A proposal by Frederick Law Olmsted Jr., again following MacMonnies's plan in general outline and approved by the Park Commission

in 1913, was also later rejected, along with successive alternatives Olmsted offered. No progress had actually been made on civic center when "Boss" Speer returned to office in 1916. His first move was to announce a "Give While You Live" campaign calculated to revive work on the center. Speer's idea was to erect a colonnade there that would inscribe the names of "Denver citizens, living or dead, who should contribute in a substantial manner to the beauty or culture of the city."[30]

Speer's vision for Denver's civic center included monumental sculptures and fountains, as well as a neoclassical municipal building at the west end of the main axis to balance the state capitol on the east, and it probably seemed to him providential when home-town-boy and animalier Alexander Phimister Proctor, whose work the mayor must have first seen at the 1893 Chicago Columbian Exposition, made a stopover in Denver in the spring of 1917. Ever the opportunist, Speer wasted no time in collaring the sculptor about recreating in bronze for his new civic center two monumental plaster staff statues that had once graced City Park. Rescued from the wholesale destruction that met Proctor's plaster animal sculptures at the close of the Chicago exposition, the popular equestrian plasters, *Cowboy* and *Indian,* had deteriorated over the years and been removed from view.[31] Proctor was obviously pleased by the mayor's overtures. More than a dozen years earlier, in reply to a letter from a boyhood chum reporting the survival and popularity of the fair sculptures and suggesting how much Denver would welcome permanent bronze versions, the artist had written:

This has been my cherished hope for years—to remodel those two equestrian statues, which were my first important work, and have them in Denver, of all places, appeals to me more than anything I know. To have them where I as a youngster used to hunt jack rabbits nearly

every holiday in the season . . . well, it would give me a lot of pleasure to do them. I am afraid Denver would think the price too high. It seems to me she is of sufficient importance now to begin to think of the artistic things. What better beginning could she make than perpetuate the Indian and cowboy, two types inseparably connected with Denver's early history.[32]

"Luckily," as Proctor put it, he had with him on the occasion of the mayor's proposal the "small model of the *Broncho Buster*" he had begun working on after the Pendleton Round-Up of 1914. As Proctor recalled what followed, Speer's "Give While You Live" campaign incentive seems to have proved instantly persuasive: "Losing no time, Speer called J. K. Mullens and Stephen Knight, two local mill owners. Mullens said that he would donate the cowboy, and Knight agreed to donate the Indian."[33]

By the end of July 1918, Proctor finished pointing up the plaster model of *Broncho Buster* to monumental size and had it ready by September to ship for casting to the Gorham Company foundry in Providence, Rhode Island. The finished bronze arrived in Denver by rail before Christmas 1919 but wasn't dedicated until December 1, 1920. Initially, Speer wanted to position *Broncho Buster* as the centerpiece of the grand plaza, but the Chicago architect Edward H. Bennett, whom the mayor brought in to draw up final working plans for Civic Center, argued that the sculpture, big as it was, still lacked the kind of scale necessary to command the space and was "incongruous" to boot. Ultimately the bronze was installed on the south end of the plaza, in front of the Colonnade of Civic Benefactors/ Greek Theater. Its cost, a mere $18,500, including pedestal and Proctor's $15,000 fee. Work on Proctor's Indian went forward at the Roman Bronze Works in New York City along with production of his cowboy in Providence, and by May 1922 *On the War Trail* was ready to set

on its granite base across the transverse north-south axis from *Broncho Buster*.[34]

Denver had already reaped rich rewards from Speer's political savvy by the time he corralled donors for the Proctor bronzes. Among the gifts and promised gifts that followed public announcement of the mayor's "Give While You Live" proposal was the painting collection of the late Junius Flagg Brown, valued at $100,000 and donated as a "perpetual loan" to the city by his heirs on December 9, 1916, on condition that a "proper structure" be provided for its display.[35] The Brown gift raised Artists' Club hopes for a permanent home on Civic Center as well as official recognition as the proper group to oversee the art donations pouring into the city. Neither hope was to be realized for many years although the club took a major leap in its transformation to a museum on February 15, 1917, when it filed a new certificate of incorporation with a name change that signaled its broadened scope and ambition. But what's in a name? Recognizing that the new Denver Art Association's interests needed full-time supervision, members voted to hire a professional director at the same annual meeting that emended the club's name.[36]

Although club member Marion Hendrie recruited Reginald Poland to fill the post almost immediately, his arrival was delayed for two years by his enlistment for duty in April 1917 on the eve of the U.S. entry into World War I. The son of a prominent Brown University art historian and museum director, the young Poland had impeccable credentials of his own, and, once on the scene, he more than fulfilled the association's expectations. From the time of his first address to the association at its April 1919 annual meeting until the end of his two-year tenure, he worked tirelessly to help the group secure a coveted home on Civic Center.[37] Despite his conventional eastern upbringing and training, it's not surprising to find Poland adopting the cause of contemporary artists and

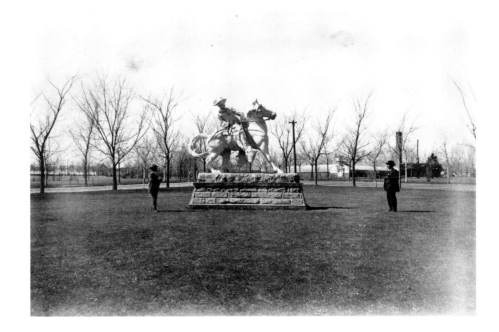

western themes when we consider that one of his instructors at Princeton was the eminent and often maverick scholar, critic, and museum director Frank Jewett Mather Jr., an early partisan of the Armory show and a vocal advocate for American art as a scholarly subject.

Among the artists Poland promoted while in Denver were Proctor and Allen Tupper True, two local products who had made the big-time, as well as prominent transplants from the East who had adopted the Southwest as their base and muse. A few months before leaving to take up his new duties as education director at the Detroit Institute of Arts, for instance, we find him writing to urge members of the Taos Society of Artists to contribute "eight pictures" to the association's 1921 annual spring exhibition. The letter expresses the association's willingness to "pay insurance and transportation on this number of pictures." The members of the Taos Society were apparently already familiar with the Denver Art Association's exhibition program since the opening sentences of Poland's letter to Walter Ufer, secretary of the society, suggest that Ufer actually solicited the invitation to participate in the association's 1921 annual: "I have your

letter of the 24th inst. And thank you for it. We would surely like one of your pictures for our exhibition and also at least one of Mr. Blumenschein's."[38] And, of course, Poland was well aware that Denver audiences would warmly welcome more paintings from the Taos Society of Artists, whose Indian-themed paintings had appeared there in 1918 in a special exhibition sponsored by the association.[39]

Closer to home, Poland exercised a strong voice in support of western-themed public art in Denver. Perhaps in response to persistent doubts about the appropriateness of Proctor's subjects to their neoclassical setting, Poland used his official clout to offer the opinion that the installation of *Broncho Buster* (1920) and *On the War Trail* (1922) would "give life to the rather formal, classic architecture" of Civic Center. In an article titled "Artistic Expression in Denver" for the September 1920 issue of the city's promotional bulletin, *Municipal Facts Monthly,* he argued that "local color has not been sufficiently apparent in material form until recently," and that Proctor's two sculptures would leave tourists and visitors with an indelible impression of "the essential spirit of the city and the

region." A few paragraphs later, after a lengthy and detailed aesthetic analysis of True's murals for the Civic Center library, Poland sounds the same note again. "As in the case of the Proctor Equestrian statues," Poland insists, the western theme of True's recently installed murals for the open-air niches of the Greek Theater (*Prospector* and *Trapper*) "ties up the architecture of Civic Center with the life of the state."[40]

Poland's review of Denver's public art treasures for *Municipal Facts Monthly* claimed that the city has mural paintings that "rank well up toward the level of the best in America"—a claim that was no doubt buttressed by the boost to True's standing that an American Federation of Arts tour brought with it. As the professional in charge of the Denver Art Association's September 1919 showing of True's work that the AFA picked up for touring, Poland was asked to contribute an article to the AFA monthly journal, *American Magazine of Art*.[41] Here, True's authenticity as a western artist earns Poland's highest accolades:

He seems an essential part of the spirit of his native western land. And through the medium of his painting

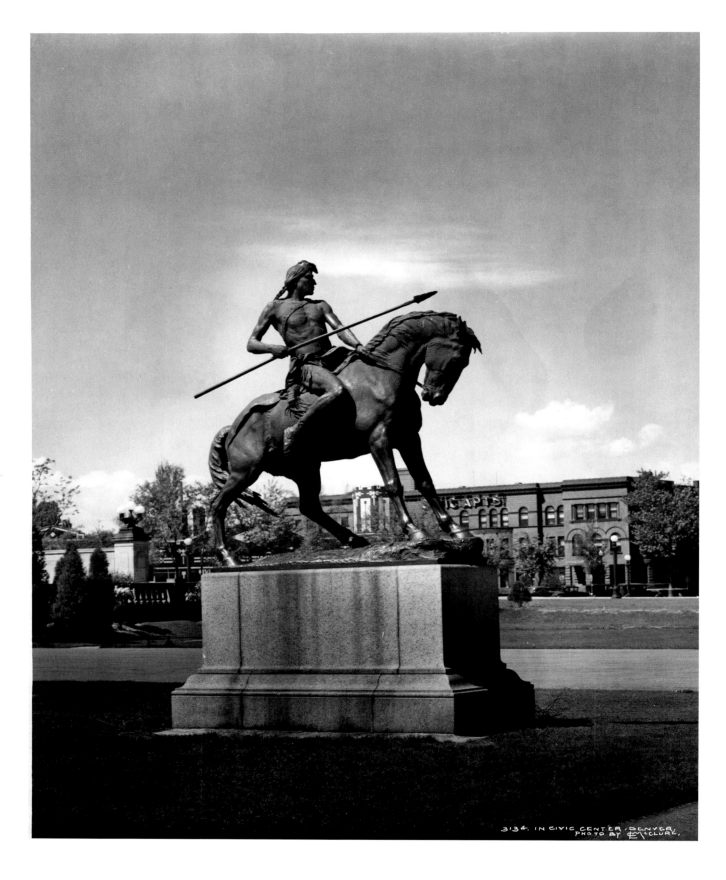

Alexander Phimister Proctor
On the War Trail, 1918–21
Photograph of monument in Civic Center,
Denver, between 1932 and 1935
Photo by Louis Charles McClure Denver Public
Library, Western History Collection

he expresses this same spirit. He has the frankness to say only what he feels. Therefore we get a satisfying message from his pictures of pioneer days in the vast plains and rugged mountains."[42]

In describing *Strays* and *The Pack Outfit,* two easel paintings in the AFA exhibition, Poland dwells on their subjects. The formal qualities of the works take a back seat:

Both [paintings] bring out the important figures clearly against the maze of indistinct and subordinate background of vegetation. The unconsciousness of these men on whose paths we have suddenly come gives us an insight into the real life of the pioneer. The beauty is deeper than pose and dress, catching the spirit of men prepared for any emergency. *Incidently* the composition and balance of tones satisfies.[43] (italics added)

Although he writes glancingly of True's aesthetic means, such as his interest in the "harmony of color," and somewhat more fully of the influence of Puvis de Chavannes and Japanese prints on True's flattened picture space, Poland returns time and again to True's subjects: "For whatever purpose he paints, he presents his beloved West."[44] In speaking of True's recently approved sketches for the Greek Theater, it is again the artist's narrative skill that grabs the critic's attention.

"The Prospector" with the Pan eager for the sight of gold and "The Trapper" entering the mysterious shadow of the woods tell a story as simple as [his murals for the Wyoming state capitol]. And they have a relation to their setting, a colonnade.[45]

Months later, in his *Municipal Facts Monthly* article, Poland devotes more space to the "exceptional qualities" of the Greek Theater murals as "works of art."

One particularly artistic feature is the motif of the tree trunks. In vertical lines and cylindrical forms they not only in themselves have architectural character, but they reflect in natural form the constructed columns of the theatre itself. Singularly fitting also is the indicated depth of the woods. Being on a curved surface, a two-dimensional picture would tend to neutralize the concavity. Thus these murals have correctly sensed the particular problem of setting and have successfully solved it.[46]

But his prose takes flight in praising True's narrative evocation of the spirit of the West:

In the graceful aspen woods a man stoops by the trickling stream to sift the gold from the sand. What could more naturally or simply tell the tale of the hopeful adventurers who first settled in the state to eventually build up a prosperous civilization?[47]

Poland's *American Magazine of Art* article ends with a prediction that True would reach ever "greater heights"—a forecast borne out by the abundance of murals he eventually installed in the public buildings of Colorado, including the state capitol, and in a number of other state capitols, including those of Wyoming and Missouri. His rank as the region's premier muralist was celebrated in *Allen True's West,* a tripartite collaborative exhibition mounted in October 2009 at three Denver institutions: the Denver Public Library, which focused on True's early work in illustration; the Denver Art Museum, which showed examples of his easel paintings; and the Colorado History Museum, which explored his murals.[48]

A lifelong supporter of Allen True's work, Anne Evans was emerging as a powerful force in the Denver art community when she bought his first "mural." Although True apparently regarded it as a mural and included it

in his "Record of Mural Decorations," by today's standards the painting he exhibited in the Artists' Club 1911 spring exhibition and sold two weeks later to Evans for $500 was too small at fourteen by forty-six inches to deserve that designation. So far as we know, too, the painting was not conceived originally for any specific architectural space, even though Evans had it installed in a niche in the stonework fireplace wall in the living room of the mountain cabin she had built near Evergreen in 1911.[49] As president of the Denver Library Commission from 1910 to 1914, Evans was in a position to give True a leg up in his early career as a muralist with a succession of library commissions: the first for a group of lunettes for Dickinson Branch Library completed in April 1913; the second for *Commerce of the Prairies,* an almost square eight-by-eight-foot canvas finished in ten days for the Warren Branch in September 1913; and the third an agreement signed in October of the same year to produce "drawings and sketches and a comprehensive plan for the complete interior decoration" of the library's Civic Center building that opened in 1910. The contract signed by Evans as president of the Library Commission specified that True was to be paid $250 on signing, $250 on delivery of the preliminary drawings, and, for personally overseeing the installation of the decorations, up to a total of an additional $5,000.[50]

Any history of art in Denver and especially at the Denver Art Museum would be incomplete without recounting Anne Evans's contributions. When she stepped up to act as interim director until a successor could be named for the museum's failed experiment with an administrative team in 1929, the *Denver Post* described Evans as having "nurtured the Denver Art museum as some housewife would care for a hothouse plant." Less condescendingly, the *Rocky Mountain News* called her a "moving spirit in artistic affairs in Denver."[51] One of her

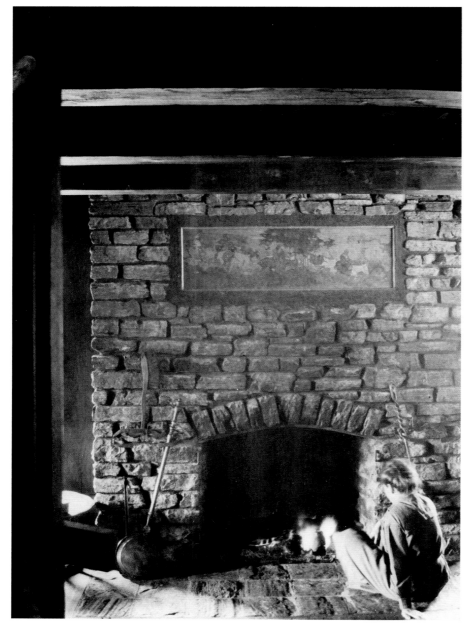

Anne Evans at the time of her 1937 dispute with Mayor Benjamin F. Stapleton over the design of a proposed Civic Center memorial to Robert W. Speer. Photo courtesy of History Colorado (Denver Post Historical Collection, 10038585). Left, living room of Anne Evans's cabin, showing Allen Tupper True's *The Trappers*, 1911, visible above the fireplace. Photo courtesy of Margaret E. Hayden.

most significant benefactions on behalf of the Artists' Club put it in possession of its first long-term home on Civic Center, a space it was to occupy from 1910 until 1925. Recalling many years later the Artists' Club's move to elegant quarters in the Civic Center library when it opened in 1910, founding club member Elisabeth Spalding credited Evans with working out the arrangements: "We knew at the time how much we owed to Anne Evans, whole-hearted member that she was of both Library and Artists' Club Boards."[52]

It seems ironic that Evans was very likely set on her path as a dominant force in Denver cultural affairs by the sort of political wire pulling she herself deplored in heated argument with Mayor Benjamin F. Stapleton in 1937 over the design of a proposed Civic Center memorial to Mayor Speer: she was quoted in the press then as saying "the art commission must be kept free of politics and political wire pulling [and] civic center of sculptured atrocities."[53] Today Anne Evans's name is seldom mentioned without dragging in a reference to her father, John Evans, second governor of Colorado Territory. But John Evans died in 1897, and rarely is his daughter's name linked to that of her older brother, William Gray Evans, the "boss of Boss Speer."[54] It was

undoubtedly William's political clout that spurred Anne's early appointments to public office by Mayor Speer—to the city's Art Commission in 1904 and to the Public Library Commission in 1907. Because it's impossible to fault her devotion to civic and cultural causes, little notice has been paid to Anne Evans's own cronyism, as in the case of Allen True, or to her preferential treatment of personal enthusiasms, exemplified by the agreement that allowed the Artists' Club to take over a choice location on Civic Center.[55]

Anne Evans's wide travels throughout the Southwest beginning early in the 1900s colored her collecting interests and left an indelible mark on the character of the Denver Art Museum for many decades.[56] Despite the willingness of the fledgling museum to accept almost anything and everything donors offered—from dolls made for

Cartoon of Anne Evans's brother, William Gray Evans, as "the boss of Boss Speer." Reproduced in *William Gray Evans 1855–1924* by Allen D. Breck (Denver: University of Denver, Department of History, 1964), 56. Denver Public Library. Top right: Frederic Douglas looks over the museum's collection of American Indian women's clothing. Right: He introduces volunteers modeling clothing from the collection in one of the Indian fashion shows he narrated at museums acrosss the country during the forties and fifties.

the tourist trade to a collection of more than five hundred ceramic elephants—the move toward specialization began early, soon after the Denver Art Association changed its name to the Denver Art Museum in 1923. Evans's own 1925 gift of a group of American Indian objects originally installed in her cabin near Evergreen set what seems in retrospect a well-calculated, as well as visionary, precedent to collect regional material. In October of the same year the trustees authorized a note at 6 percent interest to buy a collection of forty-six Navajo textiles, the museum's first major purchase.[57] Six months later, spurred by a successful exhibition of Indian loan materials that brought to light the breadth and depth of local private collections, the board voted to devote a room in its Chappell House quarters to a permanent exhibition of its Indian holdings.[58] Before 1926 was

out, Evans made a formal request to be made head of a standing committee to "upbuild a fine Indian Art Collection." In 1928, the Indian Art Committee launched a permanent interest group of patrons to study and enlarge the collection. And in 1930, during her short tenure as interim director, Evans passed the torch to Frederic (Eric) Douglas, son of her close friends and fellow Indian art enthusiasts, by promoting him from his role as salaried docent to the post of first full-time curator of a department of Indian art.[59]

Anne Evans was not alone in championing American Indian art in the 1920s, especially Pueblo watercolor painting, which was much sought after by collectors nationwide for its unique Americanness. In 1919, for instance, Mabel Dodge Sterne (later Luhan), an influential member of the Anglo art community of Taos, bought

the entire contents of a exhibition of Pueblo paintings mounted at the Museum of Fine Arts, Santa Fe, the first such exhibition anywhere. In New York the following year, the Society of Independent Artists exhibited a selection of paintings from her purchase, along with loans from the Museum of New Mexico.[60] Other prominent collectors included Ima Hogg from Houston and Leslie Van Ness Denman of San Francisco, who, like Evans, made almost yearly pilgrimages to Santa Fe in the 1920s.[61] Painter John Sloan, introduced to the genre during his first visit to New Mexico in 1919, was so taken that he wrote to Edgar L. Hewett, head of the School of American Research in Santa Fe, that this is "the only 100% American art produced in this country."[62]

Fairly early in the twenties, American Indian art began to be viewed by the art world as fine art, rather than as artifacts

The Helen Dill Gallery, City and County Building, ca. 1940. Denver Art Museum photo.

or curios. In 1922, for example, Amelia Elizabeth White opened the first Indian art gallery in New York on Madison Avenue and distributed her large collection of paintings, pottery, textiles, and jewelry to American art museums in the 1930s.[63] Evans's own large collection of Pueblo watercolors was exhibited at the Denver Art Museum in 1927 and a selection at the Museum of Fine Arts, Boston, in 1929. She gave 110 Pueblo paintings to the museum in 1932, the same year that 47 of them were featured in a limited-edition portfolio, *Pueblo Indian Painting,* published in France with an introduction by Hartley Burr

Alexander, noted expert on Native American literature, philosophy, and aesthetics, who had given two Cooke Daniels lectures at the Denver Art Museum in 1927.[64]

Evans's efforts to focus the collection on Indian art succeeded only too well. When Eric Douglas began his curatorship in May 1930, the museum had assembled 550 Indian pieces.[65] In 1947, three years after his 1944 appointment as museum director, Otto Karl Bach presented a comprehensive reorganization plan that estimated the Indian collection at between ten and fifteen thousand objects and noted

that, of these, half belonged to Douglas personally.[66] By that time it had become obvious that the Indian art department, with its own building and Douglas's privately funded staff, was taking on the character of a separate museum. As Jean Chappell Cranmer pointed out to her fellow trustees in March 1945, "Everything had been concentrated [in the Indian art department] for a long time, [and it seemed] wise to equalize the various departments." The new museum director had his work cut out for him.[67]

By the time Bach arrived on the scene, the museum had taken advantage

of the city's impending loss of the Brown painting collection to claim gallery space on the fourth floor of the Municipal Building when it opened in 1932 and to jockey into position as Denver's official art agency.[68] The allocation of galleries in the new quarters says much about the non-Indian holdings at the time: two of the nine rooms were assigned to old master and contemporary painting; two each to period furniture and to Japanese and Chinese ceramics, bronzes, prints, and paintings; one each to works on paper and to American colonial textiles and household furnishings; and a tiny space to southwestern folk art. So that visitors could see the whole sweep of the collections, the original plans were expanded to include a gallery for the display of a selection from the American Indian collection, which still occupied Chappell House as its main venue.

A bequest from Helen Dill, left to the city at her death in 1928, brought the museum its first sizable windfall for acquisitions, which, after much debate, was shrewdly spent by Donald Bear during his tenure as director (December 1934–January 1940) for a group of thirty-seven "near contemporary" late-nineteenth- and early-twentieth-century French and American works. Many of these, like Monet's *Water Lily Pond* (1904) and Winslow Homer's *Two Figures by the Sea* (1882), figure among the museum's current treasures.[69] Bear's purchases also included Allen Tupper True's *A Wanderlust Memory* (about 1912) and *New Mexico* (1926) by Thomas Hart Benton (page 109) —perhaps the first significant non-Indian western paintings to enter the collection. Aside from the Dill bequest and a $25,000 bequest from Dora Porter Mason in 1942, acquisition funds were almost nonexistent. Collection growth continued at a snail's pace, its character defined by the personal enthusiasms of donors.

Bach chose early on to ignore the well-meaning advice of Henry Francis Taylor, then director of New York's Metropolitan Museum of Art, who advised him to focus collecting efforts on western art since it was already "too late to build top quality collections [when] all the good things were already taken." Similar advice had been handed down by the Met's curator of painting Bryson Burroughs on a visit to Denver in 1930. Arguing that "every museum should be a record of the life and thought of the city and region in which it stands," Burroughs praised the museum for "making hay while the sun shines" by snapping up Indian art while it was still affordable. Trying to assemble an encyclopedic collection like the Met's would be a mistake, he added, "when you have a field out here so completely your own."[70] Acknowledging in his 1947 reorganization plan that larger, more established museums warned small museums like Denver's not to aim for a comprehensive collection and admitting that it would take eighty years at the present rate of growth to put together a "well-rounded, top-flight collection comparable to those of Kansas City, Toledo, Cleveland or Buffalo," still Bach persisted.

Looking back on his Denver career in 1964 after twenty years on the job, Otto Bach talked at length about his decision to give Denver an encyclopedic collection of world art.[71] But collection goals were apparently low on the list of priorities he set in his reorganization plan of 1947, which created four administrative divisions and laid out ways the museum could make art "part of everyday life." Bach's administrative divisions—living arts, historic arts, education, and administration—reduced the Indian and native arts department to one of four within the historic arts division, along with Asian, Mediterranean and European, and American art.[72] It was the first salvo in a power struggle that was to continue until Douglas's death from cancer in April 1956.

By the time he set up a separate department of western American art in 1955, Bach had subsumed the Indian art department into a new department of native arts and divided Mediterranean and European art into two distinct departments.[73] As late as January 1956, just four months before his death, Douglas was still protesting what he considered the relegation of the Indian collection to the status of second-class citizen within the native arts department. In a letter to Bach responding to a draft agreement concerning the disposition of his anthropological library of some thirty thousand volumes, Douglas wrote:

> I dislike the use of the term "Native Arts," [which] is in line with what is to me an unfortunate tendency in the museum to lose track of the term "Indian Arts" by lumping it under the heading "Native Art." Today, much of the fame and repute of the Museum rests on the very fact that it has this distinctive department. I object to throwing overboard a feature which has set us apart from the bulk of American museums.

In his determination to turn the museum into something other than a stand-alone museum of Indian art, Bach had by then also greatly reduced the size of the Indian art collection through sale and exchange of "near duplicates and lesser materials," a program in which Douglas had willingly participated, and one that Bach beefed up after Douglas's death the next year.[74]

Bach announced his intention to create a department of western American art at the museum's annual meeting in February 1955 in terms that suggested his motive had less to do with his interest in featuring a new collecting area than in a building to house it: "[The museum] will begin work on a new department of Western American art which will feature a major exhibition in the fall, with the ultimate goal of a new building in which to house the Americana."

Although the department was put in place in July, it was not until August

that Bach made a more detailed public announcement. His August 28 *Rocky Mountain News* column introduced Royal B. Hassrick as the curator of the new department; credited the Boettcher Foundation, the Frederick G. Bonfils Foundation, and the Lawrence Phipps Foundation for "educational" funding; and laid out plans for the department's inaugural exhibition that fall, *Building the West*. Significantly, Bach listed among the department's work load the task of making "plans for new galleries to house the growing collections."

> Following the exhibition the new department will begin its work of augmenting the present Art Museum collections in this field, finding and recording works held in private collections in the area, developing new exhibitions, lecture programs and consulting services, and beginning plans for new galleries to house the growing collections of this department.

By then, despite resounding bond issue defeats in 1947 and 1952, Bach and his board had managed to create a serviceable museum complex by acquiring property on the block just south of Civic Center and cobbling together a group of remodeled buildings and even one entirely new structure, whose construction had been mandated by the terms of the promised Kress Foundation Collection.[75] Nonetheless, Bach and the trustees had their sights set on further expansion, and the new collecting focus, like the Kress Collection, gave urgency to the building program. Museum president George Berger Jr. appealed to local pride in offering a rationale for the new emphasis on western art in an interview reported in the October 6 issue of the *Rocky Mountain Herald:*

> The need for a department concentrating on regional and native art has become increasingly apparent as a result of Denver's own expansion as a major city, and the growth of interest by the people of the region and the nation in this part of the national heritage. We have long realized that this field in which we should be paramount, is one in which we are deficient.

The article listed just two objectives of the department: second only to assembling and exhibiting a collection was "the creation of a large building to be incorporated with the present museum buildings in the block south of Civic Center for the display and preservation of regional Western art, as well as the American Indian and native art collections." The three foundation grants, readers were told, would be used "to survey and catalogue available materials and existing collections, to develop preliminary architectural plans, to hold a special exhibition, and to employ a curator."[76]

Bach's plans to assemble a long-overdue western art collection seem in retrospect calculated to inspire the same kind of enthusiasm for a new building that the promise of a Kress collection of Renaissance works had elicited three years earlier. And his proposal to consolidate the western American collection and the American Indian and native arts collection under one roof, coupled with Eric Douglas's battle with a terminal illness, may have influenced Bach's choice of Royal B. Hassrick as a western art curator capable of heading

1964 aerial view showing museum block with the renovation and construction program completed in 1956. Denver Art Museum photo.

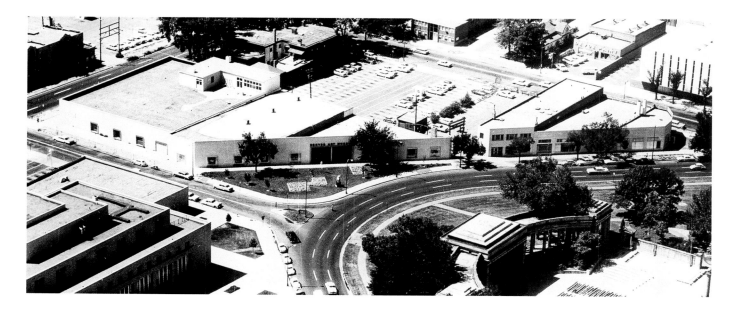

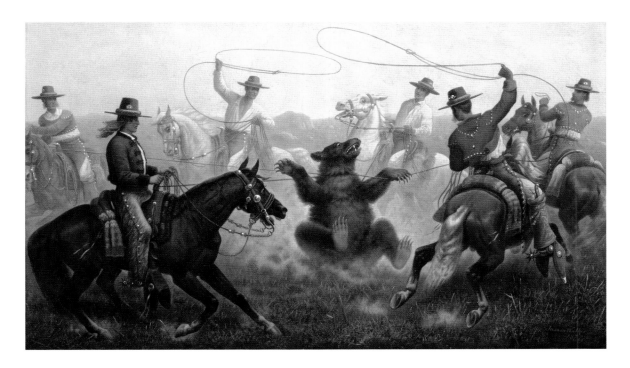

James Walker
Cowboys Roping a Bear, ca. 1877
Oil on canvas, 29 x 49
Denver Art Museum, Fred E. Gates Fund, 1955.87

up the "Americana" department he envisioned. Thirty-eight when Bach hired him, Hassrick was a trained ethnologist whose career focused on American Indian concerns. In 1944, while only twenty-seven, he published an article on the Teton Dakota kinship system in *American Anthropologist.* From 1948 to 1952, he served as curator of the Southern Plains Indian Museum for the U.S. Department of the Interior in Anadarko, Oklahoma, and from 1952 to 1954 worked as assistant general manager of the Indian Arts and Crafts Board for the Department of the Interior in Denver. As it turned out, of course, Bach's building strategy failed definitively, and by 1960 he had buried the western art department under the more inclusive "American" label, with Hassrick now designated as curator of American and American Indian art in the museum's winter quarterly of that year, *Indian Art of the Americas.*[77]

The museum's new department of western art did, however, get off to a flying start with the nation's second ever major exhibition of western American art.[78] *Building the West* was a major loan exhibition of 115 paintings and sculptures drawn from museums, dealers, and private collections nationwide and supplemented by thirty-six additional objects, primarily Indian, from the museum's own collection. Both Arthur Fitzwilliam Tait's *Trappers at Fault* and James Walker's *Roping a Bear* (now called *Cowboys Roping a Bear*), purchased for the collection later that year, appeared in the show on loan from New York dealers. Royal Hassrick and Bach's wife Cile wrote a thirty-two-page catalog that was published as the museum's October quarterly. *Western Heritage* followed in 1958, "part of the Denver Art Museum's contribution to the Centennial Year" and one of a continuing series of exhibitions tied to the programs of the Denver Public Schools.[79] *Long Jakes, "the Rocky Mountain Man,"* by Charles Deas, acquired by the museum in 1999 and now one of the signature works in its western American art collection, made its Denver debut in this exhibition of almost forty years earlier, although in a version later recognized as a copy by an unknown artist.[80]

The new emphasis on western American art resulted in a series of exhibitions and the purchase of a handful of major paintings over the next few years, but any hopes Bach harbored of jolting western art enthusiasts into supporting a new building campaign soon fizzled. It was not until the boom years of the mid-1960s that the trustees gave the go-ahead to a fundraising campaign for a new building on the museum block—one large enough to centralize all the departments and programs. From that moment until the high-rise building designed by Gio Ponti and James Sudler opened on Civic Center in October 1971, Bach's energy was divided between the design and construction process and efforts to enlarge the breadth and depth of

the collection in ways that would give it the balance and substance it needed to fulfill his dream of decades earlier. Bach was especially successful over these years in winning title to sizable collections of works in the European tradition: the Charles Francis Hendrie Memorial Collection of late-nineteenth- and early-twentieth-century paintings and sculpture (1969), the Simon Guggenheim Memorial Collection of Renaissance paintings and sculpture and English decorative arts (1952–70), the Frank Barrows Freyer Memorial Collection of Spanish colonial art from Peru (1969), and the T. Edward and Tullah Hanley Collection of nineteenth- and twentieth-century European and American art (1974). During these same years, Bach's long-standing ambition for a rounded sampling of Asian art claimed new geographic and stylistic territory with the addition of two large collections of sculpture from India, Cambodia, and Nepal.[81]

There can be no doubt that Bach's refusal to follow the advice of his eastern colleagues to collect regionally meant that the museum had lost its once-in-a-lifetime opportunity to assemble a great western American art collection that could rival those of Fort Worth's Amon Carter Museum, Tulsa's Gilcrease Museum, Cody's Whitney Gallery of Western Art, or Omaha's Joslyn Art Museum. He had, however, created an encyclopedic art museum whose "fame and repute" did not, as Frederic Douglas had boasted in 1955, rest primarily "on the very fact" that it had an Indian art department, or even an Indian and western American art department. Given his meager means, Bach's success in expanding the scope and comprehensiveness of the collections during his thirty-year tenure is astounding. Although western American art fans might bemoan his priorities,[82] he possessed an uncanny ability to enlist support from all quarters. A great believer in volunteerism, Bach made much use of unpaid honorary curators and research associates over the years,[83]

and among these was Patricia Trenton, a budding art historian who eagerly took on the task of presenting and promoting western art while Bach focused his sights elsewhere.[84] Starting as a research associate in 1967, Trenton earned her spurs as honorary curator of American art in 1972 and accolades from new director Tom Maytham in the museum's 1974 annual report.

Of greatest impact upon the [American art] department was the departure of Patricia Trenton for the Los Angeles area . . . in the late fall. In her eight years here, Pat had been a dynamo of energy and had done an immense amount of good for the department and the museum. Her enthusiasm for western American art had resulted in her encouragement of Bob Rockwell to lend large numbers of fine paintings in this field. She also marshaled the support of hundreds . . . to form Art Americana. She organized several major exhibitions of art related to the western American or southwest area, of which *Taos and Santa Fe* was only the most recent . . . Her departure leaves a very substantial gap in our curatorial ranks, and her generosity in serving as honorary curator without compensation is only one of her gifts to the museum. The current planning process is expected to reveal our overall curatorial needs and help to define the optimum direction for gaining the expertise in American arts that we need to build upon her achievements.[85]

Things, obviously, were not so bleak for Denver's western art advocates during Bach's building years as is commonly supposed. *The Western Frontier* exhibition of 1966 rivaled 1955's *Building the West* in its ambitious sweep and weight, with Russell's *In without Knocking* and Remington's *Half-Breed Trapper* on loan from the Amon Carter Museum of Western Art

and other important loans like Seth Eastman's *Sioux Indians Breaking Up Camp* (Museum of Fine Arts, Boston) and John Mix Stanley's *Indians Playing Cards* (Detroit Institute of Arts).[86] Like *The American Panorama* exhibition that followed in 1968, *The Western Frontier* satisfied two museum objectives:

First, during the period of construction of the new building, when so much of the permanent collection is in storage, it is desirable to incorporate our own material objects into temporary exhibitions. Second, the loan material will demonstrate certain gaps which exist in the Denver collections and may point up important goals for future acquisitions.[87]

Trenton's impact began to be felt in 1972 when she scoured local collections to assemble an impressive group of paintings and sculptures for *Colorado Collects Historic Western Art: The Nostalgia of the Vanishing West,* an exhibition that ran concurrently with the January 1973 National Western Stock Show and a small, but important, companion exhibition of twenty paintings by George Catlin from the Smithsonian. Rallying participation and support for these exhibitions uncovered a legion of western art fans and inspired the creation of Art Americana, whose primary purpose was to raise funds "to develop an ever-expanding visual panorama, ranging from Colonial times through the dramatic period of western expansion."[88] Trenton's ambitious *Picturesque Images from Taos and Santa Fe* of 1974 earned an extended review in *Artnews* and bested Van Deren Coke's 1963 exhibition, *Taos and Santa Fe: The Artist's Environment, 1882–1942,* its only forerunner in the field, by including ten large photomurals of the New Mexican environment among its 115 assembled paintings. In his *Artnews* review, Denver stringer Duncan Pollock made much of the way these murals by local photographer James Milmoe conveyed,

vicariously, the powerful effect of the environment on the artists and their art.[89]

Bach ended his tenure proclaiming the museum's "long and distinguished history of presenting art of the western United States" in the foreword to the *Colorado Collects Historic Western Art* catalog, and Trenton's efforts raised high expectations for the future. But a new director meant a change in direction. Under Thomas Maytham, who took over the helm from Bach in June 1974, the trustees soon forged a new collections policy and collecting plan that replaced Bach's omnivorous collecting appetite with a focused approach that singled out contemporary American art for special growth.[90] Feeling more urgency to find an experienced contemporary art curator than one in his own area of expertise, Maytham hired an assistant in the American department who would work under his guidance and launched a nationwide search for a curator of contemporary art. As a former administrator of the American department at the Museum of Fine Arts, Boston, Maytham's personal bias toward eastern subject matter meant that western art fell a bit by the wayside.

Already on the exhibition schedule when Maytham took over, *Frontier America: The Far West,* a huge traveling exhibition organized by Boston's Museum of Fine Arts to celebrate the American Bicentennial, played Denver in 1975. Hardly designed to appeal to the average western art aficionado, its goodly assortment of photographs and well-used household objects and implements brought home the harsh reality of pioneer life and gave an unusual dimension to the romantic landscape paintings also on display. It wasn't until almost two years later, just in time for Denver's 1977 stock show, that western art fans would find fifteen paintings more to their liking on view in the tiny, first-floor Discovery Gallery: *Western Masterpieces from the Buffalo Bill Historical Center* featured the only

works by American artists selected by the deputy director of Russia's Hermitage for inclusion in a cultural exchange exhibition of fifty paintings from American museums organized by Armand Hammer for the Bicentennial.[91] It is quite probable, however, that this exhibition of masterpieces from a museum in a town of five thousand in the neighboring state of Wyoming merely inflamed the frustrations of western American art supporters. Aside from Robert Rockwell's long-term loan of thirty-one works by artists like Russell, Remington, and Charles Schreyvogel, which continued to bring a western dimension to the third-floor American galleries, and a 1979 showing of *The Way West,* the Northern Natural Gas Company's collection of Karl Bodmer's 1832 expeditionary watercolors, western art seemed low on the museum's agenda.

In 1980, however, the board placed a new priority on the collection and exhibition of western art. Half of the third-floor American galleries were remodeled and given over to a continuing parade of western exhibitions under the command of Ann Daley, who was promoted from assistant in the department to curator of American art and charged with raising the profile of western art. Her first efforts turned the spotlight on Denver collections and were followed by *Masterworks from the Whitney Gallery of Western Art,* selected with advice from Peter Hassrick, then curator of the Whitney, as well as director of the Buffalo Bill Historical Center in Cody. Daley also oversaw the 1981 local showing of *Charles M. Russell: The Frederic G. Renner Collection* organized by the Phoenix Art Museum, as well as an Andrew Dasburg retrospective from the University of New Mexico. That same year, she worked closely with guest curator Peter Hassrick and the museum's associate director, Lewis Story, to organize and mount *Frederic Remington: The Late Years,* for which Hassrick, a Remington expert, wrote

the catalog. Assembled from private and public collections nationwide, the exhibition attracted kudos from scholars and collectors across the country and provoked a thoughtful column on "Denver's potential to become a Western art center" from Bill Hornby, editor of the *Denver Post.*

Hornby found himself pondering the same problem thirty years ago that has engaged us here: why had Denver, "the easily recognizable capital of the Rocky Mountain West, at least on a size and wealth basis, . . . never developed as a leading center of Western art"?[92] The subtext of Hornby's answer belies the city's status as a financial powerhouse, for he laid at least part of the blame for the collapse of "several well-meaning plans to put Colorado on the Western art map" on "the tremendous costs of building a new museum, to say nothing of acquiring meaningful art." Having described then-Governor Richard Lamm as a "fan and scholar of Western art and history," Hornby implied that it was money again, or the lack thereof, that had recently torpedoed the governor's hope of luring the National Cowboy Hall of Fame to Denver "when the Oklahoma City fathers upped their ante to keep the museum in place." Given the odds against the city's getting a stand-alone western art facility, Hornby suggested that the Denver Art Museum might offer one of "the best possibilities for a meaningful Denver center" despite its long history of presumed antipathy and neglect.

Historically, part of the problem was an attitude ascribed to the Denver Art Museum. It was said until recently that our museum, the natural center for any meaningful Western art program, looked down its scholarly nose at "cowboy artists" as mere illustrators, and that the museum directors refused to recognize the Western field as a solid school of art worthy of permanent attention.

But wowed by the current "smashing show on Frederic Remington," Hornby believed "this attitude, if it existed, [had] been shifting recently." Even so, he recognized that a display of commitment by the museum wouldn't be enough to give the city the sort of "really good, permanently displayed collection of Western art" that would make it into a "tremendous drawing card and [earn] enthusiastic support from a growing population of collectors in this booming energy capital." It all seemed to come down to money: "It is apparent that absent some spectacular private benefaction, a true center to rank with [the Amon Carter Museum, the Gilcrease Museum, and the Whitney Gallery of Western Art] must depend on a combination of existing facilities and art in private hands."

Tom Maytham seized on Hornby's column as a springboard for a letter to the editor explaining how the museum's collection program, past and present, depended almost entirely on gifts and detailing concrete evidence of the "strong and permanent commitment to Western art" the board and staff had pledged more than a year earlier. He failed to mention, however, that Daley, who had been the point person for the "smashing" Remington show, had resigned as American art curator a few days after its opening. Agreeing with Hornby that the purchase of a "major collection of Western art at today's prices" was out of the reach of any museum, he expressed the hope that the Denver Art Museum's increased emphasis on western art would "encourage individuals with major collections of Western art to donate them."[93] Despite being able to point to a full calendar of western exhibitions and the purchase of Remington's *Cheyenne* with funds from the William D. Hewit Charitable Annuity Trust, Maytham's public protestations did little to placate growing dissatisfaction with what aficionados saw as his lackluster promotion of western art.

Much of Maytham's attention was

taken up in 1982 with planning a capital building program and the successful effort to win passage in November of an $8 million bond issue to fund it. Even so, Maytham could take some satisfaction in a small, but choice, western art exhibition schedule that included *Cast and Recast: The Sculpture of Frederic Remington from the National Museum of American Art* and a showing of forty Alfred Jacob Miller watercolors and sketches from the InterNorth Art Foundation.[94] These offerings looked paltry, however, measured against the anticipated debut of William Foxley's Museum of Western Art in the Navarre Building. Hornby's forlorn hope for a deep-pocketed Maecenas with the means to fund a stand-alone museum with a "really good, permanently displayed collection of Western art" got a new lease on life when the doors opened in December 1983 on the Nebraska cattle baron's comprehensive private collection. Although Foxley's museum never fulfilled its promise to become a "tremendous draw" or a center that rivaled the programs of the great triumvirate of western art repositories, it got off to an auspicious start that embarrassed the Denver Art Museum's commitment.[95] Clearly Maytham needed a full-time curator in place in the American department to develop the kind of program that would satisfy the board's western art fans. Before his appointee arrived in mid-July of 1983, however, Maytham resigned abruptly as museum director, saying only that "the museum has gone as far as I can carry it."[96]

During the search for Maytham's replacement, which lasted for eighteen months, and throughout the short tenure of Richard Teitz as director and the first year of Lewis Sharp's leadership, Maytham's new American art curator managed to pursue his enthusiasm for decorative arts while honoring the 1980 commitment made by the board of trustees to the art of the region, "both historical and contemporary."[97] Nearing the end of his own tenure, David Park

Curry worked closely with the architects responsible for creating the new sixth-floor Betsy Magness Gallery of Western Art and American Art and assembled a remarkable loan exhibition of western painting and sculpture to celebrate its opening in February of 1989. In the catalog accompanying the exhibition, Curry wrote of the pleasure he took in his expeditionary forays into a yet unmined vein of western art:

> Knowing that an effort to develop collections of western American art would be part of my charge as curator of American art at Denver, I did a little bit of advance prospecting before moving here. As is often the case, funds were extremely limited, and the museum was not in the financial position to stake a major claim in a hot marketplace for important western pictures. One fall afternoon in 1982, while poking around the back room of an antique shop on Boston's Newbury Street, I found my first western acquisition: a horn chair that I sent ahead of me to Denver. With its masterful orchestration of robust steer horns into an almost ladylike set of elegant curves, the chair has proved one of the three most popular works of art in Denver's entire American collection.[98]

His next acquisition, an 1876 "Westward Ho" compote with imagery based on Currier and Ives lithographs, confirmed his sense of having discovered "a little vein of western material well worth digging into—decorative art." The Betsy Magness Gallery was an outgrowth of the $10 million Second Century Endowment Fund campaign headed by board vice chair Frederic C. Hamilton and announced in August 1987. Hamilton and some of his fellow trustees believed potential contributors would be more openhanded if they had solid evidence of the museum's commitment to western American art. Appointed

Jacobus (designer for Gillinder
& Sons, Philadelphia)
Covered compote, ca. 1876
Pressed glass
Denver Art Museum, funds from
Mrs. Wayne Stacey, 1984.101

in March 1988 to a three-person committee that included Bill Foxley and was charged with "establish[ing] a western art gallery on the sixth floor," Hamilton and Bob Magness announced at the September board meeting their pledge to meet the almost half-million-dollar estimated renovation cost.[99] The new gallery was ready to open just six months later, on February 23, 1989, two months after Lewis Sharp took the reins as museum director. A connoisseur of bronzes, Sharp had already impressed Denver fans of western art as a kindred spirit when, soon after his appointment in the summer of 1988, a local journalist quoted him as describing the museum's cast of *The Cheyenne* (page 248) as "the single most important Remington bronze in existence."[100] The inauguration of the Betsy Magness Gallery seemed especially promising—a new chapter in the way western American art was to be foregrounded.

The history of exhibitions featuring western art was actually far less gloomy than generally supposed during the years following the trustees' 1980 decision to place greater emphasis on "the exhibition and acquisition of fine art of all periods . . . concerned with or produced in the West." While celebrating the inauguration of "sophisticated, flexible, and well-designed new spaces for permanent and temporary exhibitions" of western art, David Curry went on to point out in his introduction to the catalog for *The Western Spirit* exhibition that

> . . . it is hardly the first western exhibition to greet the Denver public since the board passed its resolution nearly a decade ago. In the past ten years, the Denver Art Museum has hosted forty-five exhibitions that featured western art. These include modest efforts drawn from our own permanent collection, exhibitions of private collections, and ambitious undertakings circulated worldwide, accompanied by substantial scholarly catalogs.[101]

This tally is impressive, even allowing for Curry's inclusion of Native American and contemporary art in his ecumenical vision of the arts of the American West: "As we continue to explore [these arts] in the broadest sense, both esthetically and historically, we will begin to come to terms with what is surely one of the biggest territories left in the history of art."[102] Western art fans were considerably less than overwhelmed by this record of support, though, and they now pinned their hopes on Sharp, whose exhaustive knowledge of American art led one interviewer of the director-designate to pronounce him "equally at home in the OK Corral or Independence Hall."[103] Although advance notices greatly exaggerated his interest in western genre subjects, Sharp more than fulfilled expectations.

"Consummately charming and extremely affable," thus *Westword*'s art critic, Michael Paglia, described Sharp on the eve of his retirement twenty years later.[104] Taken under the wing of powerful trustees, Sharp soon surveyed the lay of the land and did his best to respect the prevailing passion for western American art among those with the means to fund the museum's progress. His first major effort as a self-styled "collections guy"[105] was the acquisition of the Daniel Wolf Landscape Photography Collection of 1,250 nineteenth- and early-twentieth-century photographs by such American masters as William Henry Jackson, Carleton Watkins, Eadweard Muybridge, and Timothy O'Sullivan. Longtime trustee Jim Wallace shepherded Sharp around and helped him raise private contributions to support the $1.5 million purchase that the board committed to in July 1990. As a New Yorker with a strong attraction to the West who'd spent his undergraduate years at Oregon's Lewis and Clark University, Sharp thought the collection's focus on western landscape photographs qualified "as a commitment to western art and the

beauty of the American West."[106] But, trustee and western art enthusiast Bob Magness had something a bit more eye-catching in mind. Convinced that the "wonderful floor" named for his late wife needed "a few anchors, a few masterpieces," he stepped forward to buy Charles Russell's *In the Enemy's Country* (page 245) for the collection.[107] Sharp, who describes the cable television pioneer as someone who always "thought big," counts the Magness family's 1991 gift of the Russell masterpiece as a significant milestone in the escalating sequence of recent events leading to the creation of the Petrie Institute of Western American Art.

Sharp sees the addition of Joan Carpenter Troccoli to the staff as deputy director in June 1996 as another such milestone. The mere presence of someone who had been director of the Gilcrease Museum sent a message that caught the attention of local western art supporters, and Troccoli's growing reputation as an emerging scholar in the field of western American art history earned the confidence of serious western art collector Philip . In addition to her administrative duties, Troccoli almost immediately began work on a comprehensive catalog and traveling exhibition of the Collection that led to a significant collaborative relationship between the museum and the Denver-based collector.[108] She also recognized the importance of Charles Deas's *Long Jakes, "the Rocky Mountain Man"* (page 187) as a landmark western painting and began campaigning for its acquisition as early as January 1997, when she learned it was on the market. Purchased in memory of Bob Magness, the painting carried a price tag that made it the single most expensive work yet acquired by the museum, and its acquisition required the enlistment of many contributors. An especially important addition to the collection, *Long Jakes* displaced Tait's *Trappers at Fault* as the museum's emblematic western work, particularly after its featured appearance in the museum's 2009 exhibition *Charles Deas*

and 1840s America, which attracted reviews from the New York Times, the Wall Street Journal, and even the UK Guardian. When Deas exhibited Long Jakes at the American Art-Union in New York in 1844, the first of his western works shown there, it caused "a sensation among the audience."[109] The same picturesque and romantic vision of a western hero that appealed to mid-nineteenth-century viewers captured the imagination of Denver contributors a century and a half later and won over countless new stakeholders in the department's future. Even the Denver Broncos lined up behind the purchase.

The gift of the William Sr. and Dorothy Harmsen Collection in 2001 was the sine qua non leading to the founding of the museum's Institute of Western American Art. The gift agreement levied a tariff of "a zillion meetings" and a "lot of heartburn" on Jim Wallace and Tom Petrie, who were among those working on it behind the scenes for months.[110] In the 1980s, after twenty years of energetic collecting, Dorothy and William Harmsen Sr. began shopping in earnest for a permanent home for the hundreds of western American and American Indian works they had accumulated. Bargaining invariably stalled when would-be beneficiaries found it impossible to raise needed funds to house and maintain the proposed gift.

Returning to Denver in 1990 from Tucson, where they retired in 1977, the Harmsens hit upon the idea of creating a stand-alone museum in a suburban mixed-use retail mall then on the drawing boards. This, too, proved prohibitively costly, and the couple began reconsidering their options. Dorothy, who sat on the Denver Art Museum board of trustees during Tom Maytham's tenure, reportedly resigned in 1979 because Bill became convinced that the museum had no interest in western art.[111] However, as Dorothy told the press at the time the gift was announced in late May 2001, she and Bill eventually decided to donate their collection to the Denver Art Museum because they "felt comfortable with the current leaders."[112]

Crafting the gift agreement meant overcoming reluctance on both sides. Lewis Sharp, who was adamant that no restrictions be placed on the gift before he would even consider formal negotiations, was initially skeptical about the overall quality of the collection, which turned out to be much higher than anticipated.[113] Tom Petrie recalls, for instance, Sharp's "ah-ha" moment on discovering the collection included George Catlin's Pohk-hong, Cutting Scene, Mandan O-kee-pa Ceremony of 1832 (page 225), the third in a series of four canvases whose other three are owned by .[114] A highlight of the Harmsen collection, the Catlin sketch's ethnographic rarity and historical importance make it invaluable.[115] The Harmsens, for their part, had to lay aside early demands like the construction of a special gallery where the collection would be shown in its entirety. Sharp's insistence on allowing no restrictions eventually prevailed, for the Harmsens were anxious to place the gift in Colorado, their home for more than sixty years. A substantial, unsolicited donation from Jim and Lucy Wallace financed the collection's move to the museum.[116]

With acceptance of the Harmsen gift, the Denver Art Museum's commitment to western American art took a dramatic leap forward, offering challenges and opportunities that mandated the creation of a new curatorial department. Even before a complete inventory of the collection, Sharp envisioned using the finest Harmsen works to beef up the museum's slim, but star studded, western holdings and provide a matrix to undergird a scholarly center for research, exhibitions, and publications, one that would provide national leadership in the field.[117] Tom Petrie vividly remembers Sharp's first talking to him about his idea for such a center as early as 1998, when Petrie joined the board of trustees.

"I want it to be more than a department and to have a scholarship and leadership function," Lewis said. He saw it as a natural aspect of Denver's role as the central city in the West. It was a great vision, and I underappreciated it at first. Over the years, I've come to see it as an epiphany.[118]

And so what began as a vision became a reality. After more than a century of vacillation, the Denver Art Museum stepped forward to take a leadership role in the study and promotion of western American art.

Notes

1 See, among others, Peter H. Hassrick, "Where's the Art in Western Art?" in Redrawing Boundaries (Denver: Institute of Western American Art, Denver Art Museum (hereafter DAM) [Western Passages], 2007), especially 10–11. In the same volume, William H. Truettner points to "new projects [that] are changing the western art landscape" ("Old West Meets New Art History: Some Reasons Why the Dust Hasn't Settled," 29).

2 Eileen Kinsella, "The New Gold Rush," Artnews 102, no. 5 (May 2003): 146. Hassrick is quoted on page 147.

3 Brian Dippie, "In the Enemy's Country: Western Art's Uneasy Status," in Redrawing Boundaries, 26 and 25. See also Brian W. Dippie, "'Chop! Chop!': Progress in the Presentation of Western Visual History," Historian: A Journal of History 66 (Fall 2004): 500.

4 Lewis Sharp and Frederic Hamilton, quoted by Mary Voelz Chandler, "Western Themes Shift to Foreground with Museum's New Wing," Rocky Mountain News, September 29, 2001.

5 Information compiled from various sources including www.usacitiesonline.com/cocountydenver.htm; and Dick Kreck, "Bites of Mile-High History," at www.denverpost.com/dncsocial/ci_10281699.

6 Worthington Whittredge, The Autobiography of Worthington Whittredge, 1820–1910, ed. John I. H. Baur (New York: Arno Press,

1969; *Journal of the Brooklyn Museum* 5, no. 1 [1942]), 46. Some confusion has occurred over the date of Whittredge's first trip west. According to Anthony F. Janson (*Worthington Whittredge* [Cambridge and New York: Cambridge University Press, 1989], 111), Whittredge's manuscript gives the year of the trip as 1866 in its opening paragraph, but what Janson calls a "typographical error" in Baur's edition of the autobiography placed the trip a year earlier. Baur, as editor, may have thought, however, that he was correcting a slip of the pen since Whittredge's original manuscript contains the irreconcilable contradiction that the expedition set out "thirty days after Lee's surrender." Putting speculation to rest, while also pointing out that Whittredge dated several western sketches and paintings 1865, Nancy Dustin Wall Moure tracked down letters published in government records proving that General Pope's tour of inspection took place in 1866 ("Five Eastern Artists out West," *American Art Journal* 5, no. 2 [November 1973]: 17–19, and 18 nn. 10–12, erroneously cited by Janson as "Three Artists out West," *American Art Journal* 4 [1974]: 2).

7 Whittredge, *Autobiography,* 45–46.

8 Mary S. Haverstock, "White Umbrellas in the Rocky Mountains," *Montana The Magazine of Western History* 16, no. 3 (Summer, 1966): 68. See also Whittredge, *Autobiography*, 64, where the painter discusses the details of the artistic obsession that provoked his second trip but remains entirely silent about his companions and Denver.

9 Alexander Phimister Proctor, *Sculptor in Buckskin: The Autobiography of Alexander Phimister Proctor*, 2d ed., ed. Katharine C. Ebner (Norman: University of Oklahoma Press, 2009), 8.

10 Federal census figures from Eugene Parsons, *A Guidebook to Colorado* (Boston: Little, Brown, and Company, 1911), 64.

11 Stephen J. Leonard and Thomas J. Noel, *Denver: Mining Camp to Metropolis* (Niwot: University Press of Colorado, 1990), 44–45. Chapter 10 deals with the Depression of 1893; chapter 11, with the economic diversity that helped spark recovery.

12 For a brief survey of the art scene in Denver from about 1877 to 1894, see Marlene Chambers, "First Steps toward an Art Museum: The Artists' Club," in Neil Harris, Marlene Chambers, and Lewis Wingfield Story, *The Denver Art Museum: The First Hundred Years* (Denver: DAM, 1996), especially 55–58.

13 Unidentified clipping headed "Progress of Art in Denver" (Henrietta Bromwell, *Art Scrapbook,* Colorado Historical Society, hereafter CHS). Primary sources for information about the organization and early activities of the Artists' Club are the *Artists' Club Minute Book (1893–96)* and *Artists' Club Record Book* kept by Henrietta Bromwell (both CHS), as well as her *Art Scrapbook* (CHS) and *Artists' Club* scrapbook (Denver Public Library, Western History Department, hereafter DPL).

14 Henry Read, quoted in *Denver Sunday Times,* April 25, 1900 (Bromwell *Artists' Club* scrapbook, DPL).

15 *Denver Municipal Facts* 5, nos. 8–9 (September–October 1922): 13. See also *Rocky Mountain News*, August 30, 1925.

16 "Realists/Impressionists," *Denver Times,* December 8, 1901 (Artists' Club clipping files, DPL). For more detailed information about the club's collecting activities, see Chambers, "First Steps toward an Art Museum," 65–68.

17 See Chambers, "First Steps toward an Art Museum," 66, for more on the eastern experiences that shaped the taste of these club leaders. See also Meredith M. Evans, "Pioneering Spirits: E. Richardson Cherry and the First Women of the Artists' Club of Denver, 1893," in *Colorado: The Artist's Muse* (Denver: Petrie Institute of Western American Art, DAM [Western Passages], 2008), 60–79.

18 See Lewis Story, "Building a Collection," in *The Denver Art Museum: The First Hundred Years,* 78 and 288 nn. 6–7. See also Chambers, "First Steps toward an Art Museum," 67.

19 Quotation attributed to Mrs. E. M. Ashley on the occasion of the Fortnightly Club meeting of February 27, 1892, reported online at http://chipeta.wordpress.com/tag/colorado-state-capitol/. The group's intention to place the sculpture on the capitol grounds is also reported in "World's Fair Notes," *Monumental News: An Illustrated Monthly Monumental Art Journal* 4, no. 3 (March 1892): 104.

20 This quotation, like the one above from Mrs. Ashley, as well as the account of the club meeting is credited to Joyce Lohse, author of *First Governor, First Lady: John and Eliza Routt of Colorado* (Palmer Lake, CO: Filter Press, 2002) at http://chipeta.wordpress.com/tag/colorado-state-capitol/. Other information about the sculpture is generally available.

21 But see James S. Thompson, "Buffalo and Indian: Preston Powers' Masterpiece in Bronze on Exhibition at the World's Fair," *Rocky Mountain News*, May 14, 1893, which the author says is based on an interview with Powers, who claimed, "at the request of the Denver ladies," to have "endeavored to reproduce to some extent the facial outlines of Ouray in his younger days." Powers also reportedly "visited the reservations and made numerous sketches from the Indians, so as to have his Indian perfect in every way." The reporter continues, "It is a well known fact to all the old Indian scouts that the Indian differs from the white man in construction." On Saint-Gaudens and *Hiawatha*, see Thayer Tolles, "Circling the Borders: Augustus Saint-Gaudens and the American West," in *Shaping the West: American Sculptors of the 19th Century* (Denver: Petrie Institute of Western American Art, DAM [Western Passages], 2010), 12–13. Tolles makes the point that Saint-Gaudens himself was not breaking new ground thematically or aesthetically: "Since the early 1840s, American sculptors modeled idealized semi-nude Indian men with hunting instruments."

22 Quoted in "World's Fair Notes," 104, where he is identified by the lesser known first name Alfred.

23 The verse appeared in *The Poetical Works of John Greenleaf Whittier*, vol. 4, *Personal Poems* (Boston and New York: Houghton Mifflin Company, 1894), 309, without a title other than "Inscription." The poem's dedication reads: "For the bass-relief [*sic*] by Preston Powers, carved upon the huge boulder in Denver Park, Col., and representing the Last Indian and the Last Bison." The verb *finds* in the third line properly takes the singular form in the print version of the poem; a disrupting comma has been added in the second line of the inscribed version; and the first line is considerably different in the original, which reads, "The eagle, stooping from yon snow-blown peaks."

24 "Mr. Indian and His Buffalo: Preston Powers' 'Closing Era' Is Moved Again and Is Seeing All Sides of the Capitol," *Denver Republican*,

May 21, 1897, 3, col. 5. The writer closes with a final barb aimed at Mrs. Ashley: "An odd feature of the latest trip made by the pair is that they brought [up] almost in front of the residence of Mrs. Ashley, who is chairman of the committee of forty."

25 Thayer Tolles discusses Saint-Gaudens's role in the project in some detail in "Circling the Borders" and suggests that the "elder statesman" (19) of American sculpture was both too busy and too ill to take on the Denver commission, though, as she says, he was "willing to dispense professional advice and tutored committee head John Flower on how to obtain the type of monument the committee desired at the fairest price" (20). From the tenor of Saint-Gaudens's letters describing his single trip to the West in 1883, the reader might also conclude, as Tolles does, that he "was not particularly at ease in the American West" (12).

26 Mary Smart, *A Flight with Fame: The Life and Art of Frederick MacMonnies (1863–1937),* (Madison, CT: Sound View Press, 1996), 219. The MacMonnies quotation is from a letter to Flower of 17 May 1907, as cited in "Indian Must Remain or No Monument to the Pioneers," *Rocky Mountain News,* June 2, 1907, 222 n. 13.

27 See Tolles, "Circling the Borders," 20–21. Tolles reports that Frederic Remington ill-naturedly refused to lend MacMonnies "props and costumes" for the project because he felt he should have been awarded the commission: "I haven't accumulated all my knowledge on this matter to glorify a Paris artist who knows no more of our West than a Turk."

28 "The MacMonnies Pioneer Monument for Denver: An Embodiment of the Western Spirit," *Century Illustrated Monthly Magazine* 80, no. 6 (October 1910): 875.

29 Smart, *A Flight with Fame,* 220 and 222 n. 16. However, it was not Olmsted's plan on which work began in 1919, as Smart says in her note, but the version devised by Chicago architect Edward H. Bennett, whom Speer called in after his return to office in 1916. In any case, Bennett's version was, like many intervening plans, including Olmsted's, an adaptation of the "MacMonnies Plan" (See Chambers, "First Steps toward an Art Museum," 286–87 n. 70).

30 This summary of events is itself a condensation of my earlier account

(Chambers, "First Steps toward an Art Museum," 68–71 and 286 nn. 65–71), which was, in turn, substantially indebted to William H. Wilson, "A Diadem for the City Beautiful: The Development of Denver's Civic Center," *Journal of the West* 22, no. 2 (April 1983): 73–83.

31 My account of events leading to the Denver commission is based on the version Proctor recalls in his autobiography, *Sculptor in Buckskin,* 176–77. Peter Hassrick gives a quite different account in *Wildlife and Western Heroes: Alexander Phimister Proctor, Sculptor* (Fort Worth, TX: Amon Carter Museum in association with Third Millennium Publishing, London, 2003), 192, although he expresses doubt about the accuracy of his primary source, 248 n. 41:11.

32 Quoted in Hassrick, *Wildlife and Western Heroes,* 191.

33 Proctor, *Sculptor in Buckskin,* 177. Hassrick reports it took much longer for Speer to persuade Mullen and Knight to make the donations (*Wildlife and Western Heroes,* 192).

34 Although much of the information in the preceding paragraph is generally available, I've depended also on Peter Hassrick's detailed catalog entry in *Wildlife and Western Heroes,* 192–93, as well as William H. Wilson, *The City Beautiful Movement* (Baltimore: Johns Hopkins University Press, 1989), 248–53. Hassrick takes umbrage at Wilson's claim that "Bennett knew" that Proctor's bronze was too "incongruous to control the plaza" and argues that the "*Cowboy* and *Indian* were clearly compatible with the monuments by MacMonnies and Powers that were already in place" (192). See also *Municipal Facts Monthly* 3, nos. 11–12 (November–December 1920): 13, where the sculpture is pictured in place on Civic Center. A reproduction of the plaster model appears in *Municipal Facts* 2, no. 4 (April 1919): 3, with a caption that reports the bronze version will be erected "this summer."

35 Lewis Story describes the collection as "twenty-eight 'famous' late-nineteenth- and early-twentieth century European and American paintings" (Story, "Building a Collection," 87). Story also explains that then-director Otto Bach returned the collection to the family in 1954 "because restrictions on the gift and the overall quality of the works were no longer compatible with museum

objectives. These restrictions stipulated that the entire collection be exhibited in perpetuity and that attributions not be challenged." Story adds, "The dark and murky palette of many of the pictures moved Otto Bach to call it, in candid moments, 'the very Brown Collection'" (290 n. 58).

36 See Chambers, "First Steps toward an Art Museum," 71–73.

37 Poland's father, William Carey Poland, was the first professor of art history at Brown University and the president of the Rhode Island School of Design from 1896 to 1907. Reginald Poland did his undergraduate work at Brown, earned M.A. degrees in art history at both Princeton and Harvard, and worked on the staff at the Museum of Fine Arts, Boston, before being recruited for the Denver post. He left Denver to become education director at the Detroit Institute of Arts and in 1926 became the founding director of the Fine Arts Gallery of San Diego, now the San Diego Museum of Art. For more on Poland's short-lived career in Denver, see Story, "Building a Collection," 76–78, as well as Poland's own publications during his tenure, including a weekly art column in the *Rocky Mountain News* and two booklets: *The Denver Art Association: Its Past and Future* (1919) and *The Denver Art Association: Prospectus* (1920).

38 Reginald Poland to Walter Ufer, Sec'y, Taos Society of Artists, 27 January 1921, with handwritten list of society members in lower left (Petrie Institute of Western American Art, Ufer archive). Hassrick reports that the Artists' Club invited members of the Taos art colony, "probably through [Bert] Phillips, to exhibit a group of paintings [in Denver] as early as the fall" of 1912, though "for unknown reasons, the show never took place" ("In Search of the Real Thing: Blumenschein in the 1910s," in Peter H. Hassrick and Elizabeth J. Cunningham, *In Contemporary Rhythm: The Art of Ernest L. Blumenschein* [Norman: Univ. of Oklahoma Press in cooperation with the Albuquerque Museum of Art and History, DAM, and Phoenix Art Museum, 2008], 81). Hassrick concludes that the Artists' Club "would thus serve as one of several facilitators for the artists of Taos to begin thinking beyond the notion of an art colony to the idea of a collaborative group" (ibid.).

39 In discussing Allen True's ties to painters in

Santa Fe and Taos, Peter Hassrick notes that the Taos Society of Artists "brought a display of its members' works to Denver in 1918." In "Allen True: The Early Years," in *Colorado: The Artist's Muse*, 29. He cites "Indian Pictures in Majority in Library Exhibition," *Denver Times*, May 1, 1918.

40 Reginald Poland, "Artistic Expression in Denver," *Municipal Facts Monthly* 3, no. 9 (September 1920): 8.

41 In "Allen True: The Early Years," Hassrick notes that "an ongoing touring exhibition," presumably the one he reports that True mounted during the winter of 1915 at the Palace of the Governors in Santa Fe, was the one that "went to Santa Fe's new Museum of Fine Arts in [July] 1919 and was eventually picked up by the American Federation of Arts and circulated nationally," 27–29. But see also Reginald Poland, "The Work of the Denver Art Association," *Municipal Facts Monthly* 3, no. 9 (September 1920): 13, and Reginald Poland, "Allen T. True: Painter of the West," *American Magazine of Art* 11, no. 3 (January 1920): 79–85. The fact that Poland mentions the AFA's request for an article about True in his account of the association's September 1919 True exhibition in his MFM annual review supports the conclusion that the AFA's sponsorship was occasioned by the Denver exhibit. Poland's AFA essay on True is reprinted with inconsequential omissions in Jere True and Victoria Tupper Kirby, *Allen Tupper True: An American Artist* (San Francisco: Canyon Leap, in association with Museum of the Rockies, Montana State University, Bozeman, MT, 2009), 198–203.

42 Poland, "Allen T. True: Painter of the West," 79.

43 Ibid., 83.

44 Ibid., 84.

45 Ibid., 85.

46 Poland, "Artistic Expression in Denver," 14.

47 Ibid., 8.

48 The exhibitors published a walking tour guide to Civic Center and nearby downtown sites where visitors could see True's murals in their original architectural settings. In conjunction with the exhibition, Colorado Public Television, KBDI, Channel 12, produced and aired a documentary. The two Greek Theater murals that take a bow in Poland's discussions above were restored in 1970 with city and

county funds. Hotel developer Stonebridge Cos., which bought the Colorado National Bank Building at Seventeenth and Champa streets in 2009, has pledged to preserve the sixteen murals of Indian subjects True installed there in the 1920s (Margaret Jackson, "Hotel Builder Nabs Old Xcel Site," *Denver Post*, March 26, 2011, 5B).

49 Variously known as *The Trappers* and *Free Trappers*, the painting's dimensions are given by Hassrick as sixteen by fifty-two inches ("Allen True: The Early Years," 19–20). See also True and Kirby, *Allen Tupper True*, 95, 98–99, 111. Since Allen True dates the painting 1912 in his "Record of Mural Decorations" and adds "not mounted by me," True and Kirby surmise that 1912 may have been the year "in which the mural was installed" (99). Ann Daley, curator for Jan Mayer, the current owner of the Evans cabin, writes that "Anne built the cabin in 1911" and hypothesizes "that the fireplace niche was finished after Evans bought the painting, so the [framed] painting could be placed in it and fit exactly, flush. It fills the opening" (e-mail communication, 3 March 2011). Hassrick describes the subject as "a procession of men and pack horses being led through sunlit sandstone hills by a friar on a white mule" (20), while True and Kirby identify the men as "Jicarilla Apaches of northern New Mexico" (99).

50 True and Kirby report these library commissions in detail (*Allen Tupper True*, 102–5). No clear record of the fulfillment of the October 1913 contract exists. The only murals True painted for the central library, *Cliff Dwellers* and *Hopi Potter*, were installed in 1916.

51 *Denver Post*, December 30, 1929; *Rocky Mountain News*, January 1, 1930.

52 Elisabeth Spalding, "Something of Art in Denver As I Think of It," December 1924, typescript of lecture presented to the Fortnightly Club (Fortnightly papers, DPL).

53 Anne Evans, quoted in *Denver Post*, June 6, 1937.

54 See Charles A. Johnson, *Denver's Mayor Speer* (Denver: Green Mountain Press, about 1969), 61–71. See also Allen duPont Breck, *William Gray Evans, 1855–1924: Portrait of a Western Executive* (Denver: University of Denver, Dept. of History, 1964), especially

91–100. A *Denver Post* (April 17, 1904) political cartoon from the Colorado State Archives, Evans Collection, lampoons "Bill the Boss of the Boss" Evans crowning "Bob the Boss" Speer at the Democratic Convention (reproduced in Breck, *William Gray Evans*, 56). Born in December 1871, Anne Evans was not yet thirty-three when appointed to the Art Commission, only thirty-five when Speer named her to the Library Commission.

55 A recent laudatory biography is a case in point: see Barbara Edwards Sternberg, Jennifer Boone, and Evelyn Waldron, *Anne Evans, A Pioneer in Colorado's Cultural History: The Things That Last When Gold Is Gone*, ed. John Maling (Denver: Buffalo Park Press and Center for Colorado and the West, Auraria Library, 2011). Although the biographers admit that Anne Evans's "family background and connections were influential in suggesting [her] initial appointments" to various powerful positions (202), they maintain that any actions she took once in office were all in a good cause: "she…worked diligently in these positions to accomplish worthwhile goals" (202). In this light, favors that lay within her own gift, such as those bestowed on True, and deals that took advantage of what the biographers call "fruitful connections between the organizations to which she was appointed," like the one she brokered between the Carnegie Library and the Artists' Club, appear entirely praiseworthy to the authors, rather than culpable in any way.

56 See Sternberg, Boone, and Waldron, *Anne Evans*, 317–18, on Evans's early trips to the Southwest and the likelihood that she may have traveled "from time to time" with her Evergreen neighbors, the parents of Frederic Douglas, Canon Winfred and Dr. Josepha Douglas, who shared her collecting interests.

57 Despite being constantly in debt during these first years, the executive committee authorized the note on October 15, 1925, to make what it must have considered an important addition to the collection since the amount still owed in October 1926 on the original expenditure of $3,100 was $1,550, slightly more than the entire 1927 acquisition budget of $1,500. See Story, "Building a Collection," 81, 289 n. 23.

58 The Capitol Hill mansion of the Chappell family was given to the Denver Art

Association in 1922 with the proviso that it be used as a center for creative arts, with the first floor serving as a headquarters for both the Denver Art Association and Denver Allied Arts and the upper floors given over to artists' studios. A fireproof exhibition gallery of 2,000 square feet was added in 1925. In 1949, the native arts collection took over the entire building (Story, "Building a Collection," 78–80 and 289 n. 18).

59 This series of events is detailed by Story, "Building a Collection," 80–82 and 289 n. 33. Later, Douglas claimed to have been named curator in 1929 (Story, 35). Douglas took over from Edgar C. McMechen, who was in charge of Indian art both before and after his appointment as assistant director in June 1925 (289 n. 35). Like Douglas, who was the only son of Evans's Evergreen neighbors and fellow Indian art collectors, McMechen was "a man well-known to Anne Evans, as he had just published [in 1924] an affectionate biography of her father" (Sternberg, Boone, and Waldron, *Anne Evans*, 332).

60 Janet Catherine Berlo, "The Szwedzicki Portfolios: Native American Fine Art and American Visual Culture, 1917–1952" (University of Cincinnati Digital Press, October 2008), 3 and 8–9, accessed at http://digitalprojects.libraries.uc.edu/szwedzicki/01000000.pdf.

61 Berlo, "The Szwedzicki Portfolios," 14–15. Even earlier, Phoebe Apperson Hearst (1862–1919), mother of William Randolph Hearst and major benefactor of the University of California, Berkeley, for whom its Museum of Anthropology is named, funded research and collecting expeditions to Peru, Guatemala, and the Southwest. Her gifts to Berkeley "ranged from Sioux Indian artifacts . . . to paintings of early Californian pioneers" (*Berkeley Daily Planet*, April 20, 2011). Hearst's interest in native arts, like that of the museum that bears her name, seems to have been "to collect, preserve, research, and interpret the global record of material culture, so as to promote the understanding of the history and diversity of human cultures" (hearstmuseum.berkeley.edu/museum/mission.php).

62 Berlo, "The Szwedzicki Portfolios," 9. See also 16–20 on the Americanness of Indian art.

63 See Berlo, "The Szwedzicki Portfolios," 10 and 15–19 on Indian material culture as art and

12–13 on White's New York gallery and later museum donations.

64 Pueblo Indian Painting (Nice: l'Edition d'Art C. Szwedzicki, 1932). See Berlo, "The Szwedzicki Portfolios," 13, on the Evans collection; 40–42 on the portfolio; and 43–44 on Alexander. Story, "Building a Collection," 81–82, reports that the initial donation of 143 watercolors by Evans and her friend Mary Kent Wallace in 1932 was later augmented by over 250 purchases from a series of annual exhibitions of work by living American Indian artists inaugurated in 1951. Following Michael Churchman (*The Kent School, 1922–1972* [Denver: 933 Sherman St., 1972]), Sternberg, Boone, and Waldron (*Anne Evans*, 338) explain that Evans first gave "a large collection of these paintings" to the Kent school, but that the collection was later considered "too valuable to hang in the school and . . . should be given to the Denver Art Museum." On the Cooke Daniels Lecture Foundation, established in 1925 by trustee Florence Martin, see Story, "Building a Collection," 290 n. 43.

65 Story, "Building a Collection," 289 n. 35, where the figure is attributed to Douglas in a report later made to the trustees, but see Story, "Building a Collection," 81 and 289 n. 29, which puts the size of the collection in 1930 at eight hundred, according to Douglas's statement in the inaugural issue of the museum's quarterly journal: "Our Indian Art Collection," *Art Register* 1, no. 1 (September 1930): 3.

66 Story, "Building a Collection," 96. Independently wealthy, Douglas was able to "approach his work with an independent spirit" (Sternberg, Boone, and Waldron, *Anne Evans*, 335) and to acquire "literally thousands of objects with his own funds" (Story, "Building a Collection," 82).

67 The main outline of Bach's struggle to wrest control of the museum from Douglas is told by Story, "Building a Collection," 94–99.

68 Responding to threats by the Brown heirs to rescind their 1916 gift in response to the city's failure to provide an appropriate exhibition space within fifteen years, the city allotted space to the museum in 1931 while the building was still under construction. As Story explains, "Both the city and the museum stood to gain" by an agreement reached in

December 1932 that gave the museum "full responsibility . . . [over] all gifts of . . . art to the city" (Story, "Building a Collection," 87–88).

69 Story, "Building a Collection," 88–90.

70 Quoted in Story, "Building a Collection," 93 and 291 n. 4.

71 *Denver Post,* July 19, 1964.

72 Story, "Building a Collection," 94–95.

73 Typed list of museum departments and their locations, Section VII of "1952 Statistics, Revised: 6/15/55," office of the director, DAM. Although Douglas was made curator of native arts as early as March 1947, with a separate curator in charge of Indian art (Story, "Building a Collection," 98), Bach delayed officially consolidating the two departments under the native arts heading until December 1948 (*Denver Post,* December 9, 1948).

74 Story, "Building a Collection," 97–99.

75 Neil Harris details the successive steps in Bach's building campaign, which began almost as soon as he arrived in Denver in 1944 ("Searching for Form: The Denver Art Museum in Context," in *The Denver Art Museum: The First Hundred Years,* 32–42). The acquisition of the Kress "Study" Collection was conditional on the construction of a fireproof, climate-controlled space—the South Wing (1954) designed by Burnham Hoyt and still in use today (Story, "Building a Collection," 94, 108).

76 *Rocky Mountain Herald*, October 6, 1955. The columnist defined the character of the proposed collection somewhat garbledly as "traditional folk arts related to the development of Western America encompassing characteristic regional forms of pioneers and Indians with the national art forms of Spanish and Northern European colonies."

77 Biographical note compiled by DPL, R. B. Hassrick papers. When Willena Dutcher Cartwright (who had curated the American Indian collection since 1946) left in October 1955, Hassrick was already on board as western American art curator, and Bach hired Richard Conn to replace her (Story, "Building a Collection," 292 n. 11 and 292 n. 21). Although Hassrick is named as curator of American and American Indian art in the 1960 DAM winter quarterly, *Indian Art of the Americas*, the staff roster in the same

publication identifies him as curator of American and native arts. In 1962, he briefly retired to ranch life, but returned to the DAM as assistant director from 1964 to 1967, when he retired to Lone Star Ranch, Elizabeth, CO, to become a rancher. Hassrick continued to write and publish books on the Plains Indians throughout his life and contributed an entertaining firsthand introduction that distinguishes the cowboy from the cattleman to *The American Cowboy,* exh. cat., by Lonn Taylor and Ingrid Maar (Washington, DC: American Folklife Center and Library of Congress, 1983), 12–13. The DAM was among the venues for this traveling exhibition.

78 Peter Hassrick, Royal's son and director of the Petrie Institute from 2005 to 2009, thinks that Otto Bach hired his dad as the curator of western art even though he had no background in this area and his Ph.D. was in anthropology and ethnology "because the St. Louis Art Museum had done [a major western art] exhibition just a year before and Denver didn't want to be left out" (Hassrick, interview by author, July 28, 2010, transcript Petrie Institute of Western American Art, DAM). No doubt Bach was responding to a groundswell of interest in western art after World War II, when "the nation was searching for cultural attributes that might explain its uniqueness and greatness" (Peter Hassrick, "Creating the West in Art," *The Magazine Antiques* 176, no. 1 [July 2009]: 40) and "pictorial magazines . . . did much to elevate public enthusiasm" (Peter Hassrick, "Western Art Museums: A Question of Style or Content," *Montana The Magazine of Western History* 42 [Summer 1992]: 28), but it is unlikely Bach considered himself in competition with the St. Louis Art Museum, whose *Westward the Way* exhibition and 280-page companion book (1954) were hardly in the same category as Denver's.

79 The "Centennial Year" being celebrated in 1959 was the gold rush to Colorado dubbed "Rush to the Rockies." Denver Public Schools began a collaboration with the museum in 1947: an annual contribution to the museum's budget offset costs associated with gallery tours and handbooks targeted to topics of study. The 1958 handbook, doubling as the museum's 1959 spring quarterly, was prepared by "staff members including Cile M. Bach, Mary Jane Downing and Royal B. Hassrick."

80 Cf. *Western Heritage* (DAM, 1958), unnumbered page 11 (where the painting is identified as *The Trapper*), and Carol Clark, *Charles Deas and 1840s America* (Norman: University of Oklahoma Press in cooperation with DAM, 2009), 190–91. The Yale University Art Gallery again lent the painting for *The Western Frontier*, July 28–October 9, 1966, another large loan exhibition like *Building the West* (see *The Western Frontier* [DAM 1966 summer quarterly], unnumbered pages 24–25, where the painting is discussed and reproduced). See also Carol Clark's essay in this volume, pages 186–191.

81 For a more expansive account of Bach's campaigns see Story, "Building a Collection," 103–11 and 295 n. 62.

82 While recognizing that "there was some element of western art that [Bach] appreciated," Peter Hassrick reported that his "father [Royal] said that Otto would rather buy a third rate Picasso than a first rate Remington" (interview by author).

83 Throughout their museum careers, the Bachs fostered volunteerism as a means of swelling a staff severely limited by budget restrictions. The museum still depends for many essential tasks on a volunteer force that numbers about five hundred men and women. Frequently called the "mother" of the DAM volunteers, Cile Miller Bach was a trained, experienced journalist first appointed to the staff at an executive board meeting in July 1946 as "agent to the Denver Schools and for press-publicity and radio scripts." Over the years she filled posts as registrar, public relations coordinator, and director of publications. In 1978, the volunteer force established an award named in her honor and given annually for outstanding service to the museum. See Story, "Building a Collection," 111 and 296 n. 88. In 1960, there were four honorary curators on the DAM staff: Dr. Campton Bell, head of the University of Denver's Theater Department, theater arts; Vance Kirkland, head of the University of Denver Art Department, contemporary art; H. M. Sarkisian, gallery owner and dealer, Oriental art; and Charles F. Ramus of the University of Denver Art Department faculty, prints and drawings (Royal B. Hassrick and Cile M. Bach, *Indian Art of the Americas* [Denver: DAM, 1960], 107).

84 Peter Hassrick, who served as an intern under Trenton while earning his master's degree in art history at the University of Denver and later collaborated with her on an exhibition and catalog, thinks she was using her experience at the DAM "to get her creds" (interview by author). After leaving Denver, Trenton went on to earn a Ph.D. at UCLA under the eminent scholar and art historian E. Maurice Bloch. She published numerous books on art and artists, including: *The Rocky Mountains: A Vision for Artists in the Nineteenth Century*, co-authored with Peter Hassrick (Norman: University of Oklahoma Press, 1983); *Native Americans: Five Centuries of Changing Images,* co-authored with Patrick T. Houlihan (New York: Harry N. Abrams, 1989); *California Light: 1900–1930*, co-authored with William H. Gerdts and Bram Dijkstra (Laguna Beach, CA: Laguna Art Museum, 1990); and *Independent Spirits: Women Painters of the American West, 1890–1945* (Berkeley: University of California Press, 1995), which she edited.

85 Thomas N. Maytham, *1974 Denver Art Museum Annual Report,* 18–19. Maytham was not able to appoint a curator with the sort of "expertise" he had in mind until 1983, when he hired David Park Curry, who shared his interest in early American furniture and decorative arts and came equipped with a Ph.D. from Yale and a stint as curator of American art at the Smithsonian's Freer Gallery of Art. Curry is currently senior curator of decorative arts, American painting and sculpture at the Baltimore Museum of Art.

86 See *The Western Frontier*, exh. cat. (Denver: DAM, 1966), where these works are cataloged and illustrated. The foreword is signed by Royal Hassrick, assistant director. Pat Trenton is not mentioned in the staff list, even as a research assistant.

87 Unsigned foreword, *The American Panorama: An Exhibition*, exh. cat. (Denver: DAM, 1968), 1. Unlike *The Western Frontier,* however, *The American Panorama* was mounted in concordance with a Denver Public Schools curriculum theme. The museum devoted the lion's share of the accompanying handbook to "The Opening of the West."

88 Patricia Trenton, *1972 Denver Art Museum Annual Report*, 19. Trenton had her sights trained on donor cultivation in establishing

Art Americana. In conjunction with the opening of *Colorado Collects Historic Western Art*, for example, her new Art Americana group threw an autograph party for fellow member Dorothy Harmsen, whose *Harmsen's Western Americana* had been published the year before by Northland Press, Flagstaff, AZ. Art Americana was the first "permanent" department support group organized to fund collection growth since 1928, when sixty-five Indian art patrons banded together with collector Allen True as chair (Story, "Building a Collection," 81, 124). Although Art Americana gradually faded out in Trenton's absence, its cause was taken up in November 1984 by DAM Yankees, later renamed Friends of Painting and Sculpture.

89 Duncan Pollock, "Artists of Taos and Santa Fe: From Zane Grey to the Tide of Modernism," *Artnews* 73, no. 1 (January 1974): 13–14. Pollock, who was art critic for the *Rocky Mountain News*, also praised Trenton's "catalogue notes prepared jointly with Native Arts curator Richard Conn [for including] an ethnographic analysis of the material" (14). Trenton's catalog, however, could hardly rival Van Deren Coke's book, which remained, of course, the standard reference on the subject until *Art in New Mexico, 1900–1945: Paths to Taos and Santa Fe* by Charles C. Eldredge, Julie Schimmel, and William H. Truettner (Washington, DC: Smithsonian Press, 1988).

90 Story, "Building a Collection," 113–16. The new collections policy approved by the board in November 1976 was based on a statement of direction adopted by the trustees in April 1975. Although Maytham told the press as early as 1974 how vital it was to hire a contemporary art curator, Lewis Story continued to fill that role, as well as that of associate director, until Dianne Vanderlip arrived in 1978.

91 In conjunction with the Cody show, Peter Hassrick, then director of the Buffalo Bill Historical Center, lectured on a topic he returned to often during his career: "Where's the Art in Western Art?" Maytham's assistant in the American department, Georgianna Contiguglia, "was responsible" for the show and also "collaborated with the Native Arts Department to put on *Art of Historic Colorado*" in the fall (Maytham, *1977 Denver Art Museum Annual Report,* 10). Contiguglia

left the DAM the next year to become curator of the Molly Brown House. She was later curator of decorative and fine arts at the Colorado History Museum and retired in 2007 as president and CEO of the Colorado Historical Society.

92 Bill Hornby, *Denver Post*, July 29, 1981.

93 Thomas Maytham, *Denver Post*, August 23, 1981. Maytham's letter to the editor shared space under the same headline with another letter touting the Sangre de Cristo Arts Center in Pueblo as the potential site for Colorado's western art center.

94 Also on the books at the time of Maytham's resignation in June 1983 was *The American Cowboy,* organized by the Library of Congress. The exhibition opened in Denver on March 7, 1984, accompanied by a catalog for which Royal Hassrick wrote an introduction based on his personal experience as cattleman and one-time cowboy.

95 Max Price, "Western Art: New Museum Will Open in Remodeled Navarre," *Denver Post,* December 13, 1983. Bill Foxley closed his museum in 1997 and sold the Navarre to Philip , who installed his own collection of western American art there after further remodeling. See Ann S. Daley interview by author, August 19, 2010, transcript Petrie Institute of Western American Art, DAM, and Matt Potter, "Always the Lady's Fault," *San Diego Reader*, August 14, 1997. Foxley served as the museum's director and published a catalog of the collection (William C. Foxley, *Frontier Spirit: Catalog of the Collection of the Museum of Western Art* [Denver: Museum of Western Art, 1983]). For more on Foxley and his collection, see J. Brooks Joyner, "Collecting the Legends," in *Legends of the West: The Foxley Collection,* exh. cat. (Omaha: Joslyn Art Museum, 2006). The essay is also available online at http://www.tfaoi.com/aa/6aa/6aa463.htm in a November 10, 2006, reprint from the catalog by *Resource Library.*

96 Thomas Maytham, *Rocky Mountain News,* June 16, 1983.

97 Minutes, board of trustees meeting, July 16, 1980. See also David Park Curry, introduction, *The Western Spirit: Exploring New Territory in American Art* (Denver: DAM, 1989), 9. Western art fans who still cavil at Maytham's failure to appoint a western art expert as his American art curator should bear in

mind Lewis Sharp's recent assessment of the scarcity of qualified candidates: Finding "really good people, who have the academic training and the experience is a real challenge" (Sharp interview by author, November 12, 2010, transcript Petrie Institute of Western American Art, DAM).

98 Curry, "Personal West," in *The Western Spirit*, 14. The chair is illustrated on page 215 of this volume.

99 Story ("Building a Collection," 125–26) explains the sequence of events leading to the gallery's founding in a sixth-floor space formerly occupied by the textiles and costume department. He lists "former trustee" William Foxley as a third member of the committee appointed to establish the western art gallery and describes both Foxley and Magness as "avid and discerning collectors of western art." Foxley, who joined the museum board in 1980, did not actually leave the board until May 1989 although he had established his privately operated museum in 1983.

100 Sharp, quoted in *Denver Post,* September 14, 1988.

101 Curry, introduction, *The Western Spirit*, 9.

102 Ibid., 10.

103 *Rocky Mountain News*, August 23, 1988.

104 Michael Paglia, *Westword*, December 10, 2009.

105 Sharp, quoted by Paglia, *Westword*, December 10, 2009.

106 Sharp interview by author.

107 Paraphrasing Magness in his interview of November 12, 2010, Sharp speaks fondly of Bob and his second wife, Sharon, and lauds Bob's ability to "pinpoint things directly."

108 *Painters and the American West: The Collection* opened in Denver in October 2000 and later traveled to the Corcoran Gallery of Art, Washington, DC, and the Joslyn Art Museum, Omaha. The catalog was copublished with Yale University Press. As early as 1998, while the exhibition was still in the works, Sharp announced a shared life-estate agreement with that made Arthur Fitzwilliam Tait's *Trappers at Fault* part of the Collection until the collector's death, when full ownership reverts to the museum. On his part, made a significant contribution to the museum for the purchase of western art and a commitment to lend the Tait and other paintings from his collection to the museum from time to time. Always transparent

in decisions about the collection, Sharp described this arrangement in the *1997–98 Denver Art Museum Annual Report*, 5.

109 Unnamed critic quoted in DAM acquisition proposal form. See also Kyle MacMillan, "2 Million Dollar Man," *Denver Post,* December 17, 2000.

110 Doug Jones, then president of the Denver Chamber of Commerce, and Nick Muller of Heppenstall, Savage, Trower & Muller, LLC were among the distinguished Colorado citizens who were helpful in forging an agreement. See Jim Wallace, interview by author, October 7, 2010, transcript Petrie Institute of Western American Art, DAM. See also Joan Carpenter Troccoli, foreword and acknowledgments, *Sweet on the West: How Candy Built a Colorado Collection* (Denver: Petrie Institute of Western American Art, DAM [Western Passages], in association with the University of Washington Press, Seattle, 2003), 6.

111 Ann Daley, "How Candy Built a Colorado Treasure," *Sweet on the West,* 25. Daley's essay documents the colorful story of the Harmsens' career as both entrepreneurs and collectors.

112 Dorothy Harmsen, quoted by Daley, "How Candy Built a Colorado Treasure," 29.

113 Personal e-mail from Joan Troccoli, 24 June 2011. See also Lewis Sharp, interview by author; Troccoli interview by author, September 10, 2010, transcript Petrie Institute of Western American Art, DAM; Wallace, interview by author; Tom Petrie, interview by author, November 3, 2010, transcript Petrie Institute of Western American Art, DAM; and Daley interview by author.

114 Petrie interview by author.

115 See Troccoli's essay on *The Cutting Scene* in this book.

116 Troccoli acknowledges the contributions of others who played a significant part in the negotiation process in her foreword and acknowledgments, *Sweet on the West,* 6–7. Also see Troccoli interview by author.

117 After a thorough, three-year evaluation by Troccoli, Daley, and curatorial assistant Mindy Besaw, the museum ended by keeping about 250 works and began deaccessioning the rest (comment by Thomas Smith during Troccoli interview by author). The evaluation eventually dragged on for almost eight years, with Hassrick and Smith deaccessioning the last large bundle of paintings after Smith's arrival in October 2008 and even reaccessioning some earlier disposals (e-mail communication from Smith, 28 June 2011). According to standard museum practice, funds from the sale of deaccessioned works are kept in a separate account and used to refine the collection with better quality works that are then credited to the original donors "by exchange."

118 Petrie interview by author.

PART TWO

Digging Deeper: The Petrie Institute 2001–2011

After its founding in 2001, just two months after the gift of the William Sr. and Dorothy Harmsen Collection, to the Denver Art Museum, the Institute for Western American Art lost no time in setting its ambitious program in motion. Seizing the fortuitous opportunity offered by trustee Tom Petrie's search for an appropriate vehicle that would honor in some significant way the bicentennial of the U.S. Military Academy at West Point, his alma mater, the institute's first director, Joan Carpenter Troccoli, initiated work on an exhibition and publication that would explore the contributions of West Point's nineteenth-century graduates to the development of the West and to what had come to be known as "expeditionary art." Troccoli herself wrote the major essay for the inaugural volume of the institute's Western Passages series, *West Point/Points West*. Identifying the book as the first in a series and sending it as a gift to colleagues nationwide proved both harbinger and surety of the

museum's intention to take a leadership role in scholarly publishing on western American art.

Despite the institute's highfalutin name and sweeping aspirations, Troccoli readily admitted that its program differed little from those of the museum's other departments: all center on collecting, exhibiting, research, and publishing. What distinguishes the institute from the Denver Art Museum's other curatorial departments is its narrowness of focus, while its breadth of vision—its agenda to position western American art in the mainstream, to study it "in the context of all the other fields in which the museum collects,"[1] sets it apart from the dedicated western American art museums that dominate the field in collection strength.

In 2002, the same year that *West Point/Points West* opened, the tiny institute staff began work on a second Western Passages publication, *Sweet on the West: How Candy Built a Colorado Treasure*, featuring Bill and Dorothy Harmsen's gift.[2] Associate curator Ann Daley provided the lead essay focusing on the Harmsens' entrepreneurial and collecting activities. As staff liaison

to the Contemporary Realism Group founded by trustee Jim Wallace in 1991, she also continued until her retirement in 2008 to guide its acquisition program after it was brought officially under the umbrella of the institute.[3]

Meanwhile, the institute's first advisory board, whose members consisted of Tom Petrie, Jim Wallace, Sarah Hunt, Bill Hewit, and Cortlandt Dietler, met to examine such early priorities as raising an endowment and planning an installation for the Harmsen Collection in the Betsy Magness Gallery. Over the years, the board's membership has expanded to include Henry Roath, Pat Grant, Ray Duncan, Nancy Petry, Chuck Griffith, Gary Buntmann, Bob Boswell, and Gerri Cohen.[4] Much of the credit for the success of the western program belongs to the advisory board, according to Thomas Brent Smith, current director of the institute. Its members, he says, "have enthusiastically assisted the staff in many avenues by sharing their perspectives, helping to find funding sources, and most importantly serving as ambassadors in the community."[5]

When she addressed the Western

History Association's annual conference in October 2003 as part of a panel on the future of western art, Troccoli focused on the challenges of the museum expansion scheduled to open in 2006.[6] By then a major donation to the building fund by Cort Dietler and his wife Martha ensured the western American art collection prominent and permanent gallery space on the second floor of the proposed Hamilton Building. Rejecting a narrow definition of western art as a set of canonical subjects or as work created by artists living in the West, or even as a matter of realistic treatment, Troccoli explained that the new galleries would contain a combination of contemporary and historical western art presented and interpreted by an interdisciplinary team made up of curators, museum educators, editors, and exhibition designers in a way that might redefine western art as mainstream American art and

bring previously ghettoized figures like George Catlin, not to mention the eternally damned Frederic Remington, back into the much larger art world—the world they inhabited when they were alive.[7]

In mid-December 2003, the institute opened *Frederic Remington: The Color of Night* from the National Gallery of Art in the North Building's seventh-floor center court, a modest but important exhibition of the painterly late nocturnes that finally brought the artist the critical approval he craved. Like *West Point/Points West,* which had appeared in the same small gallery, the show drew large crowds and critical plaudits. Unfortunately, it was to be the last special exhibition presented by the institute until mid-December 2007, well after the opening of the Dietler Galleries of Western American Art in the Hamilton Building in October 2006. The institute staff, obliged to give over the Betsy Magness Gallery as a staging

area for the museum's new Hamilton Building galleries and strained by ongoing stocktaking of the Harmsen gift and plans for the new Dietler Galleries, initiated no public programs while its galleries were shuttered or still embryonic. Plagued by health issues, Troccoli stepped down as director to concentrate on writing and research as the institute's senior scholar and was succeeded as director in the summer of 2005 by Peter Hassrick, who brought thirty-five years of experience and a renewed energy to the program.

Outlining his perspective and major goals for the institute to the advisory board at its fall 2005 meeting, Hassrick emphasized the need for an endowment of $8 to $10 million. In order to put the museum on the map as a leader in western American art scholarship, collections, and exhibitions, he argued, a reinvigorated Denver community was essential. Hassrick laid on the table action plans calling for the publication of Western Passages on a consistent,

Page 46: Joseph G. Bakos
Rocks in the Clearing, 1918-19
Oil on canvas, 20 x 16
Denver Art Museum purchase, funds from the William Sr. and Dorothy Harmsen Collection, by exchange, 2011.277

Charles Deas and 1840s America
gallery installation, 2010

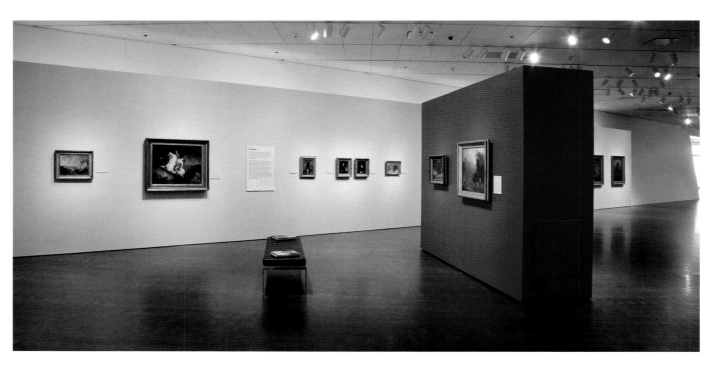

yearly schedule and the launch of an annual scholarly symposium. A systematic series of major exhibitions with companion publications loomed large in Hassrick's long-range plans. Much of 2006 was necessarily devoted to the complex task of readying the new Hamilton Building gallery for the October 7 public opening. By early 2007, Hassrick jump-started his ambitious new program with the institute's first symposium, for which he assembled a star-studded group of distinguished experts: Brian Dippie, Erika Doss, Patty Limerick, Angela Miller, Martha Sandweiss, and William Truettner. Perhaps prophetically titled "Redrawing Boundaries," the symposium played to an overflow crowd, and its wide-ranging and refreshing proceedings were published as the third volume of the Western Passages series. In September of that year, trustee and collector Tom Petrie and his wife Jane

established a $5 million endowment for the institute—including an outright cash gift of $3 million and a $2 million matching challenge pledge. In gratitude for their munificent commitment to the institute's initiatives, the department was renamed the Petrie Institute of Western American Art.

In 2006, the museum brought out a second volume of the *Contemporary Realism Collection* cataloging all thirty-five works added to the museum's collection by the Contemporary Realism Group in fifteen years of activity. Volume four of Western Passages, which appeared hard on the heels of volume three in 2007, *Heart of the West: New Painting and Sculpture of the American West*, featured the same group of works and contained an essay by associate curator Ann Daley detailing the selection procedure followed by the Contemporary Realism Group and discussing the important role its

collection played in the institute's "effort to join time and place in the narrative" on display in the Dietler Galleries of Western Art.[8] A joint celebration of the contemporary realism collection and the institute's 2007 exhibition of the drawings and sculpture of George Carlson, who is represented in that collection, the book also included an essay by Gordon McConnell praising the contemporary realism collection for demonstrating the "resilience and relevance of traditional forms of painting and sculpture" and giving the institute's "collection a critical edge and a renewable future."[9]

Hassrick's plans for an active program of groundbreaking major exhibitions, accompanied by scholarly catalogs, got off the ground in 2008 with *In Contemporary Rhythm: The Art of Ernest L. Blumenschein*, which opened in Denver in December after its debut in Albuquerque. Having first

Tom Petrie and
Thomas Smith.

Above: Joan Troccoli and Carol Clark at the
Charles Deas opening; far left: Thomas Smith,
Ray Duncan, Tom Petrie, Sally Duncan, and
Jim Wallace at the *Distant View: European
Perspectives on Western American Art* symposium
cocktail reception, 2011.

Jim and Lucy Wallace, 2009.
Bill and Dorothy Harmsen
and sons Bob, Bill Jr., and
Mike, early 1950s. Far right:
Peter Hassrick, 1981.

Above: PIWAA volunteers and staff, 2007. Back row,
Nancy DeLong, Debbie Gray, Nicole Parks, Mary Willis;
front row, Stacey Skelton, Holly Clymore.

Jane and Tom Petrie at *The Masterworks of Charles M.
Russell* opening celebration, 2009.

envisioned the retrospective show in 2004 in concert with independent scholar Elizabeth Cunningham and James Moore, then director of the Albuquerque Museum of Art and History, Hassrick had the project and his catalog contributions well in hand before taking the reins as institute director in 2005. Published by the University of Oklahoma Press as volume two in the Charles M. Russell Center Series on Art and Photography of the American West, the catalog won a Wrangler Award for best western art book of the year from the National Cowboy and Western Heritage Museum in Oklahoma City. That same year, in anticipation of the institute's participation in a tripartite exhibition of the work of Colorado muralist Allen True scheduled to open in October 2009 at the Denver Public Library, the Colorado History Museum, and the Dietler Galleries, Hassrick's essay on True's early career served as the lead essay for volume five of Western Passages, *Colorado: The Artist's Muse.*[10]

At the same time, preparations were underway for *The Masterworks of Charles M. Russell: A Retrospective of Paintings and Sculpture,* which opened in Denver in October 2009 amid kudos from the *Wall Street Journal* that included the prediction

that the exhibition might "just inspire a new appreciation for Western art as a whole."[11] First discussed in 2003 during Troccoli's directorship as a modest affair that would include works by Russell associates whose work either influenced or were influenced by him, by 2004 the show had grown into a unprecedented undertaking focused entirely on the Montana artist.[12] The size and reputation of the Denver Art Museum, as well as the support of two influential Russell scholars—Brian Dippie and Rick Stewart—undoubtedly helped secure critical loans from the three major institutional repositories of Russell's artistic legacy[13] and likely played a significant role in attracting the Gilcrease Museum as an organizing partner and the Museum of Fine Arts, Houston, as the third venue for the traveling exhibition. The wealth of material offered by the show's subject helped prompt the idea of dusting off the original plan for the exhibition as the topic for volume six of Western Passages. *Charlie Russell and Friends,* which appeared in 2010, explored Russell's friendships with some of the artists "who served as [his] private academy of art as well as his creative community."[14] Joan Troccoli provided an introduction setting the scene for a book devoted to Russell's "mutual support

society,"[15] and both Peter Hassrick and Thomas Smith contributed essays detailing Russell's special relationship with a single artist—Philip Goodwin and Maynard Dixon, respectively.

Simultaneously with her work as curator of the Russell exhibition, Joan Troccoli joined forces with Carol Clark to curate *Charles Deas and 1840s America,* which brought the little-known painter of the Denver Art Museum's 1999 *Long Jakes* purchase to national and international attention when it opened at the museum in 2010.[16] Troccoli edited the companion volumes for the two exhibitions and contributed an essay to each. Both books were published under the auspices of the University of Oklahoma Press, and *The Masterworks of Charles M. Russell* won the Wrangler Award for best western art book of the year from the National Cowboy and Western Heritage Museum.

Reviving an abandoned plan initiated in 2007 with *Redrawing Boundaries* to pair the publication of a Western Passages book with an annual symposium, volume seven of the series, *Shaping the West: American Sculptors of the 19th Century* (2010), recorded the proceedings of the symposium of the same name, for which director emeritus Hassrick, who had retired as institute director in April 2009,

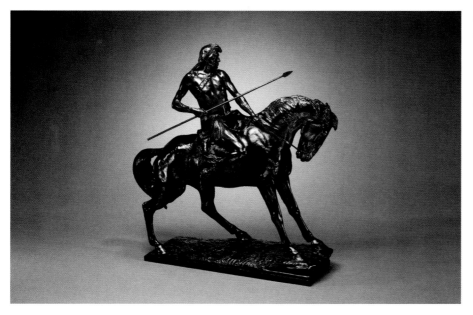

Alexander Phimister Proctor
On the War Trail, 1920
Bronze, 20¹/₈ x 19⁵/₈ x 7¼
Denver Art Museum, Funds from
Friends of Painting and Sculpture
in honor of Lewis I. Sharp, 2005.11

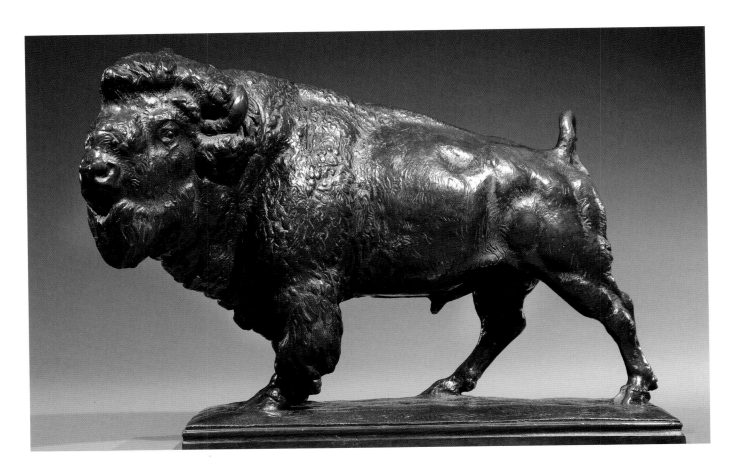

Alexander Phimister Proctor
Q Street Bridge Buffalo, 1912
Bronze, 13 ¼ x 18 x 9 ½
Denver Art Museum, funds from the Harry I. and
Edythe Smookler Memorial Endowment, Estelle
Wolf, and the Flowe Foundation, 2011.276

Facing: Top, The Dietler Galleries of Western
American Art in the new Hamilton Building,
2006. Bottom, *Creating the West in Art,* Betsy
Magness Galleries, seventh floor of the North
Building, 2009.

and Thayer Tolles, curator in the Department of Paintings and Sculpture at the Metropolitan Museum of Art, were joined on the podium by Andrew Walker, curator of American art at the Saint Louis Art Museum, and Sarah Boehme, director of the Stark Museum of Art. But, like volume five of *Western Passages, Colorado: The Artist's Muse* (2008), which was inspired by work on the forthcoming Allen True exhibition, both volume four, *Heart of the West: New Painting and Sculpture of the American West,* and the symposium that followed in January 2008, "Heart of the West: New Art/New Thinking," were prompted by the George Carlson sculpture exhibition that opened in December 2007. Similarly, it was the 2008 Blumenschein exhibition, *In*

Contemporary Rhythm, that provided the impetus for 2009's symposium, "Taos Traditions: Artists in an Enchanted Land," just as the symposium that opened the institute's second decade in January 2011, "A Distant View: European Perspectives on Western American Art," was spurred by plans for the Petrie Institute's 2013 exhibition featuring Munich-trained painters Walter Ufer and E. Martin Hennings.

Darkened for four years as the Hamilton Building was readied, the seventh floor of the museum's original 1971 building was reclaimed by the department in 2008.[17] As Denver Art Museum director Lewis Sharp explained, the move, which almost doubled the space devoted to western American art, was warranted by "strong

community interest, the department's 'aggressive, ambitious curators' and trustees and collectors willing to provide substantial financial support."[18] Petrie Institute director Peter Hassrick lobbied for the additional space to present a "balanced understanding of why the West mattered culturally and how the region's art fits within the larger canon of American art."[19] In order to "reconsider the place of western art in American cultural history," Hassrick devoted the newly renovated galleries entirely to historical paintings and sculpture of the nineteenth and the first half of the twentieth century. The Hamilton Building's Dietler Galleries now showcase modern and contemporary works created about the West since about 1930.

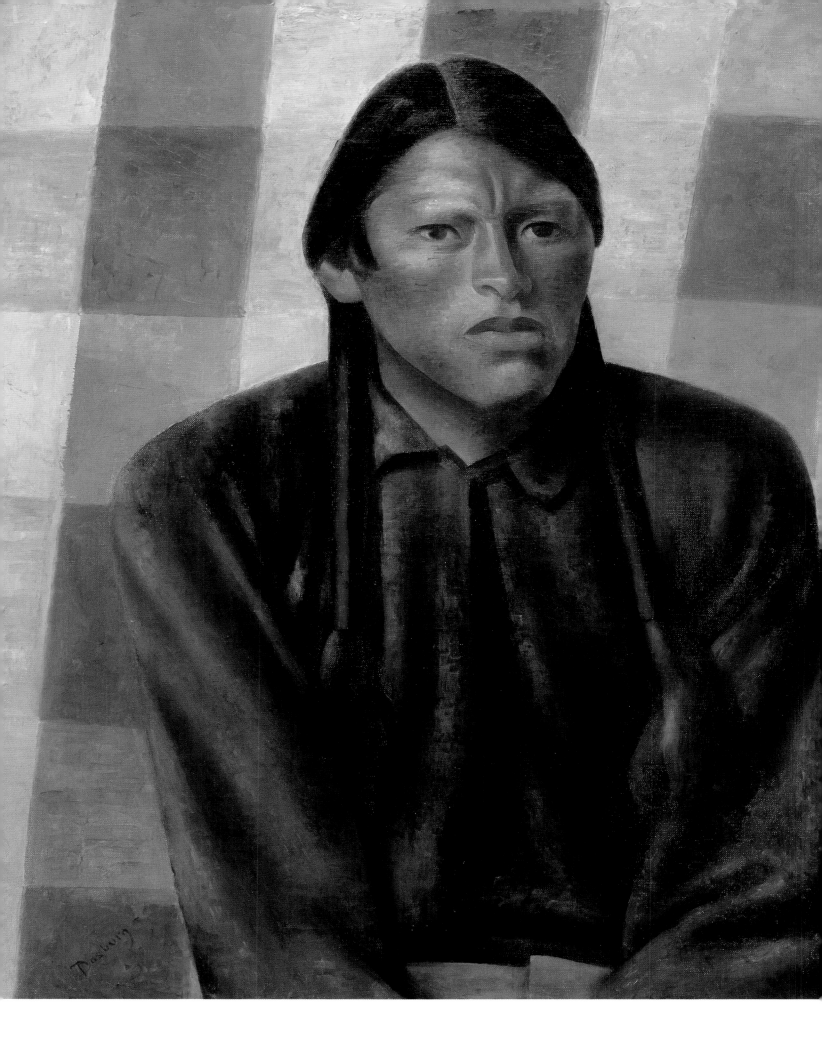

Andrew Dasburg
Bonnie, 1927
Oil on canvas, 31¾ x 27⁵/₈
Denver Art Museum, Lucile and Donald Graham
Collection, 1981.624

Peter Hurd
Portrait of Henry Stein with background of
Red Butte Ranch, Aspen, 1964
Tempera on wood, 26 x 36
Denver Art Museum, Gift of the Estate
of Marjorie B. Stein, 2004.93

Thomas Smith, who joined the institute staff as associate curator and director designate in November 2008, worked closely with Hassrick in selecting and designing the exhibition that now occupies the reclaimed seventh-floor galleries, *Creating the West in Art*, an appropriately titled, vaguely chronological exhibition that illustrates the changing interpretation of the West in art by both artists and museums. The interpretive scene is set in an introductory gallery dominated by Alexander Phimister Proctor's 1927 bronze maquette for *The Pioneer Mother* and Dean Cornwell's *Gold*

Rush II, which illustrated an article in a 1926 issue of *Cosmopolitan Magazine.* Hassrick uses these works to exemplify the concept of a "westering America," which "served as an intellectual construct for museum interpretation for decades." During these years, the first western art museums "employed [western] art as an analogue to history and viewed that history as the foundation of the democratic and capitalist systems that had made the United States a world leader by 1950." Hassrick's installation takes the view that neither this early reading of western art nor any of the succession

of approaches that followed "should stand alone. Instead, visitors to the galleries should consider the full range of [interpretive] ideas when analyzing [the works on view]." The remaining eight galleries are chiefly chronological and focus on such themes as "Creating the West's First Heroes" and the western landscape. Hassrick parlayed his cordial connections with a wide network of collectors and colleagues into temporary loans that fill in gaps and buttress his interpretive narrative.[20] The opening of the new gallery on February 19, 2009, just two months before his retirement, capped Hassrick's prolific years as

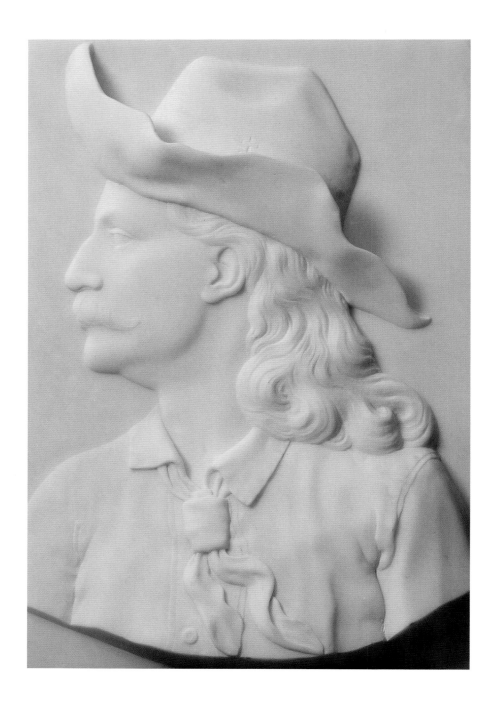

director of the Petrie Institute with a concrete demonstration of his campaign to redraw the boundaries that define western art and to restore it to its rightful place in mainstream American art.

Smith, who succeeded Hassrick as Petrie Institute director, brings a youthful enthusiasm and dedication to the role. Right out of the chute he inherited all the unfinished business for both the Russell and Deas shows while simultaneously curating *Western Horizons: Landscapes from the Contemporary Realism Collection*, the twentieth-anniversary exhibition of the collection's inception that opened in the Dietler Galleries in December 2010 on the heels of the Deas show. Smith's ambitious exhibition plan for the near term is headlined by two shows being groomed for international travel. First up is an exhibition focusing on the work of Taos Society painters Walter Ufer and E. Martin Hennings and scheduled to open in 2013 in Denver. Negotiations are underway with a Munich, Germany, venue. Smith is co-curating the second project with Thayer Tolles, who oversees the American sculpture collection at New York's Metropolitan Museum of Art. Titled *The American West in Bronze: 1850–1925*, the show is slated to open in 2014 at the Met before coming to Denver and traveling on to China. Even as these large, complex undertakings are readied, the institute will host an exhibition of the work of California painter Ed Ruscha in December 2011 and one on Georgia O'Keeffe in 2013. Smith has also curated an exhibition of paintings by contemporary Montana artist Theodore Waddell scheduled to follow the Ruscha show in spring 2012. As if all this were not enough, in

his two-plus years as director, Smith has ushered through the press two previous volumes of Western Passages and organized and presided over two day-long symposiums while working tirelessly beside Tom Petrie to secure contributions to the endowment.

This year, with a decade of dynamic programming under its belt and exciting plans for the future, the Petrie Institute of Western American Art celebrates a significant milestone—the completion of its $7 million endowment campaign. Just over three years ago Tom Petrie and his wife Jane laid the foundation for the endowment with a gift of $3 million and a promise to match other contributions up to $2 million. With his usual decisiveness and energy, Petrie made sure the challenge was met by personally canvassing the matching funds from forty-eight other supporters of the institute's mission "to recognize and promote the significance of the West in the larger picture of American cultural development."[21] Westward Ho!

Notes

1 Interview with Joan Troccoli, Kyle MacMillan, *Denver Post,* July 31, 2001.

2 At the time, the institute staff consisted of Troccoli, director; associate curator Ann Daley, who was only half-time; and Mindy Besaw, curatorial assistant.

3 At its founding in 1991, the Contemporary Realism Group was allied with the museum's Modern and Contemporary Department before moving first to the Painting and Sculpture Department, then to the Institute for Western American Art. As early as 2000, the group had acquired the "nucleus of a collection that forms a continuity with the historical western art of the 19th century" in the museum's collection (Ann Daley, *Contemporary Realism Collection* [Denver: Denver Art Museum (hereafter DAM), 2000], vol. 1: unnumbered page 4. See also Jim Wallace, unnumbered page 5).

4 Bill Hewit left the board in the fall of 2005, and Sarah Hunt resigned in early 2006. Sadly, Cort Dietler died in July 2008.

5 Thomas Smith, personal e-mail to author, 7 July 2011.

6 Other panel members were Rick Stewart, Peter Hassrick, and Byron Price. Brian Dippie moderated.

7 Joan Carpenter Troccoli, short version of lecture delivered as panelist, "The Future of Western Art," Western History Association, annual conference, October 9, 2003 (institute digital files).

8 Ann Scarlett Daley, "How the West Was Collected," in *Heart of the West: New Painting and Sculpture of the American West* (Denver: Institute of Western American Art, DAM [Western Passages], 2007), 28.

9 Gordon McConnell, "The Contemporary Realism Group: New Narratives in the Art of the American West," in *Heart of the West*, 51. *George Carlson: Heart of the West* opened December 15, 2007, and closed April 13, 2008.

10 Peter Hassrick, "Allen True: The Early Years," in *Colorado: The Artist's Muse* (Denver: Petrie Institute of Western American Art, DAM [Western Passages], 2008), 9–29.

11 Barrymore Laurence Scherer, *Wall Street Journal* (Eastern ed.), December 17, 2009, D6.

12 Joan Troccoli interview by author, September 10, 2010, transcript Petrie Institute of Western American Art, DAM.

13 The lion's share of Russell's works are held by Tulsa's Gilcrease Museum, Fort Worth's Amon Carter Museum of American Art, and the Montana Historical Society in Helena. On the probable influence of Dippie and Stewart, as well as the recently retired Hassrick, in securing necessary loans, see Kyle MacMillan, *Denver Post,* October 25, 2009.

14 Joan Troccoli, Introduction, in *Charlie Russell and Friends* (Denver: Petrie Institute of Western American Art, DAM [Western Passages], 2010), 11.

15 Brian W. Dippie, "Where the Artists and the Antelope Play: Russell's Community of Peers," in *Charlie Russell and Friends*, 24.

16 Carol Clark is professor of art and American studies at Amherst College, Amherst, MA, and the author of numerous books. Among the press attention enjoyed by the exhibition: Barrymore Laurence Scherer, "Recalled from Obscurity," *Wall Street Journal*, September 15, 2010; Paul Harris, "Hunt Uncovers Lost Paintings of a Wild West Art Pioneer," *Guardian*, September 12, 2010, accessed at http://www.guardian. co.uk/artanddesign/2010/sep/12/charles- deas-wild-west-artist; and Kirk Johnson, "Artist's Work, Out of Attics, Goes to Walls of a Museum," *New York Times*, August 25, 2010, accessed at http://www.nytimes. com/2010/08/25/arts/design/25artist.html?_ r=1&scp=1&sq=Deas&st=cse.

17 Because what is now numbered as the North Building's second floor was originally identified as the mezzanine, its upper floors have all known two designations. Somewhat confusingly, the Betsy Magness Gallery began its career on the sixth floor, which is now known as the seventh.

18 Lewis Sharp paraphrased and quoted by Kyle MacMillan, "How the West Was Seen," *Denver Post*, February 22, 2009.

19 Peter Hassrick, "Creating the West in Art," *The Magazine Antiques* 176, no. 1 (July 2009); accessed at http://www.themagazineantiques. com/articles/creating-the-west-in-art/print. Unless otherwise identified, all quotations in this and the following paragraph appear in this article by Hassrick.

20 About one-third of the 130 works on view were credited to the Harmsen Collection and one-fourth were loans from public and private collections. See MacMillan, "How the West Was Seen," and Mary Voelz Chandler, *Denver Post*, February 20, 2009.

21 Peter Hassrick, "Mission Statement," undated DAM promotional brochure.

PART TREE
Prospectors

LEWIS I. SHARP

FREDERICK AND JAN MAYER
DIRECTOR,
DENVER ART MUSEUM,
1989–2009

"I've been given credit as a western American art champion that I don't really deserve," insists Lewis Sharp. "All I really did was let the commitment blossom."[1] Talking about his career at the Denver Art Museum, Sharp repeatedly points out that he was "always very pragmatic and opportunistic." Many initiatives began, he explains, with what seemed like an opportunity for the institution and ended later as a passion or a vision. And

so it was with his support of western American art. Both Cortlandt Dietler and Bob Magness—two of the three funders who joined trustee Frederic Hamilton in making it attractive for Sharp to move to Denver from New York's Metropolitan Museum of Art, where he was chief curator and administrator of the American Wing— were avid western art fans. The fourth member of this quartet, board chair Frederick Mayer, offered Sharp advice that the new director realized would be foolhardy to ignore: "Leaving western art fans out of the institution means depriving yourself of the type of support you need to have a successful museum."[2] So from the time of his arrival in January 1989, Sharp was keenly aware of the deep pockets of feeling and funding that existed within the community of western art advocates. Although no great fan of western art, he wanted to let this group of supporters know that he embraced Denver as a western place and meant to respect its enthusiasm for western subjects in art.

Sharp is quick to correct the widespread and persistent perception that his arrival marked a watershed

moment in the history of the Denver Art Museum's endorsement of western American art. Like Peter Hassrick, whose father, Royal, became the museum's first curator of western art in 1955, Sharp is well aware of the long continuity of commitment that runs through the institution's exhibition and acquisition record. He had only just arrived on the scene, Sharp contends, when the museum's newly named Betsy Magness Gallery of Western Art and American Art opened amid the fanfare of an inaugural loan exhibition celebrating western art. Organized by the museum's then-curator of American art, David Park Curry, *The Western Spirit: Exploring New Territory in American Art* was actually the culmination of a past rich in active promotion of western-themed art. In his introduction to the exhibition catalog, Curry draws attention to this history of "involvement with the artists and art of the region" and points to the fact that the museum had "hosted forty-five exhibitions featuring western art" in the previous decade alone.[3]

Sharp readily admits that comments he made to the press when his appointment was first announced may

have inadvertently fueled the myth of his special interest in western art. He was quoted then as calling the museum's cast of *The Cheyenne* "the single most important Remington bronze in existence."[4] In setting the record straight now, he says that the work he did in western art while at the Metropolitan was not inspired by an interest in western subject matter but rather by his professional curiosity as a connoisseur. He began to dig in when trying to resolve a problem with the Met's Remington bronze collection, which had always been considered the gold standard but which, on closer examination, proved in fact to contain only a few lifetime casts of quality. As he explored this discrepancy, Sharp grew fascinated with the creative nature of Remington's collaborative relationship with his foundries, especially at the pivotal moment of the introduction of the lost-wax process to the United States, a moment that coincided with *The Cheyenne*'s production. "I used to say when I arrived here," Sharp recalls, "that I left the largest and finest American sculpture collection at the Met and came to Denver, where they had the single finest casting in American bronze."

Despite the best of intentions to demonstrate a strong commitment to the western genre of American art, the first years of Sharp's Denver tenure offered few proofs. With a single exception, a mere handful of modest shows featuring western art dotted the six years bookended by *Frontier America: Art and Treasures of the Old West from the Buffalo Bill Historical Center* (1990) and *The Real West*, a collaborative venture with the Colorado Historical Society and the Denver Public Library (1996). The only exception was *Lens and Landscape: American Photography 1860–1910*. This 1992 exhibition was the first large showing of one of Sharp's earliest major acquisitions as director: the collection of more than 1,250 vintage American photographs assembled by collector-dealer Daniel Wolf of New York, which was heavily weighted with images of the West. Trustee Jim Wallace, who took the new director "under his wing from the first moment [he] walked in the door," played a "powerful" role in helping Sharp enlist funders by positioning the collection as evidence of the museum's serious commitment to western art. Today, Sharp's not so sure this purchase seemed more than a token gesture to the champions of western subjects.

Looking back now on the milestones leading to the "blossoming" of the Petrie Institute, Sharp names the 1991 gift of Charles Russell's *In the Enemy's Country* from Sharon and Bob Magness as an important early step and applauds Bob's perceptiveness in pinpointing the western collection's need for "a few anchors, a few masterpieces," as well as his generosity in stepping forward to buy a painting of that caliber for the museum. Sharp credits western art fan Cort Dietler indirectly for recruiting Joan Troccoli as deputy director in 1996, another milestone. Dietler's sharp eye caught a press notice in the *Tulsa World* trumpeting her achievements as executive director of the Gilcrease and reporting her impending move to Denver. And, of course, Sharp commends Troccoli herself for persistently endorsing *Long Jakes* by Charles Deas as a "must have" acquisition and for curating a major traveling exhibition of Philip's impressive survey collection of western American art, another demonstration of the museum's commitment to the genre. A much expanded community of enthusiasts—including museum trustees Charles Gallagher, Tom Petrie, Bob Rich, and Jim Wallace; Doug Jones, then president of the Denver Chamber of Commerce; the Harmsens' lawyer, Nick Muller; and members of the Harmsen family—deserves credit, Sharp thinks, for helping to craft an agreement with Bill and Dorothy Harmsen that enriched the museum's collection of western art with hundreds of works. In the wake of the 2001 Harmsen gift came the founding of the Institute of Western American Art and a magnanimous gift from Martha and Cortlandt Dietler that secured a prominent gallery space for the institute in the 2006 Hamilton Building.

Sharp counts himself lucky to have brought Peter Hassrick on board to head up the institute when Troccoli relinquished her administrative role in 2005. The presence of one of the nation's foremost scholars of western art put the decisive, convincing stamp on the museum's seriousness of purpose and earned the endorsement of a confirmed western art partisan like Tom Petrie, who undertook the task of creating an endowment that would assure the institute's future. Sharp feels confident that his vision of the institute as a major national center for the study and promotion of western art will be fully realized under the leadership of Hassrick's successor, Thomas Smith, whom he describes as "up and coming," a rare find in a field where qualified and gifted curators are scarce on the ground.

"When I bought my first Russell, it should have come with a label that said it could become addictive."[5] Tom Petrie grins when he talks about how he fell under the spell of western American art and became its most dedicated booster at the Denver Art Museum. But Petrie's love affair with the West and western art in fact took root much earlier, during boyhood summers spent poring over illustrated books and in the company of older relatives who encouraged his curiosity about geography and history. It was in the pages of these adventure books that he first encountered Charlie Russell's complex vision of the West.

Although he grew up in the East, Petrie actually can't remember a time when he wasn't interested in the West, but he does recall that "something special happened coming down over the mountains and driving through Colorado" on his first cross-country trip at the age of twenty-one. After earning his B.S. degree from the U.S. Military Academy at West Point and tours of duty in Germany and Vietnam, Petrie received an M.S. in business administration from Boston University in 1970 and began working for Colonial Management in Boston as an oil analyst and then two years later for the First Boston Corporation in New York, a job that often brought him to Denver to visit Hamilton Brothers Petroleum, Champlin Petroleum, and Forest Oil.

Not long after moving to Denver in the 1980s, Petrie was introduced to the Denver Art Museum community through then board vice chair Frederic Hamilton and an expanded circle of oil industry friends that included trustees Cortlandt Dietler, Jim Wallace, and Frederick Mayer.

Most of Petrie's attention during his first two decades in Denver was taken up, however, by business concerns, especially after he founded his own firm in 1989. It was the mid-nineties before he finally made time to step up his collecting activities. No longer satisfied with Russellesque watercolors created as a hobby by a distant relative—a commercial artist for Ryan Aeronautical who had grown up in Great Falls, Montana, and haunted Russell's studio as a boy—Petrie was able to purchase his first "addictive" Russell in 1995. By the time Jim Wallace was thinking about going off the museum board in 1998, Petrie's serious interest in art, particularly western art, was well enough known that Dietler and Wallace lobbied for him as the right candidate to fill the vacancy. Their argument that a group of supporters stood ready to build on past efforts to promote western art at the museum convinced Petrie that he could make a significant contribution as a board member. When he and Wallace learned of the Harmsens' interest in donating their large collection of western American art to the Denver Art Museum, they began working to overcome the complicated obstacles that lay in the way, a campaign that included, as Petrie says, "making themselves a nuisance" to reluctant museum officials. His efforts on behalf of the 1999 purchase of *Long Jakes* by Charles Deas in memory of Bob Magness and the zealous role he and Wallace took in securing the 2001 gift of the Harmsen collection confirmed Petrie's place as a stakeholder in the museum's program.

When Petrie had accepted a seat on the museum board in 1998, director Lewis Sharp spoke to him of his idea for an institute of western American art as a museum department. Sharp envisioned the institute, he told Petrie, as a national center for scholarship in the field, a leadership role he saw as the logical outgrowth of Denver's geographic and economic primacy in the West. Petrie regards this now as a "great vision," one that he "underappreciated at first" but that he later came to see "as an epiphany." At the time the Institute of Western American Art was established in 2001, Petrie was also focusing on his role as a trustee of the Association of Graduates of the U.S. Military Academy at West Point and considering what he might do to make the academy's forthcoming 2002 bicentennial better known, especially west of the Mississippi. When Joan Troccoli, newly appointed director of the fledgling institute, learned of Petrie's search for a vehicle that would bring to public notice West Point's role in the opening of the West, she jumped at the chance to feature its germinal contribution to the history of art of the West in what became the institute's first publication and exhibition, *West Point/ Points West.* Her own interest in the work of the artists who accompanied the early military expeditions made her especially eager to champion their art as a "quintessentially American form of history painting."[6]

Petrie found himself increasingly intrigued and challenged by evidence of a rising interest in serious scholarship in western art. He was aware of Peter Hassrick's 1996 catalogue raisonné of Remington's paintings and works on paper, and, as a member of the national advisory board of the C. M. Russell Museum, he had collaborated with fellow advisory board member Jim Wallace in securing support for a catalogue raisonné of Russell's work. He was also particularly encouraged by two scholarly exhibitions organized by the National Gallery of Art in association with the Gilcrease Museum—*Thomas Moran* (1997) and *Frederic Remington: The Color of Night*, which the institute hosted in the center court of its western

art galleries in 2003–4. Inspired by these examples, Petrie, who by then had assembled the most significant collection of work by Russell in private hands, began to explore the prospect of organizing a major Russell retrospective with institute director Troccoli.

Petrie encouraged and applauded the hiring of Peter Hassrick to take over the helm of the four-year-old institute in 2005, when Troccoli decided to give up her administrative duties in the face of increasing health demands. With the flurry of activity that followed Hassrick's appointment and the renewed sense of energy attendant on the opening of the Dietler Galleries of Western American Art in the Hamilton Building in 2006, the museum's serious commitment to western American art was sealed. Soon after his arrival, Hassrick outlined an ambitious exhibition and publication program that would position the institute as the national leader in the field of western art scholarship and called on potential funders to provide a substantial endowment to fuel the program he envisioned. Two years later, in September 2007, Petrie stepped forward with a $5 million pledge that included an outright gift of $3 million and an additional $2 million matching "challenge" pledge. In recognition of this gift and Petrie's long-term commitment to western art and the Denver Art Museum, the institute received a new name in his honor, the Petrie Institute of Western American Art. In February 2011, just over three years after announcing the donation, the museum was able to declare the $7 million endowment fully pledged. As the institute's current director Thomas Smith says, "Tom Petrie is a force, and when he gets it in his head to do something, he's going to see to it that it happens."[7]

JOAN CARPENTER TROCCOLI

SENIOR SCHOLAR,
PETRIE INSTITUTE
DIRECTOR, 2001–2005

As a young graduate student, Joan Carpenter Troccoli seemed destined to make her mark in the field of European art history. Trained at the Institute of Fine Arts, New York University, she was writing a Ph.D. dissertation about the ways in which the work of early nineteenth-century Parisian-view painters presaged impressionist cityscapes of "modern life" when fate stepped in, taking her to Oklahoma City from the East with her husband in 1982.

There, after finishing her dissertation, she was introduced to western American art in a big way when she finally visited the Gilcrease Museum in 1985 and found her curiosity piqued by paintings whose features linked them to the European tradition, features "no one had ever fully analyzed."[8] She began by devouring everything she could find on Thomas Moran and Rudolph Kurz and subsequently wrote two essays on Frederic Remington for *Gilcrease Magazine.* The first of these focused on Remington's stylistic similarities to impressionism, the second on his "French connection." Now included in the standard bibliography of scholarly work on Remington, the publications led to her being hired in 1988 as curator of exhibitions at Gilcrease Museum, which, she says, was "looked upon at that time as a warehouse for other museums to use."

The American Federation of Arts picked up Troccoli's first Gilcrease exhibition, *Alfred Jacob Miller: Watercolors of the American West* (1990), for a national tour. The exhibition catalog, in which Troccoli defended her then-revolutionary thesis that Miller produced most of his watercolors in the studio, was singled out in a recent scholarly catalog as "the best focused study of the medium in relation to the artist's work."[9] Her second Gilcrease show (1993), this one on George Catlin, also toured under AFA auspices and sparked her long-term interest in Catlin's work, as well as earning her a book contract with University of Oklahoma Press. The pressure of administrative duties after her promotion to director at the Gilcrease in 1992 and the weight of scholarly work she has accomplished since arriving at the Denver Art Museum in 1996 to serve as deputy director help account for the fact that she is still "nibbling away at" the Catlin book project.

When her husband's business compelled another move in 1995, this time to Denver, Troccoli had barely time to catch her breath before supporters of western American art brought her to the attention of director Lewis Sharp. Her experience as both director and scholar at one of the nation's foremost western art museums made her an ideal candidate to fulfill the Denver Art Museum's renewed commitment to western art, as well as its need for a deputy administrator. Almost immediately after her appointment, Troccoli began organizing, at Sharp's urging, an exhibition of Philip's extensive collection of western paintings, which opened in Denver in 2000 and later traveled to the Corcoran Gallery of Art and the Joslyn Art Museum. Yale University Press co-

published Troccoli's catalog, *Painters and the American West: The Collection,* which centers on the formal qualities of the works and their connection to contemporaneous developments in the wider world of American and European art. This first professionally organized exhibition of 's lovingly and thoughtfully assembled holdings went a long way toward convincing him and other western art enthusiasts of the museum's sympathetic interest in this genre of American art.

With the gift of the Harmsen collection in 2001, followed by the creation of the Institute of Western American Art, Troccoli happily stepped into a new role as the institute's director and curator. Although much of her time was taken up with cataloging, evaluating, and refining the Harmsen gift, Troccoli began to address programmatic needs almost immediately with an exhibition of twenty-five of the most significant paintings from the collection. In 2002 she inaugurated this series of Western Passages with the publication of *West Point/Points West.* The book served as the catalog for an exhibition inspired by museum trustee and West Point graduate Tom Petrie, who was looking for a way to honor his alma mater's bicentennial year by tracing the Academy's role in expeditionary art. In the same year, Troccoli's Illustrated Commentary appeared in *George Catlin and His Indian Gallery,* published by the Smithsonian American Art Museum in association with W. W. Norton.

Troccoli stepped down as director of the institute in 2005 to assume her present position as its senior scholar. In this role she curated *The Masterworks of Charles M. Russell: A Retrospective of Paintings and Sculpture,* which traveled to the Gilcrease Museum and the Museum of Fine Arts, Houston, and earned a rave review from the *Wall Street Journal.* Troccoli's penchant for close looking at formal aesthetic features and her unfailing sensitivity to artistic sources undoubtedly contributed to *Wall Street Journal* reviewer Barrymore Scherer's conviction that the exhibition might "inspire a new appreciation for Western art as a whole."[10] Troccoli also co-curated *Charles Deas and 1840s America,* which drew the attention of the *New York Times, Wall Street Journal,* and the *Guardian* to a formerly relatively obscure artist when it opened in Denver in 2010. Troccoli not only edited the volumes that accompanied these exhibitions, but contributed an essay to both. She is currently at work on a catalog of the collection.

ANN SCARLETT DALEY

ASSOCIATE CURATOR,
PETRIE INSTITUTE, 2001–2008

Peripatetic curator Ann Daley's career trajectory brought her into intimate contact with most of the public and private western American art collections on the Denver horizon and made her an invaluable cog in the institute team until her retirement in October 2008. Not long after she began her first stint at the Denver Art Museum in 1978 as assistant in the department of American art, the trustees pledged to put "new emphasis on the art of the West through both exhibition and acquisition." Promoted to the rank of curator in 1980, Daley was entrusted with remodeling half of the third-floor American galleries and overseeing an "ongoing series of western exhibitions."[11] Among these was *Masterworks from the Whitney Gallery of Western Art,* which opened at the end of 1980. Selecting the pieces for exhibition took her and associate director Lewis W. Story to Cody to consult with Peter Hassrick, then director of the Buffalo Bill Historical Center.[12] Under the aegis of Denver Art Museum director Thomas N. Maytham, the three joined forces again in 1981 to put together for Denver audiences from public and private collections nationwide a remarkable assemblage of works for *Frederic Remington: The Late Years.*[13] Hassrick served as both guest curator and catalog author for the exhibition.

Because Maytham let it be known that he was in a hurry to fill the American art department post with a Ph.D., Daley left the museum in search of greener pastures just days after the Remington show opened on July 11, 1981—but not before she had figured in the acquisition of what has become one of the institute's most cherished holdings and one, Daley says, that still "speaks to the quality of the collection the museum hopes to build"—the third cast of Remington's second lost-wax sculpture, *The Cheyenne.* Since Daley had joined prospective donors William and Betty Ruth Hewit for the New York shopping trip on which a later cast of the subject caught their attention, Maytham assigned her at Hewit's request to search out other available, possibly better, casts. Daley calls it "a stroke of good fortune" that advice she received from Remington bronze expert Michael Shapiro led to the discovery of cast #3 in a private California collection and its subsequent purchase with funds from the William

D. Hewit Charitable Annuity Trust. In the *1981–82 Annual Report*, Maytham described the acquisition as an example of the museum's "growing commitment to expand its collections of western American art."

Daley spent the next year as curator for the Foxley & Company collection during the period of headlong growth that preceded its 1983 opening as the Museum of Western Art in the remodeled Navarre building, an experience that deepened and broadened her connection with art of the American West. In the decade that followed, her curatorial role for the private collection of trustee Frederick R. Mayer and his wife, Jan, brought Daley back into the orbit of the museum, and her concurrent advisory relationship to Holme Roberts & Owen even provided the impetus for the art museum's 1991 exhibition of Santa Fe artist Gustave Baumann's woodblock prints from the legal firm's collection, for which Daley acted as both curator and catalog author. The mid-1990s found her also curating the Coors Western Art Exhibit and Sale at the National Western Stock Show for three consecutive years while still carrying out her other curatorial duties.

Daley returned to the Denver Art Museum as adjunct curator in 1997 after director Lewis Sharp's decision to heighten the museum's commitment to western art resulted in more ambitious projects than recently installed deputy director Joan Troccoli could juggle.[14] Among the assignments Daley picked up were reclaiming the seventh-floor Betsy Magness Gallery and advising the Contemporary Realism Group on purchases for the museum while Troccoli concentrated on readying the traveling exhibition of Philip's collection for its 2000 debut and writing the comprehensive exhibition catalog. Named associate curator of the Institute of Western American Art at its founding in 2001, Daley joined Troccoli and curatorial assistant Mindy Besaw in the arduous task of accessing and evaluating the Harmsen gift of close to nine hundred objects of western art and took an active role in institute programs, including contributing a major essay about the Harmsens to *Sweet on the West,* the second book in the Western Passages series (2003). Beginning in 2004, she also met one or two times a week for two years with the team charged with installing the western collection in the gallery spaces set aside for it on the second floor of the new Hamilton Building. At her retirement in 2008, *Westword* art critic Michael Paglia praised the "perfect sense" made by her "fairly radical program" in the Dietler Galleries, citing her mix of contemporary and historical works as a practical solution to the gaps in the historical collection and commending her inclusion of Colorado artists.[15]

PETER H. HASSRICK

DIRECTOR EMERITUS,
PETRIE INSTITUTE
DIRECTOR, 2005–2009

An indefatigable Renaissance man, Peter Hassrick found ample opportunity to exercise his considerable talents as museum administrator, scholar, and writer when Lewis Sharp lured him out of retirement to head the museum's Institute of Western American Art in 2005. During his thirty-five-year career, Hassrick's reputation as an authority on western art made him much in demand as an exhibition curator and author, as well as a fount of wisdom on the whereabouts of many key works. The list of exhibitions he organized and books and catalogs he published is especially impressive in light of his long career as a museum administrator. The breadth and depth of his knowledge of both professional colleagues and western art collections across the country seem inexhaustible. Little wonder that Sharp sought Hassrick out when he began casting about for a leader who could position the institute as the nation's foremost center of advanced study of western-themed art.

For his part, Hassrick's longtime interest in promoting western art as a significant part of mainstream American art was excited by the institute's prominent inclusion in a museum devoted to the entire sweep of world art rather than in a stand-alone institution focused solely on the art of the West. Hassrick's professional career began in just such a stand-alone museum, the Amon Carter Museum of American Art, Fort Worth, where he signed on in 1969 as curator of collections. When it opened in 1961 as the Amon Carter Museum of Western Art, it "looked like an elegant mausoleum for one man's esoteric taste" for the "works of 'cowboy artists' Frederic Remington and Charles Marion Russell."[16] By the time Hassrick arrived, founding director Mitchell Wilder had already begun to enlarge the scope of the museum's holdings, though still with a strong emphasis on western

subjects. Hassrick cut his scholarly teeth on the museum's first collection catalog and developed a taste for Remington and Russell that led to his career-long advocacy of their work.

Hassrick took over the directorship of the Buffalo Bill Historical Center in Cody, Wyoming, in 1976. There he put down roots and spent the next twenty years gaining accreditation from the American Association of Museums (1980) and overseeing the center's exponential growth into the largest museum of art and history between Minneapolis and San Francisco. He left the historical center in the mid-nineties to spend the next sixteen months as the founding director of Santa Fe's Georgia O'Keeffe Museum, organizing and opening it in record time in 1997.

Never without an exhibition or writing project in the works, Hassrick's wide-ranging knowledge of western art includes deep veins of scholarship on George Catlin, William Ranney, A. Phimister Proctor, and Solon Borglum, as well as Remington and Russell. No wonder he was twice tapped by the Trust for Museum Exhibitions as guest curator and scholar for traveling exhibitions— *The American West: Out of Myth, into Reality* (2000) and *Remington, Russell, and the Language of Western Art* (2000). In "The Elements of Western Art," the chapter Hassrick contributed to the book that accompanied the first of these exhibitions, he explored recent scholarship that cast new and at times controversial light on the American West and its art. The exhibition catalog for the second decisively put to rest the media-fabricated rivalry between Remington and Russell and modeled "a formalist art history that deals with aesthetic as well as social, psychological, and political context," an approach Hassrick has repeatedly championed.[17] The final chapter, "A Different Light," reveals an exceptionally sensitive "eye" at work in a formal analysis of the similarities and differences that mark the oeuvre of the two artists.

By the time these exhibitions opened, Hassrick had been installed at the University of Oklahoma, Norman, as the Charles Marion Russell Memorial Chair in Western American Art History and founding director of the Charles M. Russell Center for the Study of Art of the American West, devoted to training the next generation of scholars. Hassrick's involvement of three graduate students as co-authors of the catalog for *The American West: Out of Myth, into Reality* was singled out as a sign that western art scholarship was "coming of age" by Brian W. Dippie, longtime professor of history, University of Victoria, British Columbia, and eminent scholar of western art.[18]

Back home in Cody, where he retired to work as an independent scholar after fulfilling a three-year commitment to the University of Oklahoma, Hassrick was impressed to find in his mailbox one day a complimentary copy of *West Point/Points West,* the inaugural publication of Western Passages. That the fledgling Denver Art Museum institute was distributing free to scholars a genuinely well-informed addition to the specialized literature on western art seemed to Hassrick to "put Denver on the map" nationally as a worthy successor to the three pacesetters in the field: Amon Carter, Gilcrease, and Cody, all of which had at one time or another "set the tone by doing symposiums and publishing catalogs and organizing major exhibits."[19] When he took over as institute director in 2005, after Joan Troccoli stepped down to concentrate on research and writing, one of Hassrick's first acts was to meet with potential funders to share his conviction that the time was ripe for Denver to "step into the void" left by the three trailblazers by creating a vibrant and ambitious educational program of research, publications, symposiums, and exhibitions focused on the West. All that was needed was a substantial endowment. By September 2007 Hassrick was able to announce a $5 million pledge from trustee Tom Petrie, a gift that gave the institute a new name and, as Lewis Sharp wrote in the museum's *2006–7 Annual Report*, the promise of a "solid future."

In addition to taking charge of countless necessary, though sometimes onerous, administrative tasks and igniting the energies of a new team of colleagues and supporters, Hassrick continued to find time for scholarly research and writing. Not one Western Passages book has been published since he took the institute reins without a contribution from Hassrick. Reflecting the range of his enthusiasms and knowledge, these pieces have included significant articles on the early career of Colorado painter Allen Tupper True; the relatively short-lived, but fruitful, professional friendship between illustrator Philip Goodwin and Charles Russell; and the life and career of sculptor Solon Borglum.

As early as 2004, while "retired" in Cody, Hassrick had joined forces with independent scholar Elizabeth J. Cunningham and James Moore, then director of the Albuquerque Museum of Art and History, to undertake a major retrospective exhibition celebrating Ernest L. Blumenschein's career. Hassrick's work on *In Contemporary Rhythm* continued through his time at the institute, finally culminating in the summer of 2008, when the exhibition opened at the Albuquerque Museum before traveling to Denver later that year and to the Phoenix Art Museum in March of 2009. Never one to rest on his laurels, when Hassrick retired at the end of April 2009 after four years as director of the Petrie Institute, he was already beginning to cast about for a new project and soon began work on an essay for the publication that will accompany the Walter Ufer and E. Martin Hennings exhibition scheduled to open in Denver in the spring of 2013.

THOMAS BRENT SMITH

PETRIE INSTITUTE DIRECTOR,
2009–PRESENT

Thomas Smith was no tenderfoot when he took over the reins of the Petrie Institute of Western American Art in 2009. His boyish looks made it hard to believe he had already spent ten of his twenty-nine birthdays in the museum world. But just a few minutes of conversation were enough to convince seasoned hands that he was the right person for the job. Enthusiasm and energy mark every step in a career trajectory that led from an undergraduate degree in fine art focused on studio work in painting to his hiring as the first curator of art of the American West at the Tucson Museum of Art at the age of twenty-six. While still in his junior year in college, Smith took the advice of one of his professors to look for an internship in order to test the strength of his longstanding fascination with museums and how they worked. Though he had no interest in western art at the time—"I think it was the last thing I was interested in"—he accepted a post at the National Cowboy and Western Heritage Museum, the only internship he could find in the Oklahoma City area.[20] Returning the next year as a paid intern, he began looking past the cowboys on view

and taking an interest in the artists as painters. Interest turned to passion, and when Smith entered graduate school at the University of Oklahoma the next fall, he had a new focus—art history with an emphasis on western American art. Longtime museum director Byron Price, who is now director of the Charles M. Russell Center for the Study of Art of the American West at the University of Oklahoma, played an inspiring role as professor and mentor during these graduate school years and encouraged Smith to continue seeking out hands-on experience in museums.

An internship at the Buffalo Bill Historical Center brought an opportunity to help with the William Ranney exhibition that opened in Cody in 2006. A longer project working on the James Bama archive as a research associate suggested the subject and supplied material for his M.A. thesis and his first publication, an article about Bama for the Buffalo Bill Historical Center's *Points West* members' magazine.[21] The challenges Smith faced when he hired on at the Tucson Museum of Art in 2007 ran the gamut from setting up a department and renovating gallery spaces to organizing and writing the catalog for a major exhibition, *A Place of Refuge: Maynard Dixon's Arizona,* the largest presentation of the artist's work yet assembled. All within a brief eighteen-month period. The exhibition, which opened in October 2008, set an attendance record, and the publication sold out two thousand copies in just six weeks.

Always ready to step up to a new challenge, Smith was eager to take on an even more demanding assignment at the Petrie Institute, which he had been watching grow since its founding in 2001. His familiarity with the robust program that Peter Hassrick and his colleagues had set in motion convinced Smith he would be joining an institution well on its way to becoming the national leader in western art. Smith believes the institute's inclusion in a large, encyclopedic museum gives it

the "capability to do more on a larger scale" than museums focused entirely on western art. He cites the fact that it was probably the Denver Art Museum's prestige that convinced the Montana Historical Society to lend some of its treasured Russell paintings for the first time ever to the 2009 retrospective curated by Joan Troccoli.

When he joined the staff of the institute as curator and director designate in the fall of 2008, Smith teamed up with retiring director Hassrick to plan and reopen the western art galleries that had been shuttered four years earlier to provide a staging area for the new Hamilton Building. Hassrick's wide-ranging knowledge of public and private holdings in the western art field and his far-reaching professional contacts made it possible to augment the museum's historical collection with enough loan objects to give the gallery over entirely to a chronological survey of nineteenth- and early twentieth-century works. Smith and Hassrick see eye to eye on most matters of philosophy, including the current division of the collection into discrete exhibition areas that devotes the Betsy Magness Galleries of the North Building to historical objects while showcasing modern and contemporary works in the Dietler Galleries of the Hamilton Building.

It's not surprising that Hassrick continues to play a role in Smith's immediate plans for the future of the institute, for he has been Smith's mentor and colleague for almost a decade. Their close collegial relationship has figured in both major exhibitions Smith currently has in the making—a western American bronzes exhibition he is co-curating with Thayer Tolles, curator of the American Department at the Metropolitan Museum of Art in New York, set to open at the Met in 2014 before moving to Denver and then on to China; and an exhibition featuring Taos Society painters Walter Ufer and E. Martin Hennings scheduled to open at the Denver Art Museum in 2013.

Plans for the Ufer/Hennings exhibition, for which negotiations with a Munich, Germany, venue are underway, grew out of a series of conversations between Smith and Hassrick shortly after the director emeritus's retirement. Hassrick has contributed a catalog essay and offered checklist recommendations and continues to help secure important loans.

Even as work continues on these major projects, Smith prepares to host an exhibition featuring paintings by California artist Ed Ruscha in December 2011 and another on Georgia O'Keeffe in 2013. He has also organized an exhibition of paintings by contemporary Montana artist Theodore Waddell for a spring 2012 premiere, oversaw the publication of two volumes of *Western Passages*, and put together and presided over two symposiums. Many hours of Smith's first years as director were spent working at the side of Tom Petrie to endow the department. Like his predecessor, Smith always has a full calendar of ambitious projects in hand and foresees a heavy work load in the institute's future.

I am indebted to Thomas Brent Smith, director of the Petrie Institute of Western American Art, for his unstinting support throughout this project. He has insisted that the story be told with scrupulous objectivity. Any failure on my part to maintain a scholarly skepticism or to pursue pertinent bypaths of inquiry that might eventually prove significant must be charged entirely to my inadequacies. I am also deeply grateful to Holly Clymore, department assistant, who has been invaluable in searching out archival information. —MC

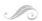

Notes

1 Lewis I. Sharp, interview by author, November 12, 2010, transcript Petrie Institute of Western American Art, Denver Art Museum (hereafter PIWAA, DAM). All quotations from Sharp not otherwise credited were made in the same interview.

2 Frederick R. Mayer, paraphrased by Lewis I. Sharp in his interview by author.

3 David Park Curry, introduction, *The Western Spirit: Exploring New Territory in American Art* (Denver Art Museum, 1989), 9.

4 Lewis I. Sharp, quoted in *Denver Post*, September 4, 1988.

5 Thomas A. Petrie, interview by author, November 3, 2010, transcript PIWAA, DAM. All quotations from Petrie not otherwise credited were made in the same interview.

6 Joan Carpenter Troccoli, "West Point and the Early Art of the American West," in *West Point/Points West* (Denver: Institute of Western American Art, Denver Art Museum [Western Passages], 2002), 46.

7 Thomas B. Smith, interview by author, December 1, 2010, transcript PIWAA, DAM.

8 Joan C. Troccoli, interview by author, September 10, 2010, transcript PIWAA, DAM. All quotations from Troccoli not otherwise credited were made in the same interview.

9 Kathleen A. Foster, "Alfred Jacob Miller, the Sketch, and the Album: The Place of Watercolor in Mid-Nineteenth-Century American Art," in *Romancing the West: Alfred Jacob Miller in the Bank of America Collection*, ed. Margaret C. Conrads, exh. cat. (Kansas City, MO: Nelson-Atkins Museum of Art, 2010), 68, n. 1.

10 Barrymore Laurence Scherer, "Before Cowboys Became Cliché," *Wall Street Journal* (Eastern ed.), December 17, 2009, D6.

11 The trustee resolution and consequent changes were reported by Thomas N. Maytham, *1980 Denver Art Museum Annual Report*, 7.

12 Ann S. Daley, interview by author, August 19, 2010, transcript PIWAA, DAM. All quotations from Daley not otherwise credited were made in the same interview.

13 In his foreword to the exhibition catalog, Thomas Maytham credits Peter Hassrick for contributing "immensely to our success in assembling a significant body of works" and thanks both Daley and Story for their "persistent pursuit of elusive works." Daley cites Lewis Story's "long term associations with people at museums" for securing many of the loans for the show" (Daley interview by author).

14 Daley interview by author, and Lewis Sharp, *1997–98 Denver Art Museum Annual Report*, 5.

15 Michael Paglia, "Ann Daley Leaves the Denver Art Museum," *Westword*, October 9, 2008.

16 Michael Ennis, "Little Big Museum," *Texas Monthly* 9, no. 4 (April 1981): 202.

17 See, for example, Peter H. Hassrick, "Where's the Art in Western Art?" in *Redrawing Boundaries: Perspectives on Western American Art* (Denver and Seattle: Institute of Western American Art, Denver Art Museum, in association with Univ. of Washington Press [Western Passages], 2007), 11.

18 For this assessment of Hassrick's mentoring of his students, see Brian W. Dippie, "Western Art Don't Get No Respect," *Montana The Magazine of Western History* 51, no. 4 (Winter 2001): 71.

19 Peter H. Hassrick, interview by author, July 28, 2010, transcript PIWAA, DAM. All quotations from Hassrick not otherwise credited were made in the same interview.

20 Thomas B. Smith, interview by author. All quotations from Smith not otherwise credited were made in the same interview.

21 Thomas B. Smith, "From Photography to Painting: The Art of James Bama," *Points West* (Fall 2007): 8–11.

5900

58

5825

5850

5800

56.0

13.0

84.4

4 MAIN CABLE - LENGHT 1313'0", DIAMETER 2¾", WEIGHT 23000 L

RT - BUR OUT
25,000,00 LBS
STEEL WEDGE
ANCHORAGE
¾ (TYP)
STEEL
PRESTRESSED ROD

180'0"

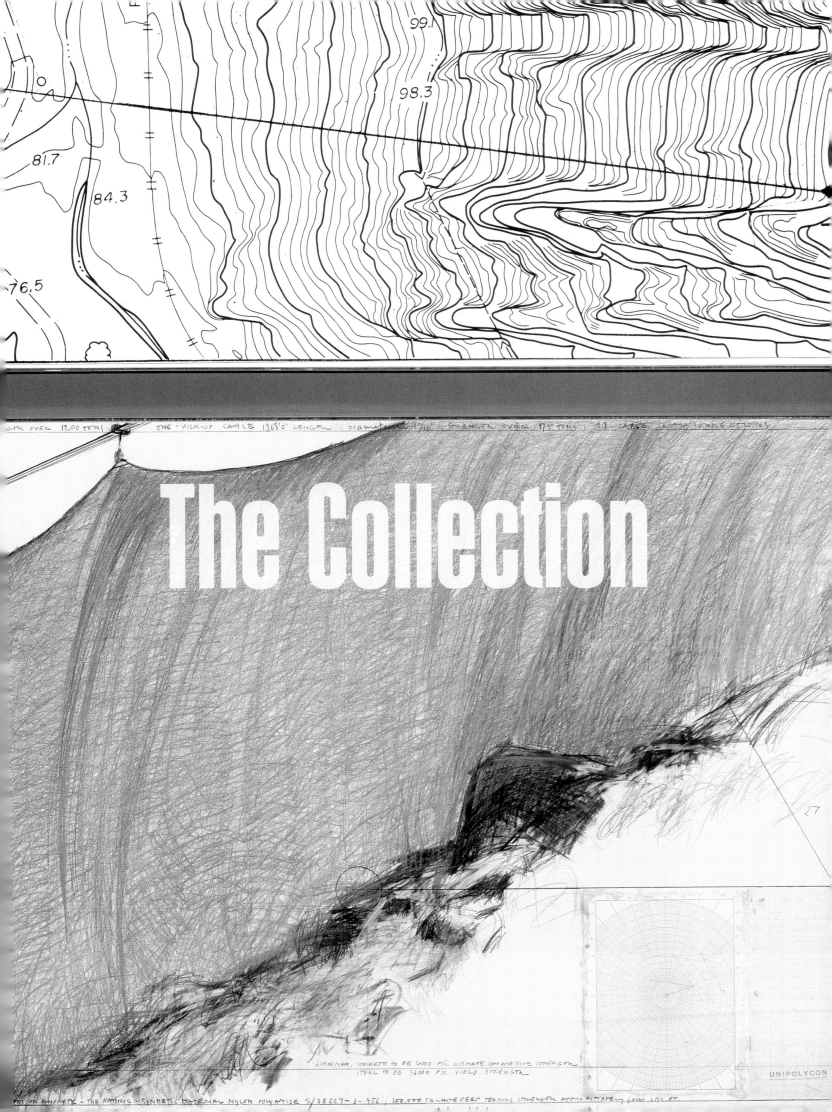

The Collection

Landscapes

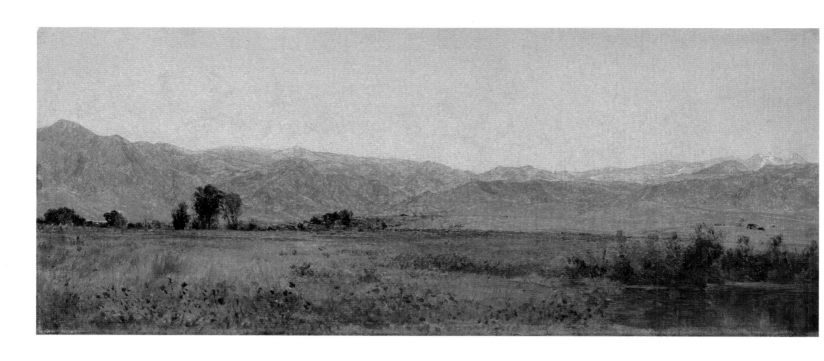

Early Landscapes of the Colorado Frontier

NICOLE A. PARKS

Nineteenth-century American landscape paintings reflect the broad and complex national mood that encompassed spiritual, economic, and social issues of the country during the time.[1] Two popular ideologies, which had profound effects on the landscape paintings of Colorado and more generally on art of the American West, were Romanticism and the belief in Manifest Destiny. Romantic philosophies found expression in all the arts and were especially evident in the visual arts in depictions of nature as uncontrollable, unpredictable, and a place where God was present. Landscape painters often created works that reflected imagination and emotion and often leaned toward the sublime. Manifest Destiny, the belief that westward expansion was a God-given right, dominated the American psyche in the 1800s. Landscape paintings were evidence of America's destiny and provided encouragement for pioneers to fulfill this right of settling the West. Artists depicting the American West translated their own vision into their works and influenced how the West was perceived by the masses.

The Colorado landscape, with its range of scenery from open prairies with long vistas to picturesque mountains, has been a source of inspiration for artists for generations (Colorado was first organized as a territory in 1861 and became a state in 1876). Early Colorado landscape artists had diverse forms of artistic training and a variety of styles, ranging from the Hudson River school and luminism to the Düsseldorf school and the English tradition, or were largely self-taught. While many artists who traveled to Colorado were in the company of government-led expeditions to survey and document topography, others voyaged west as independent or adventurous artists, in search of their own creative inspiration.

Three members of the second generation of the Hudson River school, Sanford Robinson Gifford (1823–80), John Frederick Kensett (1816–72), and Thomas Worthington Whittredge (1820–1910), traveled together in 1870 to the Colorado Territory for the purpose of finding artistic inspiration. The Hudson River school, America's first native school of landscape painting, drew influence from Romanticism and produced landscapes that were highly detailed, wild, and dramatic. These three artists, however, were known as

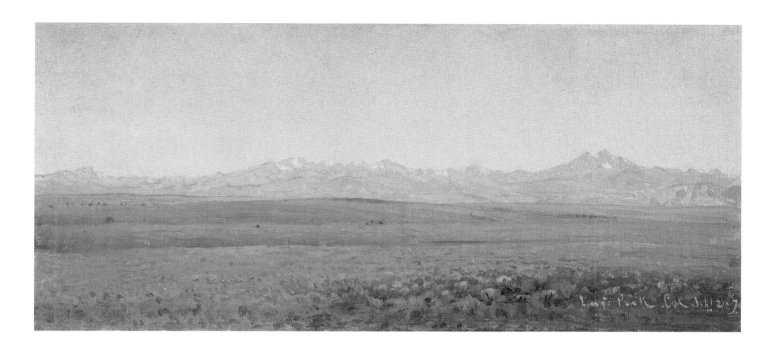

John Frederick Kensett
Snowy Range and Foothills from the Valley of Valmont, Colorado, 1870
Oil on canvas, 7 x 7½
Denver Art Museum,
Gift of Mr. and Mrs. Richard Williams, 1975.66

Sanford Robinson Gifford
Longs Peak, Colorado, 1870
Oil on canvas, 5³/₄ x 13
Denver Art Museum,
Gift of Arthur J. Phelan Jr., 2010.541

Previous pages, detail, John Sloan
Gateway to Cerrillos, 1946
Mixed media, 25³/₈ x 18
Denver Art Museum, William Sr. and Dorothy Harmsen Collection, by exchange, 2006.73
©2011 Delaware Art Museum/ Artists Rights Society (ARS), New York

luminists: they were most interested in capturing the effects of light and atmosphere in their paintings of nature and did so by producing a golden haze or imparting an overall "luminosity" to their creations.[2] The luminists held to the plein-air tradition. Their works were intimate, tranquil, naturalistic, and usually rendered on small, horizontal canvases. Gifford, Kensett, and Whittredge all produced small plein-air sketches of this type from their 1870 trip to Colorado.

For both Kensett and Whittredge, this journey was not their first trip west. Kensett had traveled west twice before, once in 1854 and again in 1857, but never ventured farther west than the Missouri River.[3] It was on his 1870 sojourn that he first saw the Colorado plains and the Rocky Mountains. Kensett's painting *Snowy Range and Foothills from the Valley of*

Valmont, Colorado illustrates the same Colorado Front Range as does Gifford's *Longs Peak, Colorado*, discussed later. Kensett's painting is freely rendered and has a sense of atmosphere that can be experienced with the human eye. Kensett was originally trained as an engraver and worked for a decade in his father's firm.[4] In 1840, when he traveled to Europe to continue his artistic studies, he focused fully on working as a fine artist. He traveled, worked, and studied in Europe for seven years and copied old masters alongside his fellow artist and friend, John W. Casilear, who also later traveled to Colorado to paint.[5]

Kensett's early works reflect qualities of the first-generation Hudson River school artists, with their focus on topologically detailed landscapes that celebrate the dramatic and uncontrollable side of the natural world. In the 1850s, he adopted the luminist

technique of showing atmospheric effects of light. The painting *Snowy Range and Foothills from the Valley of Valmont, Colorado* is a later work that exhibits Kensett's luminist sensibilities, particularly in his focus on the tranquility of the landscape in a horizontal format.

For Whittredge, the 1870 trip was his second; his first was in 1866 as a member of General John Pope's expedition that trekked south from Wyoming through Denver and into New Mexico.[6] Whittredge's *Foothills Colorado* was painted on the 1870 journey to Colorado. Much like Kensett, by this time in his career Whittredge opposed depicting the grandiose and dramatic in his paintings, instead creating intimate and tranquil landscapes. This is a far cry from his earlier artistic training at the Düsseldorf Kunstakademie (also known as the Düsseldorf Academy)

in Düsseldorf, Germany, where he enrolled in 1849 under the leadership of Emanuel Gottlieb Leutze (1816–68). There he met, befriended, and mentored fellow American landscape painter Albert Bierstadt.

Whittredge returned to the United States ten years later to apply his Düsseldorf training to American subject matter. However, he lost interest in creating dramatic and sublime landscapes and instead turned more to the style of the Barbizon school, which emphasized realistic landscapes. To Whittredge, the western landscape was the perfect model to translate onto his canvases. His second trip west with Gifford and Kensett is credited with changing Whittredge's style from Hudson River school painter to luminist, a change most likely inspired by working in close proximity to the other two artists. Whittredge's paintings from this time, for example, *Foothills Colorado* and *In the Rockies (Bergen Park, Colorado)*, illustrate his heightened emphasis on atmospheric effects and show his tendency to create more realistic landscapes.[7]

Gifford's formal art training was at the National Academy of Design and additional study under John Rubens Smith in New York.[8] For Gifford, the 1870 trip was his only trip west, and it proved to be an uninspiring adventure as he was not fond of the wide prairies or the Rocky Mountains.[9] Instead of remaining with his artist-friends to paint and draw, he joined the Ferdinand V. Hayden survey for the summer of 1870. The painting *Longs Peak, Colorado* is one of only a few paintings by Gifford from this period, and the only known work that depicts the Colorado Rocky Mountains. *Longs Peak, Colorado* highlights the Front Range looking west from the Colorado plains. This charming horizontal painting has a golden glow of light created by his painterly technique that produces the illusion of atmospheric space. Gifford separated from the Hayden survey later that same summer and rejoined Kensett and Whittredge.

John W. Casilear (1811–93), like his friend Kensett and other early Colorado landscape artists, began his career as an engraver. He became a pupil of the Hudson River school artist Asher B. Durand and traveled to Europe in 1840 with Kensett to study old master painters. His only visit to Colorado was in the summer of 1873.[10] In contrast to the plein-air sketches by Gifford, Kensett, and Whittredge, Casilear's painting *Near Greeley, Colorado* is a finished work that was created in his studio. The painting depicts the Front Range of the Rocky Mountains with Longs Peak in the background and three motionless Native American horsemen and a calm river (most likely the Platte River) in the foreground. The Native Americans are treated as an exotic element that appealed to the romantic taste of the nineteenth century, and seen as part of nature. *Near Greeley, Colorado* is similar to the three luminist sketches in that it radiates a feeling of tranquility typical of works by artists from the second generation of the

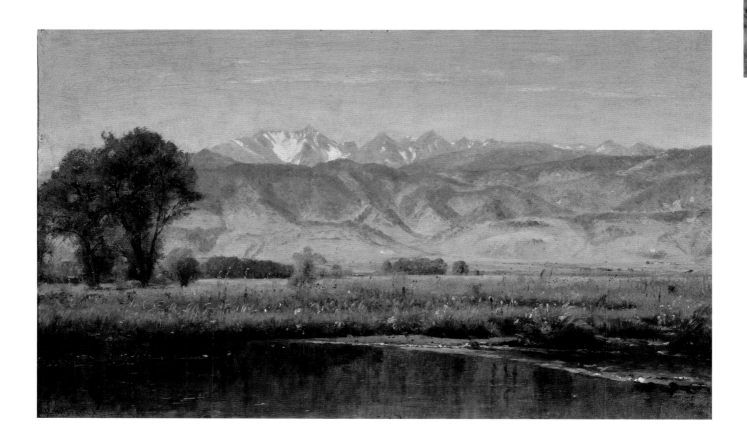

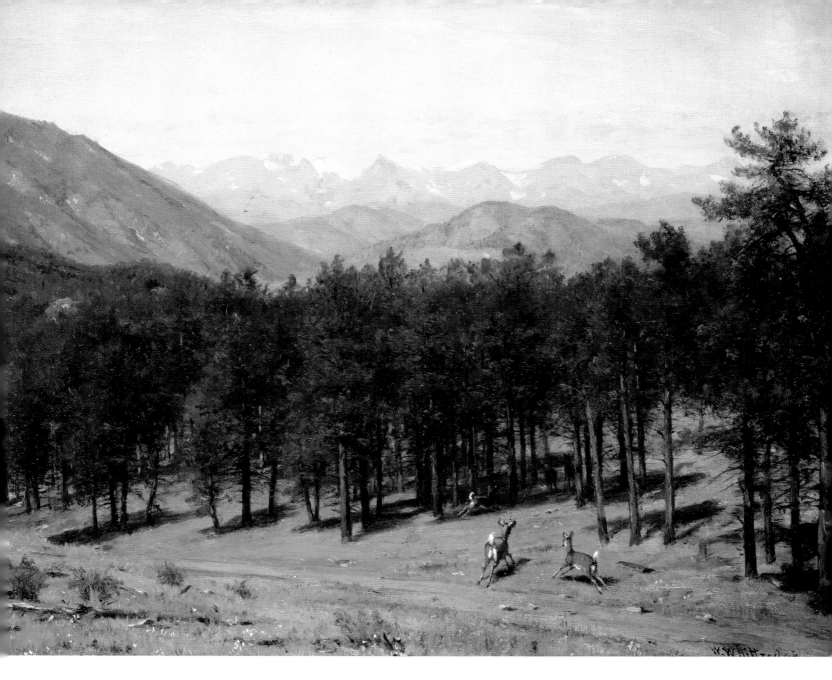

Worthington Whittredge
Foothills Colorado, 1870
Oil on paper, 11¾ x 19¾
Denver Art Museum, Gift of the Houston
Foundation in memory of M. Elliott Houston
and museum exchange, 1969.160

Worthington Whittredge
In the Rockies (Bergen Park, Colorado), 1870
Oil on canvas, 14½ x 19½
Denver Art Museum, William Sr. and Dorothy
Harmsen Collection, 2001.442

Hudson River school. This peaceful quality is in stark contrast to paintings by the first generation of the school like Thomas Cole, or other artists associated with the group such as Albert Bierstadt (1830–1902).

Although Bierstadt is often associated with the Hudson River school, he is truly a product of the Düsseldorf Academy in Germany, where he received formal art training in the 1850s. Bierstadt traveled west four times, the first in 1859 on Colonel Frederick W. Lander's Oregon Trail expedition. On three subsequent visits he traveled to Colorado, once in 1863 and then again in 1876 and 1877 at the invitation of a patron who commissioned Bierstadt's painting *Estes Park, Longs Peak.* Unlike many of Bierstadt's previous works, where he used artistic license and created overexaggerated grand paintings, this work is more realistic but still exhibits a level of artistic license as seen in the slightly exaggerated scale of the mountain peaks.

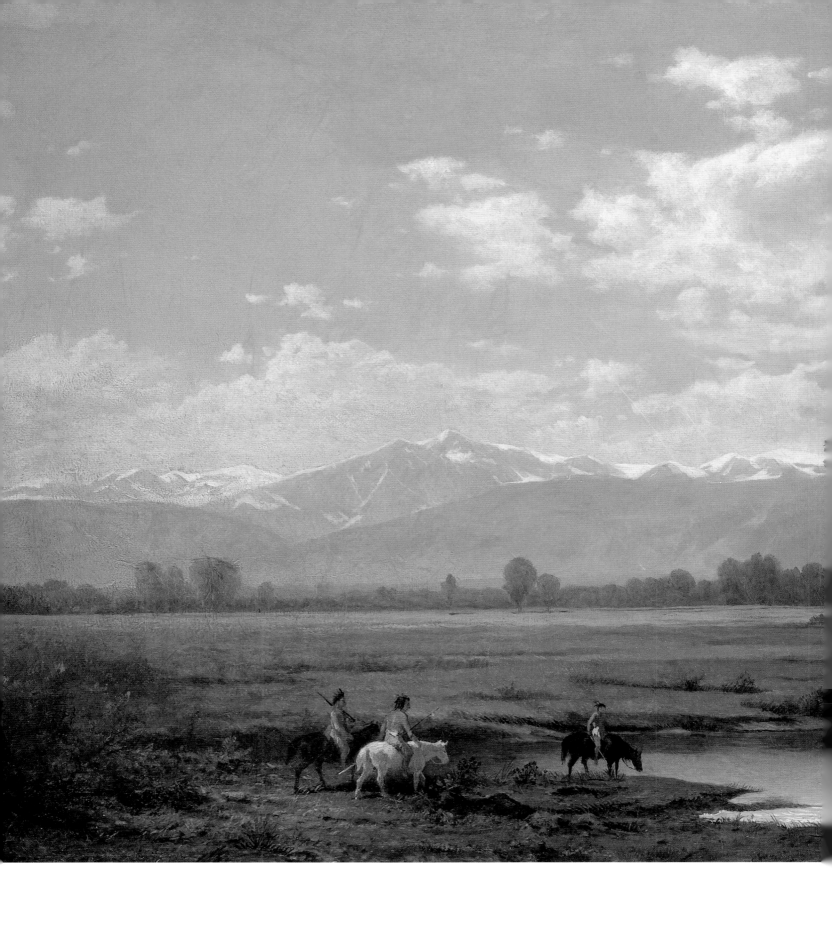

John William Casilear

Near Greeley, Colorado, 1882

Oil on canvas, 23³/₈ x 46

Denver Art Museum, William Sr. and Dorothy Harmsen

Collection, 2001.457

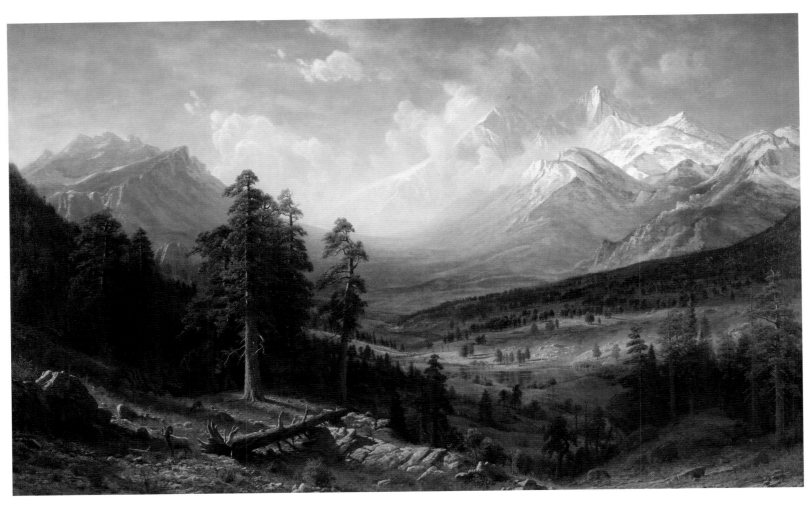

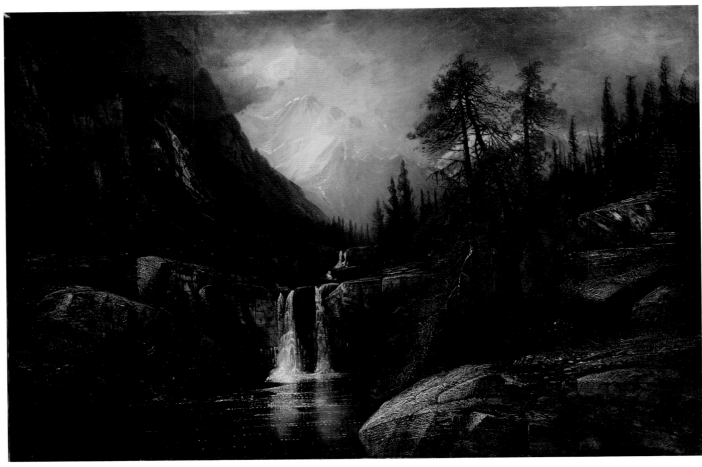

Although *Estes Park* is from Bierstadt's later period when the public was becoming less interested in artists exhibiting magnificently sublime paintings, and was seen by critics as passé, it shows his continued dedication to the Düsseldorf school. This detailed landscape has a uniform palette and varying degrees of value that create interest, and a stagelike foreground on the lower left to help draw the viewer into the painting.

An artist who was a follower of Bierstadt but lacked formal artistic training was Henry Elkins (1847–84). Elkins was from Chicago and traveled to Colorado in 1866.[11] He created numerous plein-air sketches and returned to his Chicago studio to complete the final paintings.[12] His work *After the Storm* is typical of his painting style. The artist was interested in achieving symmetry, and in this example, he rendered two tall trees on the right side of the canvas to balance the large imposing mountainside on the left. He also employed high contrasting values, keeping the lightest color at the center of the canvas to help lead the viewer into the painting. These techniques are not unlike Bierstadt's, although the result is not as grand as Bierstadt's paintings.

Another artist who began his career as an engraver, and who traveled west in the company of government expeditions, was Thomas Moran (1837–1926). Moran had no formal art training; his early artistic development was forged from several sources. Beginning in 1853, the young Moran worked at an engravers' firm. Later he worked in his brother Edward's photography studio.[13] He was influenced by the art of J. M. W. Turner and the writings of art critic John Ruskin,[14] but it was his trip with the Hayden survey to Wyoming in the summer of 1871 that marked the beginning of his prolific career as a *western* American artist.[15] Several years later in 1875 Moran visited the Mountain of the Holy Cross in the Rocky Mountains and created his first major painting of this distinctive Colorado subject. Moran painted pristine landscapes devoid of human activity, and many of them were used as promotion for the tourist and land-development industries and to support the establishment of national parks. The overt religious symbolism of the Mountain of the Holy Cross became an iconic image that confirmed America's destiny to expand across the continent and settle the West. Moran's watercolor, *Mount of the Holy Cross* (1894),

Albert Bierstadt
Estes Park, Long's Peak, 1877
Oil on canvas, 62 x 98
Denver Public Library,
Western History Department

Henry Elkins
After the Storm, 1882
Oil on canvas, 24 x 36
Denver Art Museum, William Sr. and Dorothy
Harmsen Collection, 2001.1245

Thomas Moran
Mount of the Holy Cross, 1894
Watercolor on paper, 19¼ x 13¾
Denver Art Museum, anonymous gift, 1981.16

Charles Partridge Adams
Sunset in Colorado, ca. 1900
Oil on canvas, 20 x 30
Denver Art Museum, museum exchange
with Lemon Saks, 1969.53

continues this symbolic theme. Although Moran's work captures the sublimity, or awe-inspiring beauty in nature, he was more concerned in illustrating accurate geological and geographic features. His contemporary, Bierstadt, allowed himself much more artistic license in creating his theatrical paintings.

Another self-taught artist working in the Rocky Mountains of Colorado was Charles Partridge Adams (1858–1942). Unlike other artists of the time, Adams did not travel to Colorado to find a unique subject matter for his paintings, but instead moved to Denver as a child because of family circumstances. His two sisters suffered from consumption, and one of them died before his mother moved the family to Colorado in 1876 in hopes that the climate would save his second sister.[16] Adams was a teenager when he became friends with the Denver artist Helen Chain, who helped him develop his drawings and paintings. Chain had studied under the American tonalist George Inness. It is likely that Adams in turn was influenced by Inness's moody, brooding works, as seen in the painting *Sunset in Colorado*. But tonalism is not the style of painting that Adams is best known for; instead, impressionistic works such as *Moraine Park* and *Autumn Afternoon, Rocky Mountains* are more representative of his body of work. He was known to change his style frequently, but his subject remained the interior of the Rocky Mountains rather than the mountain range from the Colorado plains.

The Colorado terrain, and in particular the Front Range of the Rocky Mountains, has been a subject for artists

Charles Partridge Adams
Moraine Park, ca. 1900
Oil on canvas, 39½ x 59½
Denver Art Museum, Funds from various donors
by exchange, 1996.8

Charles Partridge Adams
Autumn Afternoon, Rocky Mountains,
date unknown
Oil on canvas, 20 x 24
Denver Art Museum, William Sr. and Dorothy
Harmsen Collection, 2001.1246

since before Colorado statehood. In the nineteenth century, the land was an inspirational subject that spoke volumes about the societal attitudes and ethos of America and a vehicle for artists to express those ideas. There was no single school of the Colorado Rocky Mountains. Instead the American West has been portrayed in all the different styles that artists brought with them from their previous training and experiences. Those creations by these early landscape painters of Colorado helped form the idea of the West for

the broader American public and encouraged the continuation of the development of the land under the doctrine of Manifest Destiny.

Notes

1 Patricia Trenton and Peter H. Hassrick, *The Rocky Mountains: A Vision for Artists in the Nineteenth Century* (Norman: University of Oklahoma Press, 1983), 3, quoting from Oliver Larkin, *Art and Life in America* (New York: Holt, Rinehart and Winston, 1960), 176.

2 Trenton and Hassrick, *The Rocky Mountains*, 219.

3 Nancy Dustin Wall Moure, "Five Eastern Artists out West," *American Art Journal* 5, no. 2 (November 1973): 15–16; Anthony F. Janson, "The Western Landscapes of Worthington Whittredge," *American Art Review* 3, no. 6 (November–December 1976), 66.

4 John Paul Driscoll and John K. Howat, *John Frederick Kensett*, exh. cat. (Worcester, MA: Worcester Art Museum, 1985), 18.

5 Driscoll and Howat, *John Frederick Kensett*, 49. Kensett and Casilear met in New York when they both worked as apprentices in an engraving firm.

6 Janson, "The Western Landscapes of

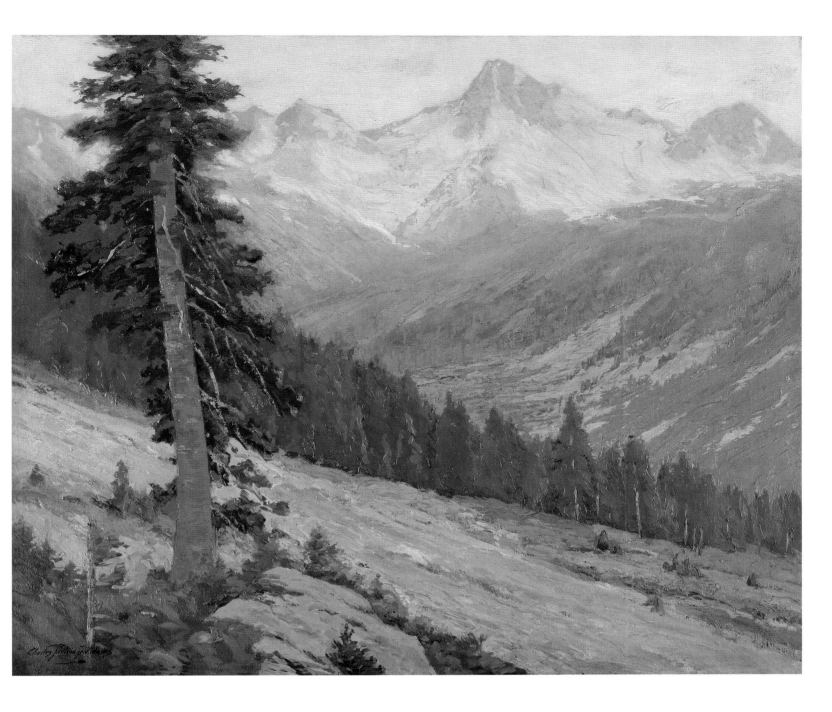

Worthington Whittredge," 58, 111.

7 Janson, "The Western Landscapes of
 Worthington Whittredge,"125.

8 Kevin J. Avery and Franklin Kelly, eds.,
 *Hudson River School Visions: The Landscapes of
 Sanford R. Gifford*, exh. cat. (New Haven, CT:
 Yale University Press, in association with the
 Metropolitan Museum of Art, NY, 2003), 5–6.

9 Natasha K. Brandstatter, "Wide Open Spaces:
 Arcadian Visions of the American West," in
 Colorado: The Artist's Muse (Denver: Petrie
 Institute of Western American Art, Denver Art
 Museum [Western Passages], 2008), 40.

10 Brandstatter, "Wide Open Spaces: Arcadian

Visions of the American West," 221.

11 Trenton and Hassrick, *The Rocky Mountains,*
 149–50.

12 Ibid, 151.

13 Nancy K. Anderson, *Thomas Moran*, exh. cat.
 (Washington, DC: National Gallery of Art,
 1997), 23.

14 Ibid.

15 Moran joined the group not as an official
 member, but as an independent artist traveling
 with the group. Andrew Wilton and Tim
 Barringer, *American Sublime: Landscape
 Painting in the United States, 1820–1880*
 (Princeton, NJ: Princeton University Press,

2002), 33. Moran was a member of the Hayden
survey one year after Gifford joined and left the
same survey.

16 Dorothy Dines, *The Art of Charles Partridge
 Adams* (Golden, CO: Fulcrum Publishing,
 1993), 10.

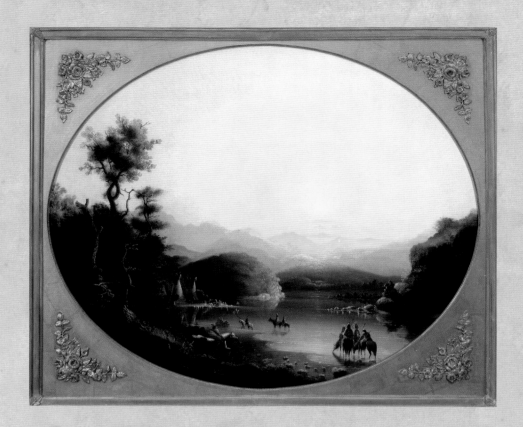

Shoshone Indians at a Mountain Lake

"A THING OF BEAUTY IS A JOY FOREVER"[1]

"These mountain Lakes have been waiting for…thousands of years, and could afford to wait thousands of years longer, for they are now as fresh and beautiful as if just from the hands of the Creator."[2]

ALFRED JACOB MILLER, 1837

KAREN E. BROOKS

American artist Alfred Jacob Miller (1810–74) penned this passage about one of many enchanting mountain lakes he encountered during his historic trip to the Rocky Mountains. In Miller's opinion, the western American landscape provided an unparalleled muse for artists of his generation and beyond.

Not even "Italy and its wonders[,] . . . Egypt, the River Nile, Cairo, and the pyramids . . . [or] Greece and her antiquities" could match the grandeur he found waiting for him—and for other "enterprising travelers"—in the West.[3]

For six months in 1837, Miller traveled in the company of Captain William Drummond Stewart, a Scottish nobleman and avid adventurer, to the extreme reaches of the "Far West." Stewart hired the young artist to visually record a journey that would

Alfred Jacob Miller
Shoshone Indians at a Mountain Lake,
date unknown
Oil on canvas, 28¾ x 35 (oval)
Denver Art Museum, Funds from Erich Kohlberg
and by exchange, 1961.25

Alfred Jacob Miller
Self-Portrait, date unknown
Pencil on paper, 9 x 7½ sheet
Joslyn Art Museum, Omaha, Nebraska,
museum purchase, 1988.10.114.2

take a caravan laden with trade goods to the thirteenth annual fur traders' rendezvous on the Green River in present-day western Wyoming and still farther into the Rocky Mountains. On the pages of a now-lost sketchbook, Miller depicted the scenery and people he came across en route to the summer rendezvous and took pains to document in rigorous detail the spectacular proceedings of the three-week gathering itself. The artist also devoted many journal pages to the weeks following the rendezvous, during which he accompanied Stewart on a hunting trip in the breathtaking Wind River Mountains. Upon his return from the West and for many years after, Miller painted western scenes for Stewart and other patrons in the United States and abroad. These finished watercolor and oil paintings were based on field sketches and notes taken on the trail.

Miller is often discussed in concert with fellow "explorer-artists" George Catlin (1796–1872) and Karl Bodmer (1809–93), whose depictions of American Indians are regularly compared to Miller's own portrayals of native people. But unlike his contemporaries, Miller surveyed the West through a wide lens, depicting not only western "characters"—American Indians, fur traders, and trappers—but also the impressive stage upon which they played, the spectacular western landscape in its myriad forms. While Catlin and Bodmer ventured westward several years before Miller, the banks of the upper Missouri River marked the extent of their travels. In Stewart's company, Miller traveled along what would soon be known as the Oregon Trail, becoming the first artist to cross

the Continental Divide at South Pass. Thus, Miller's field sketches, his notes about the expedition, and the larger finished studio paintings derived from these records provide the earliest glimpse of the central Rocky Mountains prior to large-scale Anglo settlement of the region.

Scenes of western waterways and lakes, including the Denver Art Museum's *Shoshone Indians at a Mountain Lake*, are numerous among Miller's western landscapes. One reason behind the recurrence of this theme may be the sheer abundance of water in the area surrounding the Green River rendezvous site. While most of the American West lacks salient water resources, the terrain in which Miller found himself in the early fall of 1837 proffered picturesque mountain lakes bordered by dramatic peaks around almost every bend. Located near the confluence of the Green River and Horse Creek, the rendezvous was nestled between the imposing granite spires of the Wind River Mountains to the east and the Wyoming Range to the west,

near present-day Pinedale, Wyoming. Ice Age glaciers sculpted this area, leaving wide, grassy meadows and deep mountain lakes in their wake.

Another reason for Miller's interest in mountain lakes in particular may be that, for Miller, these "glorious sheets of water" hemmed in by lofty peaks provided the ultimate romantic subjects for his canvas.[4] The prairie scenery the caravan crossed on the way to the rendezvous impressed Miller with its apparent endlessness and its isolated but often "monstrous" rock formations, but the "Mountains of the Winds" evoked the sublime, an element of Romantic art Miller had encountered and admired during his student days in Europe and on the East Coast. In his paintings, Miller attempted to capture the daunting magnitude of his surroundings but admittedly fell short of reproducing the staggering grandeur of the scenery. Miller wrote,

From immense sheets of clear water, mountains rose back of mountains, each higher than the other, until the highest terminated in needle points of solid granite, covered with snow . . . The sketch, although conveying some idea, must of necessity fall short of the enchanting reality.[5]

Romanticism, an artistic style characterized by intensity of emotion, dramatic compositions, vibrant color schemes, and painterly brushwork, heavily informs Miller's aesthetic. Miller sought to emulate artists like Eugène Delacroix and Théodore Géricault, whose imaginative, dynamic canvases of chaotic battles and turbulent storms he had studied while auditing classes at the École des Beaux-Arts in Paris. In America, Romanticism had been championed by artists of the Hudson River school on the East Coast, but had not yet been applied in earnest in the

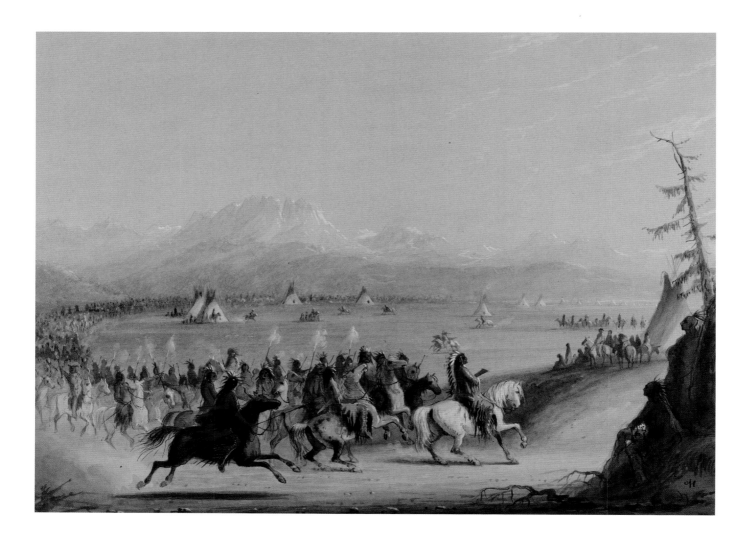

Alfred Jacob Miller
Cavalcade, 1858–60
Watercolor on paper, 10$^{1}$/$_{2}$ x 14$^{15}$/$_{16}$
Photo © Walters Art Museum, Baltimore,
37.1940.199

Alfred Jacob Miller
Green River (Oregon), 1858–60
Watercolor on paper, 9$^{1}$/$_{16}$ x 12¼
Photo © Walters Art Museum, Baltimore,
37.1940.82

art of the West. Miller was among the first to employ Romantic visual tropes in his western paintings, establishing himself as a forerunner to artists Albert Bierstadt (1830–1902) and Thomas Moran (1837–1926), who would later depict the West in a more fully developed Romantic style in their epic panoramas.[6]

As is the case with many Romantic landscapes, Miller's *Shoshone Indians at a Mountain Lake* is arranged much like a theater stage, with a rocky bluff on the right and tall, gnarled trees on the left anchoring and framing the scene.

The painting's distinctive elliptical composition is dominated by a muted sunrise over shimmering, ethereal mountains. Miller found sunrise and sunset "the most favorable time to view these Lakes (to an artist especially)," noting:

> at these times one side [of the lake] or the other would be thrown into deep purple masses, throwing great broad shadows, with sharp light glittering on the extreme tops,— while the opposite mountains received its full complement of

warm, mellow & subdued light.[7]

Such is the case with *Shoshone Indians at a Mountain Lake*, with its pastel skyline providing a dramatic contrast to the darkened midground and foreground. The morning sun illuminates the scene on the lakeshore below, revealing several groups of Shoshone Indians. In the foreground at right are four Shoshone on horseback carrying spears and wearing feather headdresses. The group stands ankle-deep just off the shore, and several of the horses lower their necks for a drink. Miller has used bright, white

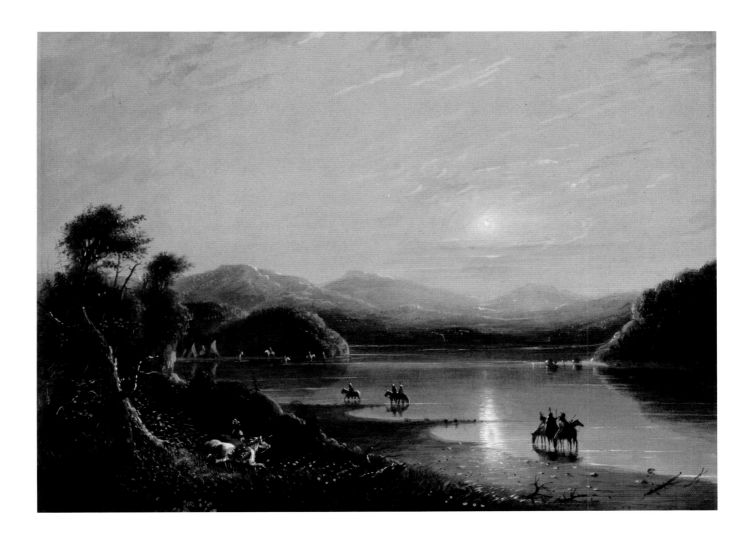

pigment to imitate the rays of the rising sun, highlighting a sipping horse's muzzle and a rider's profile as he peers to his left at another figure racing toward the lake. This lone horseman's stallion—seen galloping forward with all four legs in midair—immediately recalls Géricault's wild-eyed chargers. Just beyond, another, smaller group of Shoshone water their horses, and still further in the background, two tipis catch the morning light and are reflected in the lake. The landscape echoes into the distance, with bluffs diminishing in size toward the far end of the lake and then rising again, transformed into precipitous peaks.

This painting is one of a relatively small number of large studio landscapes by Miller.[8] Commissioned by a Baltimore patron, *Shoshone Indians at a Mountain Lake* was likely based on an earlier gouache-on-paper trail sketch

titled *Green River Mountains* (present location unknown).[9] Miller developed at least four finished paintings from this sketch (including *Shoshone Indians at a Mountain Lake*) after returning to his hometown of Baltimore, Maryland. The earliest of these studio paintings is *Green River (Oregon)* (Walters Art Museum, Baltimore), a lively, vibrant watercolor commissioned—as part of a portfolio of two hundred watercolors—by William T. Walters in 1859–60.[10] Two additional oil paintings are thought to succeed *Shoshone Indians at a Mountain Lake*. Both titled *Green River (Oregon)*, one is currently in the collection of Gilcrease Museum in Tulsa, Oklahoma, and the other is housed in Cody, Wyoming, at the Buffalo Bill Historical Center.[11] The Gilcrease's painting is almost identical to *Shoshone Indians at a Mountain Lake*; both landscapes are oval in composition and measure approximately twenty-nine

by thirty-six inches. *Shoshone Indians at a Mountain Lake* is presumed to be the third in this series of five similarly composed works, and almost certainly dates to the early 1860s, more than twenty years after the artist's return from his only trip west.[12]

Miller authority Ron Tyler has observed that the artist "usually left out vital information, such as dates and places, so that any effort to sort [his pictures] into any meaningful sequence is akin to assembling a giant jigsaw puzzle."[13] This is especially true with the series of which *Shoshone Indians at a Mountain Lake* is a part. Earlier studies have interpreted the paintings' titles literally, surmising that this body of work takes the Green River, rather than a mountain lake, as its subject.[14] It is more likely, however, that Miller's early titles were general, referring to the larger area in which the scene is located:

Green River, Oregon. "Green River" probably refers to the area surrounding the rendezvous site in Wyoming—the Upper Green River Basin encompassing both the river's source in the Wind River Mountains and its confluence with Horse Creek—rather than simply the confines of the river itself. "Oregon" refers to the Oregon Country, an American appellation for a large tract of disputed territory encompassing most of the American Northwest.[15] In 1837, this area was not yet part of the incorporated United States nor had it been comprehensively mapped; Miller was depicting uncharted territory.

During his own time, Miller did not receive a great deal of critical attention, but he was modestly praised for invigorating the national art scene with fresh, uniquely American subject matter.[16] East Coast audiences were anxious to learn more of the land beyond the Mississippi and the novel, exotic subjects of Miller's paintings piqued this curiosity. But, as Peter H. Hassrick has pointed out, despite initial acclaim for his originality and the romantic spirit in which he portrayed his subjects, Miller's star faded rather quickly and over the years the artist lapsed into relative obscurity.[17] It would be more than a century after Miller's

Map of the United States Territory of Oregon, 1838. Compiled under the direction of Col. J. J. Abert, M. H. Stansbury-Del. From the Early Washington Maps Collection, Washington State University Libraries' Manuscripts, Archives, and Special Collections, Pullman, Washington, G4240 1838.H6.

western adventure before the artist's contribution to western American art and history was rediscovered and reevaluated.

Today, Miller's body of work is considered an incomparable visual record of the era of fur traders and trappers, of the earliest relations between American Indians and white settlers, and of the landscapes of the Far West in the nascent stages of its development. His sketches, paintings, and notes help illuminate an early chapter in western American history—a remarkable but passing chapter soon to be wholly transformed by large-scale westward expansion. While it seems that Miller himself understood and appreciated his role in documenting this transitory moment in American history, he could not have know that he also stood at an important crossroads in American *art* history. Paintings like the Denver Art Museum's *Shoshone Indians at a Mountain Lake* mark the beginning of a trajectory toward an increasingly Romantic aesthetic in western American art, particularly in the genre of landscape painting. With its jewel-toned sky, theatrical composition, and atmospheric effects, Miller's *Shoshone Indians at a Mountain Lake* represents an early, Romantic response to the monumental task of translating the grandeur of the American West into paint on canvas.

Notes

1 Alfred Jacob Miller, *Lake Scene—Mountain of Winds*, from Marvin C. Ross, *The West of Alfred Jacob Miller: From the Notes and Water Colors in the Walters Art Gallery with an Account of the Artist by Marvin C. Ross* (Norman, OK: University of Oklahoma Press, 1951), notes on plate 93. Miller often invoked the words of famous authors—including this line from English Romantic poet John Keats—when describing the natural beauty of the West. Miller wrote, "As we viewed these Lakes a single line of Keats' occurred to us wherein he says, A thing of beauty is a joy forever."

2 Miller, *Lake Scene (Wind River Mountains)*, in Ross, *The West of Alfred Jacob Miller*, notes on plate 59.

3 Ibid.

4 Miller, *Lake Scene*, in Ross, *The West of Alfred Jacob Miller*, notes on plate 116.

5 Miller, *Lake Scene W. River Mountains*, in Ross, *The West of Alfred Jacob Miller*, notes on plate 81.

6 Peter H. Hassrick, introduction to *Alfred Jacob Miller: Artist on the Oregon Trail*, ed. Ron Tyler (Fort Worth, TX: Amon Carter Museum, 1982), 5.

7 Miller, *Lake Scene*, in Ross, *The West of Alfred Jacob Miller*, notes on plate 130.

8 *Shoshone Indians at a Mountain Lake*, catalogue raisonné no. 225B (oil on canvas, oval, 28¾ x 36½ in.). The Miller catalogue raisonné by Karen Dewees Reynolds and William R. Johnston is included in Tyler, ed., *Alfred Jacob Miller: Artist on the Oregon Trail*. Hereafter, catalogue raisonné will be abbreviated "c.r."

9 *Green River Mountains*, c.r. no. 225 (gouache on paper, 8½ x 12 in. According to the c.r., *Green River Mountains* is the "presumed trail sketch."

10 *Green River (Oregon)*, c.r. no. 225A, also known as *Green River, with the Rocky Mountains in the Distance* (watercolor on paper, 9¹/₁₆ x 12¼ in., 1859–60, Walters Art Museum, Baltimore).

11 *Green River (Oregon)*, c.r. no. 225C (oil on canvas, oval, 29 x 36 in., Gilcrease Museum, Tulsa, OK); and *Green River (Oregon)*, c.r. no. 225D (oil on paper, mounted on board, 8 x 10¾ inches, Buffalo Bill Historical Center, Cody, WY).

12 Two entries in Miller's account book (housed at the Walters Art Museum, Baltimore) may provide more precise dating of both *Shoshone Indians at a Mountain Lake* and Gilcrease's *Green River (Oregon)*. On September 3, 1864, Miller details two transactions. The first reads "Lake Rocky Mts 28 x 36—Thos Harris" and the second, "Wind River Mountain Lake Scene 29 x 36—P. H. Sullivan." It is quite likely, given the correlation between the canvas dimensions listed in the ledger book and the dimensions of the two Miller works in question, and further because the sale date (1864) succeeds the Walters commission of 1859–60, that these transaction notes concern *Shoshone Indians at*

a Mountain Lake and *Green River (Oregon)*.

13 Ron Tyler, "Alfred Jacob Miller," in *Alfred Jacob Miller: Artist as Explorer*, exh. cat. (Gerald Peters Gallery, 1999–2000), 36.

14 Although now known as *Shoshone Indians at a Mountain Lake*, the Denver Art Museum's painting probably changed names as it passed between owners. At one point, this work likely bore a title referencing "Green River," like its counterparts.

15 More specifically, it has been suggested that this body of work depicts Lake Fremont, an appellation that is currently included on the Denver Art Museum's exhibition label for *Shoshone Indians at a Mountain Lake*. The painting's original museum catalog card notes that Mae Reed Porter identified the work as portraying Fremont Lake during or before June 1961. Dave Vlcek, Bureau of Land Management archaeologist for the Pinedale Field Office, concurs that although it is an idealized, exaggerated interpretation, Miller's painting likely features Fremont Lake looking north and east toward Box Bay and Moosehead Bay. I would like to thank Mr. Vlcek for his help identifying the location of Miller's painting.

16 One accolade came from a *New York Morning Herald* critic on May 16, 1839, who had this to say about Miller's exhibition of eighteen western canvases at Apollo Gallery (New York) in May 1839: "The principal merit of these works is their originality—boldness and accuracy of drawing and perspective . . . The young artist has evinced great talent."

17 Hassrick, introduction to *Alfred Jacob Miller: Artist on the Oregon Trail*, 3–6.

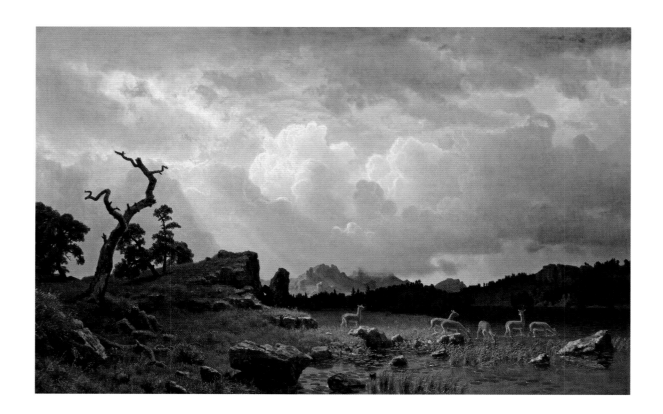

Albert Bierstadt's Wind River Country

PETER H. HASSRICK

Albert Bierstadt
Thunderstorm in the Rocky Mountains, 1859
Oil on canvas, 19½ x 29½
Museum of Fine Arts, Boston, Gift of Mrs. Edward
Hale and Mrs. John Carroll Perkins in memory of
their father, Elias T. Milliken, 43.134
Photograph ©2011 Museum of Fine Arts, Boston

Albert Bierstadt
Wind River Country, 1860
Oil on canvas, 42½ x 30½
Denver Art Museum, Charles H. Bayly Collection,
1987.47

Peering at our nation's
cultural geography from
his New England perch
in 1844, Ralph Waldo
Emerson was said to have
observed that "Europe
extends to the Alleghenies;
America lies beyond."[1] He
made this quip the year
expansionist Democrat
James K. Polk took the White House
on a ticket favoring the annexation
of Texas and a claim to all of Oregon.
Yet it became something of a mantra
for a generation of artists like Albert
Bierstadt, who was in his early teens
at the time. It shaped the way he saw
things, so that despite his affection
for painting New England scenery,
especially the picturesque profiles of the

White Mountains, he invariably turned
to the West when he wished to find
more verifiably national themes for his
work.

Scribner's Monthly recalled years
later that Bierstadt, as a youth, "was
not a prodigy in an art way." He was
known, however, for two things: "his
love of adventure" and his appeal for
popularity, which first manifested itself
in "a composition which he wrote at
school, when twelve years old, entitled
'The Rocky Mountains.'"[2]

In his early twenties, Bierstadt
turned his back on America, both
east and west of the Alleghenies, and
sailed for Europe to study painting.
He had hoped to learn from a relative
of his, Johann Peter Hasenclever, who
taught genre painting at the esteemed
Düsseldorf Academy. Sadly, Hasenclever
died shortly before Bierstadt arrived. But
this turn of events had a silver lining,

since it is generally assumed that genre painting, and especially the sentimental variety that Hasenclever ascribed to, would not have been a good fit for Bierstadt. Instead, Bierstadt grasped inspiration from more naturalistic landscape painters at the Academy, Carl Lessing and Andreas Achenbach.[3]

Upon his return to the United States in 1857 after four years abroad, Bierstadt faced a dilemma that presented itself to many expatriate students. He had to find an American theme that employed the lessons he had learned in Germany and would allow him to express himself in full measure as well. The Rocky Mountains would provide that mix. In a time of increasingly bitter sectional strife, they represented as a motif a grand though neutral and thus unifying national symbol. As a subject, they would challenge all the skills the artist had learned from his German masters. And as an adventure, they

would excite the impulses of even the most ardent explorer. Bierstadt began almost immediately to make plans for a trip into the Far West. His hometown newspaper, the *New Bedford Daily Mercury*, announced in January 1859 that Bierstadt was preparing "to start for the Rocky Mountains, to study the scenery of that wild region, and the picturesque facts of Indian life, with reference to a series of huge pictures."[4]

As was common practice, Bierstadt hitched a ride west with a government expedition. He and a group of other painters, which included Bierstadt's fellow landscapists from the White Mountains, Francis Seth Frost and Bostonian Henry Hitchings, joined a wagon road survey under the direction of Colonel Frederick W. Lander. An engineer of considerable reputation, Lander was superintendent of all roads along the Oregon Trail. The summer of 1859 required that he survey a northerly

route from South Pass, Wyoming, west toward northern California.

Lander welcomed artists to his ranks although he actually had no money to pay them or even assist them with their expenses. Lander had been affiliated with painters on western expeditions before. In 1853 he had served as an assistant engineer under Isaac I. Stevens and his Pacific Railroad Survey of the 49th parallel. The famous Indian painter John Mix Stanley and the German-American landscape painter Gustavus Sohon held official positions as artists on that survey. Lander was also known as a compelling public speaker on topics that ranged from exploration and politics to art. He lectured from San Francisco to Washington, D.C., on the merits of a transcontinental railroad, but his most highly regarded presentation was on "The Aptitude of the American Mind for the Cultivation of the Fine Arts."[5] Though not their

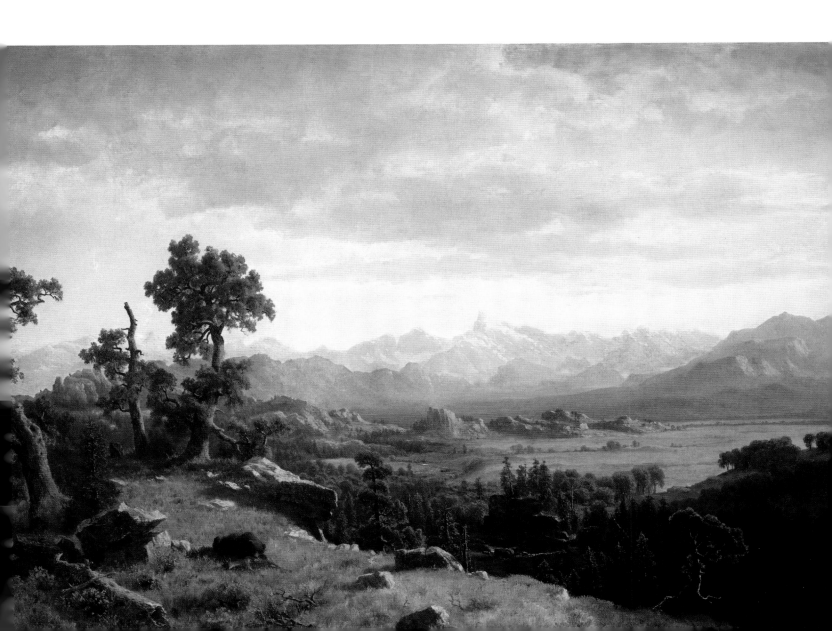

patron, he was certainly a kindred spirit for Bierstadt and the other artists who trailed west with him that summer.

Bierstadt and Frost traveled as far west as the Green River valley just beyond South Pass. Hitchings went on for several weeks,[6] and his surviving sketchbook is devoted primarily to emigrant life along the Oregon Trail.[7] What stopped Bierstadt and Frost, however, were the Wind River Mountains, a set of peaks that thrust skyward for seventy miles north and west of South Pass. They appealed to Frost, who made them the subject of one of his most accomplished western paintings, a large oil titled *South Pass, Wind River Mountains, Wyoming* (1860, Smith College Museum of Art).[8] But for Bierstadt, they were his ultimate muse.

Bierstadt's 1859 western trip also provided him with that sense of adventure he so relished and that so underscored his art production. After he and Frost left the company of Lander, they spent several weeks in and around the southern reaches of the mountains. With "a spring-wagon and six mules," he wrote to the art journal *The Crayon*, "we go where fancy leads us."[9] They especially enjoyed exploring the Big Sandy River and what is known today as the Temple Peak area.

In 1866, the great chronicler of American nineteenth-century artists, Henry T. Tuckerman, commented that "Adventure is an element of American artist-life which gives it singular zest and interest." With reference to Bierstadt's rambles, Tuckerman concluded, "This life invigorated body and mind, exhilarated the spirit, and freshened that love of and intimacy with nature, whence the true artist draws his best inspiration. It was thus that the landscape of the Rocky Mountains was studied."[10] Bierstadt enjoyed being presented as a soldier of fortune in the service of art. Subsequent accounts of his 1859 travels, which defined them as encounters with "much danger and exposure" and fraught with great "risk to life and limb," gratified the artist and

fit perfectly with the outdoorsman self-image he wished to promote over the decades to follow.[11]

The Wind River Mountains, which became the primary focus of Bierstadt's art endeavors that summer and provided the centerpiece for his initial western adventures, had been a subject for artists and national promoters for more than two decades. Alfred Jacob Miller had painted their splendorous profiles for Captain William Drummond Stewart, his patron on an 1837 pleasure trip to the area. Though some of Miller's larger paintings such as *The Pipe of Peace at the Rendezvous* (Stark Museum of Art, Texas) were publicly displayed at the Apollo Gallery in New York in 1839 and received plaudits from the press, Miller's works were never widely known.[12]

Much more fuss was made of them in 1842 when John C. Frémont ascended what he thought to be the loftiest of the peaks and gave it his name. Because Frémont had an artist, Charles Preuss, with him on his highly publicized trek, images of the mountains, Fremont Peak, and the explorer planning an American flag on its summit appeared in the broadly distributed official report that was published on the heels of the expedition's conclusion.[13] The Wind River Mountains became a symbol of America's expanding greatness. And though he admitted that "these snow-mountains are not the Alps," Frémont assured their place in art when he wrote that their "grandeur and magnificence . . . will doubtless find pens and pencils to do them justice."[14]

Bierstadt was the man for that job. He made a sizable number of oil studies and filled sketchbooks with pencil drawings and even watercolors of the southern Wind River Range, south of where Miller and Frémont had explored.[15] He may also have taken photographs of the mountain scenery, but they, unlike several dozen stereoscopic images of life on the trail, seem not to have been especially successful.[16] These were amassed in his studio upon his return home to

New Bedford. There he promptly completed one of his finest small landscape renditions, *Thunderstorm in the Rocky Mountains*. This stunning pictorial recollection, featuring a group of hesitant deer as they approach the still respite of a quiet wilderness lake, combined a sense of spiritually sublime light with a poetic naturalism. So excited were Bierstadt and his admirers by the potential for triumph with such Rocky Mountain landscapes that by January 1860 he had moved his operations to New York City where he took rooms in the famous Tenth Street Studio Building. There he joined Emanuel Leutze and Thomas Worthington Whittredge, from his Düsseldorf days, and Frederick Church, with whom he would soon be competing in the production of America's grandest pictures.

It is not known how many western views Bierstadt completed in the first six months following his return, but there were several, including one titled *Sioux Village*, another called *Rocky Mountain Passages*,[17] and a third, very large oil (four-and-a-half by nine feet) known as the *Base of the Rocky Mountains, Laramie Peak* (all of which have unknown whereabouts today). A fourth canvas of intermediate size was painted for one of Boston's wealthiest merchants, Gardner Brewer. Today it goes by the title of *Wind River Country*, and it was completed by mid-February 1860, ready for one of the walls in Brewer's mansion. Bierstadt wrote Brewer advising him of the picture's theme:

> I have at last completed your picture, and in a few days shall send it to you. I have taken the liberty of having a frame made for it, and hope it will please you. The scene I have chosen for the picture is among the Rocky Mountains. In the distance is seen a part of the Mountains called the Wind River Chain, prominent among which rises Fremonts Peak. This range is covered with snow the entire season. The low hills are

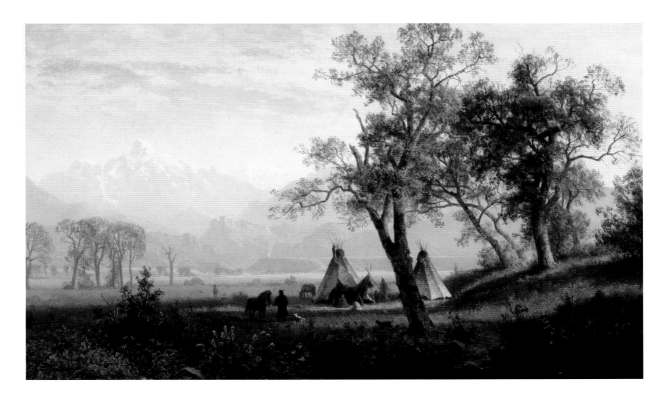

Albert Bierstadt
Wind River Mountains, Nebraska Territory, 1862
Oil on composition board, 12 x 18½
Milwaukee Art Museum, Layton Art Collection,
Purchase L1897.3
Photo by Larry Sanders

covered with pine forests, and along the river, Sweetwater its name, we find the Willow, Aspen, Cottonwood, and Spruce. A very picturesque variety of pine, found only among the Rocky Mountains, I have introduced into the foreground, and also a Grizzly bear, feeding on an Antelope…Should this picture not prove satisfactory, I will try again. Should you come to New York at any time I shall be most happy to see you, at the Studio Building, 15 Tenth Street.[18]

The only clue to an original title for this work might be the reference to Fremont Peak, but in that instance Bierstadt was wrong.[19] The high mountain in the distance was not Fremont Peak. That name had already been ascribed to a granite spire about forty miles north, which Frémont

had climbed in 1842. Today the most conspicuous summit on the horizon is known as Temple Peak, and it appears also in several subsequent grand works in which Bierstadt took the liberty, incorrectly again, to name the spire Lander's Peak.

Unlike Frémont, Bierstadt, who had actually painted and hiked among Europe's highest mountains, claimed that the Wind River Range reminded him of the Bernese Alps. In general, though, his comparison focused further south. "The color of the mountains and of the plains, and, indeed, that of the entire country, reminds one of the colors of Italy," he wrote. "In fact, we have here the Italy of America in a primitive condition."[20]

What Brewer got for his commission conformed much more to an Italian vision of the West than either a Swiss or German interpretation. Even

though the painting reveals a number of stylistic elements that mirrored Düsseldorf lessons, especially the use of successive parallel planes to reveal depth, there were far more features that were more Italianate in spirit than German. Tuckerman, in a lengthy 1867 article on Bierstadt, defined what he saw as the standard Düsseldorf elements as they appeared in typical Bierstadt paintings of that time. But most of those components do not appear in Brewer's view of Temple Peak. Tuckerman asserted that, as with other Düsseldorf models, Bierstadt's color was "frequently hard and dry," the works were devoid of "the sensuous element of the Spanish and Italian schools," that "pure light is often wanting," and "soft pure light" was absent altogether. Moreover, Bierstadt's production was "inclined to the sensational" and was generally "more clever than tender."[21]

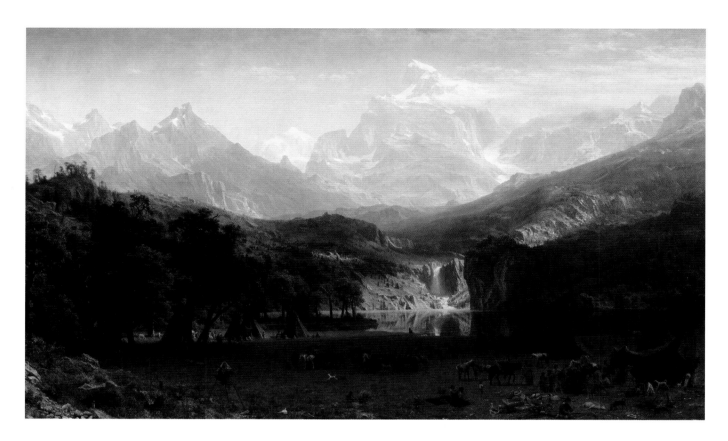

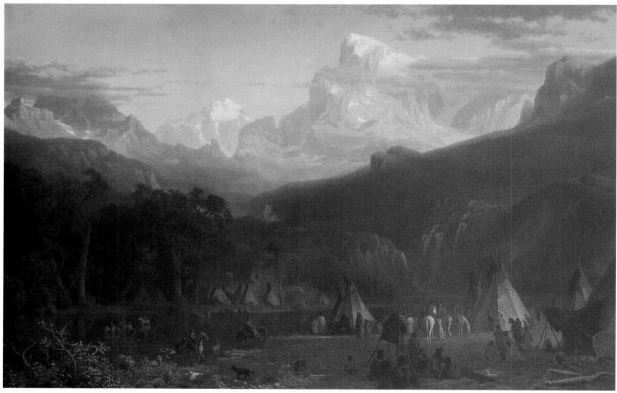

Top: Albert Bierstadt

The Rocky Mountains, Lander's Peak, 1863

Oil on canvas, 73½ x 120¾

The Metropolitan Museum of Art, New York,

Rogers Fund, 1907 (07.123). Image ©The

Metropolitan Museum of Art / Art Resource,

New York

Bottom: Albert Bierstadt

Sunset Light, Wind River Range of the Rocky

Mountains, 1861

Oil on canvas, 38 x 59

Courtesy of the Trustees of the New Bedford

Free Public Library

Yet in almost all of these categories *Wind River Country* defies such description. This painting turned out to be one of the first in the promised series of Rocky Mountain sensations, which subsequently included *Sunset Light, Wind River Range of the Rocky Mountains* (1861) and *The Rocky Mountains, Lander's Peak* (1863). In terms of light and color, sentiment, and even scale, *Sunset Light* rather resembles *Wind River Country*. It is not until his early magnum opus, *The Rocky Mountains, Lander's Peak*, that Bierstadt abandons his sense of the scene as an Italian reverie and creates a full-blown, Düsseldorf "Great Picture" with all the qualities of Tuckerman's description.

One aspect of *Wind River Country* that does reflect Düsseldorf propensities is the stagelike, well-lit foreground with the genre scene of a grizzly bear caught enjoying his main course of the day, a fallen antelope. In the other paintings in the series, Bierstadt selected Indians as the introductory scene. He appreciated each subject equally—wild animals and natural man. Some critics felt that with the introduction of such secondary themes Bierstadt compromised the "solitary grandeur" of his work— "sacrificed sublimity of impression to variety of interest."[22]

But the bear in Brewer's canvas is not a distraction, but rather an exotic interlocutor who establishes the rawness of nature's alpine wilds revealed beyond. Bierstadt's childhood essay about the Rockies had been mostly about a bear hunt. Now the bear was the hunter, suggesting the vulnerability of those who might consider him prey. The bear is merely a theatrical device designed to open the scene on the Big Sandy River (not, as Bierstadt asserted, the Sweetwater River) that leads the viewer's eye to the point of divine culmination, the summit of snow-capped Temple Peak. The soft, suffused light enhances the picture's spirituality, rendering this a poetic anthem to his recent reminiscences of Rocky Mountain wonder.

In subsequent smaller works, like *Wind River Mountains, Nebraska Territory* (1862), Bierstadt found equal success with integrating a theatrical genre element, this time a Shoshone Indian encampment, into the scene. Although slightly more prominent in the composition than the bear, the Indians are dwarfed by the scale of the noble cottonwoods and only help the viewer appreciate the grand and divine presence of Temple Peak beyond.

Bierstadt would go on from these early, harmonious, tenderly poetic works to live up to Tuckerman's critique of him as a Düsseldorf practitioner. By 1863 when he painted *The Rocky Mountains, Lander's Peak* and began to consider his masterpiece *Storm in the Rocky Mountains—Mt. Rosalie* (Brooklyn Museum), he had changed his tone and would rightly deserve the criticism of being rather less "refined in sentiment" than fellow American painters of his day. He would be known to have sacrificed poetic splendor for "hard-featured rationalism," his light "pitched on too high a key" and left "cold and glaring."[23] *Wind River Country* was an interlude with the tender side of nature.

Notes

1 There is evidently no published source for this quote. It is something Emerson said rather than wrote. I am grateful to Walt Whitman scholar Roberts French for this quote and its history.

2 "Albert Bierstadt, N.A.," *Scribner's Monthly* 3 (March 1892): 605.

3 Ibid., 606.

4 *New Bedford (MA) Daily Mercury*, January 17, 1859.

5 E. Douglas Branch, "Frederick West Lander, Road-Builder," *The Mississippi Valley Historical Review* 16 (September 1929): 183–84.

6 Jourdan Moore Houston and Alan Fraser Houston, "Lithographer Henry Hitchings: Educator and 'Early Devotee of Landscape Art,'" *Imprint: Journal of the American Historical Print Collectors Society* 26 (Autumn 2001): 6.

7 Hitchings's 1859 sketchbook contains sixty-eight drawings of graphite on paper and is in the collection of the Yale University Art Gallery, New Haven, CT.

8 See Jourdan Houston, "Francis Seth Frost (1825–1905): Beyond Bierstadt's Shadow," *American Art Review* 6 (August–September 1994): 147.

9 *The Crayon*, September 1859, 287.

10 Henry T. Tuckerman, "Albert Bierstadt," *Galaxy Magazine* 1 (August 15, 1866): 679–82.

11 "Albert Bierstadt, N.A.," 607.

12 See "Apollo Gallery—Original Paintings," *New York Morning Herald*, May 16, 1839.

13 J. C. Frémont, *A Report on an Exploration of the Country Lying between the Missouri River and the Rocky Mountains …* (Washington, DC: Printed by order of the U.S. Senate, 1843).

14 Ibid., 243.

15 See Barbara Cyviner Listokin, "A Bierstadt Sketchbook," *Master Drawings* 18 (Winter 1980): 376–79 for examples of Bierstadt's pencil sketches and *Shoshone Indians— Rocky Mountains* of 1859 from the Rollins Collection, Cornell Fine Arts Museum in Winter Park, FL, as an example of his watercolor field work.

16 See Howard E. Bendix, "Discovered!! Early Bierstadt Photographs, Part One: The Lander Expedition," *Photographia* 6 (October 1974): 4–5. An explanation of his failed efforts to photograph landscape views appears in Bierstadt's letter from the Rocky Mountains, 10 July 1859, published in *The Crayon*, September 1859, 287.

17 See Nancy Anderson and Linda S. Ferber, *Albert Bierstadt: Art & Enterprise* (New York: Hudson Hills Press, 1990), 146.

18 Letter from Albert Bierstadt to Gardner Brewer, 10 February 1860, Massachusetts Historical Society, Boston.

19 For a discussion of the painting's title see Gordon Hendricks, *Albert Bierstadt: Painter of the American West* (New York: Harry N. Abrams, Inc., 1973), 96.

20 *The Crayon*, 287.

21 Henry T. Tuckerman, *Book of the Artists* (New York: Putnam, 1867), 392.

22 *Round Table* 1 (February 27, 1864): 169. The art critic James Jackson Jarvis agreed with this assessment in *The Art-Idea* (New York: Hurd and Houghton, 1864), 191–92.

23 Ibid., 192.

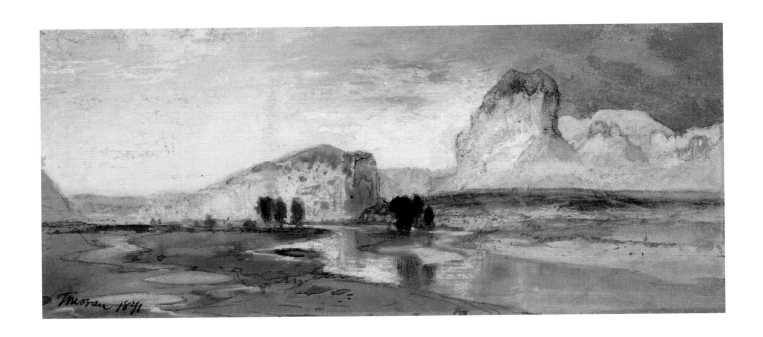

Moran and the British Landscape Tradition

KATHLEEN STUART

Thomas Moran (1837–1926) painted *Sunset Cloud, Green River, Wyoming* in 1917. He was eighty years old and in the last decade of his life. The picture clearly had meaning for him.[1] Its subject—the starkly beautiful landscape of southwestern Wyoming, which Moran first visited in 1871—held pride of place in his imagination for nearly half a century, resulting in upward of eighty paintings, about fifty watercolors, and a further few dozen drawings and prints.[2] He painted a greater number of Grand Canyon pictures, but, in the words of one Moran scholar, he "claim[ed] the [Green River] landscape as his own,"[3] returning to it and painting it until the very end of his life.

Moran, whose reputation was made with two large-scale pictures of iconic vistas of the American West, *Grand Canyon of the Yellowstone* (1872) and *Chasm of the Colorado* (1873–74),[4] was born in Bolton, England. He emigrated with his family in 1844, settling near Philadelphia. His training began, as it did for many of his generation in America and England, as an apprentice in a wood engraving firm. At eighteen, after only two years with the firm, Scattergood and Telfer of Philadelphia, he left and joined his brother Edward's photography studio. There he was introduced to two notable Philadelphia artists, the Irish-born marine painter and watercolorist James Hamilton (1819–78) and the German landscapist Paul Weber (1823–1916). Their instruction proved invaluable to the young Moran, but more crucial to his development was the fact that

they exposed him to images of works by England's greatest landscape artist, Joseph Mallord William Turner (1775–1851), and writings by the influential English critic and Turner's champion, John Ruskin (1819–1900), himself an artist.[5]

Turner's pictures and Ruskin's words had a profound impact on the largely self-taught Moran. Ruskin's *Modern Painters*, whose first volume was published in America in 1847, guided readers on how to "see" a landscape, including how to compose a picture for pleasing effect and how to convey both foreground detail and vast space. His manual *The Elements of Drawing*, which appeared in 1857, was more specific, with detailed instruction on how to draw a leaf, a rock, or the trunk of a tree, and included the recommendation that the reader closely study Turner's paintings by tracing prints of them.[6]

Ruskin illustrated his lessons with engravings after drawings and paintings mostly by Turner, which the older artist had published early in his career under the title *Liber Studiorum* (1807).

From Ruskin, Moran absorbed a sensitivity to painting the "truth" in landscape, an attribute that became one of his trademarks and which would differentiate him from his chief rival as a painter of the West, Albert Bierstadt (1830–1902).[7] With encouragement from Ruskin's teachings, Moran began sketching out of doors, in front of the subject. With his brothers he explored the forests of southeastern Pennsylvania, making studies of waterfalls and woodland streams.[8] These he worked up

into finished watercolors and paintings, which sold well and provided money to buy supplies and books—including his own copy of Turner's *Liber Studiorum*.[9] Elements of Turner's designs are evident in several of Moran's early sketches, for example, *Bridge over the Schuylkill, Philadelphia* (1856), whose composition is closely comparable to that of Turner's view of the Swiss city of Basel, published as plate 5 of part 1 in the *Liber Studiorum*.

Moran's first opportunity to see original works by Turner came in 1858 at an exhibition of contemporary British art hosted by the Pennsylvania Academy of the Fine Arts in Philadelphia. In addition to Turner's first watercolors

to be shown in America, the exhibition featured works by Ruskin and by a group of artists known as the Pre-Raphaelites, whose landscapes Ruskin praised for what he called their "truth to nature," especially their attention to geologic detail.[10] Two works from the exhibition that likely left a deep impression on Moran were Ruskin's *Fragment of the Alps* (about 1854–56),[11] with its brilliantly colored boulder dominating the foreground; and John Brett's *The Glacier at Rosenlaui* (1856),[12] which expertly combined foreground detail with a vast landscape receding into the distance.

Moran put these visual lessons to good use on his first long-distance

Thomas Moran
First sketch made in the West at Green River, Wyoming, 1871
Graphite, watercolor, and white gouache on wove paper, 3¾ x 8
Gilcrease Museum, Tulsa, Oklahoma, 0236.882

Thomas Moran
Sunset Cloud, Green River, Wyoming, 1917
Oil on canvas, 9¾ x 13¾
Collection of Bernadette Berger

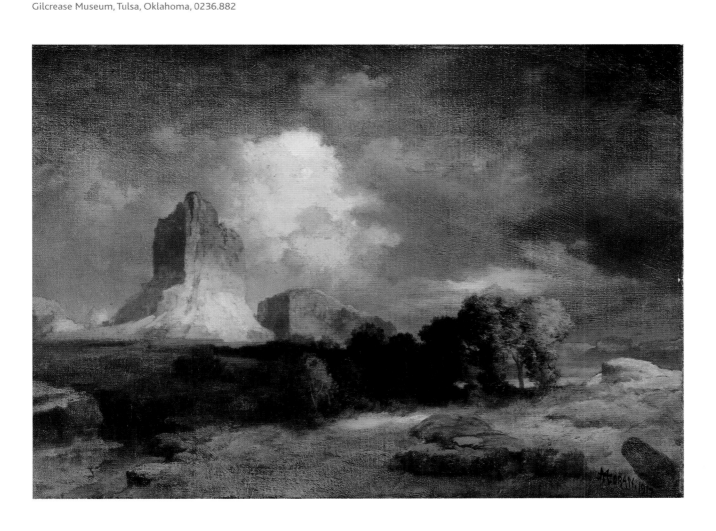

Charles Turner
after Joseph Mallord William Turner
"Basle," plate V from *Liber Studiorum*,
London, ca. 1808–19, Aquatint
Yale Center for British Art, Paul Mellon
Collection, L 21136 (Folio A)

Thomas Moran
Bridge over the Schuylkill, Philadelphia, 1856
Graphite, watercolor, and white gouache
on wove paper, 6½ x 11⅝
Gilcrease Museum, Tulsa, Oklahoma, 0226.798

sketching trip. In the summer of 1860 he traveled to the south shore of Lake Superior in the Upper Peninsula of Michigan. In an area known as Pictured Rocks, he made sketches, many with color notes, of the intricately carved sandstone cliffs and shoreline caves. As he had done with his Pennsylvania drawings, he worked up these studies into finished watercolors and oil paintings back in his studio. Two drawings from that trip—*At Miners River, Pictured Rocks, Lake Superior*[13] and *The Great Cave, Pictured Rocks, From the East*[14]—demonstrate that Moran followed Ruskin's advice to study nature closely.

Two years later, in 1862, Moran and his brother Edward traveled to England with the express purpose of

seeing paintings by Turner in London's National Gallery. Armed with a copy of Turner's *Liber Studiorum*, they traveled along England's southern coast to the locales where the older artist had made his pictures. They compared the actual landscape with the finished work and concluded that Turner was not looking at "nature" as closely as they might have inferred from reading Ruskin. Quoted about 1881, Moran observed that "[Turner's] landscapes are false . . . they contain his impressions of Nature, and so many natural characteristics as were necessary adequately to convey that impression to others."[15]

The experience was instructive, and Moran's sketches on this trip, and those he made on a European sojourn four years later, display a broader handling

and a greater freedom of design. In giving more play to his imagination, he was following the crucial second part of Ruskin's message: that the artist's experience of nature must always be mediated by his imagination.[16] In Italy, inspired by the broad sweep of the Roman countryside, Moran drew his first panoramic landscapes sketches, among them *The Campagna near Rome*.[17] He also made close studies of Italy's distinctive flora: in the Borghese Gardens outside Rome he drew the sinuous, twisted trunks of ancient oaks and clusters of the region's characteristic umbrella pines.[18] Traveling north into the Alps, he sketched his first mountain views, including at least one recorded by Turner, *Pass of Faido*.[19] As the landscape expanded, so did Moran's vision. Here began the sensibility that he would translate into his western vistas.

In 1870 an assignment from *Scribner's Monthly* gave Moran an opportunity to "see" the western landscape, albeit secondhand. He was commissioned to illustrate an article by Nathaniel P. Langford, "Wonders of Yellowstone," for which he was provided with field sketches made by members of the 1870 Washburn-Doane expedition.[20] The sketches were rough and inexpertly drawn, but they whetted Moran's appetite to see the actual landscape that inspired them.

The following year he had his chance. Moran was invited to join the U.S. Geological Survey team headed by Dr. Ferdinand V. Hayden, whose assignment was to describe and map the Yellowstone Territory. The transcontinental railroad had been completed just two years earlier, and Moran traveled by train from

Philadelphia across the plains and into southern Wyoming. Green River was his first stop.

The town lay along a river of the same name. It was a fledgling railroad junction with a train depot, schoolhouse, church, hotel, and brewery.[21] These details of human habitation seemed no longer to hold Moran's interest as when he sketched Pennsylvania's Schuylkill River fifteen years earlier. Instead, it was the dramatic landscape of castellated buttes and steep-sided bluffs south of the town—known as Toll Gate Rock and the Green River Palisades—that seized his imagination.[22] But his eye and hand did not simply record what lay before him. The years of looking at Turner's and Ruskin's carefully composed images had trained him to see the view as a picture. For his first western sketch, he

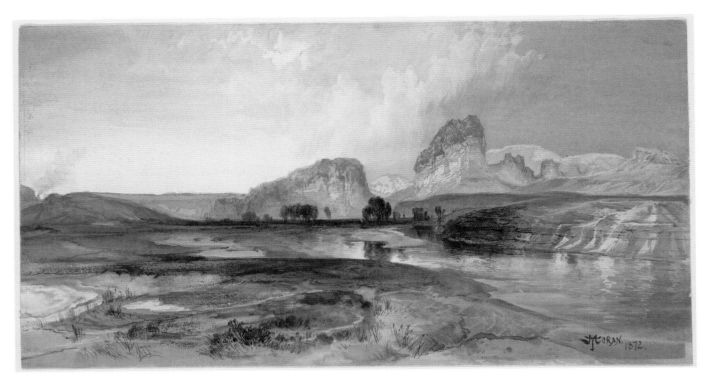

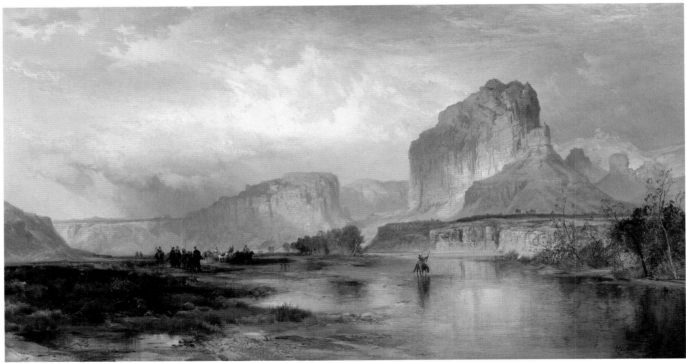

Top: Thomas Moran
Cliffs, Green River, Wyoming, 1872
Watercolor over graphite on thick, smooth,
beige wove paper, 6 x 11$^{11}$/$_{16}$
Gift of Maxim Karolik for the M. and M. Karolik
Collection of American Watercolors and
Drawings, 1800–1875, Museum of Fine Arts,
Boston, 60.428. Photograph ©2011 Museum of
Fine Arts, Boston

Bottom: Thomas Moran
Cliffs of Green River, 1874
Oil on canvas, 25$^1$/$_8$ x 45$^3$/$_8$
The Amon Carter Museum of American Art,
Fort Worth, Texas, 1975.28

chose a broad, horizontal composition to evoke the landscape's vast sense of space, and positioned himself looking to the northeast so that the buttes' ridgeline and the river receded in a long diagonal sweep toward the far horizon. He inscribed it "First sketch made in the West at Green River, Wyoming" and later added touches of watercolor and gouache, perhaps to memorialize this singular event.[23]

Moran made at least one additional sketch of Green River that summer[24] and followed it up with a more finished watercolor the next year. The design of these first sketches provided the template for the bulk of the Green River oil paintings Moran produced over the next nearly five decades. In one of the earliest of these—*Cliffs of the Green River* (1874)—he introduced a group of Native Americans on horseback, a picturesque addition but a fictional detail by the date of the painting.[25] These figures became a staple of his subsequent variations on the subject.

At least two further compositional schemes of the Green River subject are known, each painted in multiple versions, each with slight variations. In one design—for example, *Green River, Wyoming* (1879)—Moran positioned himself directly south of the buttes and recorded a view looking north that emphasized the verticality of the geologic forms. Another composition, as seen in *The Cliffs of Green River* (1887), describes the scene from the opposite direction, with the river dominating the foreground.

Sunset Cloud, Green River, Wyoming represents possibly a unique version of the subject. Neither a preliminary sketch nor any variations have been identified. Here, Toll Gate Rock and the Palisades

Thomas Moran
Green River, Wyoming, 1879
Watercolor, pencil, and opaque white
on paper, 10$\frac{1}{8}$ x 14$\frac{5}{8}$
Jefferson National Expansion Memorial,
National Park Service

occupy the left third of the picture, reversing the position they hold, for example, in the finished watercolor of the "first sketch." Although the title of this painting, which it has had at least for the past three decades, suggests a view toward the east, with the setting sun illuminating the scene, it is more likely that the view is from behind the buttes, looking west, with the rising sun painting the clouds and rock formations in tones of gold, cream, and what Moran called "salmon red."[26] Small in scale (measuring about ten by fourteen inches), this intimate picture might be thought of as a portrait of an old friend reimagined from memory. Green River has become a lush, verdant landscape glowing in the early-morning light.

Moran returned repeatedly to Green River until very near the end of his life. As late as 1923, three years before his death, he made a visit documented by a watercolor inscribed with the location and date.[27] What hold this austere landscape had on him is not known, but a possible answer may be suggested by the similarity of Green River's expansive, carved limestone landscape with that of the Yorkshire Dales in the north of England, not far from his native Bolton. As a young boy, Moran may have seen pictures of this wilderness of moors and rugged outcrops or perhaps even visited it before the family left for America when he was seven, imprinting on his imagination a landscape of ancient rock and endless vistas that he would recall in Green River, his "rite of passage to the West."[28]

Notes

1 Moran's thumbprint in the lower right corner was not a sentimental gesture but one meant to authenticate the painting and thereby foil copyists whose forged "Morans" had begun to proliferate in the market.

2 Figures for the number of Moran's Green River paintings and watercolors were provided by Stephen L. Good and Phyllis Braff, co-authors of the forthcoming catalogue raisonné of the paintings of Thomas Moran; verbal communication with the author, March 9, 2011. Stephen Good noted the existence of records for a painting by Moran of Green River dated about 1923, when the artist was eighty-six.

3 Nancy K. Anderson, *Thomas Moran*, exh. cat. (Washington, DC: National Gallery of Art, 1997), 49.

4 Both are in the Department of the Interior Museum, Washington, DC; Anderson, *Thomas Moran*, nos. 41 and 47.

Pen-y-ghent in the Yorkshire Dales
©The Lakes and Dales
http://www.thelakesanddales.com

Thomas Moran
The Cliffs of Green River Wyoming Terr. USA, 1887
Oil on canvas, 15$^1$/$_8$ x 27$^1$/$_8$
Courtesy of American Museum of Western Art—
The Anschutz Collection

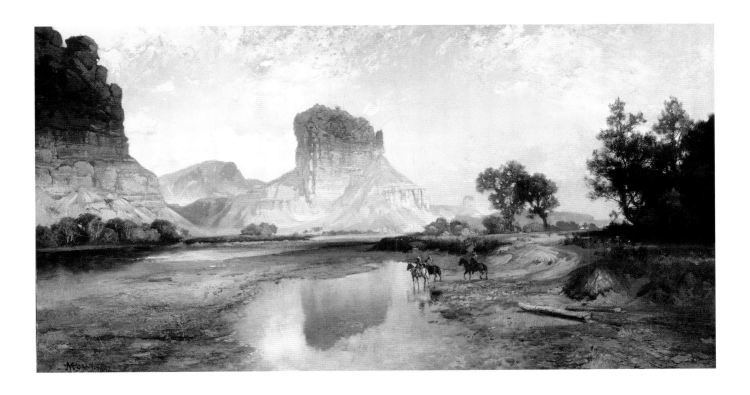

5 Andrew Wilton and Tim Barringer, *American Sublime: Landscape Painting in the United States, 1820–1880*, exh. cat. (Princeton, NJ: Princeton University Press, 2002), 260; Anderson, *Thomas Moran*, 25.

6 Anderson, *Thomas Moran*, 25.

7 Albert Bierstadt's large-scale, theatrical pictures reached their peak of popularity in the 1860s; Linda S. Ferber and William H. Gerdts, *The New Path: Ruskin and the American Pre-Raphaelites* (Brooklyn, NY: Brooklyn Museum, 1985), 232. See, for example, *Storm in the Rocky Mountains—Mt. Rosalie* (1866, Brooklyn Museum, inv. 76.79), reproduced in Nicole A. Parks, "Albert Bierstadt's Colorado," *Colorado: The Artist's Muse* (Denver: Petrie Institute of Western American Art, Denver Art Museum [Western Passages], 2008), 50–51.

8 See, for example, Anne Morand, *Thomas Moran: The Field Sketches, 1856–1923* (Norman: University of Oklahoma Press, 1996), nos. 3 and 4.

9 Anderson, *Thomas Moran*, 284.

10 Ferber and Gerdts, *The New Path*, 109–133 passim.

11 Harvard University Art Museums, Fogg Art Museum, Cambridge; Ferber and Gerdts, *The New Path*, plate 5.

12 Tate Gallery, London; Robert Hewison, *Ruskin, Turner, and the Pre-Raphaelites*, exh. cat. (London: Tate Gallery, 2000), no. 202.

13 Gilcrease Museum, Tulsa, OK, inv. 1326.756; Morand, *Thomas Moran: The Field Sketches*, no. 12.

14 Gilcrease Museum, Tulsa, OK, inv. 1326.762; Morand, *Thomas Moran: The Field Sketches*, no. 17.

15 G. W. Sheldon, *American Painters* (New York: D. Appleton and Co., 1881), 123, quoted in Carol Clark, *Thomas Moran: Watercolors of the American West*, exh. cat. (Austin: University of Texas Press, 1980), 9 n. 7.

16 Anderson, *Thomas Moran*, 25.

17 Gilcrease Museum, Tulsa, OK, inv. 0276.861; Morand, *Thomas Moran: The Field Sketches*, no. 161.

18 Gilcrease Museum, Tulsa, OK, invs. 0276.869, 1376.926; Morand, *Thomas Moran: The Field Sketches*, nos. 183, 185.

19 Cooper-Hewitt National Design Museum, NY, inv. 1917-17-12A; Morand, *Thomas Moran: The Field Sketches*, no. 190. For Turner's watercolor, *The Pass of St. Gotthard, near Faido* (1843, Thaw Collection, Morgan Library & Museum, NY), see Hewison, *Ruskin, Turner, and the Pre-Raphaelites*, no. 54. Ruskin made a watercolor of the same view, *Rocks in Unrest* (about 1845–55, Thaw Collection, Morgan Library & Museum, NY); see Hewison, *Ruskin, Turner and the Pre-Raphaelites*, no. 57.

20 Anderson, *Thomas Moran*, 46.

21 Ibid., 48.

22 Moran may have seen photographs of the Green River landscape taken by Andrew Joseph Russell and published in Dr. Ferdinand Hayden's *Sun Pictures of Rocky Mountain Scenery* (1870); Joni Louise Kinsey, *Thomas Moran and the Surveying of the American West* (Washington, DC: Smithsonian Institution Press, 1992), 29, including n.17.

23 Anne Morand points out that no other known drawing from this trip contains as much color; Morand, *Thomas Moran: The Field Sketches*, 36.

24 Cooper-Hewitt National Design Museum, NY, inv. 1917-17-7; Morand, *Thomas Moran: The Field Sketches*, no. 203.

25 Wilton and Barringer, *American Sublime*, 248.

26 Morand, *Thomas Moran: The Field Sketches*, 9.

27 *Green River Cliffs*, 1923; in the collection of the Autry National Center (incorporating the Southwest Museum of the American Indian and the Women of the West Museum), Los Angeles; Clark, *Thomas Moran: Watercolors of the American West*, no. 278.

28 Clark, *Thomas Moran: Watercolors of the American West*, 56.

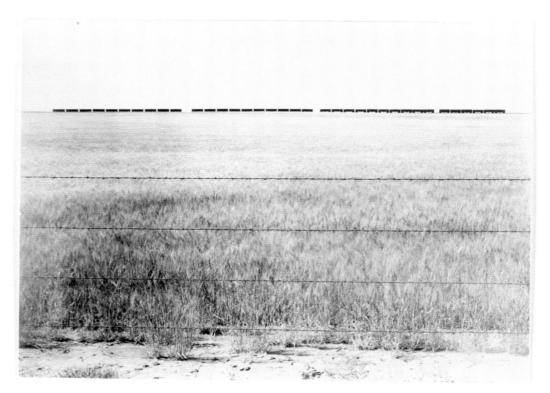

Marjorie Content
Kansas, 1934
Gelatin silver photograph, 4⁹/₁₆ x 6¼
Museum of Fine Arts, Houston,
museum purchase with funds provided
by Clare and Alfred Glassell and an
anonymous donor, 92.206

Alfred Stieglitz
Georgia O'Keeffe, 1933
Gelatin silver photograph, 8¾ x 7½
Museum of Fine Arts, Houston,
The Target Collection of American
Photography, gift of Target Stores,
78.63. ©2011 Georgia O'Keeffe
Museum / Artists Rights Society (ARS),
New York

Modernist Road Trip

EMILY BALLEW NEFF

n human history, the concept of traveling long distances is hardly new. It dates back to before the Neolithic Age, when nomadic hunter-gatherers scavenged for food across whatever distance was necessary to survive. A modern version of that pursuit endures today in the road trip, which began with the advent of the automobile, better roads and highways, burgeoning American tourism, and promotional slogans like "See America First." Now canonized as a sacred American ritual, the road trip recalls significant moments in American history—indeed it is inseparable from them: Lewis and Clark canoeing and portaging along the Missouri River

to the Pacific; the mass movement of nineteenth-century Anglo-European settlers to the West; Indian Removal and the Cherokee Trail of Tears; the migration of African Americans leaving the South; Woody Guthrie wandering the open road and singing folk songs in halls from Oregon to New York; post–World War II leisure travel to national parks in sleek Airstreams; and most famously in literature, Jack Kerouac's *On the Road*, a meandering existential hymn that captured the voice of a new Beat generation. These are stories of movement, migration, travel, and what happens along the way, including what writer Mary Austin called "the third thing . . . the sum of what passed between me and the Land."[1]

American artists, particularly those traveling to or through, or living in, the American West in the early decades of the twentieth century had no option but

to confront the "great fact" of the land, as Willa Cather wrote, and when they did they often expressed their landscape revelations in the most vibrant and innovative artworks of the period.[2] Although less-heralded than the ones listed above, their road trips nonetheless marked an important moment in their self-discovery and a deeper awareness of the frequently changing physical qualities of the American landscape, which no matter how familiar it becomes, never loses its power to astonish.

In 1901, on a trip to Taos, New Mexico, by wagon, Frederic Remington remarked on "the near . . . and far," stunned by how southwestern light flattened forms and thwarted perceptions of space and distance.[3] Georgia O'Keeffe, too, was keenly perceptive to western optics, frequently calling this same phenomenon "the

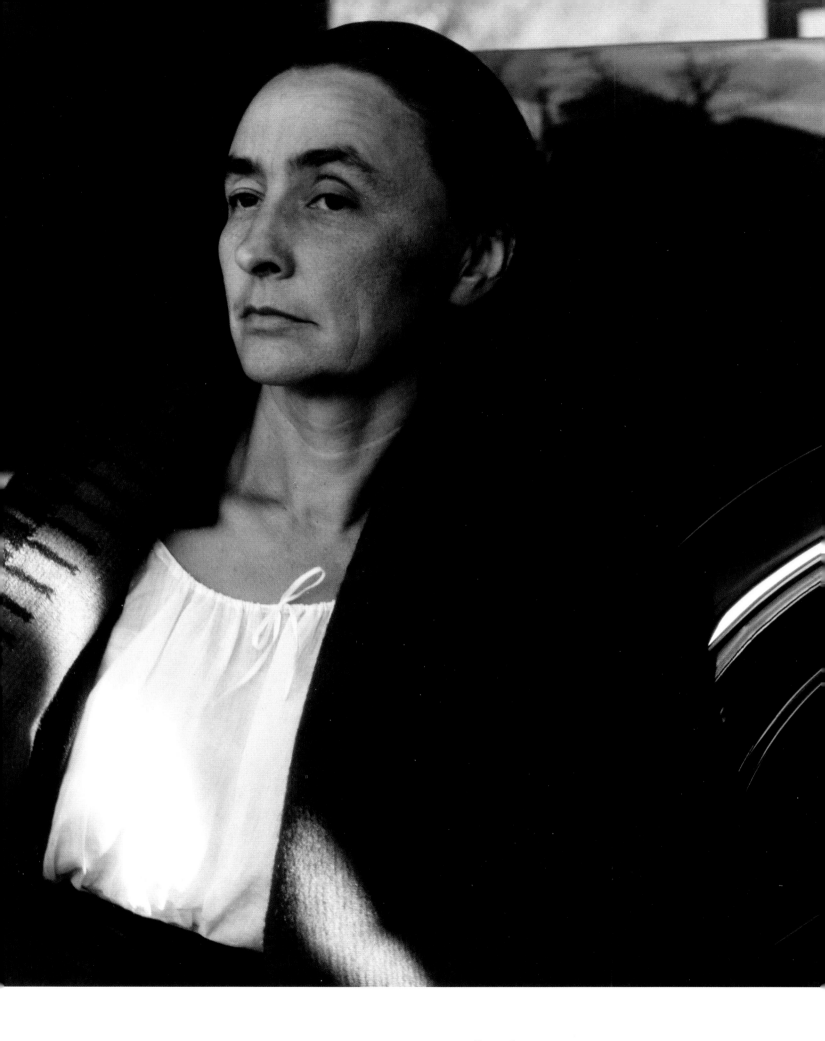

faraway nearby."[4] Unusual among her peers for her love of the Texas Panhandle—its fierce wind, blazing sky, sheet lightning, and limitless space—O'Keeffe equated her experience of the landscape near Canyon, Texas, with silence and freedom, once observing, "It is absurd the way I love this country."[5] O'Keeffe also connected with other desert places, such as her beloved Red Hills near Abiquiu, New Mexico, and later the badlands of the Black Place farther west—forsaken areas she revered and redeemed through her art. These stark landscapes lured her back to New Mexico summer after summer beginning in 1929 when a Model T Ford gave her the freedom to travel independently and to find places to explore and paint.

Once, in 1934, she met her friend Marjorie Content in Chicago, where they began the drive to New Mexico in Content's Packard. The road and the car were generative forces for both artists. In a stunning—and spontaneous—photograph from this journey called *Kansas*, Content locked a view of wheat fields into place with crisply delineated barbwire tautly stretched across the surface, while tiny railroad boxcars set against the sky appear like Morse code moving across the page.[6] It was a thrilling moment for both of them when they stopped to capture the view. When they arrived in New Mexico, O'Keeffe, not surprisingly, bought a new Ford. Indeed, her close association with and fondness for the automobile compelled her husband, Alfred Stieglitz, to photograph her with an Indian blanket wrapped over her shoulders, posed next to the sleek, glistening tire of her car. The blanket and tire served as symbols of the newfound freedom discovered during her first trip to New

Mexico when she discovered, as she later phrased it, "This is my world."[7]

And there are other important tales of western travel and migration. Arthur B. Davies, like so many other artists and writers of the time, recovered from tuberculosis in the West. Once healed he eventually returned, finding in California's Pacific Coast a new Arcadia, as if the West represented rebirth and the promise of pastoral harmony between nature and man.

The creation myth of the Taos Society of Artists, which flourished in New Mexico between 1915 and 1927, revolved around a road trip too, although this one concerned a now-infamous damaged wagon wheel. Joseph Henry Sharp, who had visited Taos in 1893, shared his memories of the visit with Ernest L. Blumenschein the following year while both were studying art in Paris. Four years later

Edward Hopper
Jo in Wyoming, 1946
Watercolor on paper, 13$^{15}$/$_{16}$ x 20
Whitney Museum of American Art,
Josephine N. Hopper Bequest, 70.1159

Maynard Dixon
Roadside, 1938
Oil on canvas, 30¼ x 40¼
Brigham Young University Museum of Art

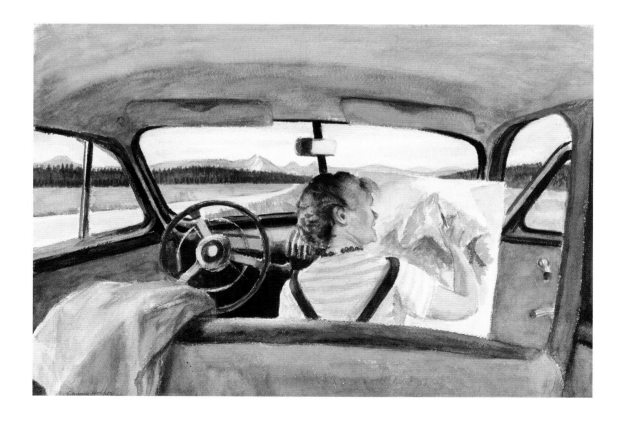

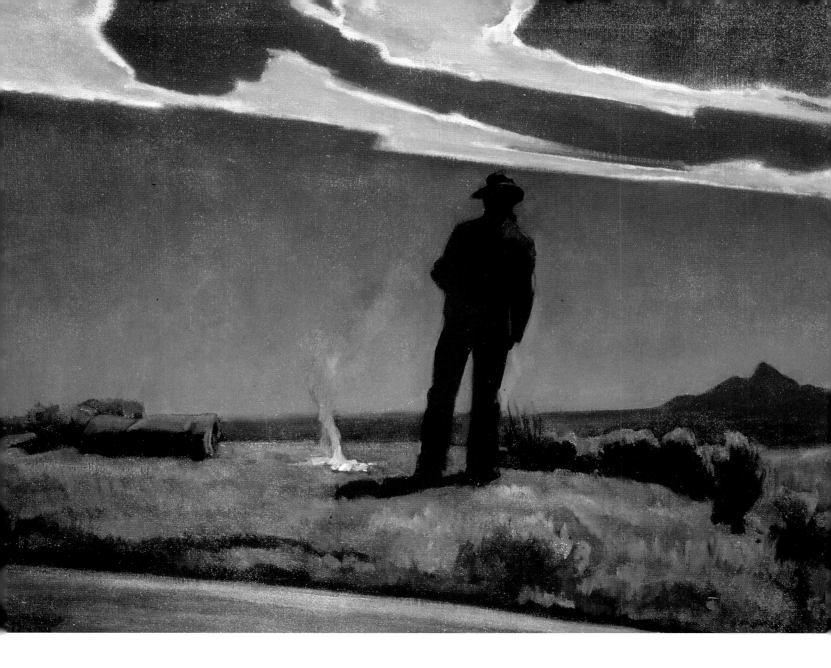

Blumenschein, traveling with his friend Bert Phillips, followed up on Sharp's earlier encouragement and visited Taos. The story goes that it was the broken wagon wheel that did it. Blumenschein went ahead to Taos to find a blacksmith who could repair the wheel, becoming more and more transfixed by the "sparkling and stimulating" landscape that he witnessed.[8] The two painters decided to stay. Phillips settled there and Blumenschein began spending his summers in Taos in 1910 and moved there permanently in 1919. Soon other artists arrived and, by 1915, the Taos Society of Artists was officially launched.

The cerebral Stuart Davis frankly complained of his western travel,

describing his brief trip to New Mexico in 1923 as nearly devoid of work. Riding around the area on a horse (he learned how to ride in New Mexico) and also a car or truck, he "did not do much work because the place itself was so interesting. I don't think you could do much work there except in a literal way. You always have to look at it."[9] Nonetheless, Davis's numerous letters and postcards show that his experience strengthened and clarified his artistic goals.

Edward Hopper, despite being seemingly untouched by his journey to Santa Fe in the 1930s, returned to the West in the 1940s to explore the region. Hopper's watercolor of his

wife Jo painting a Wyoming peak from the perspective of the front seat of their automobile captures the unique western experience, in which, as the artist observed, the only encounter with the vast landscape is from the vantage point of a railroad car or, as here, a car window. Hopper emphasizes the car itself and its domelike interior as an enabler of artistic activity. The coat thrown across the back of the driver's seat serves as surrogate for the artist, who clearly occupies the back seat.

In 1932, photographer Dorothea Lange and her husband, the painter Maynard Dixon, traveled from Taos back home to San Francisco. Their marriage continued to dissolve as they

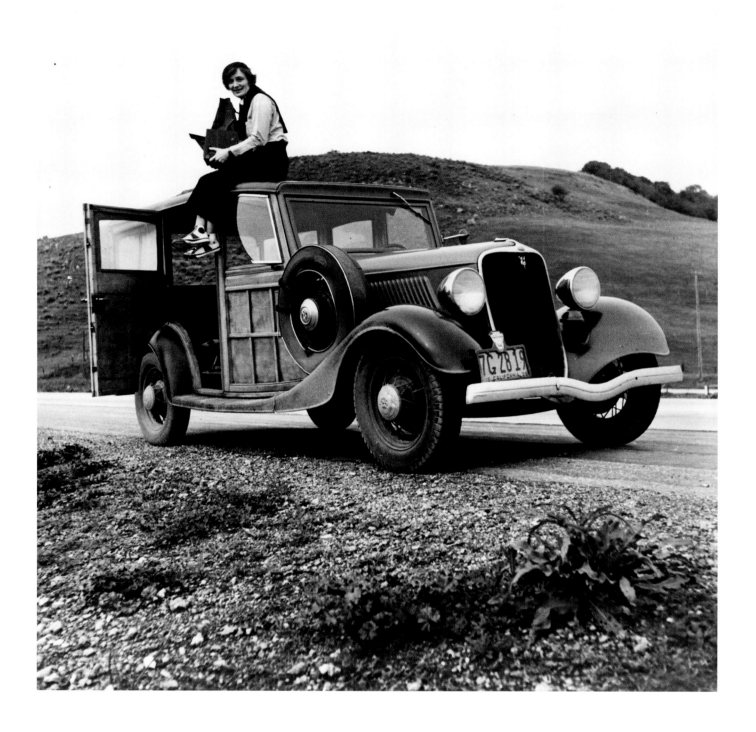

were confined to their automobile for days. Their experience, however, of an unending landscape dotted with homeless men walking along the highway with bundles on their backs changed their artistic paths; in Lange's case, forever. She turned from portrait to documentary photography, focusing on rural life during the Depression and in the process producing heartbreaking images now seared in American memory. Dixon, for his part, departed from his usual landscape subject matter and embarked on his "forgotten man" series of paintings that captured the social unrest and suffering of the Great Depression in order to take account of the deplorable working conditions he witnessed at Hoover Dam's Boulder City and the longshoremen strikes he observed at the Embarcadero in San Francisco. This artistic path had its origins along Route 66.

It is clear that these artists' experiences in the West required a recalibration of perspective—both atmospheric and personal. On one hand, artistic conventions thwarted the reality of western spaces—the raking light, crystalline air, and bold colors—and, on the other, the experience of traveling through or living in it was life-altering for those new to its capacity

to enthrall, to terrify, and, as writer D. H. Lawrence described it, to cause the observer "to attend."[10]

Among all of these roving American artists of the first half of the twentieth century, Thomas Hart Benton is unusual because he published his observations about regional life as he traveled across America. *An Artist in America* (1937) is based on Benton's travel by foot, horse, train, and car, as he made sketches for later use in the studio. Benton was fascinated by what he perceived as an innate American restlessness: "We cannot stay put. Our history is mainly one of migrations."[11] Benton dreamed of going places, and his first artworks were of trains. He described the train as a "symbol of adventurous life . . . it was the prime space cutter and therefore the great symbol of change." Indeed, he wrote, "As soon as I was able to get loose from my mother's skirts, I followed the boys of Neosho [Missouri] to the railroad station and watched with the yearning loafers of the town the evening passenger [train] roll in."[12]

Not surprisingly, trains occur with some frequency in Benton's art, including his 1926 painting *New Mexico*, which features a train racing across the desert toward the West in the painting's mid-ground. The landscape looks

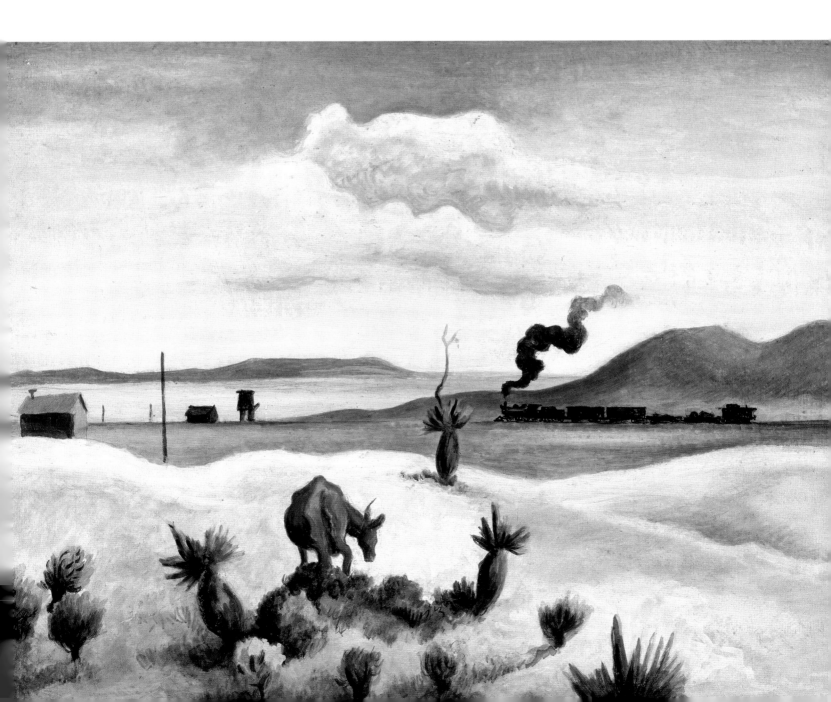

benign, even jolly or, at least, spirited. Benton includes a distant mesa and hills, foreground cactus and shrubs, a cow oblivious to the noise and action in the distance, and, finally, telegraph poles, a water tank, and a flowering yucca, which help to anchor the sun-baked landscape into place. Benton had observed that the "most substantial things in the little western towns are the grain elevators and water tanks by the sides of the railroads. These stick up and face the open land with the hard defiance of their utility."[13]

In *Kansas*, Content stresses pattern and horizontal movement without any suggestion of verticality, the photograph's abstract harmony suggesting a piece of music, an ode, or even a hymn. In *New Mexico Landscape*, Benton is more earthbound, finding verticality a defiant, perhaps necessary, feature of the open West. Indeed, Benton's description of vertical elements prefigures that of abstract expressionist painter Clyfford Still. Partly reared on the Alberta prairies of Canada, Still remembered the hardship of Dust

Bowl conditions on family land, where "man and . . . machines ripped a meager living from the topsoil . . . yet always and inevitably with the rising forms of the vertical necessity of life dominating the horizon."[14] Elsewhere he described this same phenomenon of verticality, "aspirational thrusts" or "life lines," like telegraph poles, grain elevators, water tanks, church steeples, or oil derricks, that, in insistently horizontal deserts and plains, rise above to provide a landmark or, literally, to give the viewer a sense of perspective. Without them, the landscape experience could disrupt spatial orientation, similar to what transfixes wanderers in the desert who become disoriented, lost, and even hallucinatory with the unending sameness. There is nothing nightmarish about Benton's landscape, yet there is in the work of his student Jackson Pollock, who, as Benton noted, followed his own "bumming trips across the country."[15] In Pollock's early work, Benton noted a "mystic strain" and commented on Pollock's "penchant for all the spooky mythology of the West."[16] This is

perhaps best played out in Pollock's *Going West*, a strange composition with estranged features—unhitched wagon, windmill, false-front building, odd landforms—that do not appear connected to one another but are enveloped by dark, murky swirls of paint in a vision of moonlight madness.

Benton did not care for the artists who flocked to 291, Stieglitz's avant-garde gallery on New York's Fifth Avenue. Benton had little patience for the "droning talk of the aesthetic soul probers."[17] Yet much of this professed dislike may have stemmed from his wavering self-esteem, which often manifested itself in bravado. He complained that "their cultivated sensibilities had always affected me adversely. When I got among them I felt as if I were down cellar with a lot of toadstools."[18] Among the group, however, John Marin stands out as one artist who might have appealed to Benton, not only for his congenial personality, impatience with theoretical art debate, and Yankee no-nonsense pragmatism, but also his interest in

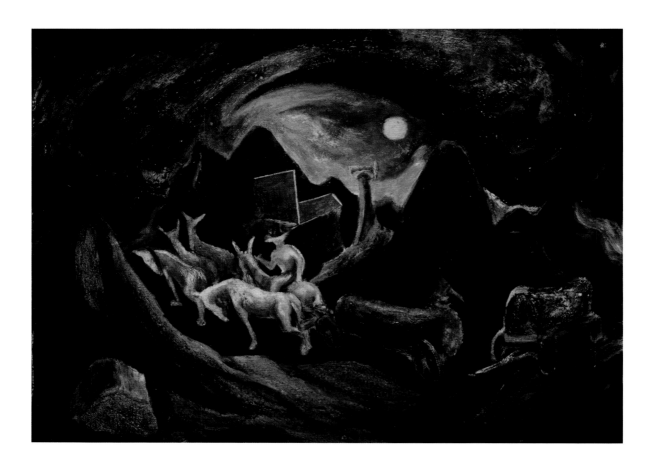

Jackson Pollock
Going West, 1934–35
Oil on fiberboard, 15½ x 20¾
Smithsonian American Art Museum, Washington,
D.C., Gift of Thomas Hart Benton, 1973.149.1
©2011 The Pollock-Krasner Foundation / Artists
Rights Society (ARS), New York

John Marin
Near Taos, No. 5, ca. 1930
Watercolor on paper, 12½ x 16½
Denver Art Museum, William Sr. and Dorothy
Harmsen Collection, 2001.453

travel, observation, and his thorough absorption of *place*, whether Maine, Austria, or Taos, where he traveled two consecutive summers in 1929 and 1930. Borrowing a car from the Taos doyenne Mabel Dodge Luhan, Marin toured the countryside and created what he called "maps," portraits of places that, for an artist long associated with abstraction, were, as his friend John Ward Lockwood noted, not very "abstract."[19]

Marin's first summer in Taos consisted of trout fishing its clear waters and capturing what he could of the remarkable landscape, which he in fact described as a "dogoned [*sic*] country."[20] A year later, by the summer of 1930, after having absorbed and come to terms with the landscape and its sensations, Marin began to produce watercolors of greater complexity. Still, as the scholar Van Deren Coke

discovered in his research on Marin in New Mexico, Marin's shimmering watercolors of New Mexico are remarkably place-specific, including the vibrating and skittering watercolor titled *Near Taos, No. 5*, which Coke described as a view from the "west end of Hondo Valley looking north [northwest of Taos, and just west of Arroyo Hondo]."[21]

Atypically for Marin, he included horses in this agricultural scene. A

John Ward Lockwood
Rain Across the Valley, 1932
Watercolor on paper, 14½ x 18½
Denver Art Museum, Gift of Ward Lockwood,
1959.61

rich fertile valley made up of irrigated plots of land, this area of New Mexico is, as Marin noted, "*horse* country."[22] Although Arroyo Hondo is in an area associated with Spanish villages, Pueblo culture is never far away in this hybridized environment of Pueblo, Spanish, and Anglo peoples. In fact, it is Pueblo traditions of farming and husbandry—mostly the tending of goats and sheep, as horses were not as needed—that distinguished Taos and other Pueblo cultures, as well as the Navajo, from the semi-nomadic tribes that had previously dominated the imagination of Americans. This

view, of course, changed with the early twentieth-century descent on the Southwest by tourism and science, and the artistic land rush to New Mexico where the landscape itself was modern, with its wide open spaces, sharp geological contours, vivid colors, and bracing air. In addition, in the search for a more authentic American art through the promotion of so-called primitive cultures—an essential aspect of American modernism—Anglo-European artists discovered and romanticized the harmony between man and nature symbolized by Pueblo culture and, specifically, agriculture,

in a world in which such fundamental relationships were perceived to be upset by a rapidly changing economy. City-weary artists seized on and promoted the way the land and the people had endured as a model for living. Drawn to similar motifs, Marin's good friend Lockwood echoed Marin in his watercolor of a more literal scene of horses set within plotted lands in Taos Valley, a scrim of thunderstorms in the distance stabilizing the verdant landscape.

Now more closely associated with the Transcendental Painting Group of the 1930s, Raymond Jonson's early

works of the 1920s in New Mexico are especially deserving of attention because they perfectly capture the near obsession with the question of what is "American" at the time. Chastised by a critic for his decision to leave Chicago, where he produced stage design and dramatic lighting, Jonson arrived in Santa Fe in 1922 and observed, "This place is as American as I found in Chicago. In truth, this is the site of the real American—the original one."[23] In other words, the unusual geology and landforms of New Mexico combined with its ancient cultures provided Jonson with the means to express both Americanness and modernity. In *Pueblo Series, Acoma*, thunderstorms punctuate the background but also create a curtainlike effect in the left foreground, revealing in the center a jagged monumental landform and distant adobe dwellings on a mesa. Rhythmic passages of dark shadow and bright sunlight pulsate in a canvas filled with the stylized shapes of clouds, mountains, and trees, and illuminated by nearly shocking colors of yellow and red complemented by blues, pinks, and purples. The foreground landform and the twelfth-century cliff dwellings of Acoma at distant right suggest a modern skyscraper dramatically lit by klieg lights. Jonson has successfully merged modern city life with the ancient American cultures that, in effect, produced the first "skyscrapers"—an anthropological bricolage that captures the twinned concerns of the period: what is modern and what is American?

Painter John Sloan is usually defined by his membership in The Eight, a group of moderately rebellious American artists who, in 1908, set up their own independent exhibition of paintings outside the traditional National Academy of Design. During this period Sloan was deeply interested in forceful brushwork and social realism—the realities of modern city life as experienced by poorer members of society. His political leanings were for a time socialist, but propaganda in art was not of interest to him. Innovative art was, and in 1913 Sloan helped organize the Armory Show, which famously introduced European modern art to the American public. Beginning in 1919, motoring with friends west, Sloan spent several months a year in Santa Fe for nearly thirty years. He entered into the community fully, participated in its parades and processions, and became an associate member of the Taos Society of Artists. A great and forceful crusader, Sloan championed contemporary Native American art, mounting in 1920 in New York among the first exhibitions of abstract watercolors by artists associated with San Ildefonso Pueblo. In 1931, Sloan organized and mounted the Exposition of Indian Tribal Arts at New York's Grand Central Art Galleries, yet another initiative to take Native American art beyond the confines of anthropology and ethnology and into a wider field of, simply, art.

Yet none of this crusading zeal, intense political feeling, and gritty realism is present in *Gateway to Cerrillos* (page 300). Perhaps mellowed by time—he would die at age eighty just five years later—Sloan painted this charming scene of a well-loved site as a southwestern pastoral. Two artists appear on opposite sides of the road. Presumably Sloan is at lower right before his easel and his second wife, Helen, is posed on a rock above. Their car is a short distance away from the main road that cuts through the Cerrillos Hills south of Santa Fe in an area associated with the "Old West" because of its frenzied nineteenth-century mining activities. This region of New Mexico is not like the cultivated valleys near Taos, but is arid, rugged, and bleached dry. Low mountains and hilly terrain assume peculiar forms. Gulches and arroyos share space with the ubiquitous junipers and piñons that dot the landscape. Yet Sloan's landscape is soft and mellow, and shares little with works by artists like O'Keeffe and Marsden Hartley, who sought a thorough, analytical understanding of the landscape in order to find its painterly equivalent. Instead, Sloan, using a light touch, fills the canvas with lush, sensuous color, creating something supple and pretty from a harsh and unforgiving environment. Unlike the Newark, New Jersey, gas station attendant Benton encountered in the drive from Albuquerque to Gallup, who claimed that in this country "there ain't a damn thing to see," Sloan provides a reassuring promise that there is not only something to see, but also to love.[24]

Much of the research used in this essay is drawn from my exhibition catalog The Modern West: American Landscapes, 1890–1950 (New Haven and London: Yale University Press in association with the Museum of Fine Arts, Houston, 2006). I would like to thank Ashleigh Holloway for her helpful comments.

Notes

1 Quoted in Augusta Fink, *I—Mary: A Biography of Mary Austin* (Tucson: University of Arizona Press, 1983), 195.

2 Willa Cather, *O Pioneers!* (1913; reprint, New York: Vintage Classics, 1992), 8.

3 Frederic Remington used the phrase in an unpublished essay titled "Taos," written in 1901 (Archives, Frederic Remington Art Museum, Ogdensburg, NY).

4 Georgia O'Keeffe used the phrase "faraway nearby" and its variants throughout her career, and also used it as the title for one of her paintings, *From the Faraway Nearby* (1937, Metropolitan Museum of Art, NY).

5 Georgia O'Keeffe to Anita Pollitzer, 11 September 1916, in Jack Cowart, Juan Hamilton, and Sarah Greenough, *Georgia O'Keeffe: Art and Letters*, exh. cat. (Washington, DC: National Gallery of Art; Boston: New York Graphic Society Books, 1987), 157.

6 Marjorie Content to Jean Toomer, 11 June 1934, James Weldon Johnson Collection, Yale Collection of American Literature, Beinecke Rare Book and Manuscript Library, Yale University, Toomer Papers (Box 8, folder 251).

7 Benita Eisler, *O'Keeffe and Stieglitz: An American Romance* (New York: Penguin Books, 1991), 451.

8 Laura M. Bickerstaff, *Pioneer Artists of Taos* (1955; revised and expanded ed., Denver: Old West Publishing Co., 1983), 31 and also 27.

9 James Johnson Sweeney, *Stuart Davis*, exh. cat. (New York: Museum of Modern Art, 1945), 15.

10 D. H. Lawrence, "New Mexico," *Survey Graphic*, May 1931, 152–55.

11 Thomas Hart Benton, *An Artist in America* (1937; reprint Columbia: University of Missouri Press, 1968), 65.

12 Ibid., 70–71.

13 Ibid., 205.

14 Quoted by David Anfam, " 'Of the Earth, the Damned, and of the Recreated': Aspects of Clyfford Still's Earlier Work," *Burlington Magazine* 135, no. 1,081 (April 1983): 260–69.

15 Benton, *An Artist in America*, 337.

16 Ibid., 338.

17 Ibid., 46.

18 Ibid., 48.

19 John Ward Lockwood quoted in Walter E. Stevens, "John Marin in New Mexico," *Southwestern Art* 2, no. 2 (March 1968): 12.

20 John Marin (1929) in *Selected Writings of John Marin*, ed. with an introduction by Dorothy Norman (New York: Pellegrini and Cudahy, 1949), 128.

21 Van Deren Coke, *Marin in New Mexico/1929 and 1930*, exh. cat. (Albuquerque: University Art Museum, University of New Mexico, 1968), 32.

22 John Marin to E. C. Zoler, 25 August 1929, in Coke, *Marin in New Mexico*, 32.

23 Samuel Putnam, "Lost: One America; Provincetown to Santa Fe," *Chicago Evening Post Magazine of the Art World*, 1926, quoted in Sharyn Rohlfsen Udall, *Modernist Painting in New Mexico 1913–1935* (Albuquerque: University of New Mexico Press, 1984), 101–2.

24 Benton, *An Artist in America*, 238.

Raymond Jonson
Pueblo Series, Acoma, 1927
Oil on canvas, 36½ x 43½
Denver Art Museum, William Sr. and Dorothy
Harmsen Collection, 2001.441

New Mexico Recollection #6

THE AMERICAN WEST IN A EUROPEAN METROPOLIS

HEATHER HOLE

New Mexico Recollection #6 is one of a series of southwestern landscapes painted in Europe by Marsden Hartley. Begun in Germany in 1923, the "New Mexico Recollections" series explores Hartley's memory of the bright desert landscape around Taos and Santa Fe and also reflects his experience of the urban spaces of post-war Berlin. In the Recollections, these two very different places come together to create a psychological and emotional landscape that reveals Hartley's disillusionment, his grief, and his fear.

Hartley's images of New Mexico were not always so somber. When he first traveled to the state in June of 1918, Hartley intended to cast off all outside artistic influences and form a new, modern style. He began recording the striking desert terrain in colorful and engaging pastel drawings. Highly representational and even optimistic in tone, these works represented a major stylistic shift for Hartley.

Earlier in the decade, Hartley had become a pioneer of modernist painting. He was one of a select group of artists associated with Alfred Stieglitz's 291 gallery in New York, which played a crucial role in introducing the United States to European modern art. In 1912 he traveled to Europe, and over the next three years participated in groundbreaking avant-garde artistic movements in both Paris and Berlin. He was living in Berlin when World War I broke out in 1914, and in that year produced what has become his best-known work, *Portrait of a German Officer*. This extraordinary memorial image uses abstract coded personal references to pay tribute to slain cavalry officer Karl von Freyburg, a man with whom Hartley was in love.

Hartley's decision to move to New Mexico at the end of the war and dedicate himself to recording its distinctive terrain represented a dramatic break from his earlier career. Yet Hartley never intended to devote himself to the naturalism of the early pastels indefinitely. Rather, he saw the works as a necessary step in the process of forming a new and original abstract style. This was the great advantage of New Mexico for Hartley: he saw it as a pristine and untouched landscape that could give rise to an equally unique form of art, if only the artist was willing to learn from it. As he put it:

There is nothing in conventional

esthetics that will express the red deposits, the mesas, and the Canyon of the Rio Grande . . . It is not a country of light on things. It is a country of things in light, therefore it is a country of form, with a new presentation of light as problem.[1]

Hartley's new aesthetic would be and must be American. His interest was not only in originality for its own sake; it was also in a national art independent of European influence. Based on what is arguably the most American of all subject matter, the landscape itself, such

a style would be firmly rooted in home soil. He wrote:

America extends the superb invitation to the American painter to be for once original. Originality does not lie in a something superimposed. It is a something understood. All originals are as they must be, natural products.[2]

The optimism of Hartley's early New Mexico pastels did not last. He struggled to translate his vision of the Southwest into oil, eventually leaving for New York in the fall of 1919, never

to return. Hartley continued to paint the New Mexico landscape from memory for about a year, producing several strong works in an increasingly abstract manner, including *Landscape, New Mexico* (1920). But by 1921 he had despaired of supporting himself as an artist in the United States and had entirely abandoned his New Mexico project. That spring, he sold off all the artworks still in his possession and used the proceeds to depart for Europe. By all appearances, he had given up on the idea of creating a unique and authentically American modern style.

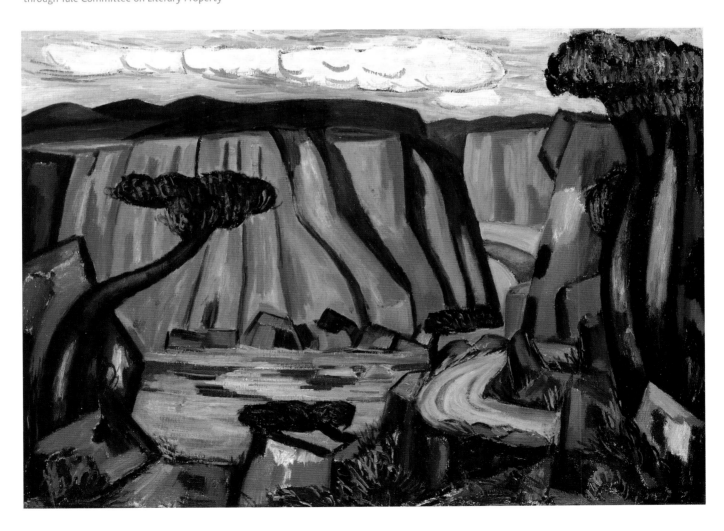

Yet only a few years later, during a period of introspection and solitude, Hartley began again to paint the landscape he had left behind. Today referred to as his New Mexico Recollections series, these pieces are far darker and more ruminative than the earlier works.[3] The series, of which *New Mexico Recollection #6* is a part, explores not New Mexico itself but the memories of New Mexico that lingered with Hartley. By extension, they brood over the nature of memory itself.

New Mexico Recollection #6, like the other Recollections, was shaped as much by Hartley's experience in Europe as in New Mexico. Hartley executed the series in two bursts of activity: the first in Berlin in 1923, and the second in Paris in 1924.[4] Though the painting is undated, stylistic elements including its brownish palette, dry brushwork, and blocky composition place *New Mexico Recollection #6* in the Berlin group.

Berlin was a city filled with memories and laden with significance for Hartley. It was there in 1913–15 that he had completed some of his most successful avant-garde work, and there that he had lost Karl von Freyburg. Hartley had not been back to Berlin since the war forced him to leave Germany in 1915, and when he returned in the fall of 1921 he experienced the city as a haunted place. In his letters he described Berlin as a "cemetery of despairs" comparable to an ancient ruin.[5] He wrote:

It all seems so foolish for any one coming to Berlin—for it is like—either as you knew it—or as I have known it—so like a new Pompeii in the mind—just a row of surviving cellar structures and a column or two to indicate the style of life.[6]

It is perhaps not surprising that this environment would lead him to work and rework the subject of memory in a sustained way.

Berlin also offered Hartley more immediate cultural and personal challenges. Germany after the war was full of political and social upheaval, and the city of Berlin had become a lightning rod for conservative German attack; it was viewed as "a loveless metropolis of

Marsden Hartley
Portrait of a German Officer, 1914
Oil on canvas, 68¼ x 41³/₈
The Metropolitan Museum of Art, New York, Alfred Stieglitz Collection, 1949, 49.70.42
Image ©The Metropolitan Museum of Art / Art Resource, New York. Permissions granted through Yale Committee on Literary Property

Marsden Hartley
Landscape, New Mexico, 1919–1920
Oil on canvas, 28 x 36
Whitney Museum of American Art, New York, purchase, with funds from Frances and Sydney Lewis, 77.23. Photo by Geoffrey Clements. Permissions granted through Yale Committee on Literary Property

left-wing intellectuals, pornography, and mass consumption."[7] Rapid oscillation between unheard-of social freedom and angry reaction against that freedom characterized this culture in flux. In 1923, rampant inflation wreaked havoc on the economy and destabilized the already shaky Weimar government. Hartley described this moment as one of enormous disparity between those who had access to funds in other currencies and those who did not, recalling, "it was they [foreigners] who ate all the caviar and pheasant, while the hungry Germans outside were peering in at the window."[8]

By 1923 Hartley had also weathered a long and difficult illness, during which he had glimpsed his own mortality.[9] Though he had initially participated enthusiastically in Berlin's active nightlife, by 1923 he was hiding himself away, "avoiding thereby the ab-norm or sub-norm of those who can only live from theatre to theatre or dance to dance—or even picture to picture."[10]

During this period of reflection and isolation, Hartley began to paint the New Mexico landscape again and again. In these images, forms and objects recur and disappear in a landscape removed from everyday experience. Many of the paintings explore similar compositions or subjects with subtle, yet crucial, variations, almost in the way that a recurring dream will include familiar elements slightly rearranged.

For example, *New Mexico Recollection #6* is one of several Recollections in which Hartley revisits the subject of a desert riverbed or arroyo. Likely inspired in part by his experience of the Rio Grande River, he first explored this subject in pastel in 1918, and continued to do so in oil in 1919 and 1920. In 1923, he produced paintings that re-imagined the riverbed in a darker palette. These include *New Mexico Recollection #6* and the closely related painting, *Landscape #5*. Both paintings show the same curving river canyon, with loosely painted rocks in the foreground and mesas in the middle distance. Yet where *Landscape #5* is grayish in tone and seems to show a river full of water, *New Mexico Recollection #6* is painted in browns and shows a drier streambed.

In these paintings, as in many of the Recollections, Hartley depicts two trees, one on either side of the composition. This is perhaps the most frequently repeated symbolic device in the series. In many paintings, the tree on the left is dead or injured, and the tree on the right is living, if bent or twisted. The two trees are usually separated by a chasm or gorge, and they often seem to reach toward each other. Both *New Mexico Recollection #6* and *Landscape #5* show trees in this configuration, though the left-hand tree in *Landscape #5* is broken while the corresponding tree in *New Mexico Recollection #6* is merely bending.

A more dramatic and emotionally charged example of this type of composition is *Landscape and Mountains*. The theme of yearning embedded in Hartley's symbolic pairs of trees is perhaps most explicit in this work. On the left side of this canvas is a shorter tree, seemingly cut off at mid-trunk. It is grouped with a stylized cow's skeleton, linking it to an image of death. On the right side of the arroyo, a taller and healthier tree has grown almost horizontally in an effort to reach across the central divide, though it has not succeeded. Hartley

Marsden Hartley

Landscape #5, ca. 1923

Oil on canvas, 23 x 35½

Image courtesy National Gallery of Art, Washington, D.C., Alfred Stieglitz Collection, 1922/1923 (1949.2.2). Permissions granted through Yale Committee on Literary Property

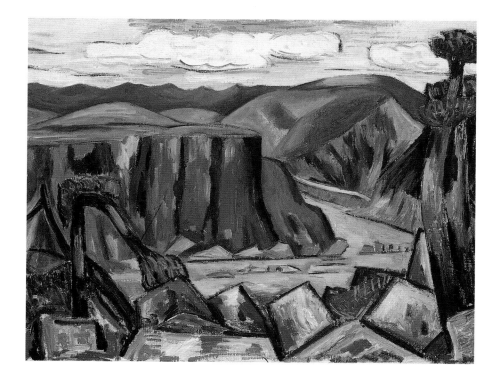

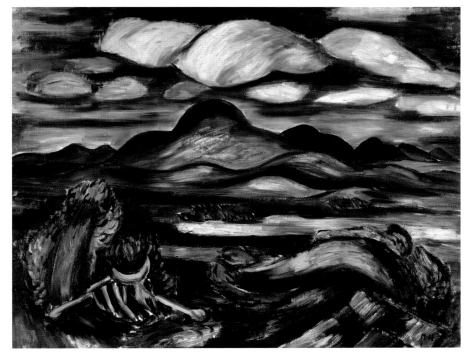

Marsden Hartley
Landscape and Mountains, ca. 1923
Oil on canvas, 25¾ x 31¾
Hirshhorn Museum and Sculpture Garden,
Smithsonian Institution, Gift of Joseph H.
Hirshhorn, 1966. Photography by Lee Stalsworth,
66.2372. Permissions granted through Yale
Committee on Literary Property

has inscribed his initials at the base of that tree, linking it to himself. Given that Hartley was in Berlin and almost certainly remembering his experiences with von Freyburg, the image of a living thing attempting to reach across an unbridgeable divide toward a dead one is especially poignant. This painting, and to some extent all of the Recollections, seems to meditate on loss and grief.

In addition to their more personal themes, Hartley's New Mexico Recollections also explore his concerns about American artistic and national identity. Hartley's depictions of New Mexico had been explicitly connected to his desire to create an authentic American modernism from the beginning. Yet, the Recollections are among the most difficult and tortured depictions of an American landscape painted in this period. They speak not only to his private losses, but also to his realization that creating a new American modernism free from any European influence was impossible, at least for him.

The Recollections, including *New Mexico Recollection #6*, both explore Hartley's memories of the southwestern landscape and express the sadness and loss he experienced in Europe. Hartley's New Mexico project was the first in a series of efforts undertaken by American artists after World War I to create a new style that was both recognizably homegrown and equal to anything Europe had to offer. But while modernists would continue to search for an American aesthetic in the southwestern landscape for decades to come, by 1924 Hartley had realized he would not be the one to find it.

Notes

1 Marsden Hartley, "Aesthetic Sincerity," *El Palacio* 5, no. 20 (December 9, 1918): 332.

2 Hartley, "Aesthetic Sincerity," 332–33.

3 The name commonly used for this series, "New Mexico Recollections," comes from Hartley's own description of the paintings as "New Mexican landscape recollections" in an April 28, 1923 letter to Alfred Stieglitz. The numbers in many titles first appear, and were almost certainly assigned, during the inventory of Hartley's estate after his death. When Stieglitz first exhibited Hartley's Recollections in March of 1925, his twenty-five works were not individually titled, but appeared in the catalog as "Landscape and Still-Life (These canvases are part of the work resulting from the historic Hartley Auction, held in The Anderson Galleries, May, 1921)." See *Alfred Stieglitz Presents Seven Americans,* ed. Alfred Stieglitz (New York: The Anderson Galleries, 1925).

4 See Marsden Hartley to Alfred Stieglitz, 17 July 1923 and Marsden Hartley to Alfred Stieglitz, 18 December 1924. Alfred Stieglitz/ Georgia O'Keeffe Archive, Beinecke Library, Yale University (hereafter, Stieglitz/O'Keeffe Archive, Yale).

5 Marsden Hartley to Alfred Stieglitz, 23 May 1923. Stieglitz/O'Keeffe Archive, Yale.

6 Marsden Hartley to Alfred Stieglitz, 17 July 1923. Stieglitz/O'Keeffe Archive, Yale.

7 Jeffrey Herf, *Reactionary Modernism: Technology, Culture, and Politics in Weimar and the Third Reich* (Cambridge: Cambridge University Press, 1984), 35.

8 Marsden Hartley, *Somehow a Past: The Autobiography of Marsden Hartley,* ed. Susan Elizabeth Ryan (Cambridge, MA: MIT Press, 1995), 107.

9 Hartley had contracted syphilis, and endured a series of arsenic treatments as a result. Marsden Hartley to Alfred Stieglitz, 1 March 1923. Stieglitz/O'Keeffe Archive, Yale.

10 Marsden Hartley to Alfred Stieglitz, 17 July 1923. Stieglitz/O'Keeffe Archive, Yale.

【 121 】

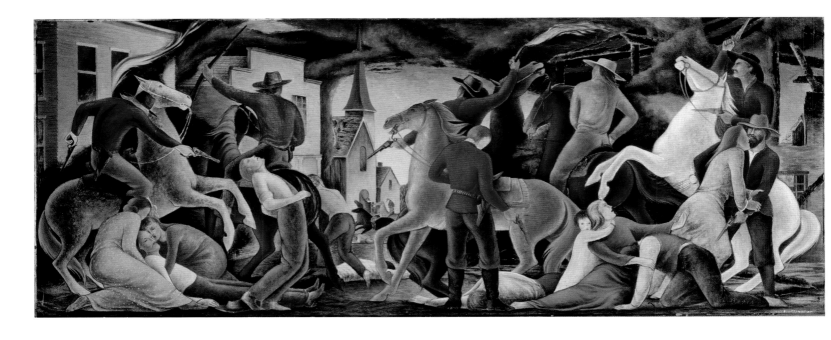

Colorado Painters and Printmakers

BETWEEN THE WARS (1918–1941)

HUGH GRANT

One hundred years before the time frame covered in this essay, the first professional artist to portray America's West, including Colorado, visited the state. The 1819–20 government expedition of Major Stephen Long brought painter Samuel Seymour along. Other artists such as Albert Bierstadt, George Caleb Bingham, Thomas Moran, and T. Worthington Whittredge recorded the beautiful scenery of the Rocky Mountains for patrons in the East. The Pikes Peak Gold Rush in 1858 brought many people into the area, including artists. The accomplished painter John Howland came to Colorado in 1859.

He prospected for gold, painted many works, and stayed. By 1886, the state of Colorado was ten years old and distinguished artists including Charles Partridge Adams, William Bancroft, Helen Henderson Chain, Joseph Hitchins, Richard Tallant, and Harvey Otis Young had established studios. The Artists' Club of Denver, forerunner of the Denver Art Museum, was founded in 1893.

This essay covers the rich artistic history of Boulder, Colorado Springs, and Denver between roughly the end of World War I and the beginning of World War II. Artistic endeavors elsewhere in the state also deserve recognition and scholarship, as do more diverse media such as sculpture and design. I have focused instead on the founding of important schools and groups from the Broadmoor Art Academy, established in 1919, to the emergence

of surrealism and abstraction, culminating in the founding of the modernist group "15 Colorado Artists" in 1948. From the initial inspiration of Colorado's beautiful mountain peaks to more adventurous art forms that characterized the 1940s onward, Colorado art has much to offer the nation.

Denver Armory Show

ART IN COLORADO between the wars was symbolically heralded by a controversial landmark show, the *Twenty-fifth Annual Exhibition of the Denver Art Association*, held in 1919 at the Denver Public Library. Notoriously nicknamed the "Denver Armory Show," a reference to the 1913 New York Armory Show that shocked America, the exhibition provoked strong

reaction from the press and the public by including works in the impressionist, fauvist, and restrained cubist styles. To our eyes today the paintings in the show do not look particularly adventurous. But at that time the headlines in the *Rocky Mountain News* blared "Bolshevism in Art" (April 17, 1919) and "Library Art Exhibit Called 'Fraud' and 'Monstrosity' by Two Writers" (April 20, 1919).

Denver painter and educator Henry Read was one of those writers (despite the fact that he, too, had work in the exhibition), declaring: "Indeed, one might be pardoned for thinking that by accident the rejected instead of the accepted pictures had found their way to the walls of the gallery . . . modernism is responsible for the eccentricities of the collection."[1] Some of the artists in the exhibition, in addition to Read, were Jozef Bakos, George Elbert Burr,

Emma Richardson Cherry, Walter Mruk, Albert Olson, Robert Reid, Francis Drexel Smith, Elisabeth Spalding, Margaret Tee, and John Thompson, all from Denver, plus Gustave Baumann, William Penhallow Henderson, and B. J. O. Nordfeldt from Santa Fe and Bert Phillips from Taos.

Modernism Continues

JOHN THOMPSON (1882–1945) was the first modernist artist in Colorado, though his later works became more stylistically conservative. Born in Buffalo, New York, he studied in New York City and then in Europe from 1902 until the beginning of World War I, where he saw the Paul Cézanne retrospective in Paris in 1907. He initially came to Colorado in 1914, returning permanently in 1917. Jozef

(also spelled "Josef" or "Joseph") Bakos (1891–1977) had been Thompson's student in Buffalo and followed him to Colorado. Bakos began teaching at the School of Art of the University of Colorado in Boulder in 1919. In 1921 Bakos and Walter Mruk—both in the Denver Armory Show—along with Fremont Ellis, Willard Nash, and Will Schuster, formed Santa Fe's first modernist art group, *Los Cinco Pintores* ("The Five Painters"). They were popularly known as "the five nuts in adobe huts."[2] Nash later taught at the Broadmoor Art Academy in Colorado Springs during the summer of 1931, and Bakos at the University of Denver from 1932 to 1934.

New York impressionist Robert Alexander Graham (1873–1949) relocated to Denver in 1920. Both Graham and Thompson taught Frank Vavra (1892–1967), an exceptional

impressionist beginning in the 1920s before he turned to an abstractionist style in the late 1940s. Vavra met Kathleen Huffman (1906–84), an accomplished watercolorist, at the Denver Art Academy in 1924, where they were both enrolled. Both Frank and Kathleen knew a good thing when they saw it, and they were married on December 24, 1924, at Denver's swank Hotel Metropole.

Another painter in Colorado between the wars was Elisabeth Spalding (1868–1954), one of the original founders in 1893 of the Artists' Club of Denver. Although primarily known for her impressionist watercolors, in the late 1920s she turned to adventurous, expressionist brushstrokes for her watercolor landscapes.

its school in the early 1960s. Some of the faculty, including Chenoweth, then began the Department of Art at Colorado College in Colorado Springs. The Academy's famous teachers included Lawrence Barrett, George Biddle, Arnold Blanch, Edgar Britton, John Carlson, Adolf Dehn, Otis Dozier, Laura Gilpin, Yasuo Kuniyoshi, Ernest Lawson, Charles Wheeler Locke, Frank Mechau, Robert Motherwell, Henry Varnum Poor, Robert Reid, Boardman Robinson, and Birger Sandzén. Among its many students at various times were Eric Bransby, Mary Ann Bransby, Charles Bunnell, Eduardo Chavez, Ken Goehring, Ethel and Jenne Magafan, Peppino Mangravite, Edward and Donna Marecak, Jackson Pollock, Francis Drexel Smith, Lew Tilley,

and Al Wynne, all of whom became accomplished artists.[3]

Robert Reid (1862–1929) and John Carlson (1875–1947) were the Broadmoor Art Academy's first two instructors. Reid taught there during the summers of 1920 to 1927; Carlson in the summers of 1920 to 1922. In May 1933, George Biddle wrote to his Groton School classmate, President Franklin Roosevelt, suggesting a federal program to employ artists, which resulted in the Works Progress Administration (WPA), with other programs to follow, that paid artists to do murals and other public art works. Biddle subsequently taught at the Colorado Springs Fine Arts Center from September 1936 through May 1937. During the 1930s and early 1940s more than twenty-five Colorado

Broadmoor & the WPA

IN 1919, the Broadmoor Art Academy was founded in Colorado Springs, evolving into the Colorado Springs Fine Arts Center in 1935. The art colony in Colorado Springs became a major force in art instruction and national art activity, somewhat overshadowing Denver until the mid-1940s. The Center's influence then began to wane because it did not encourage abstraction and was not attached to a degree-granting academic institution. Although a few of the teachers, such as Jean Charlot, Mary Chenoweth, and Emerson Woelffer, were open to modernism by the late 1940s and 1950s, the Center closed

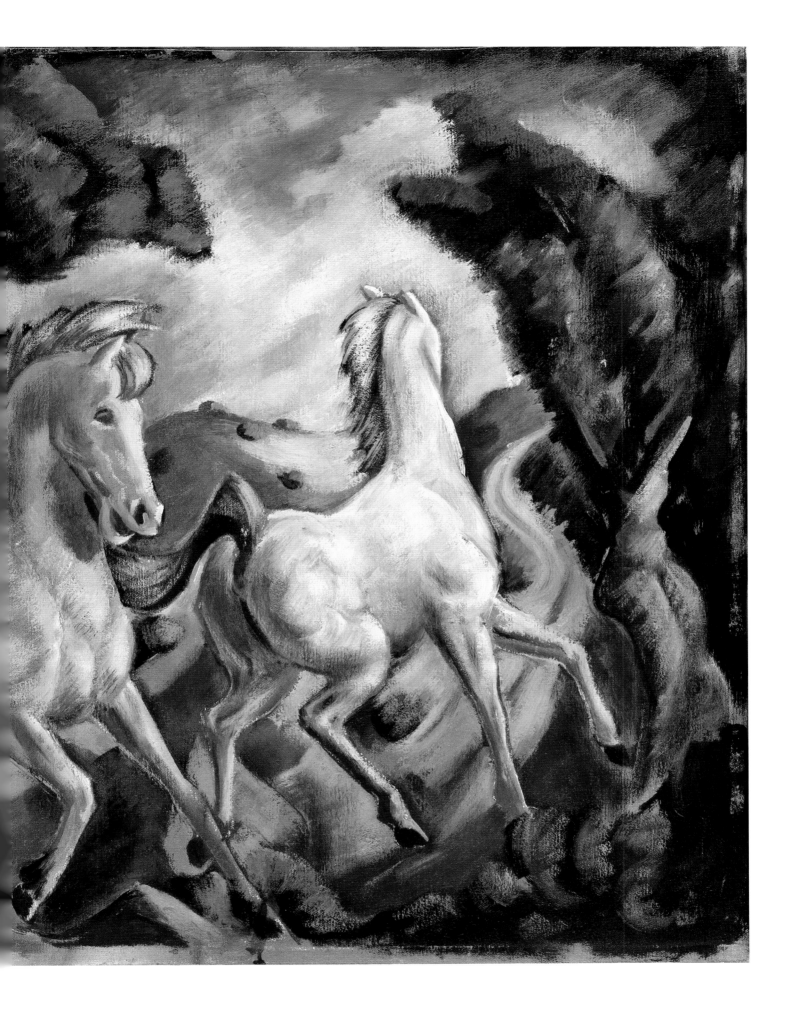

artists produced murals and sculptures for American public buildings, mostly under federal government programs for which they received commissions through national juried competitions—an indication of the talent and depth of the fine artists in Colorado.

Colorado has had a particularly important history of printmaking. In the summer of 1936, Charles Locke (1899–1983) was the principal teacher of Lawrence Barrett (1897–1973) at the Colorado Springs Fine Arts Center. Barrett became a master lithographer and etcher, attracting many students to Colorado to study with him. He taught lithography and etching at the Fine Arts Center and did virtually all of the printing there from the fall of 1936 to 1952.[4] In this capacity he collaborated in

printmaking with many notable artists including Herbert Bayer, George Biddle, Arnold Blanch, Randall Davey, Adolf Dehn, Doris Lee, Peppino Mangravite, Edward Marecak, and Boardman Robinson. Dehn was a critic in lithography at the Fine Arts Center for the summer of 1940 and taught there for the next two summers.

Jackson Pollock (1912–56) studied at the Colorado Springs Fine Arts Center in 1937, particularly lithography with Barrett. Painter Archie Musick (1902–78) wrote the following story about Pollock in his book *Musick Medley*:

> Five of us decided to make a killing with a limited edition folio of lithographs. The five were: Guy Maccoy, Joseph Meert, Bernard

Steffen, Jackson Pollock and Archie Musick . . . At the time of which I write Pollock was a nobody like the rest of us. His hay-pitching scene for the folio was neither better nor worse than our offerings . . . Yet it was Pollock who was to streak across the sky like a comet, pioneering the school of abstract-expressionism while remaining steadfastly loyal to [Thomas Hart] Benton . . . The folio was a flop.[5]

In 2010, the Denver Art Museum, through curator Thomas Smith, laudably acquired this Pollock lithograph, now called *Stacking Hay*, though it is titled *Harvest* in Musick's book.[6]

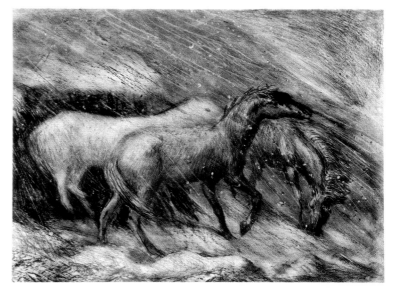

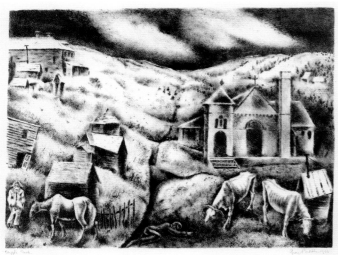

Top right: Lawrence Barrett
Rain and Snow, early 1940s
Lithograph, 8¼ x 10⅝
Collection of Kirkland Museum
of Fine & Decorative Art, Denver

Bottom left: George Biddle
Cripple Creek, 1936
Lithograph, 16 x 20
Collection of Kirkland Museum
of Fine & Decorative Art, Denver

Bottom right: Jackson Pollock
Stacking Hay, ca. 1935
Lithograph, 9¼ x 12¼
Denver Art Museum, Funds from the William
Sr. and Dorothy Harmsen Collection, by
exchange, 2010.393. ©2011 The Pollock-Krasner
Foundation / Artists Rights Society (ARS),
New York

Regionalism

REGIONALISM, also known as American Scene Painting, was a consequence of the search for a truly American art form. Ongoing since the late 1800s, this quest had already given the world American impressionism and the Ashcan school, as well as American modernism and abstraction starting in the 1910s. All these movements had roots in European styles, although the greatest American artists made important contributions. Regional paintings, however, portrayed American subjects with an entirely American approach. They are stylized to the extent that they are not realism or impressionism, but they are still representational and not abstract. They comprise a kind of "modernist regional" style. Excellent examples of regionalism done in Colorado include works by Jozef Bakos, George Biddle, Adolf Dehn, Eve Drewelowe, Nadine Kent Drummond, the Magafan sisters, Frank Mechau, Boardman Robinson, Louise Emerson Ronnebeck,[7] and Elisabeth Spalding. Even though John

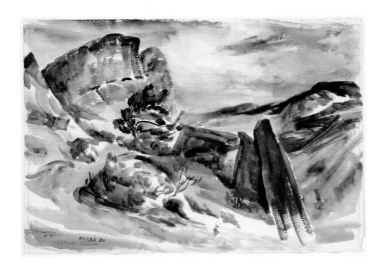

Top left: Joseph G. Bakos
Part of the Red Rocks, 1933
Watercolor on paper, 15 x 21
Denver Art Museum, Gift of the W.P.A., 1934.8

Top right: Adolf Dehn
Farm Yard, 1934
Lithograph, 12¾ x 17⁵/₈
Denver Art Museum, Funds from the William D.
Hewit Charitable Annuity Trust, 1985.302

Facing top: Jenne Magafan
Evening Light, late 1930s
Oil on panel, 15 x 20
Collection of Kirkland Museum
of Fine & Decorative Art, Denver

Bottom left: Eve Drewelowe
The Farmhouse, late 1930s
Watercolor on paper, 20½ x 28½
Collection of Kirkland Museum
of Fine & Decorative Art, Denver

Bottom right: Nadine Kent Drummond
Pueblo Street Scene, ca. 1940
Watercolor on paper, 13¾ x 19
Collection of Kirkland Museum
of Fine & Decorative Art, Denver

Facing bottom: Frank Mechau
Wild Horses (six panels), 1936
Tempera on plywood, 45¾ x 102
Denver Art Museum, Gift of Mrs. Frank Mechau,
1972.27F

Carlson's painting *The Onrush* dates to about 1920 and Birger Sandzén's *Moonrise in the Mountains* along with Charles Bunnell's *Untitled (Colorado Springs Area)* to 1928, regionalism was not confined to the 1930s, just as it was not confined to the Midwest, and these works qualify as distinguished regionalism. In 1951 Paul K. Smith was still painting in his distinctive regionalist style, which he began in the early 1940s. Smith also began doing abstractions in the 1940s and kept producing in both these styles for the rest of his life. On the other hand, once Frank Vavra turned to abstraction he stopped doing his more traditional paintings. Starting in the 1940s, regionalism became largely displaced by abstract art and, to a lesser extent, surrealism.

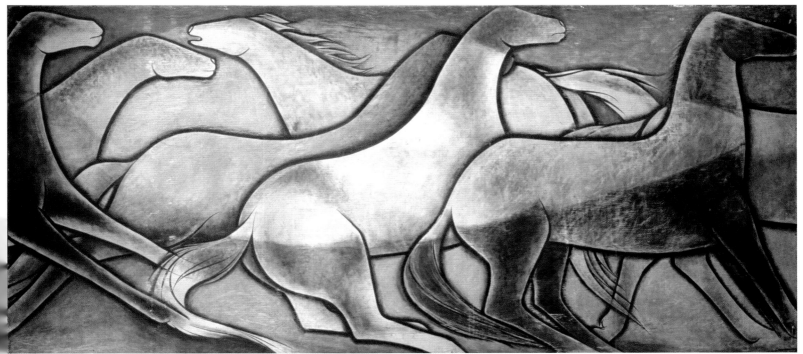

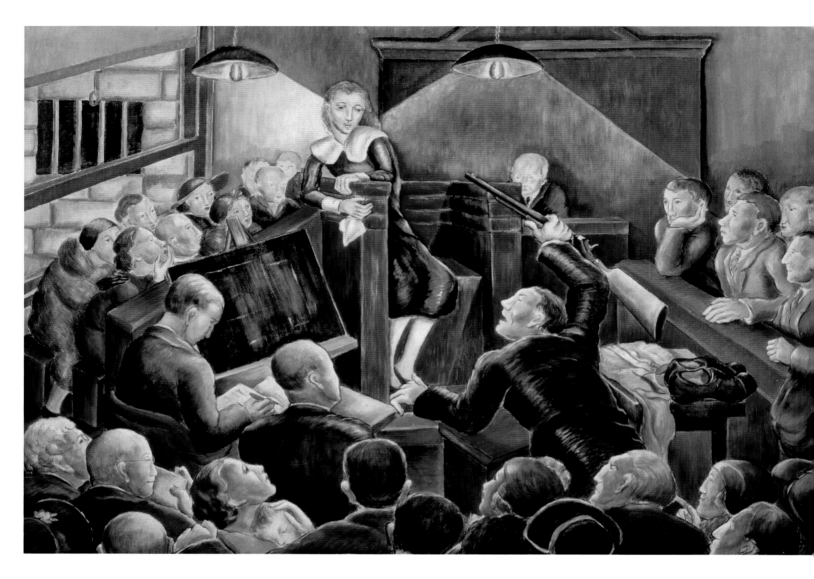

Top: Louise Emerson Ronnebeck
The People vs. Mary Elizabeth Smith, 1936
Oil on canvas, 34 x 50
Collection of Bruce and Jaren Ducker, Denver

Left: Boardman Robinson
Opera House, Central City, 1933
Lithograph, 13¼ x 7
Collection of Kirkland Museum
of Fine & Decorative Art, Denver

Facing top: Elisabeth Spalding
Central City of July, 1922, 1938
Oil on board, 30 x 34
Collection of Kirkland Museum of Fine &
Decorative Art, Denver

Facing bottom: John F. Carlson
The Onrush, Pikes Peak, 1920
Oil on canvas board, 12 x 16
Collection of Julie and Robert Lewis, Denver

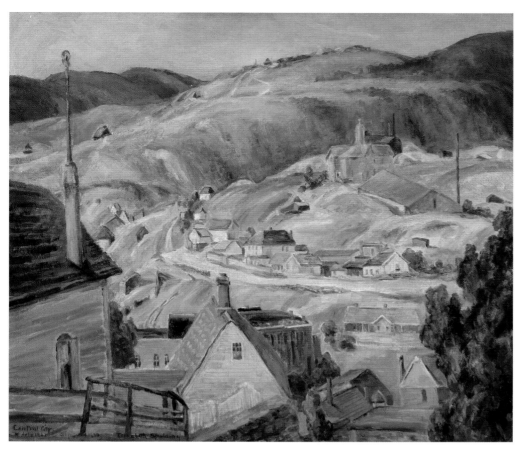

Facing top: Birger Sandzén

Moonrise in the Mountains, Rocky Mountain

National Park, Colorado, 1928

Oil on canvas, 20 x 24

Collection of Julie and Robert Lewis, Denver

Facing bottom: Charles Ragland Bunnell

Untitled (Gold Ore Mills near old Colorado City),

1928

Oil on canvas, 20 x 24

Collection of Kirkland Museum of Fine &

Decorative Art, Denver

Paul K. Smith

Houses in Victor, 1951

Oil on canvas, 30 x 40

Denver Art Museum, museum purchase

for Anne Evans Collection, 1951.33

Early Art Groups in Boulder

Eve Drewelowe (1899–1988), who would become a Colorado modernist painter, received the first graduate degree in fine arts from the University of Iowa in 1924.[8] Shortly thereafter she and her husband, Jacob Van Ek, moved to Boulder where he had been offered a teaching position at the University of Colorado. Drewelowe and others helped found the Boulder Artists' Guild by 1926 and she exibited there from 1926 to 1946. The Boulder Artists' Guild seems to have dispersed in the late 1940s, but another group, the Boulder Art Association, founded in 1923, continues today.

In the summer of 1931, five painters formed a group, calling themselves "The Prospectors": Muriel Sibell (later Wolle), Gwendolyn Meux (Mrs. A. Gayle Waldrop), Virginia True, F. C. (Frederick Clement) Trucksess, and Frances Hoar (Mrs. F. C. Trucksess). They were all members of the fine arts faculty of the University of Colorado as well as members of the Boulder Artists' Guild. Additionally, Virginia True was a trustee and exhibition chairman of the Boulder Art Association. From 1931 to 1941, the Prospectors showed their work in twenty-two states.[9]

Muriel Sibell Wolle (1898–1977) notably documented the ghost towns of Colorado and the West with her accomplished paintings in watercolor and drawings in lithographic crayon. These were published with her commentary in at least six books and pamphlets. She taught in the

Art Department at the University of Colorado from 1926 to her retirement in 1966 and served as department head from 1928 to 1949.

Denver Artists Guild

IN 1928, fifty-two charter members of the newly established Denver Artists Guild participated in its inaugural exhibition. (The three longest-active fine art organizations in Colorado are the Guild;[10] the Denver Art Museum, which traces its origin to the Artists' Club of Denver in 1893; and the Boulder Art Association, founded in 1923.) Founding members of the Guild included Donald Bear, Clarence Durham, Laura Gilpin, Robert Graham, Elsie Haddon Haynes, Vance Kirkland, Albert Olson, Arnold Rönnebeck, Francis Drexel Smith, Elisabeth Spalding, David Spivak, Margaret Tee, John Thompson, Allen Tupper True, and Frank Vavra.

In 1948, the Guild was fractured, but continued to operate, when some of its more modern artists broke away and participated in a rival exhibition at the Denver Art Museum—at the same time and across the hall from the Guild's annual exhibition. This controversy recalls the earlier heated debate touched off by the 1919 Denver Armory Show about the validity of modernism. Denver exemplified the widespread disputes about abstraction superseding traditional painting that occured in America during the 1920s, then regionalism holding sway over abstraction in the 1930s, and the dominance of modern art forms established in the 1940s. The Denver Artists Guild's 1948 schism was a seminal moment in Colorado art history, when the moderns formally broke with the traditionalists. The progressive group, calling themselves "15 Colorado Artists" (ten of whom taught at the University of Denver), were

Elsie Haddon Haynes
Untitled (St. Thomas Seminary, Denver), ca. 1926
Pastel on paper, 14 x 22
Collection of Kirkland Museum of Fine & Decorative Art, Denver

Allen Tupper True
A Wanderlust Memory, ca. 1912
Oil on canvas, 36¾ x 36⅞
Denver Art Museum, Funds from Helen Dill bequest, 1936.2

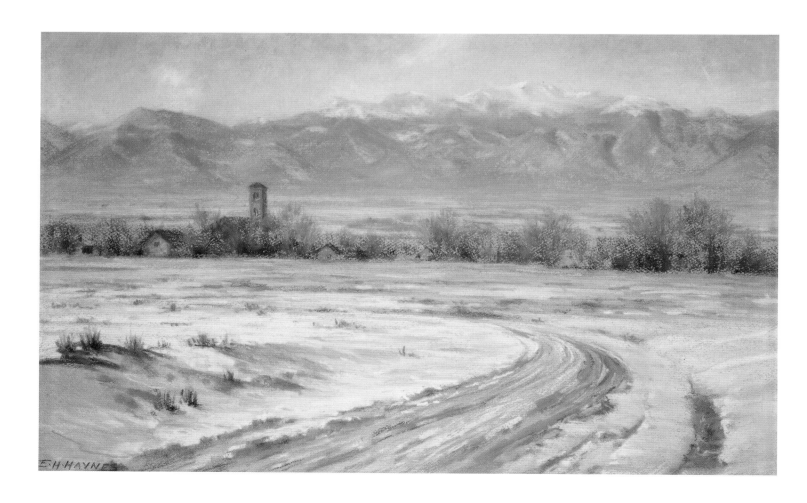

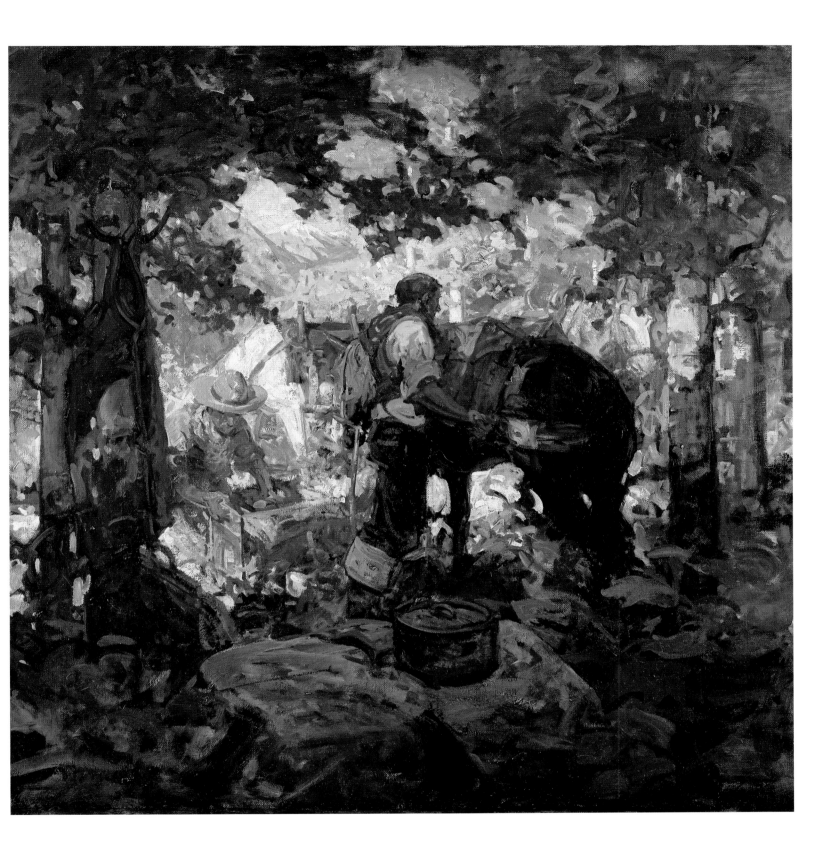

Don F. Allen, John Billmyer, Marion Buchan, Jean Charlot, Mina Conant, Angelo di Benedetto, Eo Kirchner, Vance Kirkland, Moritz Krieg, Duard Marshall, Louise Emerson Ronnebeck, William Sanderson, Paul K. Smith, J. Richard Sorby, and Frank Vavra. At this time, Charlot was head of the Colorado Springs Fine Arts Center art school (1947–49) and Kirkland was director of the University of Denver School of Art (1929–32, 1946–69).

When Arnold Rönnebeck (1885–1947) became a founding member of the Denver Artists Guild in 1928, he was director of the Denver Art Museum (a position he held from 1926 to 1930). He is principally known for his lithographs and metal sculpture, such as a bronze bust of Anne Evans (1871–1941). A painter herself, Evans was the daughter of Colorado territorial governor John Evans and one of the thirteen founders of the Artists' Club of Denver in 1893.

The University of Denver

THE CHAPPELL SCHOOL of Art operated at Thirteenth Avenue and Logan Street in Denver from 1924 to 1928 with H. A. W. (Jack) Manard as its founding director. The University of Denver then purchased the Chappell School with a grant from the Carnegie Foundation and hired Ohio painter Vance Kirkland (1904–81), who at age twenty-four became the founding director of the present University of Denver School of Art, which opened on January 3, 1929. With the faculty that he both built and inherited from the former Chappell School, he encouraged modern art forms and effected a shift of the state's art center from Colorado Springs to Denver in the mid-1940s.

In 1932, as Kirkland's senior students approached graduation, the university refused to give credit for art courses toward degrees. Kirkland resigned and began the Kirkland School

Vance Kirkland
Mountain Ruins, 1932
Watercolor on paper, 14⅝ x 19⅞
Denver Art Museum, Gift of Vance H. and Anne O. Kirkland, 1982.371

Arnold Rönnebeck
Bust Portrait of Anne Evans, 1932
Bronze, 17½ x 16½
Denver Art Museum, Presented by Friends of Miss Anne Evans, 1932.12

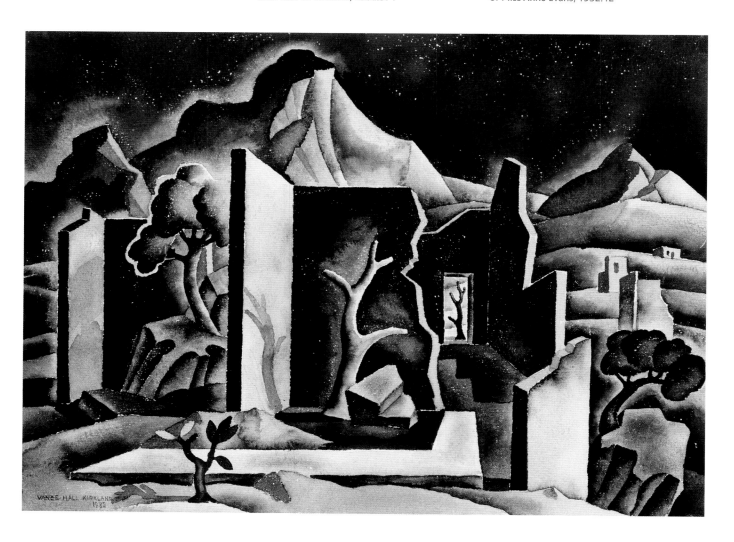

of Art in Henry Read's old art school building two blocks east of Chappell House (now Kirkland Museum of Fine & Decorative Art). By 1933 Kirkland had an agreement with the University of Colorado "Denver extension" (UCD) that his students could get credit there toward graduation for their art courses. He thereby also founded the UCD art department and initiated its art program.

In 1946, when Kirkland had more than two hundred students, the University of Denver hired him back with a salary equal to the chancellor's. Over the years Kirkland's faculty included three directors of the Denver Art Museum who were also very fine artists: Arnold Rönnebeck (director 1926–30), Donald Bear (director 1934–40), and Otto Bach (director 1944–74). Many other important artists taught under Kirkland including Julio de Diego, Roger Kotoske, Barbara Locketz, Robert Mangold, Frank Mechau, Anne Van Briggle Ritter, Beverly Rosen, William Sanderson, Margaret Tee, John Thompson, Maynard Tischler, and Frank Vavra.

Kirkland did paintings of "designed realism" from 1926 to 1944, surrealism from 1939 to 1954, and began to move into abstraction in 1947. In 1953 he would invent his mixtures of oil paint and water, which gave his paintings surfaces unlike those of any other abstract expressionist. He started his unique dot paintings in 1963—well past the period covered by this essay, but an evolution in style that had its roots in his formative years as a Colorado artist.

This very brief history of Colorado art only begins to suggest how many significant works were created during the roughly twenty years between the twentieth century's two world wars. Other artists would arrive later, such as German Bauhaus master Herbert Bayer (1900–85), who came in 1945 and stayed nearly thirty years in Aspen. But during a span of time that saw both Prohibition and the Great Depression, Colorado artists made important contributions not only to Colorado and the West, but to America's art history.

Notes

1 "Library Art Exhibit Called 'Fraud' and 'Monstrosity' by Two Writers," *Rocky Mountain News*, April 20, 1919. This headline included two articles, "Modernist Offering Draws Ire of Visitors," by Henry Read and "Want City to Put Ban Upon All Such 'Outrages'," by Horace Simms.

2 See, for example, Dorothy Harmsen, *American Western Art: a Collection of One Hundred Twenty-five Western Paintings and Sculpture with Biographies of the Artists*, (Denver: Harmsen Publishing Co., 1977), 8, 150; also, Frederick Ellis (son of Fremont Ellis) obituary in the *Santa Fe New Mexican*, March 8, 2011.

3 For illustrations of some of these teachers' and students' works see Stanley L. Cuba and Elizabeth Cunningham, *Pikes Peak Vision: The Broadmoor Art Academy, 1919–1945*, exh. cat. (Colorado Springs: Colorado Springs Fine Arts Center, 1989); and Robert L. Shalkop, *A Show of Color—100 Years of Painting in the Pike's Peak Region—An Exhibition in Honor of the Centennial of Colorado Springs, 1871–1971*, exh. cat. (Colorado Springs: Colorado Springs Fine Arts Center, 1971).

4 Cuba and Cunningham, *Pikes Peak Vision: The Broadmoor Art Academy*, 75.

5 Archie Musick, *Musick Medley—Intimate Memories of a Rocky Mountain Art Colony* (Colorado Springs: Creative Press Adv., Inc., 1971), 85.

6 Ibid. *Harvest* is illustrated on page 86.

7 Louise did not use the umlaut "ö" in her name, whereas her husband, Arnold Rönnebeck, did use it.

8 Facts about Eve Drewelowe's life are taken from her autobiography, *Eve Drewelowe* (Iowa City, IA: University of Iowa School of Art and Art History, 1988). Drewelowe's estate resides at the University of Iowa.

9 Muriel V. Sibell, "With 'The Prospectors' in Colorado," *The Palette*, Fall 1931, 9–14; Sara Sanderson, "The Prospectors Exhibit," *Colorado Alumnus*, March 1932, 5–7. Archives, University of Colorado at Boulder Libraries.

10 The Denver Artists Guild changed its name in 1990 to the Colorado Artists Guild to more accurately reflect the geographical range of its membership.

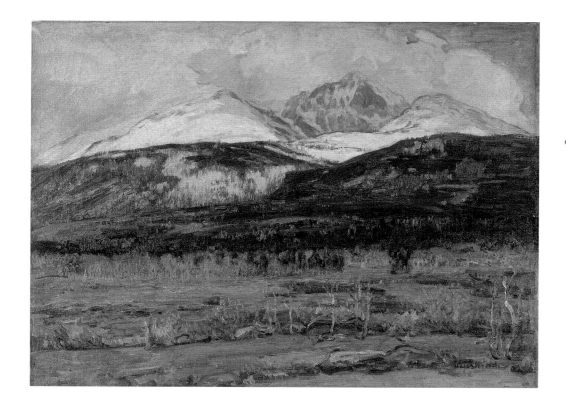

Eastern Passage: Hiroshi Yoshida

AND HIS DEPICTION OF WESTERN AMERICA

RONALD Y. OTSUKA

The Japanese painter and woodblock-print artist Hiroshi Yoshida (1876–1950) studied European-style oil painting in Japan and developed close ties with artists and collectors in the United States.[1] Charles Lang Freer (1854–1919), whose collection of Asian art formed the Freer Gallery of Art in Washington, D.C., owned a watercolor by Yoshida, and through this connection, Yoshida held his first American exhibition at the Detroit Museum of Art, now the Detroit Institute of Art, in 1899.[2] Yoshida made subsequent trips to the United States in 1903–5 and 1923–25 with the painter Fujio Yoshida (1887–1987), who became his wife in 1907.[3]

In December 1923, the couple departed from Tokyo, a city devastated by the great Kanto earthquake of September 1, 1923. They took their paintings and prints and artworks by other artists to sell for disaster relief. Although very few of Yoshida's pictures sold, his prints attracted great attention. This and other factors persuaded him to concentrate on printmaking after he returned to Japan.[4] On their return voyage to Tokyo, the couple journeyed around the world, visiting Europe, Egypt, India, present-day Pakistan, Afghanistan, Singapore, Burma (Myanmar), China, and Korea.

Yoshida sketched and painted the places he visited in the United States and later made woodblock prints of particular scenes. (He did an oil-on-canvas painting of Colorado in 1924; however, this image of the Rocky Mountains was never made into a print.[5]) His American prints included metropolitan cityscapes of New York and Pittsburgh and natural vistas of Niagara Falls, the Grand Canyon, Mount Rainier, and El Capitan in Yosemite National Park. In March 2011, the Denver Art Museum acquired a fine impression of *El Capitan*. In this 1925 print, Yoshida evokes the majesty and beauty of Yosemite through subtle variations of color and tone. He bathes the cliff face of El Capitan in warm light and contrasts it with a blue sky and shadowed foreground.

Yoshida's prints of the American West (*El Capitan*, *Grand Canyon*, *Mount Rainier*, and *Moraine Lake* in Canada) were among the first subjects he published after his return to Japan in 1925. Fundamentally, Yoshida adhered to the traditional Japanese method of creating prints that required a woodcarver and printer to combine

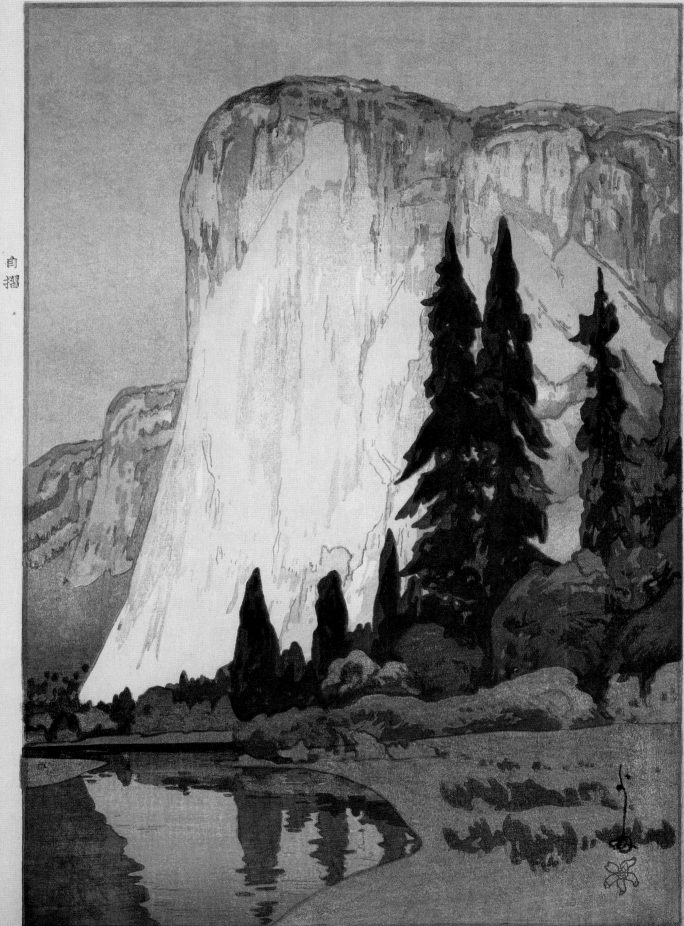

自摺

大正拾四年作

ヨセミット谷 エルキャピタン

El Capitan

Hiroshi Yoshida

their skills with those of an artist to produce a print. As a member of the *shin hanga* (new print) movement of the early 1900s, he sought to revitalize traditional printmaking methods of the seventeenth through nineteenth centuries. Other artists in the early 1900s belonged to the *sōsaku hanga* (creative print) movement, which advocated that its artists carve their own woodblocks and do their own printing as a means to inspired self expression.[6]

Normally, Yoshida would brush his design onto a thin sheet of paper with black ink, and the woodcarver would paste the sheet face down onto a cherrywood plank. The carver then cut through the paper into the wood, leaving the ink design in relief. In addition to the pictorial image, the carver made two registration marks on the woodblock, one in a corner and the other along an adjacent edge. This became the keyblock, and the printer pulled impressions from it, one for each intended color, by inking the block,

laying a thin sheet of paper on it, and applying downward pressure on the back of the paper. These printed sheets were in turn pasted face down onto additional woodblocks. The carver then cut away excess areas, leaving raised zones for each color in addition to the two registration marks indicated on the keyblock. Following a similar process as before, sheets of thicker paper were imprinted consecutively, one color at a time, until the entire color sequence was completed to produce a final print. By applying colors in even or graded shades, the printer produced tonal variations, like the darkening sky of *El Capitan*. Yoshida sometimes repeated a block to painstakingly apply four or five different shades of a color in superimposed succession.[7]

Yoshida was well established as an European-style painter when he made his first woodblock print in 1920 under a commission from the Meiji Jingu Hōsan Kai (Meiji Shrine Support Association). Produced as a hanging

scroll, *Meiji Jingū no Shinen* (*Sacred Garden in the Meiji Shrine*) was printed by Shōzaburō Watanabe (1885–1962), the central figure in the *shin hanga* movement. Watanabe employed a team of woodcarvers and printers to execute the designs of artists who incorporated Western-style elements into their work. When Yoshida returned to Tokyo in 1925, he ended his association with Watanabe and hired his own group of carvers and printers to produce prints. By that time, Yoshida was familiar with all aspects of the printing process and sometimes did his own printing and carving of blocks.

In 1926, after focusing on subjects drawn from his foreign travels, Yoshida turned to depictions of Japan. Among the prints by Yoshida in the Denver Art Museum's holdings are views of the Kiso River and Kamo River made in 1927 and 1933. In these prints, he deftly uses light and atmosphere to suggest a different mood, season, or time of day. The execution of these prints required

Attributed to Utagawa Kunisada
Japan, Edo period, 1835
Cherrywood keyblock with registration marks,
9¹/₈ x 14
Denver Art Museum, Gift of
Mrs. Frederick H. Douglas, 1961.10

Facing, top: Hiroshi Yoshida
Kiso River, Japan, Showa period, 1927
Color woodblock print, 10½ x 16
Denver Art Museum, Gift of Mr. and
Mrs. Mortimer H. Staatz, 1974.111

Facing, bottom: Hiroshi Yoshida
Kamogawa in Kyoto, Japan, Showa period, 1933
Color woodblock print, 10¾ x 15¾
Denver Art Museum, Gift of Mr. and
Mrs. Mortimer H. Staatz, 1974.110

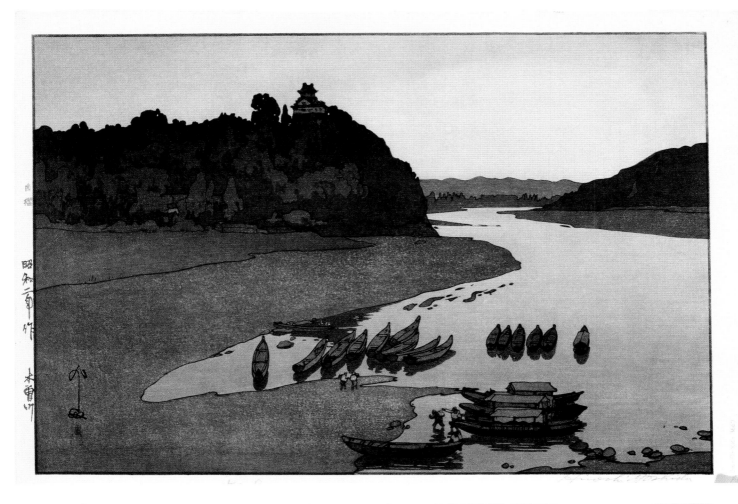

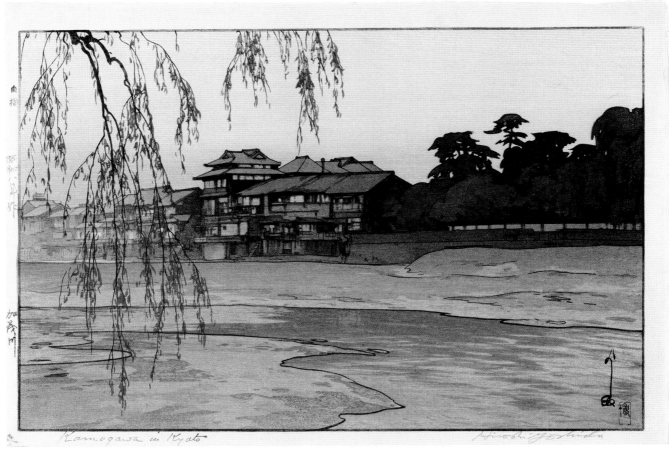

Kamogawa in Kyoto Hiroshi Yoshida

Carleton Eugene Watkins
El Capitan, Yosemite Falls, ca. 1865
Albumen print, 7½ x 4½
Denver Art Museum, Daniel Wolf Landscape
Photography Collection: Funds from Mr. and
Mrs. George G. Anderman, Nancy L. Benson,
Florence R. and Ralph L. Burgess Trust, 1990
Collectors' Choice, J. Rathbone Falck, General
Service Foundation, Mr. and Mrs. William D.
Hewit, Mr. and Mrs. Edward H. Leede, Pauline
A. and George R. Morrison Trust, Frederick and
Jan Mayer, Newmont Mining Corporation,
O'Shaughnessy Fund, Volunteer Endowment
Fund, Ginny Williams, Estelle Wolf, anonymous
donors, and the generosity of our visitors, with
additional support from the voters who created
the Scientific and Cultural Facilities District,
1991.397.19

careful control over the registration and alignment of each woodblock to achieve the subtly nuanced colors. Yoshida closely supervised the production of his prints and approved only the sheets that met his rigorous standards. A title and date was printed in Japanese along a side margin, and the translated title and signature in Roman lettering was penciled by Yoshida along the lower margin.

At the time, Japanese prints did not have edition numbers, and it was very rare to have different states of a particular design. However, Yoshida created color variations of certain prints, including *El Capitan*. A variant of the Denver Art Museum's print exists in which the sky remains the same color, not descending in graded shades from dark to light blue as it does in the Denver print.

Yoshida used a vantage point for *El Capitan* that was almost identical to the photograph *El Capitan, Yosemite Falls* taken by Carleton E. Watkins (1829–1916) around 1865. Watkins first photographed Yosemite in 1861, and his

photographic prints played a significant role in the decision by the United States Congress to declare Yosemite "inviolate." The bill signed by President Abraham Lincoln on June 30, 1864, was the first federal action to set aside state parkland specifically for preservation and public use. Watkins returned to Yosemite in 1865 and again in 1866 with the California State Geological Survey.[8] Undaunted by the cumbersome camera equipment he used, Watkins advanced the technical limits of open field photography. His striking images were in part responsible for Yosemite becoming a national park on October 1, 1890.

In 1862, Watkins's photographs of Yosemite were exhibited at a New York gallery, where Albert Bierstadt (1830–1902) saw them. The photographs inspired Bierstadt to make a trip to California in 1863.[9] Bierstadt spent several weeks in and around Yosemite and began a series of large-scale oil paintings of the valley and its waterfalls after he returned to his studio in New York. Bierstadt combined elements from his personal sketches with photographs to create paintings that depicted Yosemite as one seamless (but idealized) panorama.[10] Around 1870, more than fifty years before Yoshida did

his woodblock print, Bierstadt painted a Yosemite landscape in oil on canvas that portrays El Capitan with Sentinel Rock, Upper Cathedral Rocks, Lower Cathedral Rocks, the Three Brothers, and Upper and Lower Yosemite Falls.[11] Like the majority of artists who depicted Yosemite, Bierstadt traveled there from east to west.

Unlike Watkins, Bierstadt, and other American artists, Yoshida reversed the usual pattern and traveled eastward from Japan to America to create a stunning image of *El Capitan*. His print captures the scenic majesty of Yosemite and bridges the artwork of East and West. The acquistion of *El Capitan* benefits both the Petrie Institute of Western American Art and the Asian Art Department. The print connects the American West and Japan and offers testimony to Hiroshi Yoshida, an artist who crossed the Pacific Ocean to reach "The Captain" of Yosemite.

Notes

1 The Japanese term *yōga* (Western painting) refers to artwork by Japanese artists done with traditional European materials and techniques. It does not refer to pictures of "western" America although such paintings may be classified as *yōga*. The chronology in Toshi Yoshida, ed., *Yoshida Hiroshi Hanga Shū/Collection of Woodblock Prints by Hiroshi Yoshida* (Tokyo: Riccar Art Museum, 1976), notes that Hiroshi Yoshida became a student of Sōritsu Tamura, knew Kinkichirō Honda, and traveled to the United States with Hachiro Nakagawa in 1899. These three *yoga* artists were leading proponents of European-style oil painting in Japan.

2 J. Noel Chiappa, Hiroshi Yoshida biography; http://mercury.lcs.mit.edu/~jnc/prints/yoshida.html. Last accessed February 9, 2011.

3 Julia Meech and Gabriel P. Weisberg, *Japonisme Comes to America, 1876–1925* (New York: Harry N. Abrams, Inc., 1990), 139, note that he went to Boston, New York, Detroit, Indianapolis, Saint Louis, and elsewhere, often for commercial exhibitions. See Eugene M. Skibbe, "The American Travels of Yoshida Hiroshi," *Andon* 43 (January 1993): 59–74.

4 Oliver Statler, *Modern Japanese Prints: An Art Reborn* (Rutland, VT, and Tokyo: Charles F. Tuttle Company, 1956), 171, recounts Fujio Yoshida's description of this trip to the United States.

5 Bonhams & Butterfields San Francisco sold this painting in 2006; http://www.bonhams.com/eur/auction/14043/lot/6012/. Last accessed March 11, 2011.

6 See Amy Reigle Stephens, Hiromi Okamoto et al., *The New Wave: Twentieth-Century Japanese Prints from the Robert O. Muller Collection* (London: Bamboo Publishing; Leiden: Hotei-Japanese Prints, 1993).

7 Toshi Yoshida, "Introduction to My Father's Woodblock Prints" (*Chichi no Hanga ni Tsuite*), in Yoshida, *Yoshida Hiroshi Hanga Shū*, n.p.

8 Peter E. Palmquist and Thomas R. Kailbourn, *Pioneer Photographers of the Far West: A Biographical Dictionary, 1840–1865* (Stanford: Stanford University Press, 2000), 580.

9 Nancy K. Anderson and Linda S. Ferber, *Albert Bierstadt: Art and Enterprise* (Brooklyn: Brooklyn Museum, Inc., 1990), 79.

10 See, for example, Bierstadt's *Sunrise, Yosemite Valley* in the Amon Carter Museum collection; http://www.cartermuseum.org/Inspiring_Visions/Bierstadt/bierstadt_art.html. Last accessed February 10, 2011.

11 Donated to the Colorado School of Mines in Golden in 1938, the painting was restored by Denver Art Museum conservation department staff and exhibited at the museum in 2009. See "Uncataloged Bierstadt 'Discovered' at Mines"; http://magazine.mines.edu/2010/Summer/Departments/inside.html#uncataloged. Last accessed March 1, 2011. Also see a letter from Frederick J. Fraikor that discusses this painting in the *Colorado School of Mines Magazine*; http://minesmagazine.com/?p=1286. Last accessed March 1, 2011.

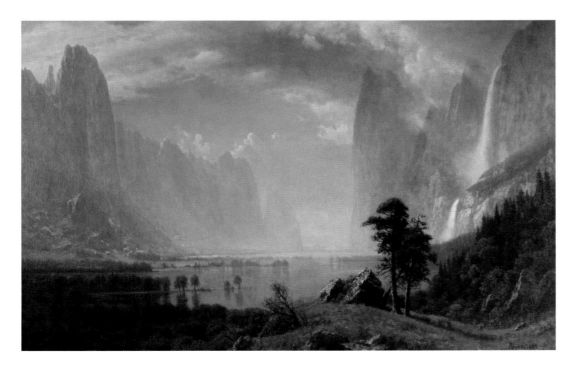

Albert Bierstadt
Yosemite, ca. 1870
Oil on canvas, 38 x 60
Colorado School of Mines, on
long-term loan to the Denver
Art Museum, 21.2009

Contemporary Works

Reframing Traditional Realist Painting in the West

DON STINSON

Since perspective drawing first allowed the representation of space and depth on flat panels or canvas, artists have been critically involved in defining the concept of a "view." This idea of isolating a portion of land or scenery for the eye to absorb all at once has been extended to everything from the design of baroque vistas meant to be viewed by kings in seventeenth-century France to the creation of eighteenth-century English country gardens, and now even to the golf course views of retirement communities around Phoenix or Palm Springs. Since the invention of perspective in fifteenth-century Italy, landscape painting has produced a pictorial understanding of land that has been extremely influential. In fact, painting has played a defining role in our formation of the concept of "landscape." Art historians and cultural geographers are still in active discussions about which came first: depictions of landscape through painting, or the term "landscape" itself.[1]

In the American West, Thomas Moran's paintings of Yellowstone and the Grand Canyon and Albert Bierstadt's grand vistas of Yosemite can be said to have helped shape our national identity. They inspired the idea of preserving areas of land as national parks to be protected and shared with the public.[2] In Colorado, Bierstadt's paintings of Mount Rosalie (Mount Evans) and Moran's *Mount of the Holy Cross* helped to define the value of public land and support the establishment of Rocky Mountain National Park.

Karen E. Kitchel
American Grasslands, 1997
Oil on wood, 12 x 12 each, series of 20
Denver Art Museum, Funds from
the Contemporary Realism Group, 1998.60

Is the shape of our contemporary landscape still important? The answer is, of course, yes. Landscape is the world we live in. Landscape is an evanescent tableau defined as much by our perceptions and experiences within it as by the solid matter and measurable realities of the landmarks around us. Landscape contains our experience of it all: the buttes, the gorges, rivers, and grasslands; the exurbs, suburbs, greenbelt, the city parks, and the city itself.

The contemporary landscape paintings in the collection of the Denver Art Museum provide a unique opportunity to evaluate and understand developing views of the contemporary West in the context of the enduringly productive strategies of realist art. Over the past twenty years, the Denver Art Museum has amassed a significant and unique collection of work by realists practicing in the West today. The best works focus on a conceptual reframing of traditional realist painting techniques.

This essay proposes criteria for examining and thinking about contemporary landscape painting in general as well as for specific paintings in this collection.

WHEN WE LOOK at a successful landscape painting, we see both the painter's vision and the landscape he or she was looking at. But an important landscape painting invariably represents something more than a picture of what we see. Landscape painting represents *a way of seeing*; a way of bringing together subject, form, and technique that helps us understand how we inhabit the spaces we occupy.

"Landscape is tension," British cultural geographer John Wylie has said. He suggests that landscape exemplifies a variety of tensions that animate the study of the land, such as those between proximity and distance, as in the choice between a close-up view or a vista.[3] There is also the tension between observation and inhabitation—is the landscape a scene we are looking at or a world we live in? A revolution in landscape studies emerged in the mid-1980s, which even today is still largely ignored in the critical discussion of landscape painting. A full-scale and thorough academic investigation of how some influential readings of landscape in the field of cultural geography have been presented and explored in the work of contemporary landscape painters such as Chuck Forsman and Rackstraw Downes, to name just two, is greatly needed. For now, it is appropriate to borrow Wylie's idea of "tensions" and use them to organize the discussion of a few landscape paintings in the Denver Art Museum.

Robert Bateman
Polar Bear Skull, 1991
Acrylic on board, 13⁵/₈ x 29
Denver Art Museum, Funds from
the Contemporary Realism Group,
1997.353

Clyde Aspevig
Montana in October, 1998
Oil on canvas, 50 x 40
Denver Art Museum, Funds from
the Contemporary Realism Group,
1999.34

Life and Death

ROBERT BATEMAN is principally
a wildlife painter. In *Polar Bear Skull*,
Bateman's interest in conveying a
"biological specificity" is well matched
to his dry build-up of an intricate matte
surface of acrylic paint.[4] The artist puts
his considerable skills to work rendering
the still-powerful presence of a long-
dead predator. A decaying skull lies
among the grasses on Canada's northern
tundra. The horizon is high and the sky
is a distant sliver of cold, pale blue. The
paint handling is subtle and delicate
in the fragile strands of living grasses
moving in the wind. With equal delicacy,
Bateman presents a detailed patina of
mold and algae on the surface of the

bone. Even in this barren environment,
the skull's surface is given over to a crust
of primitive life returning. Because the
story of a great predator falling prey to
the elements of a harsh environment
is not spelled out, the viewer, left with
a sense of the fragility of life, is free to
contemplate the preciousness of every
delicate blade of grass.

Keith Jacobshagen, a resident of
Lincoln, Nebraska, paints the landscape
within a sixty-mile radius of his home.
He works from field sketches and
watercolors that he paints on-site, often
from his car. Jacobshagen's painting *By
June the Light Begins to Breathe* (page
160) renders the cultivated patterns
of the land close to his home under
an expansive sky. He paints the shapes
of fields and trees, clustered into

windbreaks in this rural landscape, with
the detail and clarity of a small-scale
mosaic. Extending these patterns of
human cultivation on the land toward
the horizon with a subtle rendition of
linear perspective, the artist masterfully
compresses a great depth of space into
a narrow band of land. The title gives
the dramatic atmosphere of the large
sky the human quality of breath. In
Jacobshagen's picture the tonal glow
along the horizon truly opens the
whole composition up, filling it full of
dancing airy clouds and life-sustaining
atmosphere.

With its low horizon and large,
carefully modulated sky, this work can
be tied to a central source of European
landscape traditions beginning with
depictions of a region of agricultural

land west of Venice by the artists Giovanni Bellini, Titian, and Paolo Veronese,[5] and one might also look to the great Dutch landscapes of the seventeenth century. The Italian tradition is sometimes associated with an aristocratic elite viewing the hardships of rural life through a beautiful veil of light and color,[6] but the context is different for Jacobshagen's work. Painted at the turn of the twenty-first century, the rural landscape of the Midwest—sometimes referred to dismissively as "flyover country"—becomes a soaring celebration of the overlooked aesthetic qualities of Jacobshagen's home ground. The artist displays a superb mastery of his subject and clearly delights in letting the touch of his brush dance to different rhythms in sky and land. His hopeful relocation of European landscape devices to semi-rural Nebraska brings new meaning and life to the tradition.

Culture and Nature

CLYDE ASPEVIG'S *Montana in October* is a fantasy of a pure place from the artist's Montana childhood rather than a specific place. Working from memory, Aspevig is free to omit the detritus of culture's presence and other modern distractions.[7] This landscape of the imagination is rendered in what looks to be a wet-on-wet, direct painting technique often necessitated by painting outdoors. His handling of light is sensitive and convincing. The high horizon line in Aspevig's hands creates a sense of pleasant intimacy with the folding natural forms; a soft foliated gulch leads up a rocky gap into the rolling hillside. He avoids the clichés of blossoming high mountain valleys and snow-capped peaks. Wilderness and nature are not threatening here, but a sheltering respite from the unpleasant intrusion of modern life.

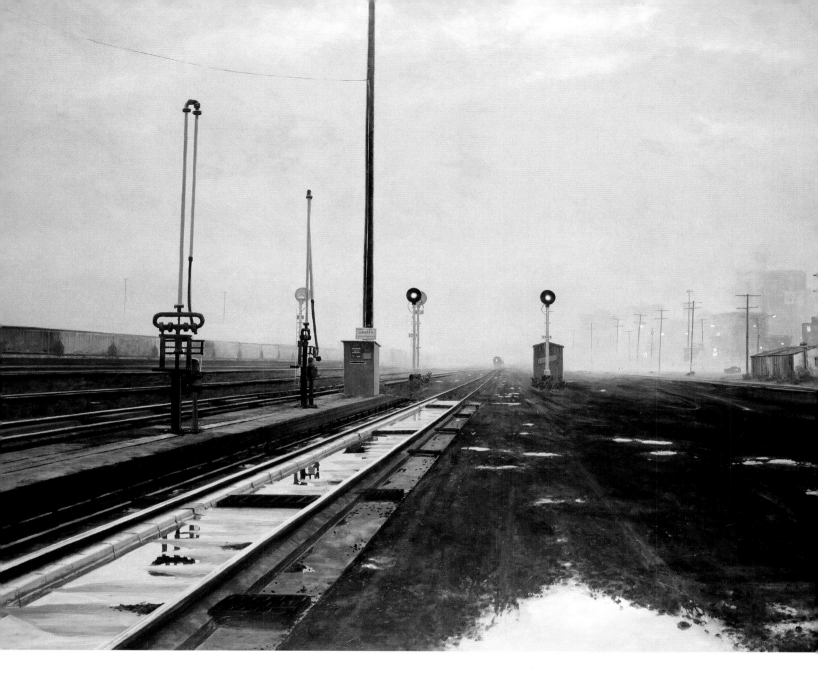

Daniel Morper
Fog, 2000
Oil on canvas, 51 x 65
Denver Art Museum, Funds from
the Contemporary Realism Group,
2005.30

Chuck Forsman
Aggregate, 2002
Oil on panel, 51 x 51
Denver Art Museum, Funds from
the Contemporary Realism Group,
2004.62

Daniel Morper's *Fog*, on the other hand, presents an urban landscape. It includes all of the man-made material that Aspevig works to leave out. Morper's delicate tonal handling of the fog softens this industrial landscape. The fog obscures even the hint of a vista or view of nature in the distance.

The horizon line is placed just below the mid-point of the composition. The vertical equilibrium is maintained by an electrical pole, which is placed just to the left of the centerline, extends up to the upper edge of the canvas, and then is reflected in puddles of water on the tracks along the damp ground

below. This image could seem a still and elegiac poem to a dying industry but for the electric spark of life in the streetlights of town. This glow of life extends out to the rail yard and to the green glow of the signal lights framing the tracks. Just to the right of center, offset by the powerful vertical of the

electrical pole on the left, the focal point of the painting emerges out of the fog and into view. The composition turns around the small silhouette of an approaching locomotive; the beam of the train's headlamp is dim but visible on the horizon. In this painting, life and culture in the form of a train, the once-civilizing industrial machine of late 1800s America, make a return.

But will the train stop? Among the tracks on a raised platform are two pieces of vertical apparatus for servicing and refueling the locomotive; behind them sits a long row of freight cars designed to carry coal. The green lights on the signal poles indicate that because diesel fuel, or the fuel in the form of coal in a cargo car waiting on the side track, are not needed, the train will pass through this town today and on most days. In *Fog* the grand vistas of the West recede behind a painterly haze of atmosphere, and the lovingly rendered industrial details of a technological narrative emerge to tell the story on their own terms.

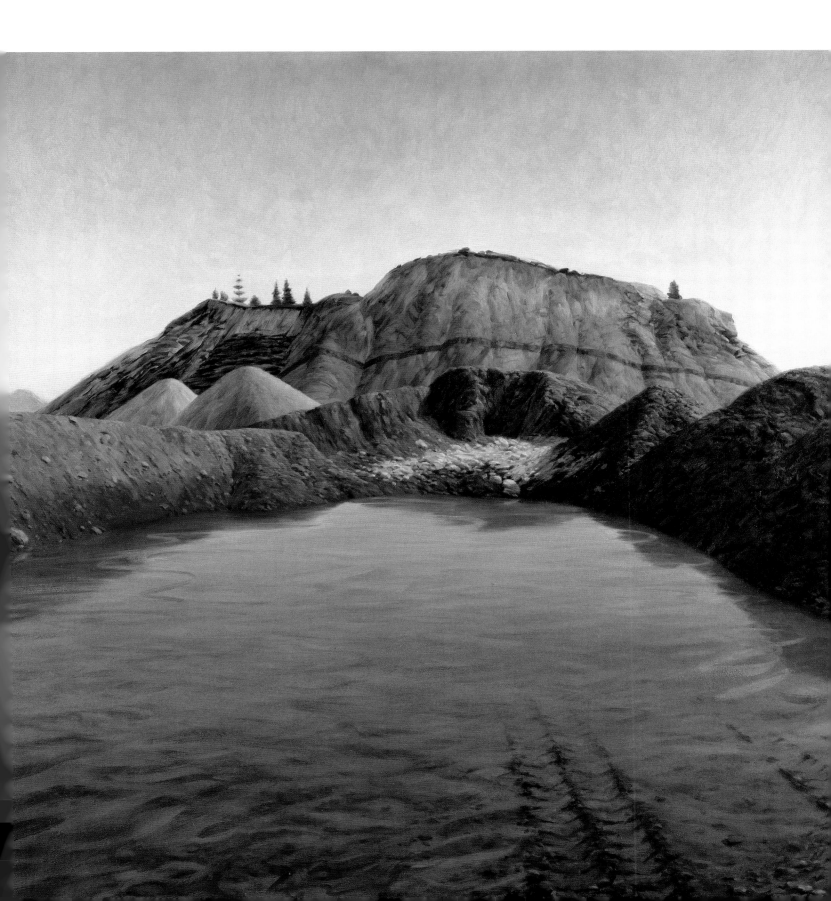

The title of Chuck Forsman's painting *Aggregate* describes the subject (a gravel mine) as well as the artist's painting process. It is important to note that Forsman is both an accomplished painter and photographer. When working as a photographer he concentrates on capturing all that he wants to communicate within one frame of film. When photographing for a painting, he accumulates information in the form of photographic images that he uses to construct preliminary drawings. In the drawings, he works out the composition for the painting from an aggregate of sites and images.[8] The view in this painting brings together a pond at an abandoned aggregate mine near Boulder, Colorado, with a vista from another location on Colorado's Front Range.

Forsman has been exploring the effects of industry on the natural environment in his paintings since the early 1970s. For most of that time he has been a friend of the photographer Robert Adams, who Forsman cites as one of his primary influences.[9] In 1975 Adams was one of nine photographers included in an influential exhibition titled *New Topographics*.[10] These photographers were received as a new model for environmentally concerned photography even though presented by the curator, William Jenkins, as apolitical formalists representing the American landscape with a new clinical objectivity.[11] Aware of these tensions within the practice of photography, Forsman was also engaged in the act of painting contemporary western landscapes that in the context of Adams's work came to be called the "New West."

In these paintings Forsman combines formal clarity and environmentally engaged themes into complex and beautifully constructed images that move beyond the possible neutrality of a photograph to question our assumptions about nature, culture, and what is beautiful in our landscape, even still.[12]

In *Aggregate* Forsman's painting technique is virtuosic and inventive. He relies on the sheer beauty of his paint handling to hold the viewer's engagement with his often-difficult subjects. Bravura paint strokes indicate tire tracks, which lead the viewer into the water from the lower right of the painting. The water looks wet and moves seamlessly from transparency to reflective opacity. The carefully realized liquid surface reaches the embrace of a red embankment just slightly below the center point of the panel. The shape of the cliffside above echoes the silhouette of the embankment. The viewer is gently placed right in the middle of this invented landscape of artfully layered degradation and beauty. By painting the spectacle of our own environmental destruction, Forsman finds fresh meaning in the old romantic poetry of the grand western vista.

Near and Far

IN *American Grasslands* Karen Kitchel presents a series of microcosmic views. Each individual panel in this series depicts a specimen of grass in a close-up, fully realized oil painting. The series consists of twenty individual square panels, which are installed in a grid along the wall. By organizing her micro or near views within the conceptual framework of this grid, she knowingly places her paintings in the macro or far-reaching context of the principle that organizes the American landscape west of the Appalachian Mountains, the land ordinance grid developed by Thomas Jefferson and Jared Mansfeld in the late 1700s. Andro Linklater, in his book, *Measuring America*, states: "The desire to possess land drew people westward, but it was the survey that made possession legal." And the survey, he writes, "made buying simple whether by squatter, settler, or speculator."[13]

Kitchel roots her work in *American Grasslands* in an "earlier view of

the western landscape, a landscape organized by commercial interests, the railroad, ranching, and farming."[14] In other work Kitchel has built grids analogous to the checkerboard of the section right-of-ways granted to the intercontinental railroads and to the intimately scaled intervals of a walk along the tracks behind her former home in Denver.

Beginning in the 1970s, the grid became a powerful conceptual device in the work of some prominent artists. Chuck Close's large-scale black and white headshots composed into a grid system with tones imposed over the individual portraits are probably the best-known example. The grid is also associated with postmodern fragmentation in the work of Pat Stier and appears in late modernism's most reductive form in the work of artists such as Agnes Martin and Sol LeWitt. In these artists' work, as in Kitchel's, the grid is more than a compositional device; it is a structure for organizing ideas about systems, process, and form. The grid in *American Grasslands* includes these readings and also reaches through them, into history and forward to the impact of the grid on how we inhabit the land today.

Kitchel makes the grid definitively her own in *American Grasslands* by integrating the details and specifics of a close-up view of nature into the narrative of western expansion. Her oil on panel technique is painterly and controlled. The careful development of these fragmented views compresses a portion of time as well as space within each panel. Her subjects—prairie, pasture, crop, and lawn—lend themselves to varied and elegant strokes, which Kitchel skillfully builds into layered and complex surfaces using traditional oil painting techniques. Kitchel's inventive coupling of traditional techniques with conceptual structures based not only in art, but in science and American history, should be a guide and inspiration for the next generation of landscape artists.

THERE ARE TENSIONS inherent in the making of a landscape painting, and there are tensions between various approaches and traditions of landscape painting. Tensions such as those discussed here between life and death, near and far, or culture and nature are important ways of framing the discussion. A successful landscape painting does not necessarily resolve any of these tensions—it is animated by them. The qualities of successful landscape paintings are integral to our understanding of landscape itself.

The contemporary landscape paintings in the Denver Art Museum collection provide opportunities to evaluate and understand these developing views, especially as they pertain to the contemporary American West.

Notes

1 John Wylie, *Landscape* (London & New York: Routledge, 2007). In the introduction, Wylie lays out several current and historical discussions of this issue.

2 For Albert Bierstadt, see Nancy Anderson and Linda Ferber, *Albert Bierstadt: Art & Enterprise* (New York: Hudson Hills Press, 1990). For Thomas Moran see Nancy K. Anderson, *Thomas Moran* (Washington, DC: National Gallery of Art, 1997).

3 Wylie, *Landscape*, 1. I have taken Wylie's concept of tensions in the landscape (outlined in Wylie 1–11) and applied it to the art of landscape painting. I have also used one of his categories of tensions: Culture and Nature, invented one of my own, Life and Death, and changed his category Proximity and Distance to Near and Far for the purposes of talking about specific works of art in this essay.

4 Ann Daley and Peter Hassrick, *Contemporary Realism Collection* (Denver: Denver Art Museum, 2006), n.p. [entry on Bateman].

5 Denis Cosgrove, *Social Formation and Symbolic Landscape* (Madison: University of Wisconsin Press, 1998), quoted in Wylie, *Landscape*, 60–61.

6 Ibid.

7 Daley and Hassrick, *Contemporary Realism Collection*, n.p. [entry on Aspevig].

8 Chuck Forsman, Western Horizons Lecture, Denver Art Museum, January 11, 2011.

9 Ibid.

10 Robert Adams et al., *New Topographics: Photographs of a Man-Altered Landscape* (Rochester, NY: International Museum of Photography at George Eastman House, 1975).

11 Deborah Bright, "The Machine in the Garden Revisited: American Environmentalism and Photographic Aesthetics," *Art Journal* 51, no. 5 (1992): 65.

12 See Deborah Bright, "Of Mother Nature and Marlboro Men: An Inquiry into the Cultural Meanings of Landscape Photography," in *The Contest of Meaning: Critical Histories of Photography*, ed. Richard Bolton (Cambridge, MA: MIT Press, 1989). Also available online at http://www.deborahbright.net/PDF/Bright-Marlboro.pdf. Last accessed April 28, 2011.

13 Andro Linklater, *Measuring America: How an Untamed Wilderness Shaped the United States and Fulfilled the Promise of Democracy* (New York: Walker & Company, 2002), 164, 166.

14 Quoted from an ongoing conversation with the artist begun in 2002 in Kitchel's Denver studio and printed in *Salient Ground*, a Robischon Gallery brochure, Denver, 2002.

Karen E. Kitchel
American Grasslands: Praire #3, 1996
Oil on wood, 12 x 12
Denver Art Museum, Funds from the Contemporary Realism Group, 1998.60.13

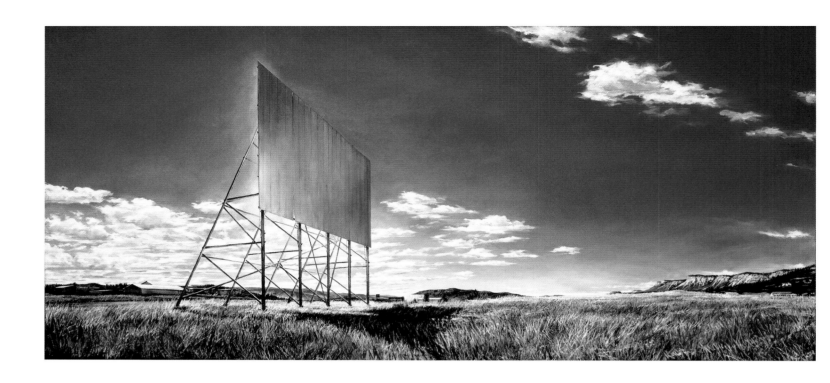

The Necessity for Ruins

ANN SCARLETT DALEY

The *Necessity for Ruins* (1998) by Don Stinson, is, to my mind, an excellent example of contemporary realist painting in the western collection at the Denver Art Museum. Contemporary—in that it is painted by a living artist about the times in which he lives—and realistic in style, subject, and content. Two large panels of wood, one bigger than the other, depict an abandoned drive-in movie theater near Chama, New Mexico. The large and silvery movie screen on the left presides over a silent landscape of short indigenous grasses and weeds. The smaller panel on the right shows the derelict projection booth against a background of unchanging low foothills and a brilliant blue sky. High mountains are visible in the distance. On the side of the wooded hill at the center of the painting are white satellite dishes, a forecast of the future. A field of headless speaker posts resembles a patch of yucca.

By creating two paintings instead of one continuous panoramic landscape Stinson has invited the viewer to pause and to reflect. An actual drive-in movie speaker stands nearby as a sentinel relic.[1] Through it, it is possible to hear the sounds of wind and the truck traffic from the nearby highway, adding to the sensation of the passage of time. Only the landscape feels like a timeless segment of the western high plains, in contrast to the come-and-gone feeling of the old drive-in, a significant part of the social web of the community when it was built in the 1950s.

The title, *The Necessity for Ruins,* was inspired by a small book of the same name by John Brinkerhoff Jackson (1909–96), published in 1980.[2] Jackson

Don Stinson
The Necessity for Ruins, 1998
Oil on panel (set of two)
40 x 84 *left* and 40 x 56 *right*
Denver Art Museum, Funds from the
Contemporary Realism Group, 2000.147A-B

defines a traditional monument as "an object which is supposed to remind us of something important."[3] He wrote that today "history means less the record of significant events and people than the preservation of the reminders of a bygone domestic existence and its environment."[4] In discussing the human need to memorialize ruins, Jackson refers to an interval of neglect and discontinuity that is artistically and spiritually essential to the consideration/appreciation/evaluation of what we see around us. Stinson acknowledged this period of neglect of abandoned structures when he said that he paints culture in repose, or western settings experiencing a pause. He calls his paintings of modern ruins "portraits that record human passage and its effect across geography and time."[5] We find the need for markers in our lives, for an occasion to reflect on the

past—in our case, not to consider the Roman Coliseum but ordinary forsaken buildings of the past, close to where we live. Markers/ruins are both personal indicators of the past and stimulus for nostalgia (what movie do I remember seeing at a drive-in theater?) as well as philosophical signposts (what marks of progress or destruction have we left on the Earth?). And even sociological questions are raised, such as what led to the creation of the drive-in theater and what led to its demise? "Inventing" ruins are one way we mark the passage of time.

Placing the drive-in movie theater in the context of recent American history gives a time frame for these vernacular monuments. The world's first drive-in movie theater opened in Camden, New Jersey, on June 6, 1933. The movie was *Wife Beware* starring Adolphe Menjou. The advertisement said: "Drive-In

Theatre—World's First—Sit In Your Car—See and Hear Movies—25 c per car—25 c per person—3 Or More Persons One Dollar."[6] According to an article by Mark Wolfe published in *Colorado Heritage*, the typical location for an outdoor theater was the edge of town, along a highway or secondary access road. Most sat within two or three miles of the limits of a town large enough to support their operation. In rural areas, they were on the way to another community of some size. By 1948, more than five hundred drive-ins were in place across the country; by 1953 there were four thousand. In this era following World War II, the cars were big, and fast food was beginning to be popular. Television was new, but families had a tradition of going to the movies together. And for young people, the back seat of the family automobile offered new-found privacy. Almost as

soon as drive-in theaters hit their peak in the late 1950s, the fad started to decline. The freedom associated with the car had lost its luster. Television had gained prominence. And other factors were at work: land values had increased; vandalism occurred; a different, younger crowd came.[7] The same white satellite dishes depicted in Stinson's painting represented the new technology that put drive-in theaters out of business. VCRs eventually changed the way people could view movies, and those same second-run B movies were available at grocery stores. The ruins we see today are the last vestiges of the once-popular auto-centric entertainment craze that

in retrospect was short lived. It was followed by a period of neglect followed by a reassessment in the 1980s. An artist growing up in the West at that time could reconsider the traditional western landscape and could begin to view abandoned drive-ins, gas stations, and trailers as ruins significant to the history of man and nature in the West.

As a landscape painter, Stinson is an extension of the nineteenth-century tradition of artists traveling to make personal discoveries in the territory of the West. Artists such as Albert Bierstadt and Thomas Moran are known for their dramatic paintings of places now familiar to us but unknown to most

Americans in the 1800s. Bierstadt came west with survey teams and sketched his direct encounters with the terrain. He returned to his studio in New York where he developed large theatrical paintings that emphasized the grandeur of the land—paintings that were romantic in both subject and imagination. Thomas Moran, who also came west from his eastern studio, chose to paint the most spectacular geologic elements of the West: the vivid colors of Grand Canyon, the paint pots of Yellowstone, and the colorful cliffs of Green River, for example, but without the distracting indications of the presence of man, such as railroad

Don Stinson
Cisco, No Services, 1997
Oil on panel with mixed media predella
and steel frame, 36 x 60
Image courtesy of the artist

disintegrating with grasses and weeds reclaiming the land. He began painting his signature landscapes, with dilapidated roadside structures, in the mid-1990s.

In all of Stinson's paintings there is the concept of transition—he depicts a moment in time. Ruins clearly testify to change, providing the motivation for restoration and pointing toward the future. Stinson understands the cycle of the West and believes that the change is positive: "At the edge of many small towns, drive-in movie screens, motels, gas stations and trailer homes sit abandoned. As ruins they become stunning monuments of obsolescence but they also represent change and the possibility that something else, different and perhaps better may be along the road ahead."[8]

tracks or towns. The twentieth- and twenty-first-century approach of Don Stinson is one of realism as opposed to romanticism. Rather than denying the passage of time, Stinson has found a message in the forsaken buildings in the open countryside. He has used authenticity rather than fantasy while painting in the nineteenth-century method of layered oils and attention to detail.

The earlier nineteenth-century artists had, of necessity, to travel in groups of survey teams usually accompanied by military or government expeditions. Stinson, in contrast, is a native of the West and has traveled alone

to places off the conventional path from Colorado to Texas, both states in which he has lived. Topographical maps have been vital components of his trips, just as they were to surveyors/explorers in the nineteenth century. The son of a geologist, as a boy Stinson saw remote areas from the backseat of the family car, going to sites where his father would be "sitting on a well" or studying a land formation. In the summers he worked on oil rigs in Wyoming and Colorado. Following his formal academic education, Stinson took a seasonal job as a Federal Express driver in remote portions of Colorado, observing outbuildings that sat neglected and

Notes

1 The metal speaker is from the Sunset Drive-In Theatre in Lakewood, Colorado.

2 John Brinckerhoff Jackson, *The Necessity for Ruins and Other Topics* (Amherst: University of Massachusetts Press, 1980).

3 Ibid., 91.

4 Ibid., 90.

5 Don Stinson, "Artist's Statement," Robischon Gallery exhibition, Denver, May 2000.

6 Mark Wolfe, "Silver Screens Under Starry Skies: Drive-In Theatres at Colorado's Corners," *Colorado Heritage* (Winter 2007): 2–23.

7 Ibid.

8 Stinson, "Artist's Statement."

Dancing on a Line

TIMOTHY J. STANDRING

During the early 1960s, not only did high and low art compete for the public's attention, but the avant-garde also found itself under attack from a number of unexpected upstarts. Pop art images of Campbell's soup cans, jet plane crashes, and Marilyn Monroe on the one hand and examples of minimalist, hard-edge, and color-field paintings on the other questioned the prevailing dominance of abstract expressionism. Meanwhile, Norman Rockwell continued to provide *Saturday Evening Post* covers and Andrew Wyeth received the Presidential Medal of Freedom.[1] Those seeking direction and

clarification of the current situation in the visual arts were left scratching their heads in wonderment, since art criticism was found to be less about the objects themselves and more about the words that described them.[2] As a result, the assumptions as to what constituted a work of art became ever more fragmented, and with uncertainties pervasive throughout the American art world during this period, it must have been a challenging—or conversely liberating—time for anyone aspiring to become an artist.

One wonders, then, what was going on in the mind of the artist Keith Jacobshagen during his formative years throughout the early 1960s when he not only made the brave decision to shift his focus from design and illustration to the fine arts, but even more courageously decided to stake his artistic claim on painting landscapes of the continental

Midwest of the United States. To some, this was a subject bereft of anything progressive in terms of the visual arts. But to others, its extraordinary expanse of sky and distant horizon held a beauty all its own that became increasingly understood as part of the vast open skies associated as well with the American West. In this respect, Jacobshagen responded to his surroundings as prior midwestern realists Grant Wood, Thomas Hart Benton, and John Stueart Curry, among others, had done before him, but with even more conviction. After all, what other American painter claimed the horizon line as the primary focus of his art?[3]

Around 1963, Jacobshagen "woke up" to his surroundings of flat land and big skies by figuring out a way to capitalize on his formative art school experiences and go about painting the fields around Wichita, a snug

midwestern community in Kansas that was, to be sure, far from the frenzied art world of New York or the laid-back art community of Los Angeles.[4] This is a place where sky and land intersect on a distant horizon line as nubby as a thread of raw silk, and where one can sit for hours under the huge sky watching the clouds float over the seemingly endless undulations of nearby hills. The space above the Great Plains provided endless stimulus to such an extent that his compositions of sky kissing the strip of land at the horizon—the basic ingredients of *By June the Light Begins to Breathe*—have continued unabated for nearly half a century. Indeed, they have become synonymous with his name not only in the United States but abroad, as the appearance of one of his works in the *Times Literary Supplement* in 2004 confirms.[5]

By painting objects such as clouds and atmospheric conditions that reconfigure at the blink of an eye, Jacobshagen clearly faced enormous challenges ahead, which he tacitly acknowledged when he initiated a journal in 1965, the year in which he began to face up to his decision to become an artist. Having mustered enough self-confidence during his formative years to forge ahead, he admits that he owes this sense of self to having received sage advice from mentors William Dickerson on artistic discipline, Bill Fuhri on the sensitivity of placing marks and what they mean on a sheet of paper, and Robert Sudlow on the act of painting itself. Experiences that also bolstered his courage include receiving a B.F.A. and an M.F.A. in Kansas as he trained to become a professional graphic designer, then working as a cartoonist for Hallmark Cards and taking an artistic wanderlust to New York and Los Angeles to gauge the worth of his artistic achievements up to that point in his career. During these career movements, he also became quite aware of the artwork of Willem de Kooning, Mark Rothko, Philip Guston, Frank Stella, and Barnett Newman, and, in a strange twist, began to sense that their collective artistic intentions were closely aligned to his vision of the expanse of the Great Plains. Exposure to their works brought him to realize that "paint was something that could transcend subject matter," a statement that reveals an artist whose sensibilities are eminently subtler than a fleeting glance at his works would suggest. As such, his own acceptance of action painting and gesture clearly buttressed the aesthetic possibilities he imbued in his works of the Great Plains.[6]

By 1968, Jacobshagen had settled in Lincoln, Nebraska, where he committed to paint within the sixty-mile radius surrounding the "Star City." At first, he finished most of his canvases on-site, but by 1978 he abandoned plein-air painting because he felt it was a "tyranny" that limited the poetic, artistic, and painterly impulses fundamental to his intuitive artistic drives. The artistic shift he undertook was substantial for the rest of his career, since he subsequently allowed memory and his imagination to play an increasing role in his artistic production. Since he gradually began to think of his paintings as fictions rather than as recordings of natural events, he adjusted

Keith Jacobshagen
By June the Light Begins to Breathe,
1999–2000
Oil on canvas, 41$^{1}/_{2}$ x 61$^{1}/_{2}$
Denver Art Museum, Funds from
the Contemporary Realism Group,
2000.146

Keith Jacobshagen
Journal entries, 22 February
and 19 March 2000
Courtesy of the artist
Photograph by Roger Bruhn

Keith Jacobshagen
N. 134th & Mill Rd, September 16, 1997
Pastel on paper, 5 x 7
Courtesy of the artist
Photograph by Kiechel Fine Art

Keith Jacobshagen
Towards the Gas Storage Tank on Hwy 6,
September 9, 1998; Pastel on paper 5 x 7
Courtesy of the artist
Photograph by Kiechel Fine Art

his working procedures accordingly and preferred to finish works in his studio. By doing so, he was in fact admitting that the act of painting itself played as important a role as the subject matter.

The more he gazed at the sky, the more demanding it became to render what he was absorbing; and in a parallel manner, the more he addressed the canvas with paint in his studio, the more he needed to work on it to bring it to conclusion. A close look at the surface of *By June the Light Begins to Breathe* shows that he not only worked up the clouds with impasto, dry brush, and countless number of glazes, but he also scraped off some of the paint to reveal the painting's ground of terra-cotta red for the strip of land along the lower edge of the painting. Perceiving that the transformations of shapes, density, hues, tones, and light became ever more subtle and complex, Jacobshagen had to figure out how to paint such phenomena. The harder he looked, the harder he had to work to achieve ever-more-subtle gradations and transformations. By noticing that passages of cerulean merge

with splotches of rose-madder, with both hues further accented when seen against billowing puffs of cumulous clouds painted with brilliant Chinese-white pigments, he was challenged to find the most effective means of applying paint in order to convey these fleeting atmospheric shifts. In other instances, he would muddle streaks of cirrus clouds with gray blemishes here and there and glaze streaks of amber and tangerine—all in an attempt to dance between painting-for-its-own-sake and representing the appearance and dissipation of the clouds. And when the paint and subject respond to each other in perfect harmony—as they do throughout *By June the Light Begins to Breathe*—they achieve an unmistakable magic that viewers feel almost immediately when looking at this painting.

It should not be surprising then to learn that Jacobshagen painted this work both with his imagination and by referring to sketches made on-site prior to his time in the studio. He often uses an *aide-mémoire* in the form of

sketches (with journal entries) in pencil, pastels, or watercolors, and in some cases, photographs. But it was a struggle to bring the work to fruition, as we learn from one of his letters in which he writes that he "pecked away at it doing my best to seduce and bring the paint to a more vigorous description of space, light and formal engagement, which meant that I also had to change some other visual components of the image. 'For every action there is a reaction' I believe the saying goes."[7] In other words, Jacobshagen possessed enough self-awareness to recognize that the tension and verve required to bring the work to conclusion had waned. And on the odd occasion when the inspiration bulb would dim, he would consult those sketches and notes that he had made on-site, which he called his "field notes."

Jacobshagen's working methods find parallels in those of John Constable (1776–1837), one of many artists he greatly admires for his like practice of keeping a journal of his on-site experiences, jotting down notes, like a diarist, on specific time, place, and

moment-to-moment meteorological readings. Two such examples are *N. 134ᵗʰ & Mill Rd*, which includes a note that the temperature that day was 83 degrees, and *Towards the Gas Storage Tank on Hwy 6*, which gives the temperature as 80 degrees and notes that he was fifty-seven years old when he drew this pastel. For Jacobshagen, these works on paper serve not just to slow down his vision, but also to reinforce his memory of a place, thereby setting up the foundation for his eventual mediation of the visual data into his final compositions. He would usually produce these sketches during the later part of the day, often within perhaps an hour after the sun had dipped beneath the horizon. In other instances he would capture a setting sun beneath opalescent skies, enhancing the glow with touches of rose, cerulean, and violet. Keenly aware that artistic decisions begin the moment he applies media to paper, canvas, or a copper plate, Jacobshagen knew that his repetitive out-of-doors sketching activities became a means of internalizing the material that would subsequently be drawn to the surface during his work in the studio. Moreover, as he very much wished to fix his experience back in his studio, he would continue to write about these afternoon outdoors working sessions. In part, he wanted to invigorate his memories with his journal entries, such as these written on the 22nd of February and the 19th of March, 2000, that reference visually and verbally *By June the Light Begins to Breathe*.[8] But it also appears that the stimulus of the heavens triggered observations about bigger issues, like life itself and the quality of our existence, as when he writes that "I've built a strong emotional momentum that is bringing the sky into its own."

Jacobshagen's working procedures reveal that he is solving artistic problems at the most cerebral level, even if the final result might be quite sensate. Like the artists he feels over his shoulder watching him paint, he is able to impart many different moods to the work by changing his palette, manipulating the paint across the surface by scumbling, applying glazes or impasto with brushes or a palette knife, using a dry brush technique, and so forth, or even framing the composition in a certain way. While he refuses to abandon recognizable reality, he nonetheless makes countless numbers of aesthetic decisions about the components he chooses to use by taking liberties with the various sketches of the places by adjusting their tone and focus as he sees fit, and then imbuing the overall composition with a poetic quality that only a keenly focused artist could achieve. So, if we believe that Jacobshagen modifies what he observes, it is plausible to suggest that his art is not terribly far in intentionality from the poetic interventions that Andy Warhol bestowed on his images of Marilyn Monroe, from the manipulations that Robert Motherwell produced with his assembly of blocks of white against planes of black, or from the formal arrangements that Frank Stella gives to his shaped canvases. As a result of his efforts, we experience the Great Plains as he does, as a place charged with lyrical energy that we behold and share collectively. As Jacobshagen himself stated, "I am interested in that state that someone can get in when looking at something extraordinary."[9]

Notes

1 Calvin Tomkins, *Off the Wall: Robert Rauschenberg and the Art World of Our Time* (New York: Penguin Books, 1981), offers a superb overview of the period.

2 Tom Wolfe, *The Painted Word* (New York: Farrar, Straus & Giroux, 1975).

3 For a contextual overview of Jacobshagen's work with respect to the Great Plains, see *Beyond the Horizon: Paintings by Keith Jacobshagen, 1990–2005* (Sioux City, IA: Sioux City Art Center, 2005).

4 Biographical information was drawn from interviews by L. Kent Wolgamott: "Painter," *Lincoln Journal Star*, July 19, 2000, A1, A10; "Beyond the Horizon: A Q & A with Keith Jacobshagen, the Pre-Eminent Painter of the Plains," *Lincoln Journal Star*, May 1, 2005, K1,

K4; Melissa Rountree in "Keith Jacobshagen," exhibition pamphlet (Overland Park, KS: Johnson County Community College Gallery of Art, 1993); and from the gimlet-eyed reporting of Kyle MacMillan in the *Omaha World-Herald*: August 28, 1988; May 17, 1998; April 8, 1990; September 25, 1993; and April 27, 1997, among his many postings on the artist. I also learned much from the sensitive essays on the artist by the following: James Butler, *Heartland Painters* (Chicago: Frumkin & Struve Gallery, 1985); Chris Waddington, "Keith Jacobshagen at Roger Ramsey," *Art in America*, October 1989, 219–21; John Arthur, *Keith Jacobshagen* (New York: Babcock Galleries, 1990); Linda C. Hults, *The Contemporary Landscape* (Wooster, OH: College of Wooster Art Museum, 2002), 13–16; Virginia Campbell, "Far & Wide," *Southwest Art*, April 2004, 86–89; and Joni L. Kinsey, "The Artful Plains of Keith Jacobshagen: Sublimity and Space," in *Beyond the Horizon: Paintings by Keith Jacobshagen*, 7–17.

5 *Times Literary Supplement* (London), June 25, 2004, 19.

6 "I think as a representational painter you have to have a certain sophistication. I still don't understand representational painters that don't look at abstract painting, that don't look at formalist painting. I can't imagine how they can make representational imagery, how they can deny the great strength abstraction has because it's inherent, whatever you think." Keith Jacobshagen quoted by Kyle MacMillan, *Omaha World-Herald*, August 28, 1988, unpaginated.

7 Letter from Keith Jacobshagen, April 2000, object file, Denver Art Museum.

8 Jacobshagen's journals deserve to be better known; see Keith Jacobshagen, "Personal Journal," in *The Changing Prairie: North American Grasslands*, ed. Anthony Joern and Kathleen H. Keeler (New York: Oxford University Press), 42–45; and Diane Stickney, "From Notebooks to Landscapes: For Lincoln Painter Keith Jacobshagen, a Habit of Making Quick Sketches Has Paid Off," *Omaha World-Herald*, June 12, 2008.

9 Interview with Jacobshagen by Joni L. Kinsey, March 4, 2005, quoted in "The Artful Plains of Keith Jacobshagen: Sublimity and Space," 16.

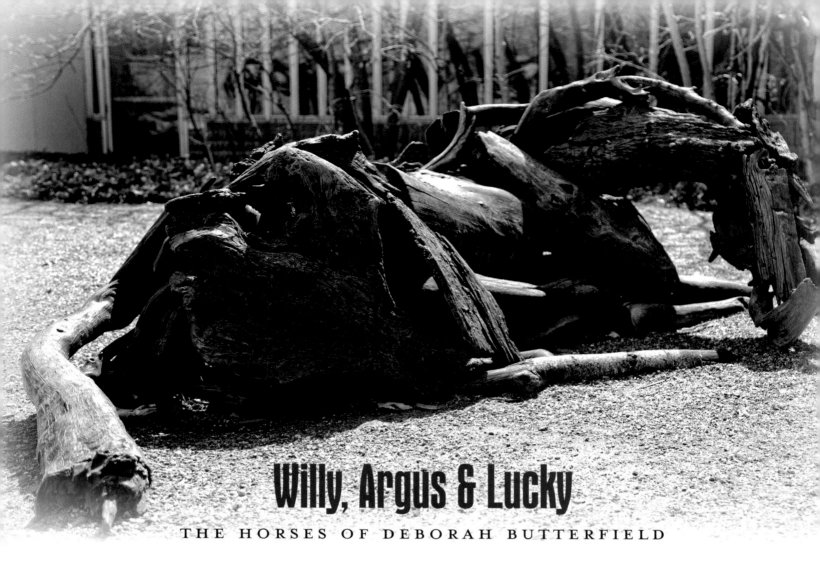

Willy, Argus & Lucky

THE HORSES OF DEBORAH BUTTERFIELD

GWEN F. CHANZIT

Deborah Butterfield

Lucky, 1996–97

Painted and patinated bronze, 33½ x 93¾ x 59½

Denver Art Museum, Funds from the Enid and

Crosby Kemper Foundation, UMB Bank Trustees,

1996.198.3

Argus, 1996–97

Painted and patinated bronze, 84¾ x 100 x 37

Denver Art Museum, Funds from the Enid and

Crosby Kemper Foundation, UMB Bank Trustees,

1996.198.2

Willy, 1996–97

Painted and patinated bronze, 85 x 92 x 54¾

Denver Art Museum, Funds from the Enid and

Crosby Kemper Foundation, UMB Bank Trustees,

1996.198.1

The group of three sculptures by Montana artist Deborah Butterfield in the Denver Art Museum's Kemper Courtyard is both site-specific and horse-specific. The lifesize horses appear to be at home—at pasture—in the sunken, grassy area of the courtyard. In fact, the individual horses after which they are fashioned each had at one time been at pasture on the artist's own property in Bozeman. There is *Lucky,* resting on the ground, whose graceful position brings to mind a reclining nude; *Argus,* standing with head down; and, with a twisted backward glance, *Willy,* her palomino who passed away on the way home from surgery at Colorado State University. The artist said she knew she would make a major work honoring her ties to Colorado. So when the Denver Art Museum commissioned Butterfield to create a signature work for the institution, *Willy, Argus & Lucky* came into being. The grouping was installed in May 1997 and has been a favorite of both visitors and staff ever since. From the beginning, Butterfield planned the tripartite work to be situated in the enclosed area adjoining the garden level entrance to the museum's historic Gio Ponti–designed building.

For as long as she can remember, Butterfield, now famous for her singular approach to equine sculptures, has felt a vital kinship with horses. She grew up in Southern California and as a youngster rode and drew horses, like many girls her age. But instead of trading those girlish interests for others, Butterfield only became more committed to horses

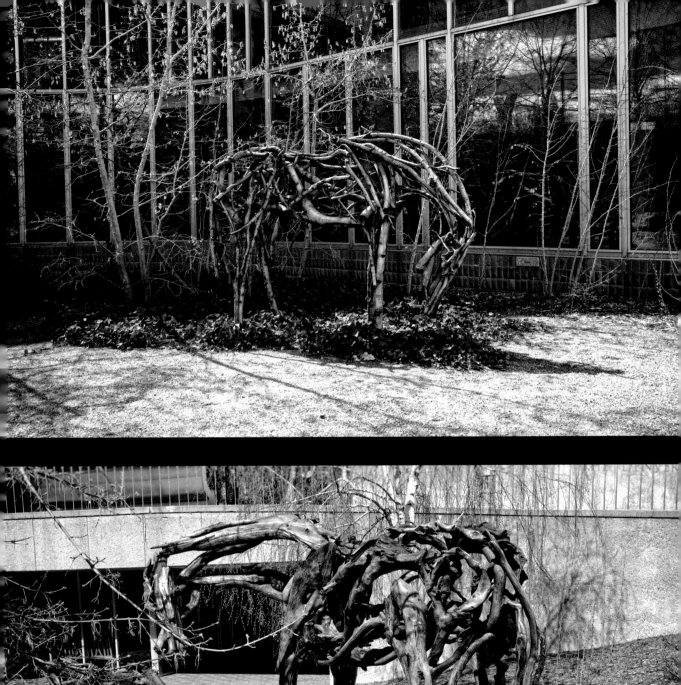
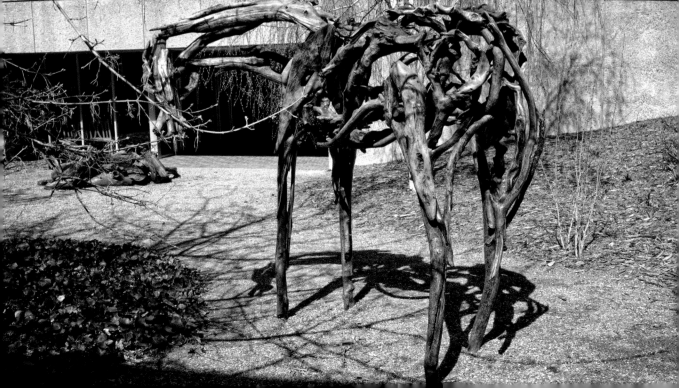

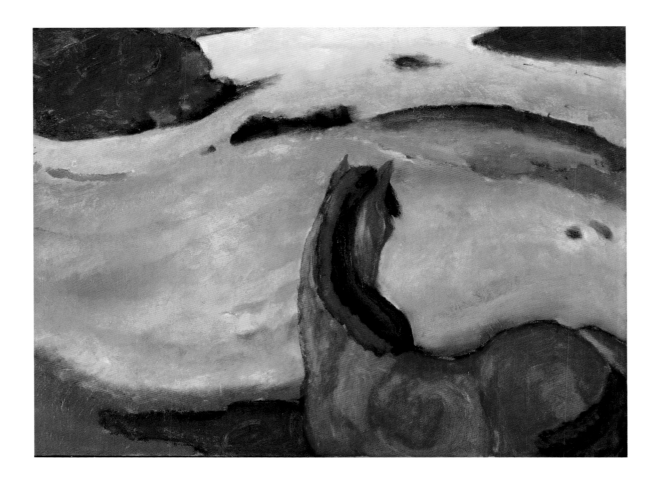

Franz Marc
Horse in a Landscape, 1910
Oil on canvas, 33½ x 44
Museum Folkwang, Essen, Germany

Deborah Butterfield
Willy, Argus & Lucky, 1996–97
Painted and patinated bronze
Denver Art Museum, Funds from the
Enid and Crosby Kemper Foundation,
UMB Bank Trustees, 1996.198.2, 3, 1

as she matured. Coming of age as an artist during a time when the only serious art seemed to be conceptual, Butterfield had to reconcile the fact that her subject-based works would be at odds with those of her colleagues.

Yet, if out of *contemporary* fashion, the subject of the horse has a long and much respected history in art. Some of the earliest depictions on cave walls in southwestern France represent horses.[1] And from Roman times forward, the equestrian statue was a favored type— famously represented by statues such as *Marcus Aurelius* and *Gattamelata*, and even into modern times—often commissioned to commemorate

knights and warriors, nobles and political leaders. Depictions of the horse also occupy a central role in western American art, from representations of cowboy bronco busters to those of Indian buffalo hunters.

No doubt, the best known horses in art were fashioned as war horses, especially those of field commanders in the cavalry. History tells us that conquests were often determined by which side had the best and the most horses. That fact was not lost on Butterfield, whose early explorations with sculptural horses were decidedly anti-militaristic. It was during the Vietnam War, and her intention was

to make a horse that would defy the traditional relationship between horses and war.[2]

Equestrian sculptures have also been interpreted according to a relationship between horse and rider, in which the position of the rider, shown as being in control, is often interpreted broadly as the mastery of reason over animalistic nature. Nothing could be farther from Butterfield's intention.

Her association with the subject embodies a very different relationship. For her, the content is personal, not sociological or historical. Even the supreme strength traditionally portrayed by the horse is not part of

Butterfield's interpretation. Her horses are more expressive, more vulnerable, approachable. She looks to depict the nature of an individual horse, and she understands the relationship between the human and the equine as mutually respectful. She also presents these magnificent creatures as autonomous beings in their own space, who would be fine without human intervention.

Butterfield's studies have included Asian, African, and American Indian art. Among sculptural precedents, images of the Chinese Tang dynasty horse—often portrayed freer of human interference than horses in western art—may provide her closest model. Yet of all the artists who took the horse as subject, the closest in sensibility may be the German expressionist painter Franz Marc, who identified so much with the soul and the spirituality of the horse that he wrote an essay whose title asked the question, "How Does a Horse See the World?"[3]

Through her own daily activities with horses, Butterfield partakes in a relationship that includes communication, mutual respect, and even identification with physical gesture. She is a horsewoman who rides dressage, provides daily care, and today makes her life on a ranch where horses are the central focus. She describes an empathetic response while working on a sculptural figure that enables her to feel each position, each weight shift, each motion.

When Butterfield arrived at the University of California, Davis, in 1969, she at first worked in ceramics. Fortunately she encountered extraordinary teachers there—in particular, the renowned ceramic artist Robert Arneson, who himself practiced and encouraged unconventional approaches. Early on, she made her horses of plaster on a steel armature. Then she added materials such as mud, twigs, and sticks. Even today, Butterfield works independent of the tides and trends of art movements.

By the end of the 1970s, as her reputation was growing, she tired of having to repair horses made from fragile, unstable materials. Turning from natural materials to scrap metal,

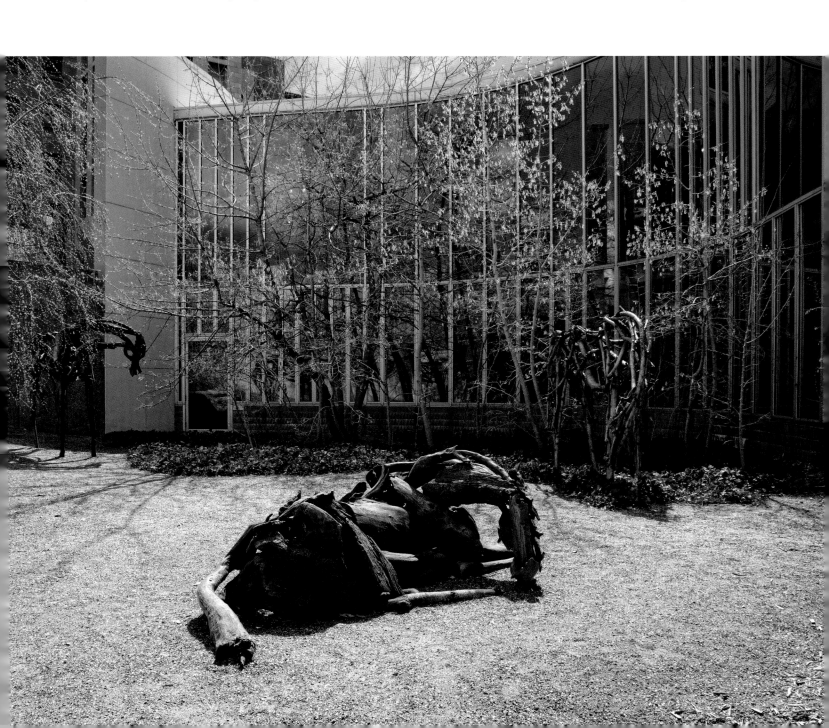

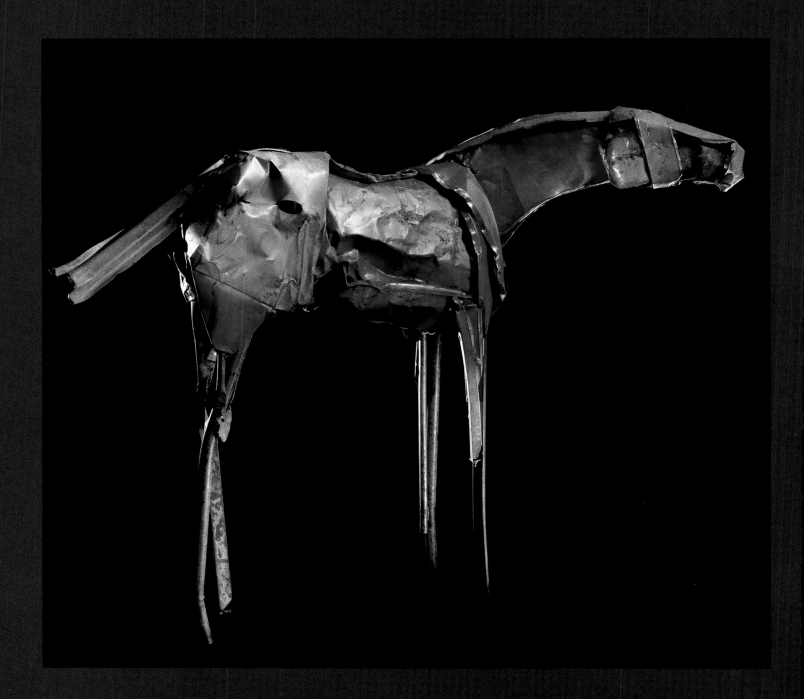

Deborah Butterfield
Orion, 1988
Painted steel, 82 x 106 x 30
Denver Art Museum, Funds from
Bonfils-Stanton Foundation, 1988.163

in works like *Orion* (1988) she used found steel—sometimes from old cars and farm equipment—which she cut, bent, and welded to express the horse. In addition to what today might be interpreted as an ecologically friendly venture, Butterfield has always acknowledged that these leftover steel pieces carry their own history to the work, which adds emotional content. In the mid-1980s, Butterfield found the best of all worlds when she turned to constructing with sticks, branches, and bark, and then had the individual wooden parts cast in bronze to be reassembled later. This combination enables the artist to work the parts directly, to realize the horse in space, and also to integrate interior spaces with mass so that we see both inside and outside at once. It allows the relationship of part to part, and of the whole to the setting. This method also enables her to retain the expressive look of sticks and vines without the fragility of those materials.

Even her armatures are made by making casts of branches. As she develops the form, she chooses which casts will be the structural support instead of turning to manufactured steel. She then constructs the wood branches and twigs around the armature. In the case of *Willy, Argus & Lucky*, Butterfield included branches saved from trimming the weeping birch tree on the museum site. The casting of these horses, each weighing between 1,600 and 2,000 pounds, was done over a period of six months at the Walla Walla Foundry in Walla Walla, Washington.

After the cast parts are reassembled, Buttterfield uses a welding torch to bring the parts together, making cuts and changes. When the parts are fashioned according to her vision, the work is tooled and the surface textured like wood; then it is sandblasted. Next she carefully patinas the bronze surfaces, first applying spray and then painting by hand to give the look of the original wooden branches. Finally the sculpture is sealed with heated wax.

Butterfield begins each work without direct sketches or maquettes; she prefers to build directly with her materials. Intuitively and by trial and error she finds her three-dimensional figure. Her method is so extraordinary that most people who see the works assume they are made of wood. Only when they touch them do people realize the material is metal. And surely part of the sculptures' allure is that they are the exception to the typical museum "do not touch" rule. It's okay for visitors to handle these sculptures. When she constructed *Willy, Argus & Lucky*, she knew they would be sited near an educational center of the museum in a place where schoolchildren would gather, and she purposely made them less spiky than some of her others.

Willy, Argus & Lucky are graceful, calm, and individually compelling. As a group, they relate to each other as well as to their setting. People experience them from across the way; from directly above near the original first floor entrance; and also on eye level—both standing among them in their grassy home and looking at them through the interior windows of the lower level. From these windows, it's as if a museum interior has extended into the outdoors, where these beautiful creatures beckon both young and old to come pay a visit.

Notes

1 Two important sites with Paleolithic cave paintings of horses are the complex of caves at Lascaux, near the village of Montignac in southwestern France; and Chauvet-Pont-d'Arc cave near the commune of Vallon-Pont-d'Arc in southern France.

2 Deborah Butterfield, interview by Marcia Tucker, in *Horses: The Art of Deborah Butterfield* (Coral Gables, FL: Lowe Art Museum, University of Miami; San Francisco: Chronicle Books, 1992), 17–19.

3 Franz Marc, *Briefe, Aufzeichnungen und Aphorismen*, 2 vols. (Berlin: Cassirer, 1920), I:121–22. English translation by Ernest Mundt and Peter Selz in Herschel B. Chipp, *Theories of Modern Art* (Berkeley, Los Angeles and London: University of California Press, 1968), 178–79.

Donald Sultan
Black Lemons May 20 1985, 1985
Charcoal on paper, 59¾ x 48
Collection of the Modern Art Museum of Fort
Worth, Gift of Mr. and Mrs. F. Howard Walsh Jr.

Motherwell's Angus by Theodore Waddell
WHOSE CATTLE ARE THESE?

DEAN SOBEL

As a painter living in New York during the early 1960s, Theodore Waddell faced a predicament, not unlike one shared by other artists who emerged in the shadows of abstract expressionism as it was developed by towering figures like Jackson Pollock, Clyfford Still, Mark Rothko, Robert Motherwell, and others more than a decade earlier.[1] This movement was so original it had become an albatross, a monkey on one's back. But by the start of the sixties, abstract expressionism had been reduced to a "style" so pervasive it was being taught in art schools and in the process, watered down to the point where it had none of the transformative

and humanistic qualities intended by its first generation of artists. This caused, alternately, a crisis in determining how painting should move forward but also a groundswell of potential in stimulating fresh ideas. Artist and critic Allan Kaprow, in his prophetic essay, "The Legacy of Jackson Pollock," described this condition concisely:

But *what do we do now?*[2]

Certainly pop art was the most evident movement to challenge the authority of abstract expressionism, but by the middle of the 1960s it became clear that pop would be short-lived and not of interest for most painters, including Waddell, who preferred "textures" (his term) and more earnest forms of art-making to the ironies of pop art and its reliance on low-culture appropriation and machine-created appearance.[3] As pop's reign began to recede in the

late 1960s, many young artists, often referred to as post-minimalists, began to prune select elements from abstract expressionism—its concern for a timeless monumentality, attention to touch and process, and adherence to personal feeling—and graft them onto their practice. As a result, new and rejuvenated art forms that embraced—somewhat startlingly—a variety of narrative, representational, or human qualities began to emerge.[4]

It is within this context that Waddell's work should be considered. Having returned to his native Montana to continue his studies and teach (and ultimately establish residence), Waddell began working in various sculptural idioms throughout the late 1960s and early 1970s before returning to the easel, where he slowly developed a highly personal approach to painting in which the process, gesture, and touch

of abstract expressionism were joined with his—and the art world's—new tolerance for images. Perhaps most important, Waddell began to instill aspects of his own autobiography into his works, which with the exception of his stays in New York and later Michigan for a graduate degree were indebted to his birthplace in the American West, particularly the western plains of Montana and Idaho. While his year in New York was significant—he speaks and writes about this time as being well spent—Waddell became increasingly drawn to the qualities and sensations (and scale) of the American western landscape, which he knew he could make uniquely his own. In doing so, he would establish a dialogue with not only abstract expressionist artists, but equally with the great artists who define the art history of the region, figures like Albert Bierstadt, Frederic Remington, and Charles Russell, whose subject matter and spirit he would reinterpret in contemporary terms.

By the early 1980s, Waddell had refined his working methods into what has become his signature approach— paintings in which he incorporated animals (cattle, horses, sheep, and, sometimes, dogs), into expressive, painterly, nearly abstract backgrounds that suggest the landscape. These backgrounds, which are composed of gestural, atmospheric passages of brilliantly applied paint, engulf whatever figural elements he has included to create allover patterns in which figure

and ground fuse in the shallow space of the picture plane.

In these ways, Waddell's work, not entirely coincidentally, can be linked to a larger movement in American art developed by artists of his generation and often described as "new image" painting or "new figuration." Artists working in this style include Susan Rothenberg and Donald Sultan, who similarly introduced, albeit tentatively, representational images into otherwise painterly, formalist surfaces.[5] As a result, we can see these artists as a linchpin between the formal practices of the 1950s and 1960s and the more content-laden, imagistic tendencies of many movements of the last thirty years, including the international neo-expressionism movement of the 1980s but also the prevalence of representational art that marks so much of the art of the 1990s and beyond.[6]

Waddell's *Motherwell's Angus* (1994) represents the zenith of his mature approach. This large work (measuring roughly six feet square) includes suggestions of Waddell's characteristic pasture animals, here cattle, rendered as bold, bulbous black ovals spread across the composition in a seemingly random pattern. These small black oblongs—it's hard to describe them in more specific (i.e., representational) terms—are placed within a luminous, painterly field built up from off-white paints punctuated in small areas by whispers of subtle, nearly sky-blue. The background (a snow-swept landscape?) is rendered

with masterful, highly gestural strokes and palette-knife work, ranging from dabs and drips to long paint-passages and, in a few instances, near-sgraffito-like incisions made with hard tools, such as the end of his brush.

Motherwell's Angus embodies perhaps Waddell's most significant feature: an overall surface quality that seems to shimmer with his distinctive touch and gesture. Combined with his astute sense of tone, the effect of this painting is as much aligned with the work of late nineteenth-century European artists like Claude Monet and Pierre Bonnard as it is with that of Motherwell and the abstract expressionists, let alone Bierstadt or Russell.

The point of view in *Motherwell's Angus* is ambiguous; the space of the painting is so shallow and flattened that it appears, initially, as if we're seeing a pasture from an aerial perspective, from a plane that has just taken off. More likely, Waddell has upturned his perspective this severely so that the painting reads like the "allover" compositions of abstract expressionist painting (though it also recalls, subtly, the flattened, lateral space of classical Chinese landscape paintings). Like his New Image contemporaries, particularly Rothenberg, who would tether her horses and other subjects with lines and Xs to the edges of her compositions— thus snapping the figures toward frontal flatness—Waddell pulls his images flat against the picture plane

Theodore Waddell
Motherwell's Angus, 1994
Oil on canvas, 72 x 72
Denver Art Museum, Gift of Barbara J.
and James R. Hartley, 1999.84

Claude Monet
Waterloo Bridge, 1903
Oil on canvas, 25 x 383/4
Denver Art Museum, Funds from
Helen Dill bequest,1935.15

Robert Motherwell
Elegy to the Spanish Republic #172 (With Blood),
1989–90, Acrylic on canvas, 84 x 120
Denver Art Museum, Acquired in memory of Lewis
W. Story through the generosity of the Dedalus
Foundation and the following donors: Florence R.
& Ralph L. Burgess Trust, Laurencin Deaccessions
Fund, Vance Kirkland Acquisitions Fund, and the
Marion G. Hendrie Fund, 1994.1134

as a means to retain the strict dictums of late modernist painting that, again, link him to a generation seasoned on the orthodoxy of art of the 1950s and Greenbergian flatness.[7]

It is significant that Waddell landed on Motherwell as a harbinger of potentiality. Like all the abstract expressionists, Motherwell created a unique, highly personal signature "image" that he used throughout his career. For Motherwell, this was the large, swelling, bulbous forms most eloquently expressed in his ongoing (and best-known) "Elegy to the Spanish Republic" series. Though Motherwell worked in other important series (such as his very different "Je t'Aime," "Summertime in Italy," and "Open" series) it's certainly the Elegies and related works that Waddell evokes through the arced, black shapes in his Angus series of paintings, drawings, and prints.[8] For both artists, bold black forms express a kind of timeless grandeur while adding visual power and "weight" to their compositions.

Motherwell frequently struggled when assigning titles to his non-objective works. In the Elegy series, he strove for a nomenclature that expressed his feelings about the tragedy of the Spanish Civil War, particularly as it

was described through the writings of Spanish poet/activist Federico García Lorca, a favorite of Motherwell's. Describing his choice of the word "elegy," Motherwell said that it was "an effort to symbolize a subjective image of modern Spain [in terms of] funeral pictures, laments, dirges, elegies—barbaric and austere."[9] As one critic has observed, rather than represent Lorca the man in his Elegies, Motherwell chose to follow the dictum of symbolist poet Stéphane Mallarmé, "to paint, not the thing, but the effect it produces."[10]

Titles are vital for Waddell as well, as these verbal keys provide an opportunity for narrowing down meaning while provoking a deeper mental focus on the part of the viewer. In describing the Motherwell's Angus series, he explains that "except for the fact that the title implies Angus, hence subject matter, this painting could be considered totally abstract."[11] It's this desire to pull his work back from total abstraction that allows us to read Waddell's paintings in more specific ways. Beyond the many formalist considerations—color and tone, touch and gesture, perspective and spatial flatness, etc.—and the ways he pays homage to his sources and influences, it is important not to ignore the content of Waddell's painting. The cattle and other animal subjects that mark his career symbolize noble, isolated individuals—surrogates for humankind and possibly the artist himself. Like

virtually all the abstract expressionists who had disbanded and relocated to remote places like the Hamptons (Pollock, de Kooning), Maryland (Still), or Connecticut (Motherwell) after mid-career, Waddell has found strength in his relative isolation in Montana and Idaho, far removed from the centers of the art world. Perhaps above all else, *Motherwell's Angus*, among its many attributes and meanings, expresses—through simple paint on canvas—feelings of peace, solitude, pride, comfort, and harmony. This is perhaps the work's, and Waddell's, crowning achievement.

Notes

1 Waddell studied painting at the Brooklyn Museum Art School during 1962 and 1963.

2 Allan Kaprow, "The Legacy of Jackson Pollock," *ARTnews*, October 1958, 24–26.

3 Conversation with the artist, January 5, 2011.

4 See, for example, the work of Eva Hesse, who literalized abstract expressionist gestures into solid, new materials; Joel Shapiro, who crafted minimalist sculptures into simple house forms; Brice Marden, whose paintings of the late 1960s were scaled to human proportions and done in romantic earth tones evocative of particular places; and Jackie Winsor, who used the processes of wrapping, pounding, or carving as an end in themselves.

5 The term "New Image Painting" has its origins in the Whitney Museum of American Art's eponymous 1978 exhibition, curated by Richard Marshall. The term "New Figuration" was applied by Russell Bowman in his early

study of the New Image and neo-expressionism in his 1982 exhibition *New Figuration in America* at the Milwaukee Art Museum. As many chroniclers of the movement have observed, the abstract expressionist Philip Guston, who in the late 1960s abandoned his abstract style for figuration, was a model for this new approach to painting by a younger generation.

6 In my view, if anything defines the pluralistic art of the past two decades, it would be the tendency toward subject matter (oftentimes hard-hitting, such as death) and the desire, amid the cacophony of a hyperactive art world, for works that veer toward "spectacle." For a further discussion of these tendencies, see my "Above the Radar: The Logan Collection in Context," in *Radar: Selections from the Collection of Vicki and Kent Logan* (Denver: Denver Art Museum, 2006), 43–51.

7 Through a series of essays and reviews, art critic Clement Greenberg proposed, among many other ideas, that advanced painting had to acknowledge its inherent two-dimensionality. See, for example, his "Towards a Newer Laocoön," *Partisan Review* 7 (1940): 296–310.

8 According to the artist, there are twenty paintings in this series, as well as many related drawings and prints.

9 Quoted in Robert C. Hobbs, "Motherwell's Elegies to the Spanish Republic," in Jürgen Harten, *Robert Motherwell* (Düsseldorf: Städtische Kunsthalle, 1976), 29–34.

10 Ibid.

11 Statement by the artist, on deposit in the object file at the Denver Art Museum.

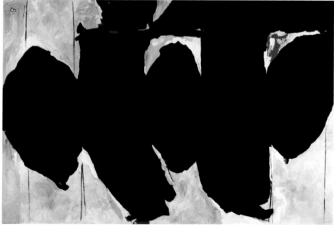

MICAH MESSENHEIMER

E ntropy, as stated in the Second Law of Thermodynamics, is a measurement of the instinctive state of highly disordered equilibrium toward which energy tends. Accordingly, an understanding of the concept in art can be found in representations of chaotic structures or environments. Throughout David Maisel's photographic oeuvre, entropy is visualized through issues that are central to existence in the American West today. In his series that deal explicitly with water—*The Lake Project* (2001–02), and *Terminal Mirage* (2003–05)—the viewer is confronted with the unraveling of the interconnected web of culture and nature as a symbol for the entropic. According to environmental writer William L. Fox, this rupture is quintessentially modern, reflected in contemporary society's "essential, existential fear. . . the anxiety of estrangement from the world."[1] At no previous time has a single species so drastically altered geologic time or made its effects visible in such a short period. One can therefore characterize Maisel's recording of human markings on the land as *entropological*, a term defined by French anthropologist Claude Lévi-Strauss as "the discipline concerned with the study of the highest manifestations of this process of disintegration."[2]

Archaeological and paleontological references in Maisel's writing bear

Robert Smithson
Plunge, 1966
Steel, 14½ x 19 each unit
Total of 10 units with
square surfaces
Denver Art Museum,
Gift of Kimiko and John Powers, 1977.672

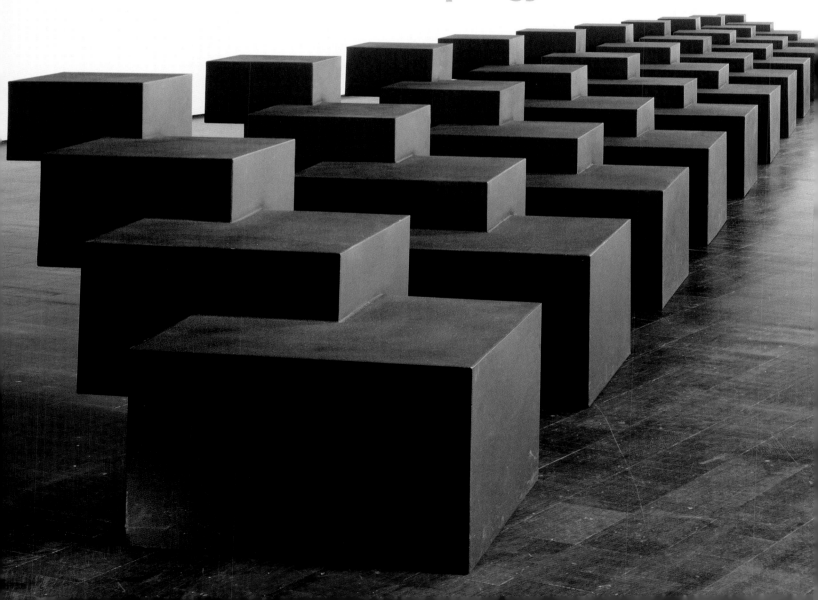

On Entropology

strong resemblance to similar preoccupations of sculptor and land artist Robert Smithson. In 1990 Maisel received a National Endowment for the Arts grant that allowed him to travel to the western states to work on his series *The Mining Project*. Here he began shooting in color and utilizing greater distortions of scale and abstraction. With color media, water became a more prominent feature in his work; due to its vulnerability to environmental contamination, water has the ability to assume kaleidoscopic hues. The appearance of the land was a motivator for Maisel's move to the West in 1993, where, as he states, "the bones of the landscape are exposed."[3] Yet possibly more important reasons were those of subject and site. By this point, Maisel was photographing "deconstructed

the concept is represented by what he considered universal, valueless forms that "neutralize the myth of progress,"[6] evident in his statement that "In the ultimate future the whole universe will burn out and be transformed into an all encompassing sameness."[7] Smithson also posits that minimalist forms could slow the entropic cycle by redefining time from linear to disjunctional.[8] Maisel's work, as with all photographic media, captures a suspended instant of time; yet his goal is the converse: to express the frenetic velocity of entropy while making visible the schisms in the human-environmental system. For Smithson art becomes the *mark* of entropy, whereas for Maisel, art illuminates the *process* of entropy. Maisel explicitly seeks reaction, while Smithson finds clarity in inaction, contending:

particularly true of his understanding of abstraction, which Smithson sees as "renderings and representations of a reduced order of nature." In opposition to his modernist peers, he argues that abstract art cannot be approached without an understanding of nature and faults them for their failure to consider the expression of entropy on the environment, contending, "Abstraction is a representation of nature devoid of 'realism' based on mental or conceptual reduction. There is no escaping nature through abstract representation; abstraction brings one closer to physical structures within nature itself."[11] Curiously, Smithson found the camera—an instrument strongly associated with its descriptive power—most suitable for creating this union.[12] This quality is also

THE VIVID WATERS OF DAVID MAISEL AND ROBERT SMITHSON

landscapes of strip mines, cyanide leaching fields, ore concentrators, and tailings ponds,"[4] partially inspired by Smithson's proposed remediations for abandoned mine sites. Although Smithson never made a conceptual distinction between his work in the West and his work elsewhere, his writings show a fascination with the visible effects of entropy on the western landscape. He made a tactical decision to site his seminal work, *Spiral Jetty,* at Rozel Point, Utah, due to the contiguity of abandoned oil wells—drawing a conceptual association between petroleum and fossilization—and aimed for the work to likewise become a fossil of his own creation.[5]

These processes of human and geological time are visual expressions of entropy for both artists. Yet, Maisel and Smithson illustrate surprisingly different formal conceptions of the term: Maisel's version is marked by otherness and hyperreality, whereas for Smithson

Perception as a deprivation of action and reaction brings to mind the desolate, but exquisite, surface-structures of the empty "box" . . . As action decreases, the clarity of such surface-structures increases. This is evident in art when all representations of action pass into oblivion. At this stage lethargy is elevated to the most glorious magnitude.[9]

Maisel finds an inherent dialectic in Smithson's work in the conflict between the natural and the rational: "a closed epistemological system which questions perception and knowledge."[10] Similar dialectics can be detected in Maisel's work—city vs. desert, beauty vs. horror—yet, in photographing, Maisel offers a decidedly cultural view of the western landscape. In his writings, Smithson also encourages a unified consideration of humans and nature—and of art and nature. This is

evident in Maisel's work. By exposing environments that are, in large part, caused by a dangerously increasing rate of entropy, his photographs present a decidedly lucid picture of the structures in which it acts.

In *The Lake Project*, Maisel establishes that water has been treated as an extraction industry comparable to others in the West, and *The Lake Project 1* (2001) clearly illustrates this parallel. The use of "lake" in the title of the work gives some indication that one is viewing a body of water; however, all that can be immediately identified are three vertical bands of color, which, in their intensity and abstraction, immediately remind one of a non-representational painting. On closer scrutiny, sand and greenish pools of standing, brackish water emerge, bisected by a road on the left side of the photograph. The powdery white mineral deposits on the right appear to have been scoured through,

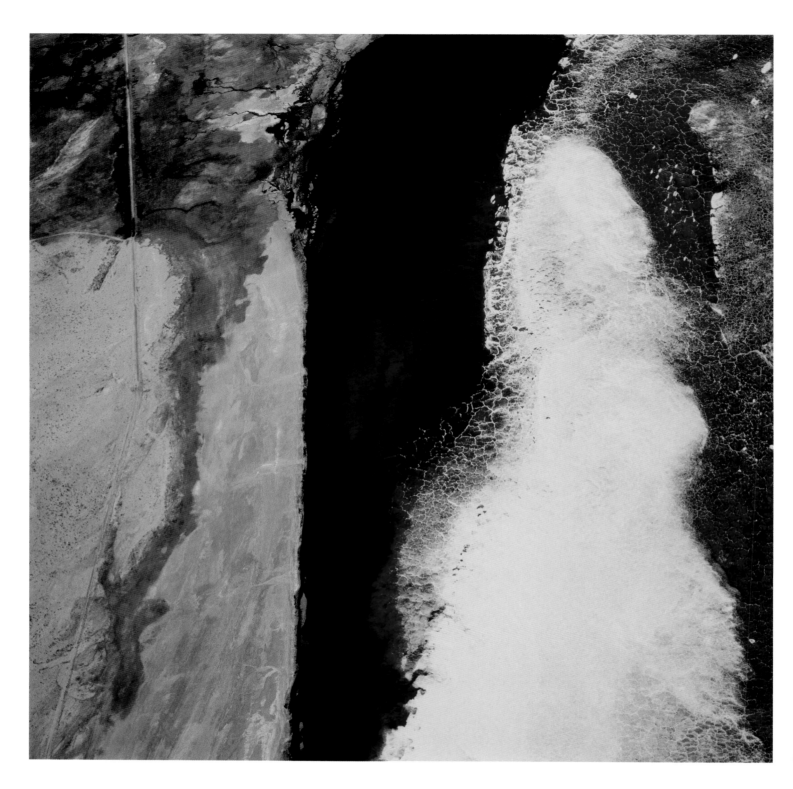

David Maisel
The Lake Project 1, 2001
Chromogenic color photograph, 15 x 15
Denver Art Museum, Gift of Alan Manley,
2010.543

David Maisel
The Lake Project 25, 2002
Chromogenic color photograph, 48 x 48
Courtesy the artist

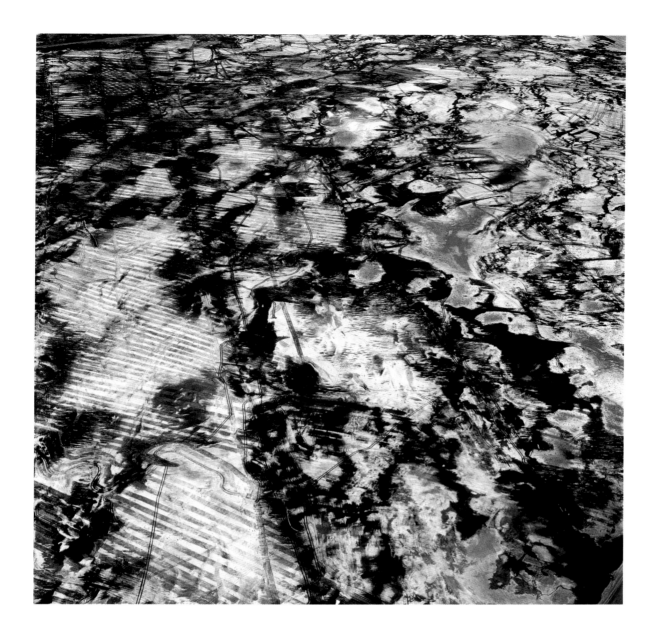

revealing capillary-like rivulets that coalesce into a carmine stream running through the center. This visceral linkage of human blood and water manifests the essential bond between Maisel and Smithson—Maisel is able to make visible Smithson's poetic and hallucinatory lines: "On the shores of Rozel Point I closed my eyes, and the sun burned crimson through the lids. I opened them and the Great Salt Lake was bleeding scarlet streaks. My sight was saturated with the color of red algae circulating in the heart of the lake, pumping into ruby currents, no they were veins and arteries sucking up the obscure sediments."[13] Maisel purposely

utilizes the aerial view as a formal expression of entropy: by abstracting landscape and condensing large areas of space, one is unable to place where one is and what one sees. No traditional artistic references of foreground or background are available for the viewer; thus one is unable to locate a horizon or determine a sense of scale, resulting in contextual disorientation. However, a frame of reference is of immeasurable importance to the meaning of this work.

Common adage proclaims that water tells the stories of the West. Central to an understanding of its importance are the frequently oppositional issues of water rights and environmental

sustainability. Prior to the 1913 diversion of its source river by the Los Angeles Department of Water and Power, Owens Lake, California—the site of the *Lake Project*—was saline, but blue in color, and maintained a surface area of over one hundred square miles. As a result of the city's expropriation, by 1926 its waters had exsiccated for the first time in over 800,000 years, turning the resulting bed into arid mineral flats.[14] Constant, toxic dust storms now endemic to the Owens Lake playa are over one hundred times more severe than those on other dry desert lakes, as frequent saturation and desaturation of the soil causes a

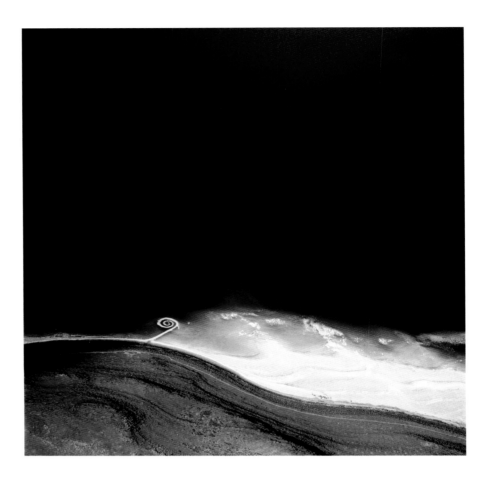

David Maisel
Terminal Mirage 4, 2003
Chromogenic color photograph, 48 x 48
Courtesy the artist

cracked, brackish surface particularly prone to airborne erosion.[15] Yet, despite appearances, the lake is teeming with life, albeit singular and extraordinary. Like the section of the Salt Lake chosen by Robert Smithson for *Spiral Jetty*, the remaining alkaline water is subject to infestations of microscopic halobacteria and unicellular algae that give it a vivid, blood-red hue; these organisms require extreme salinity to survive and are so resilient that they are among the exceptional organisms believed to exist on other planets in the solar system,[16] befitting the otherworldliness of Maisel's photographs.

Federal rulings have required Los Angeles to control the dust rising off Owens Lake. The remediation seems benign—refilling the lake with minimal amounts of water and seeding with salt tolerant plants. Yet, these efforts

are intensive: the bed of the lake must be bulldozed and leveled and massive ditches and berms constructed to contain and recirculate the water.[17] Smithson offers an anecdote that illustrates how such attempts to turn back time result in greater complexity than intended:

I should now like to prove the irreversibility of eternity by using a *jejune* experiment for proving entropy. Picture in your mind's eye the sandbox divided in half with black sand on one side and white sand on the other. We take a child and have him run hundreds of times clockwise in the box until the sand gets mixed and begins to turn grey; after that we have him spin anti-clockwise, but the result will not be a restoration of the original division,

but a greater degree of greyness and an increase of entropy.[18]

In his essay "Entropy and the New Monuments," Smithson references the cultural historian and critic Wylie Sypher's definition of entropy: "Entropy is evolution in reverse."[19] Smithson discerns that entropy is necessary for the functioning of society. Yet, as Ron Graziani highlights, "by reconceptualizing the sublime . . . as a slow, drawn-out, low energy form of entropic inevitability—instead of a traditional pictorial image of an awe-inspiring powerful force—Smithson's narrative of modern society's entropic confinement collided with those seeking transcendence."[20] This understanding is quite evident in the toxicity of the sites Maisel photographs. In these waters we see a contraction of life to a few resilient

species rather than an evolutionary diversification. Furthermore, the acts of transferring water or minerals across the desert are themselves entropic processes. Remaking the environment to suit human needs changes both the recipient and the source environments. Such acts mark a species that feels unconstrained by evolution and places itself at a distance from its own environment, hauntingly echoing Sypher's definition. There is no need to live near water, our primary requirement for life, as we can take it from elsewhere.

Smithson's writings provided the impetus for Maisel's subsequent project, *Terminal Mirage*, and led the photographer on a search for imposed structures around the Great Salt Lake. The use of "terminal" in the title denotes the lake's lack of a natural outlet, a circumstance resulting in its characteristic brackishness. Yet, humans have altered this property through extraction and reconstruction of the lake's contour. Thus, "terminal" also parallels the devitalized physical condition of the lake as a consequence of intervention. Maisel considers this work "rational mapping"—giving order to cataclysmic sites.[21] As such, his photograph of Smithson's *Spiral Jetty, Terminal Mirage 4* (2003), at first seems atypical; at the outset, Maisel endeavored to photograph the work as an homage. Indeed, the predominantly cool color palette found in only a few other images from *Terminal Mirage*, and the diminutive size of the earthwork in relation to land and water, lend the photograph a unique sense of placidity.[22] Yet, in the context of Maisel's entropology, we can also see *Spiral Jetty* as an indictment: a formal structure no different than those in Maisel's other images. Smithson justifies the practice of land artists as linked to the natural progress of entropy that continually affects the land, but more suggestively, to processes of industrialization and suburban sprawl. As he sees the concept as a valueless state, he makes no differentiation between these activities.[23] Maisel, in contradiction, notes a growing disconnect between humans and the ecologic system caused in part by industry and sprawl, without exculpating himself—as a denizen of the West—as a causal factor. In many respects these artists chose the same remote, western spots as industry and the military—both uncovered in Maisel's photos—for the same reasons. It allowed them both space and the lack of an intrusive eye: these were hidden terrains.

Notes

1 William L. Fox, "Shadowlands," introduction to *Oblivion*, by David Maisel (Tucson, AZ: Nazraeli Press, 2006), n.p.

2 Claude Lévi-Strauss, *Tristes Tropiques*, trans. John Russell (New York: Criterion Books, 1961), 367. Robert Smithson notes the need to consider art within Lévi-Strauss's framework in "Art Through the Camera's Eye," in *Robert Smithson: The Collected Writings*, ed. Jack Flam (Berkeley: University of California Press, 1996), 375.

3 David Maisel, interview by Geoff Manaugh, *Archinect*, March 20, 2006; http://www.archinect.com/features/article.php?id=35223_0_23_0_M. Last accessed 1/13/2011.

4 David Maisel, "The Enchantment of the Aesthetically Rejected Subject," artist's statement about *The Mining Project*; http://www.davidmaisel.com/works/picture.asp?cat=min&tl=the%20mining%20project. Last accessed 2/28/11.

5 Robert Smithson, "The Spiral Jetty," in *The Writings of Robert Smithson: Essays with Illustrations*, ed. Nancy Holt (New York: New York University Press, 1979), 111.

6 Smithson, "Entropy and the New Monuments," in *The Writings of Robert Smithson*, 13.

7 Ibid., 9.

8 Ibid., 10.

9 Ibid., 12.

10 Maisel, "Unraveling Smithson: Some Thoughts and Considerations Regarding Robert Smithson's Art and Writings and Their Effect and Influence on My Own Art Practice" (2004); http://davidmaisel.com/works/inf_pre_ess_smithson.asp. Last accessed 1/13/2011.

11 Robert Smithson, "Frederick Law Olmstead and the Dialectical Landscape," in *The Writings of Robert Smithson: Essays with Illustrations*, ed. Nancy Holt (New York: New York University Press, 1979), 122.

12 Smithson, "Art Through the Camera's Eye," 374. Smithson states: "It appears that abstraction and nature are merging in art, and that the synthesizer is the camera."

13 Smithson, "The Spiral Jetty," 113.

14 Wayne P. Armstrong, "Why Owens Lake is Red," *Desert Magazine* 44, no. 4 (1981): 23; and Marith C. Reheis, "Owens (Dry) Lake, California: A Human-Induced Dust Problem," in *Impacts of Climate Change on the Land Surface*, United States Geological Service (1997); http://geochange.er.usgs.gov/sw/impacts/geology/owens. Last accessed 1/13/2011.

15 Reheis, "Owens (Dry) Lake, California." The lake is notable for being the worst single-point source of airborne particulate matter in the country, with dust storms—termed "Keeler fogs" in local vernacular after a town on the east shore of the lake—carrying loose, microscopic particles of arsenic, cadmium, chromium, and other heavy metals.

16 Armstrong, "Why Owens Lake is Red," 24.

17 David Maisel, "The Owens Lake Project," *Nieman Reports* 59, no. 1 (2005): 17.

18 Smithson, "A Tour of the Monuments of Passaic, New Jersey," in *The Writings of Robert Smithson*, 56–57.

19 Wylie Sypher, *Loss of the Self in Modern Literature and Art* (New York: Random House, 1962), 74, quoted in Smithson, "Entropy and the New Monuments," 13.

20 Ron Graziani, "Robert Smithson's Picturable Situation: Blasted Landscapes from the 1960s," *Critical Inquiry* 20, no. 3 (1994): 431.

21 Maisel, "Unraveling Smithson."

22 A second photograph, *Terminal Mirage 15*, 2003–05, featured on Maisel's website but not included in his book, is much more forbidding—with red waters, a charcoal-black landscape, and the glowing white form of *Spiral Jetty* centered in the work. For image, see: http://www.davidmaisel.com/works/photo/ter_gr1_m_15.jpg. Last accessed 1/13/2011.

23 Although Smithson does note a difference in their ultimate form. "A Sedimentation of the Mind: Earth Projects," in *The Writings of Robert Smithson*, 82.

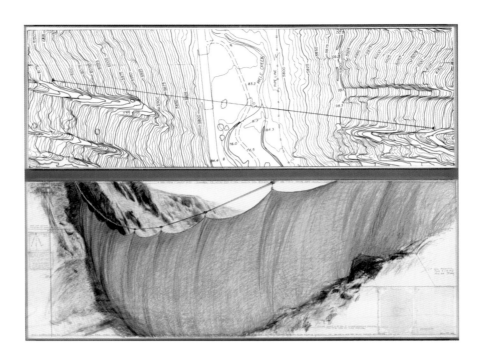

Valley Curtain

PROJECT FOR RIFLE, COLORADO

JILL DESMOND

"...our work is a scream of freedom."[1] CHRISTO

Christo
Valley Curtain, Project for Rifle, Colorado, 1972
Graphite, crayon, and collage on paper,
32 x 96 and 36 x 96 (two panels)
Denver Art Museum, Partial gift of Judy and
Ken Robins and funds from various donors
by exchange, 1996.17. ©Christo 1972

Christo and Jeanne-Claude
Valley Curtain, Rifle, Colorado, 1970–72
©Christo 1972
Offset lithograph, 33 x 25$^1$/$_{16}$
Denver Art Museum, Gift of Christo
and Jeanne-Claude, 1995.139.1.
Photo by Harry Shunk

On the morning of August 10, 1972, about 215 miles west of Denver, in the Grand Hogback Mountain Range, a crowd of approximately one hundred people watched as the rip cords for Christo and Jeanne-Claude's now legendary *Valley Curtain, Rifle, Colorado 1970–72* were pulled.[2] A gargantuan orange curtain was hoisted across the quarter-mile–wide chasm of Rifle Gap. The billowing fabric remained intact for only twenty-eight short hours before the unpredictable Rocky Mountain winds thundering through the valley began to tear the curtain. The gusts were so strong, they were said to generate enough force to power two ships similar in size to the Queen Mary.[3]

Christo and Jeanne-Claude were not discouraged, as their artistic practice had long been inspired by the allure of the ephemeral—a beguiling and recurring element in their work. "Nobody kicks a butterfly because it's so fragile and temporary," said Jeanne-Claude. "No one says, 'I'll look at the rainbow tomorrow.'"[4] In light of the fleeting nature of this temporary art work, Christo and Jeanne-Claude were aware of the importance of documenting their projects and were committed to creating a legacy of original drawings, collages, photographs, scaled models, and other supporting materials as lasting records of their artistic endeavors.

Valley Curtain was Christo and Jeanne-Claude's sixth architectural-scale project and first major venture in the U. S. Inspired by the rugged beauty of the landscape and the overwhelming sense of freedom associated with the American West, they, like many artists before them, found themselves caught

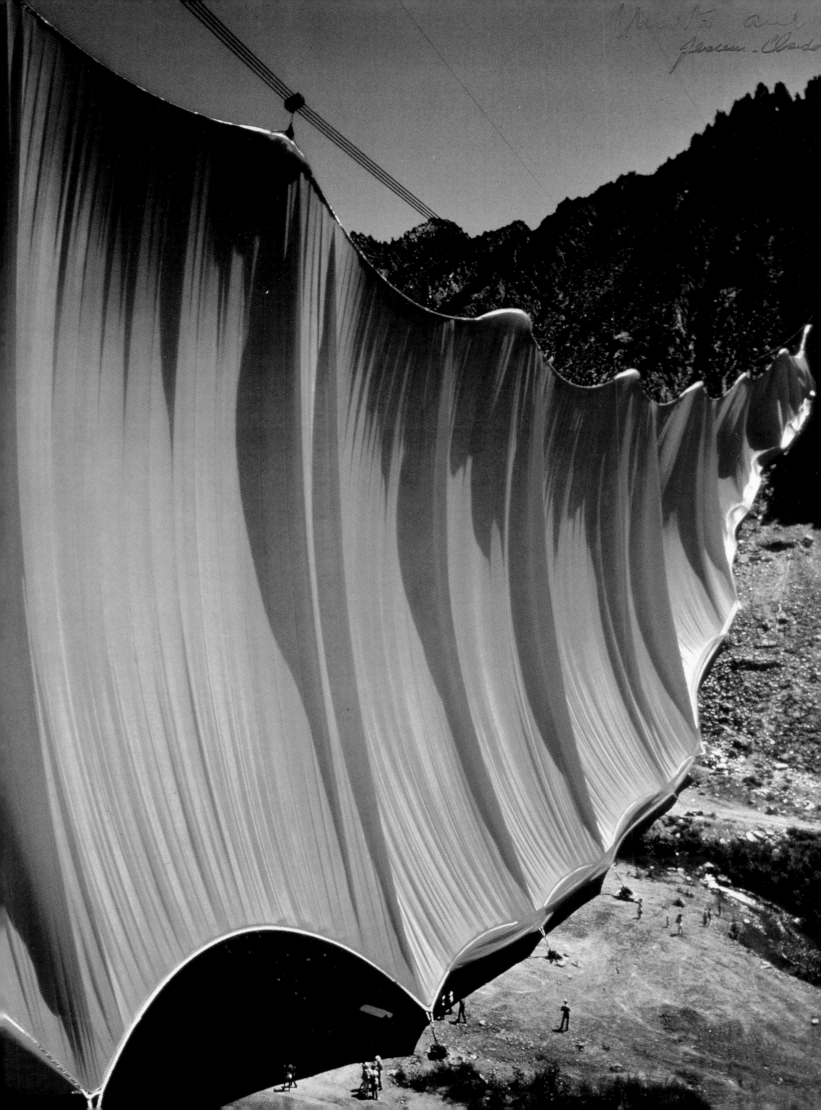

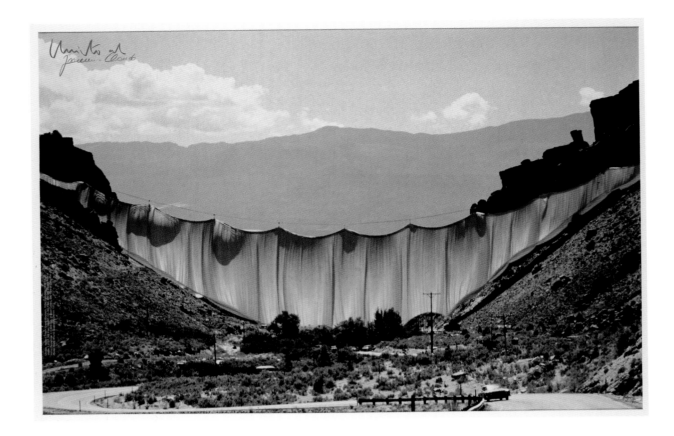

Christo and Jeanne-Claude
Valley Curtain, Rifle, Colorado, 1970–72
©Christo 1972
Offset lithograph, 33 x 25$^{1}$/$_{16}$
Denver Art Museum, Gift of Christo
and Jeanne-Claude, 1995.139.2
Photo by Harry Shunk

up in a romance that resulted in an enduring love affair with the region that later inspired other projects.

In 1996, the Denver Art Museum received a partial gift of a large preparatory drawing, *Valley Curtain, Project for Rifle, Colorado* (1972) from longtime Denver Art Museum donors Judy and Ken Robins. The remainder of the acquisition was funded by the generosity of numerous donors. This original work consists of two separate panels: the upper panel is a topographical map of the area known as Rifle Gap, while the lower depicts a detailed working drawing for the project complete with dimensions, handwritten installation notes, and superimposed annotated drawings that refer directly to specific construction details for the project. The combination of a topographical map with a rendering of the proposed project evolved as a signature style of Christo's.

The topographical map in the upper panel locates and orients the curtain in the landscape, providing viewers with geographical points of reference and allowing them to conceptualize the terrain. It also conveys the near-perfect natural symmetry of the site, which results from its having been slowly carved by an ancient glacier. Christo adapted this symmetry and hung the curtain from the same elevation on both sides of the valley, allowing him to fill the void with a perfectly proportioned crescent moon shape.

In contrast, the detailed drawing in the lower panel portrays a more intimate rendering by the hand of the artist. Expertly drafted, the drawing illustrates Christo's characteristic quick and precise sketching technique in a peripheral view of the installation. This altered perspective offers viewers insight into the sheer scale of the project and encourages them to imagine what the curtain would have looked like from this vantage point.

Color and composition are primary as the artist considers the volume and form of the curtain that fills most of the drawing's surface. This bold, dominant form contrasts with the more carefully rendered details of the surrounding terrain. The drawing shows the curtain's structure seamlessly integrated with the landscape and emphasizes the scale and beauty of the site.

Like many artists, Christo develops the idea for each project in drawings, photographs, and collages; however, unlike the work of most other artists, these preparatory drawings survive as the lasting records. Once settled on an idea, Christo and Jeanne-Claude would begin the arduous task of securing approvals and permits from entities including various federal and state organizations, highway departments, telephone companies, utility companies, local agencies, private companies, private land owners, and local residents.

Christo and Jeanne-Claude were determined to maintain total artistic control and the freedom to realize their true uncompromised vision. This was supported by their decision to completely fund all projects themselves—mainly through the sale of original works. While this meant that many projects took decades to realize, Christo and Jeanne-Claude remained passionately driven by their mission— to bring art and people together.

The massive undertaking of projects such as *Valley Curtain, Rifle, Colorado 1970-72* is a testament to the dedication and unwavering persistence exercised by Christo and Jeanne-Claude throughout their long and prolific collaboration. The surviving documentation only hints at the colossal scale of the project, and it is only when one begins to unravel the complexity of the process and the specific details of the installation that the sheer magnitude of the project comes to life.

The suspended curtain covered an area of 142,000 square feet and spanned 1,250 feet between the two peaks of Rifle Gap. It was made from 426 fifty-six-inch-wide panels of tightly woven industrial nylon polyamide. The fabric was custom dyed a bright orange to contrast with the blue Colorado sky. The curtain was sewn together by eight people; it took four weeks and weighed about 8,000 pounds when it was finished. The installation required 110,000 pounds of steel cable that was used to anchor and hang the curtain from above. However, the true legacy of *Valley Curtain* is not defined by the overwhelming details of its construction, but instead the awe-inspiring sense of beauty and the sincere appreciation for the environment that it generated.

Valley Curtain temporarily obstructed the landscape, making it invisible, but this had in fact the opposite effect and heightened viewers' awareness of the pure physicality of the location. Christo and Jeanne-Claude recognized the benefits of visually and spatially unifying large-scale objects with the environment long before contemporary theories on site-specific and land art were formed. They were true pioneers in their understanding of the correlation between objects, environment, and people.

The Denver Art Museum has two prints by Christo's official *Valley Curtain* photographer, Harry Shunk. The prints show the final, realized project and offer the viewer a glimpse of its imposing scale and magnitude.

In 1997 the Denver Art Museum presented an exhibition to celebrate the twenty-fifth anniversary of the project, titled *Christo and Jeanne-Claude: Valley Curtain, Rifle, Colorado 1970– 1972—A Documentation Exhibition.* The show consisted of more than 170 objects including collages, drawings, preliminary studies, scale models, photographs, and the museum's *Valley Curtain, Project for Rifle, Colorado* drawing—among other supporting documentation. The show coincided with the announcement and subsequent launch of Christo's current *Over the River, Project for the Arkansas River.*

Christo (Christo Vladimirov Javacheff) was born in Gabrovo, Bulgaria, on June 13, 1935. His future wife and longtime collaborator Jeanne-Claude was born on the same day in Casablanca, Morocco. In 1957, Christo fled the communist bloc for Paris, where he met Jeanne-Claude in October 1958. Arriving in Paris as a refugee and escapee from behind the Iron Curtain, Christo embraced the notion of freedom—an ideal that would drive and inspire his entire artistic output.

Christo began wrapping everyday objects such as tin cans, bundles of books, and jerrycans as early as 1958. The constant, recurring thread of his work is fabric and the act of wrapping. The artist coined the term *empaquetage*, translated simply as "packaging," in 1961 to describe his work. Christo and Jeanne-Claude married and moved to New York City in 1964. They became an unstoppable team, wrapping public buildings, monuments, and nature, and were inseparable until Jeanne-Claude's death in 2009.

The passion, persistence, and commitment of the two artists never faltered. While the documentation of each project is secondary to its actual realization, these remaining objects are the lasting records. Christo and Jeanne-Claude's work begs us to reconsider our surroundings and reminds us that when something is wrapped, the mystery of what is hidden and invisible becomes an unexplained and much anticipated affair.

Notes

1 Christo quoted in Jeffrey Kastner, "Social Fabric," *Artforum*, May 2005, 68.

2 This is the official title of the realized project, but the preparatory drawings and collages were titled as follows: *Valley Curtain, Project for Rifle, Colorado.*

3 Ted Dougherty quoted in Nancy Clegg, "Wrap Session," *Westword*, July 16–22, 1997, 28.

4 Jeanne-Claude quoted in "Nature, Gift-wrapped," *Rocky Mountain News*, January 6, 1997.

Trappers and Cowboys

Long Jakes, the "Rocky Mountain Man"

CAROL CLARK

A western trapper in full regalia was a rare sight on the streets of New York City, so it's little wonder that Charles Deas's painting of such a character thrilled viewers in 1844. Deas had submitted *Long Jakes* to the American Art-Union, an organization that offered an artist compound benefits—a quick sale followed by public exhibition in the nation's cultural capital. Deas was successful. The Art-Union's managers paid him the substantial sum of $500 for the painting, and they put it on view, first in a commercial gallery on Broadway and then in the organization's own galleries nearby.

When *Long Jakes* arrived in New York City Deas was in Indian Territory, attached to a federal military expedition under the command of Major Clifton Wharton. They left Fort Leavenworth in mid-August 1844 and traveled up the Missouri and along the Platte River to enforce the federal government's Indian policies at the Grand Pawnee villages. Although Deas was far from the East Coast, it's likely that one of his family members living in New York sent him the rave reviews critics gave the picture. Hyperbolic it might have been, but praise like "extraordinary masterpiece" and "sensation" surely thrilled the twenty-five-year-old artist, who sought national recognition four years after he had left New York to travel in the West and settle in St. Louis.[1]

A subject drawn from the country's newest territories by an artist considered a westerner, *Long Jakes* fulfilled a call for American artists to paint "themes essentially American."[2] The picture also suited the taste of members of the merchant class who began to collect art that matched their expansionist desires. But why was this picture of an aging trapper astride a black horse so appealing? One reason may be the clarity of Deas's presentation. He constructed well-defined shapes and chose bold, contrasting colors so that a viewer easily grasps each element in the composition. By positioning the trapper twisted in the saddle, Deas showed the man's face, making it easier for viewers to connect to him as an individual. He sports a full beard, and his sunburned cheeks (and even rosier nose) are framed by long hair held back by a rakishly cocked but battered hat. Groomed and attired quite differently from those who came to look at his representation in a New York City

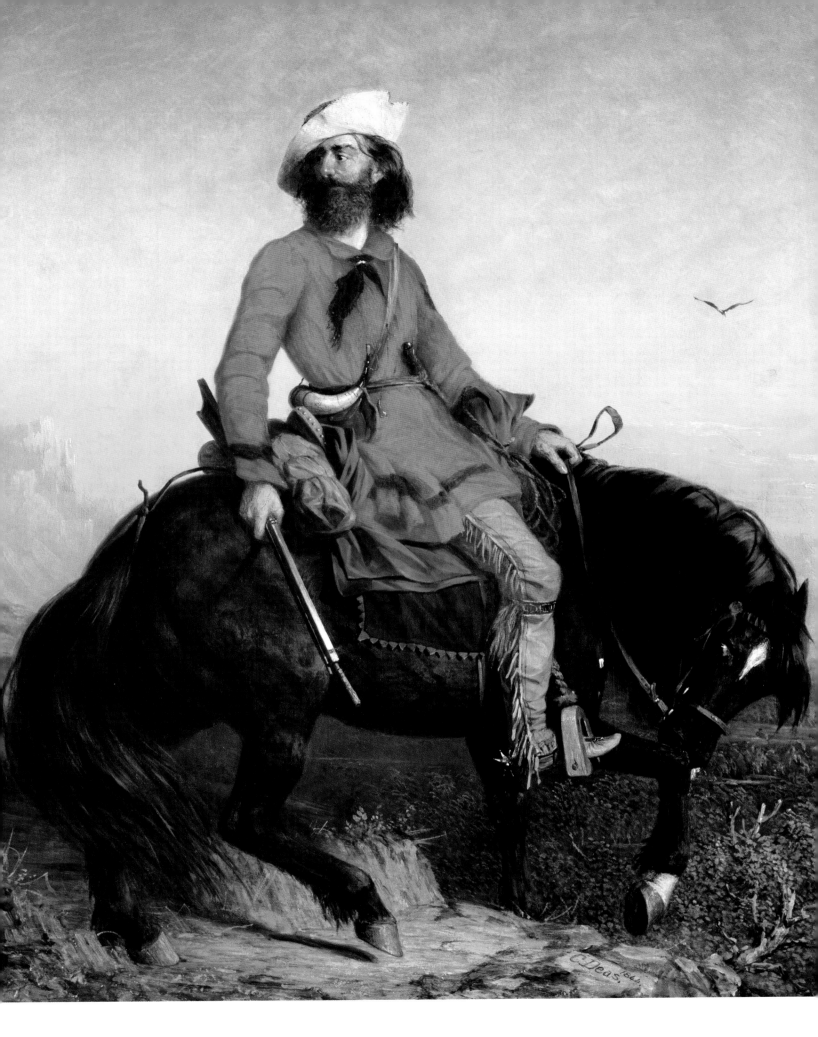

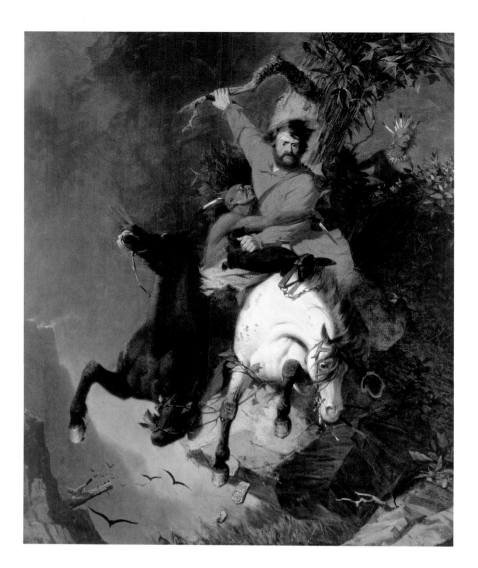

Previous page: Charles Deas
Long Jakes, "the Rocky Mountain Man," 1844
Oil on canvas, 30 × 25
Denver Art Museum, jointly owned by the Denver Art
Museum and American Museum of Western Art–The
Anschutz Collection; purchased in memory of Bob Magness
with funds from 1999 Collectors' Choice, Sharon Magness,
Mr. and Mrs. William D. Hewit, Carl and Lisa Williams,
Estelle Rae Wolf-Flowe Foundation, and the T. Edward and
Tullah Hanley Collection by exchange, 1998.241

Charles Deas
The Death Struggle, 1845
Oil on canvas, 30 x 25
©Shelburne Museum, Shelburne, Vermont

Facing, top: *New York Illustrated Magazine of Literature and
Art 2* (July 1846): Henry William Herbert, "Long Jakes, the
Prairie Man," illustrated with steel engraving Long Jakes
(after Charles Deas), by William G. Jackman, Newberry
Library, Chicago, A5.6575. Photo courtesy of The Newberry
Library; Bottom: *New York Illustrated Magazine of Literature
and Art 2* (September 1846): Henry William Herbert, "The
Death Struggle," illustrated with steel engraving The Death
Struggle (after Charles Deas), by William G. Jackman,
courtesy of American Antiquarian Society, Worcester,
Massachusetts

gallery in 1844, Deas's imaginary trapper probably evoked interest as an exotic yet accessible character from the West.

The figure's twisted pose allowed Deas to show all of the trapper's weapons—a knife tucked into his belt, a powder horn slung across his chest, and a rifle grasped in his right hand. He is armed, and he is ready; but ready for what? Deas's artistic decisions set up a narrative that a viewer can follow and extend. Something on the trail behind them, out of our sight, has startled the horse and its rider. Each turns his head to look back. The white of the horse's bulging eye suggests fear, but the wary trapper is in control. He flexes his foot in the stirrup and draws our attention to a glinting spur, positioned to quicken his horse's pace. The rifle shows the trapper's command of modern technology, and his facial features reveal a Euro-American heritage. But he has otherwise taken on native ways: his fringed leggings are Indian-made and embellished with quillwork, as are his moccasins. Long Jakes united East and West—what his contemporaries called "civilization" and "savagery"—to adapt to a new environment. When he appeared in New York, Long Jakes's separate identities fused into a new national character—the westerner.

Deas showed Long Jakes at a moment of transition. The trapper's horse has taken the first step off a high bluff that the two will relinquish as the sun sets behind them. The artist's decision animated his composition, but it also underscores the role of the fur trapper, who by 1844 was seen as a distant ancestor of new entrepreneurs extracting wealth from the West. If *Long Jakes* projected a peaceful economic transition, *The Death Struggle*, Deas's submission to the Art-Union in 1845, told a different story. I imagine that contemporary viewers constructed their own narratives around the images, but they also read stories that a popular author spun in response to them. Published in 1846 with engraved reproductions of *Long Jakes* and *The Death Struggle,* Henry William Herbert's fiction embedded Deas's art in tales of American men recovering their masculinity, which Herbert thought they had lost, by engaging in violent western encounters, one of which had erupted into war with Mexico.

Twenty years after its association with one war, *Long Jakes* appeared in support of another. The painting was

diction; and at that solemn moment the artillery of the castle of St. Angelo gave a detonating salvo.

When all was ended, a voice proceeding from the crowd, made itself heard :—" To the Vatican! let us carry *Maestro Fontana* to the Vatican!"

The enthusiastic people followed the advice, and despite his resistance, the *maestro* was carried in triumph, as far as the palace, in the arms of his fellow-citizens.

Fontana on entering the apartment of the holy father, threw himself upon his knees ; but Sixtus, raising him with benignity, extended his hand, while he thus addressed him :

" You have worthily fulfilled your task ; I will worthily recompense you ! From to-day you are a Roman knight, and you have a pension of a thousand ducats from the treasury :—I shall find means of employing your talents."

Fontana made obeisance and withdrew from the audience of the Holy Father in a state of mind more easily to be imagined than depicted.

Eight days afterward he was the happy husband of the beautiful Antonia. A long prosperity was the reward for that terrible trial to which he had been subjected.

LONG JAKES, THE PRAIRIE MAN.

SEE ENGRAVING.

Known to no other land.—Scott.

BY HENRY WILLIAM HERBERT,
Author of " Marmaduke Wyvil," " The Brothers," " Cromwell," &c.

THAT is the picture of a man. A man emphatically, and peculiarly ; a man, at an epoch when manhood is on the decay throughout the world ; when individuality and personal characteristics and personal influence are yielding everywhere to the pre-eminence of masses. A man of energy, and iron will, and daring spirit, tameless, enthusiastic, ardent, adventurous, chivalric, free—a man made of the stuff which fills the mould of heroes.

It is good for a land to have such men among her children ; for it is in the hearts of such men that burns the deathless love of liberty and country, when selfish greed and the base love of gain has quenched it in the sordid bosom of the burgher—that throbs the innate chivalry of nature, long after that grand feeling has become a bye-

word and a mockery on the lips of the truckling trader.

As soon shalt thou tame the ocean eagle, and call him fluttering from your dovecotes to pick crumbs from your hands ; as soon shalt thou bind the unicorn with his band in the furrow, and compel him to harrow the valleys after thee, as thou shalt win Long Jakes from the sure rifle and swift courser, and lure him to the desk and the pen, or teach him that the trickeries of trade are nobler than the darings of manhood.

A lie has gone forth through the world, during these fat and lazy days of peace ; the traffickers of the nations have waxed wanton and vainglorious ; and in the insolent sublimity of their petty successes they have imagined themselves princes, boasted themselves the rulers of the universe, proclaimed it loudly that henceforth utility alone should govern, that wealth alone and trade should sway the mind of empires, and chivalry and honor be to all men, what they are to the merchant princes, a mockery and a wind-blast.

This lie it is, which has prevailed so far, and alarmed so thoroughly the minds of wise and thinking men, that there are many even of the best and most religious who would even welcome war with all its havoc, all its horrors, as the sole thing that can wipe away this loathsome and corrupting blight from the hearts of men ; the sole thing which can create even a passing elevation in the minds of the multitude, which can lead them to suppose that men have higher capabilities than that of hoarding money ; and that there *are* successes of more importance to mankind than those of thriving bankers ; interests of greater moment than the spinning of cotton, or the boiling of molasses—that there are such things, in a word, as truth, and honor ; as patriotism and glory ; and that the whole aim and intention of man's life, and the world's existence is not, as the merchants would have us to believe, mere selfishness and mammon.

There are spirits in the world—and it is good and wholesome that these overgrown traders should sometimes be reminded of it—spirits of bookmen toiling in solitude beside the midnight lamp ; spirits of hardy and adventurous sailors furrowing the trackless ocean with their daring keels ; spirits of bold and fiery hunters roving the wild interminable prairies on steeds as proud and independent as their riders ; the slightest word, the most casual deed of whom is in the eye of the philosopher of vaster influence for good or evil, of wider import to the weal or wo of nations, than all the collected gains of the united merchants of every age and clime and country, from the days Tarshish and of Tyre, to those of New York and Liverpool.

" Mind, your promise," said Clarence, " mind your promise !"

" She's a good, kind-hearted girl, I know," replied Anna, " and of course I can excuse her for being a *friend* of yours ;" and thus saying, she handed him the letter.

We have drawn the last picture in our little story, dear reader, and we hope you will not throw it aside with a " pshaw !" We have spoken freely in some parts, but we have endeavored to tell the truth, and for that we trust you will give us credit. There's many an unwritten tale of blighted hopes, of crushed affections, in this great city of ours, that would bring tears to the eyes, and make the heart sick with sorrow. In the poor milliner girl, Clara Morton, and the rich and courted Ellen Livingston, you see where virtue once reigned without the WILL to keep possession of her lovely palace. In Viola Linton, the dancing girl, you see Virtue, beset by a thousand temptations, guarded by STRENGTH OF MIND. " The ways of Virtue are pleasantness, and all her paths are peace," but

" Vice is a monster of such hideous mien,
That to be hated needs but to be seen."

DUTY.

BY WILLIAM GILMORE SIMMS.

I

Well hast thou said that mine was but a madness,
The toys I sought, the pleasant hopes pursued,
Sweetly they seem'd to smile, and shapes of gladness
Gather'd in fancy, won as soon as wooed ;
But scarcely has the sage denounced the treasure,
Thus quickly yielding to the grasp and lure ;
How small its worth, how very brief its measure,
How formed to cheat, how little to endure.

II

There is nought sure but sorrow and transition,
And best he wills who to his task has brought
The stern resolve to work in his condition,
Nor to its profit, nor its loss, give thought ;
The duty is not less assign'd to being,
Though not a smile of fortune crowns the toil ;
There is no refuge from the task in fleeing,
And wisdom makes it happiness to toil.

III

Not from the bird or beast we take our moral ;
Man, only, has the privilege to wear
The crown of thorns, far nobler than the laurel,
And wins his immortality from care.
He forfeits his high destiny, imploring
That freedom which is subject to his will ;
The dog that sleeps, the bird that sings in soaring,
These are but lowly vassals at his will.

THE DEATH STRUGGLE.

BY HENRY WILLIAM HERBERT,
Author of " Marmaduke Wyvil," " Cromwell," " The Brothers," &c.

SEE ENGRAVING.

" Her love itself could never pant
For all that beauty sighs to grant,
With half the fervor hate bestows
Upon the last embrace of foes,
When grappling in the fight they fold
Those arms that ne'er shall loose their hold :
Friends meet to part ; love laughs at faith,
True foes, once met, are joined 'till death."
BYRON. *The Giaour.*

'TWAS a clear calm morning in the earliest autumn time, before a single touch of frost had painted the leaves of the maple with its hectic crimson, or robed the hickory in its golden glory. There was a thin yellow haze on the far horizon to the eastward, where the earth met the sky, leagues upon leagues aloof, in a long wavy dark blue line ; more like the surface of a rolling but unbroken sea, than of the firmer and more stable element. The atmosphere overhead was of the purest, palest blue, scarce darker than the tint of the aquamarine, with a few fleecy clouds floating at an extreme height, their lower edges just touched with the faintest amber by the first rays of the yet unrisen sun.

It was a lovely sight, that fair and tranquil dawning ; and lovely was the scenery it looked upon—the meeting of the first wooded swells of the rocky mountains, and the illimitable plain of the wild prairie land. On this side, millions and tens of millions of green acres, waving and rustling with their rich grasses, to the light western breeze, and sparkling with their diamond dewdrops to the young sunbeams—on that, a labyrinth of wild and broken knolls, here thick and tufted with the unpruned umbrage of the virgin forest, there grim and gray with cliff and crag, hoarient with pyramid and spire, hewn by the hands of nature out of the hard and herbless granite. And far beyond all, and above all, immeasurable peaks of misty azure, uncertain whether cloud or mountain, looming gigantically up against the morning sky.

At about half a mile's distance from the commencement of the open prairies, and within the maze of knolls, and spurs from the loftier ridges, which I have described, there was a little lap, or hollow, surrounded, as it would seem, on every side by steep and abrupt hillocks covered with

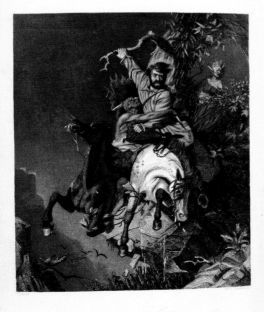

then in the collection of Marshall O. Roberts, who acquired it sometime after the Art-Union distributed the picture by lottery to one of its members in December 1844. Although he likely purchased it sooner, the first record that Roberts owned the painting was in 1864, when he lent it to New York's Metropolitan Sanitary Fair, held to benefit Union troops. At the same time Roberts was reaping unconscionable profits from the sale of ships to the government during the Civil War, he was polishing his reputation as a beneficent cultural leader.

In 1864, when *Long Jakes* hung at the Sanitary Fair, Deas lived just a few miles away. Yet he did not see his picture at the fair because his home was the Bloomingdale Asylum for the Insane.

Deas's commitment to Bloomingdale in 1848 removed him from the art world, and the press took little notice the few times his work was on public view while he was confined. Yet one of these showings stimulated a new life for *Long Jakes*. The picture was included in an 1853 exhibition in New York City that celebrated, among other things, the painted image of George Washington. The critic for the *New York Times* admired *Long Jakes*, and although he did not mention a connection, I wonder whether some of the patriotic fervor suffusing the exhibition might have rubbed off on the western trapper.[3] Perhaps having seen the painting at the *Washington Exhibition*, a New York art dealer issued a fine, large print of the picture created by master lithographer Leopold Grozelier.

Printed in colors and published as *Western Life, The Trapper*, the lithograph is rare today, but there is evidence it had wide distribution in the late 1800s because it inspired several artists to make copies of *Long Jakes*. It's clear that the lithograph, rather than the steel engraving commissioned in 1846 or the painting itself, was the model for the painted tributes because most of these works, such as the one by an unknown artist on the facing page, show the more handsome face and imposing figure of Grozelier's interpretation.

By 1897, when an unknown bidder paid $70 for *Long Jakes* at the auction of Roberts's collection, Deas and his work had been long forgotten. During the 1930s, rising American nationalism spurred interest in nineteenth-century scenes of "old" American life, which

Leopold Grozelier
Western Life, The Trapper, ca. 1855
Long Jakes, "the Rocky Mountain Man"
After Charles Deas
Color lithograph, printed by J. H. Bufford, Boston, for M. Knoedler, 23⁹/₁₆ x 29⁵/₁₆ (sheet), Yale University Art Gallery, Mabel Brady Garvan Collection, 1946.9.636

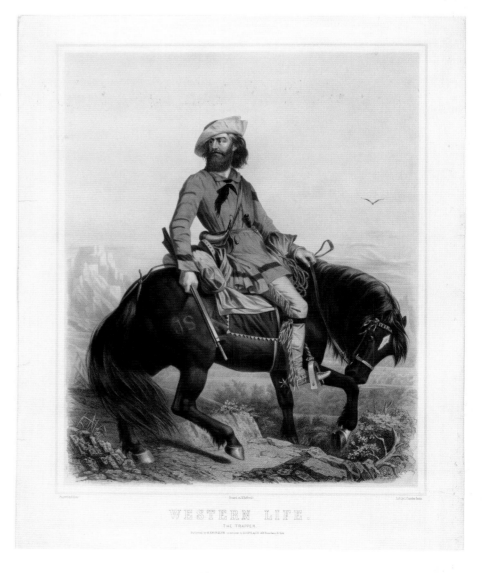

WESTERN LIFE.
THE TRAPPER.

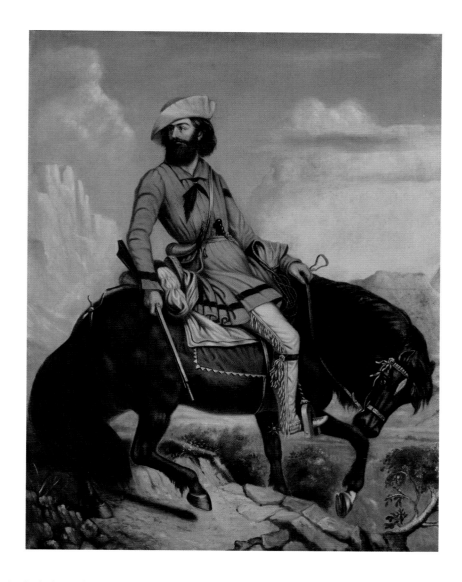

Unknown artist, after Charles Deas
Long Jakes, "the Rocky Mountain Man"
Oil on canvas, 33½ x 26
Yale University Art Gallery, Mabel Brady Garvan
Collection, 1932.292

included Deas's paintings, then known only from descriptions in exhibition brochures and newspaper reviews. *Long Jakes*, with its multiple "stand-ins"—two printed reproductions and a dozen copies—especially tantalized collectors and art dealers. But it wasn't until 1985 that a rising art market coaxed the picture out from under a bed in Minneapolis. Like many "lost" works, it had a murky recent history, which included the picture's long stay in a shipping crate, by then destroyed along with the labels that might have told a story of its travels.

Drawn in by Long Jakes's vibrant red coat, visitors to the museum today encounter a character from "the outer verge of our civilization," as one New Yorker located him in 1845.[4] Those who saw *Long Jakes* in the mid-nineteenth century had at hand a verbal portrait

of the artist, published in the popular journal *Spirit of the Times*. "Rocky Mountains . . . the soldiers called Mr. Deas" because he dressed like a fur hunter and had a free, "Rocky Mountain way of getting along," wrote an officer who knew Deas on the Wharton Expedition.[5] Did Deas fashion himself after his imaginary subject? If so, it gives us one more way to understand the artist and to approach the lone, oddly appealing trapper he painted at the height of his brief career.

Notes

1 "The Extraordinary Masterpiece of Art . . . ," *New Mirror* 3, no. 24 (September 14, 1844): 384, and "The Art Union Pictures," *Broadway Journal* 1, no. 1 (January 4, 1845): 13. For more about Deas and his work, see Carol Clark, with contributions by Joan Carpenter Troccoli, Frederick E. Hoxie, and Guy Jordan, *Charles Deas and 1840s America* (Norman: University of Oklahoma Press, 2009), published in conjunction with an exhibition held at the Denver Art Museum in 2010.

2 [Henry T. Tuckerman], "Our Artists—No. V: Deas," *Godey's Magazine and Lady's Book* 33 (December 1846): 250–53.

3 "The Washington Exhibition at the Art-Union Rooms," The Fine Arts, *New-York Times*, March 17, 1853, 2.

4 "The Art Union Pictures," 13.

5 [J. Henry Carleton], journal entry dated August 16, 1844, "Occidental Reminiscences: Prairie Log Book; or Rough Notes of a Dragoon Campaign to the Pawnee Villages in '44," *Spirit of the Times* 14, no. 40 (November 30, 1844): 475.

Still in the Saddle: Cowboys in American Art

B. BYRON PRICE

Previous page: Frank Mechau
Rodeo-Pickup Man, ca. 1930
Oil on canvas, 31¾ x 39
Denver Art Museum,
Gift of Anne Evans, 1935.9

Edward Borein
Untitled (Vaquero), ca.1920–30
Watercolor on paper, 9⅝ x 14¾
Denver Art Museum,
Gift of Michael Howard, 1977.59

Charles M. Russell
That Night in Blackfoot Was A Terror, 1910
Watercolor on paper, 16 x 13
Denver Art Museum, In memory of
Dr. John Cunningham, a gift of his
granddaughter, 1991.609

For nearly two centuries, artists have helped create and shape the iconic image of the American cowboy. Pictures of horseback herders in western North America began appearing in travel literature and the illustrated press in the early 1800s when the region and its inhabitants were but dimly known east of the Mississippi River. Most such imagery was in the form of rudimentary wood engravings that supplemented stories and descriptions of the activities of Mexican vaqueros and their emerging American counterparts in Texas and California. Decorative and sometimes fanciful portrayals also could be found on hand-tinted stone lithographs and on the canvases of at least a few easel painters. Works in the latter category ranged from equestrian portraits to dramatic action scenes depicting lasso-wielding horsemen snaring wild cattle and horses.[1]

Pictorial representations of cowboys began to appear with greater frequency during the post–Civil War era, a reflection of increasing public interest in the West and the region's booming range cattle industry. The rambunctious and sometimes deadly antics of the drovers who delivered herds of cattle overland from Texas to northern markets garnered considerable comment in the press, most of it negative. The stereotype of cowboys as an unsavory lot, prone to violence, mayhem, and criminality, persisted for years, and the illustrations that often accompanied such reports— as well as a generation of lurid dime novels—reinforced this belief.[2]

But as civilization began to smooth some of the rough edges off the frontier and barbed wire fences enclosed the open range, more sympathetic visual and literary portrayals of range riders began to appear. By the early 1880s, W. A. Rogers (1854–1931), Rufus F. Zogbaum (1849–1925), Frederic Remington (1861–1909), and other artist-correspondents were presenting readers with a more romantic, exuberant, and heroic view of cowboy life in a host of illustrated periodicals.[3]

Remington's cowpunchers stood out from the rest. They were reckless horsemen, crack shots, rugged individualists, and the embodiment of masculine virtue. A gradual movement from hard-edged illustration to impressionistic easel painting and timely collaborations with such influential writers of the range as Theodore Roosevelt and Owen Wister further enhanced Remington's reputation for cowboy art. His interest in the wild riders of the unfenced range never waned, and by the time of his death in 1909 his imaginative representations of their fatalism and fortitude in the face of danger were the lofty measure by which other delineators of the type were judged.[4]

Charles M. Russell (1864–1926), the only artist to ever approach Remington's reputation and popularity as a portrayer of cowboys, did so from the discerning perspective of an insider. In 1880, at the age of fifteen, Russell had left home and family in St. Louis for the wilds of Montana. There he hired on with a roundup outfit, wrangling horses and pursuing the life of a cowboy in the Judith Basin for the better part of a decade. A self-taught artist, "Kid Russell" also possessed a keen eye for detail and a droll sense of humor, qualities reflected in the crude sketches, paintings, and wax figures he turned out to amuse his fellow punchers.[5]

His work slowly improved, and in 1892 Russell abandoned life on the range to become a fulltime artist. Firsthand observation and stories told

by others informed his work and lent it a narrative quality that often masked deeper truths. Russell was himself an effortless and engaging raconteur and correspondent, whose crisp pen and ink and watercolor illustrations decorated not only books and short stories but letters to friends as well.[6]

Cowboys remained a favorite subject and were the inspiration for some of his most memorable works, among them *Bronc to Breakfast*, *In Without Knocking*, *Jerked Down*, and *The Fatal Loop*. When Russell began modeling bronze sculptures in 1904, his first subject, *Smoking Up*, depicted a cowpuncher on a spree.[7]

In 1883, just a year after Russell wrangled horses at his first Montana roundup and Remington's first cowboy illustration appeared in *Harper's Weekly* magazine, frontiersman-turned-showman William F. Cody launched Buffalo Bill's Wild West, an extraordinary traveling entertainment that was part circus, part rodeo, and part history lesson. To help bring the frontier alive, Cody hired real cowboys; celebrated their roping, riding, and shooting skills; exaggerated their distinctive dress for the arena; and touted their role in the "winning of the West."[8]

For more than three decades, colorful advertising posters, some of which covered the walls of entire buildings, heralded the coming of Cody's troupe at venues throughout the United States and Europe. Many of these masterpieces of chromolithography showcased the company's cowboy contingent in action, borrowing some poses and compositions from photographs and previously published illustrations.[9]

As a public relations gesture, Cody made his cast available to pose for artists on the lookout for authentic western material. Remington, Charles Schreyvogel (1861–1912), and Edward Borein (1872–1945), among others, took advantage of the opportunity. Unlike most of the artists who visited the Wild

West grounds, Borein had spent several years punching cows on the California coast before becoming a New York illustrator and knew a real cowboy when he saw one.[10]

Artists who managed to observe cowboys in the field, however, could not always get them to strike the desired pose, especially when their fellow punchers looked on. "He 'poses runnin' to the best advantage and thinks artists ought to be women," Remington said of the self-conscious cowhands he sketched on his periodic trips west. "He will ride his horse up and down cut bank to let you observe the horse action, and is obliging while you pretend to stare at the horse instead of him."[11]

Sculptor Alexander Phimister Proctor (1860–1950), meanwhile, discovered that cowboys also could be withering art critics. His equestrian monument, *Cowboy*, installed on the grounds of the World's Columbian Exposition in Chicago in 1893, garnered praise in the press for its realism and artistic expression, but so offended a group of visiting cowpunchers from Buffalo Bill's Wild West that they proposed dumping the plaster horse and rider into a nearby lagoon in protest. Cody, however, intervened before they could carry out their plan.[12]

By the turn of the twentieth century a number of American sculptors had modeled noteworthy cowboy subjects, among them Hermon A. MacNeil's (1866–1947) standing cowboy with lasso exhibited at the Chicago Art Institute in 1896, Solon Borglum's (1868–1922) *Lassoing Wild Horses*, accorded a "Place of Honor" at the Paris Salon in 1898, and *Cowboy About to Mount a Bronco* by Walter Winans (1852–1920), the silver medalist at the Paris Exposition of 1900.[13] None of these accolades, however, approached the near universal acclaim accorded Remington's first bronze, *The Broncho Buster*, modeled in 1895. The *New York Times* thought the work, whose cantilevered form seemed to defy gravity, exhibited "genuine taste and talent,"[14] and the *English Art Journal*

Solon Borglum

Lassoing Wild Horses, modeled 1898,
this cast 1902
Bronze, 33 x 19½ x 33
Denver Art Museum, William Sr. and Dorothy
Harmsen Collection, by exchange, 2011.9

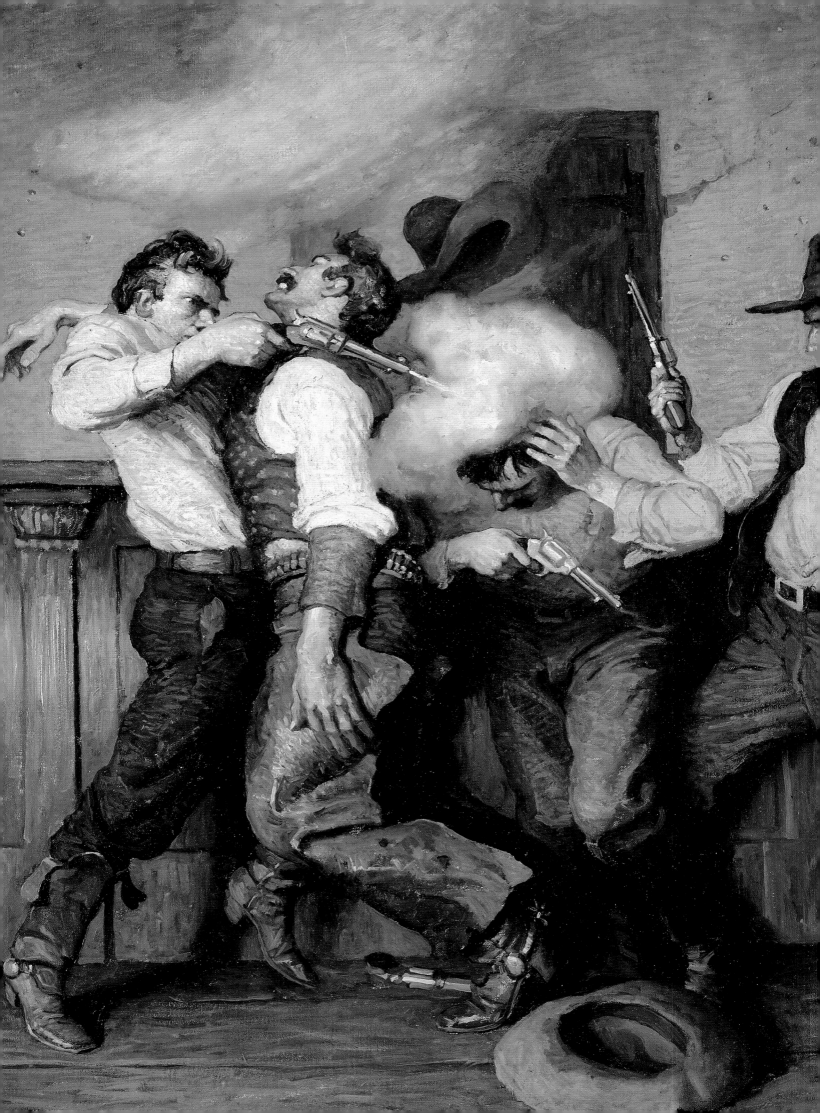

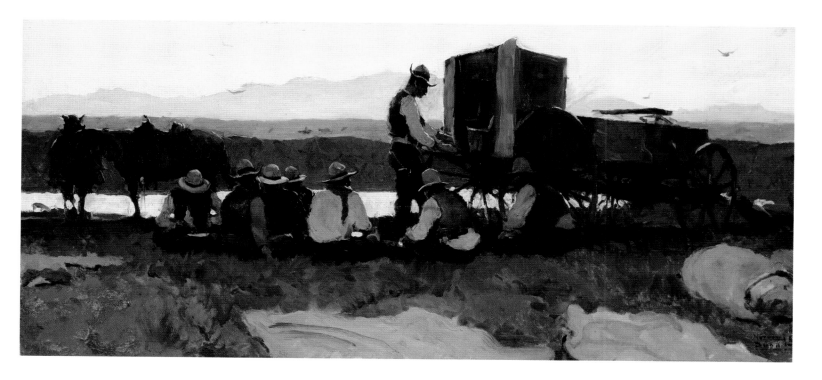

N. C. Wyeth
Gunfight, ca. 1916
Oil on canvas, 33½ x 24
Denver Art Museum, William Sr. and Dorothy
Harmsen Collection, 2001.443

Harvey Dunn
The Chuckwagon, 1915
Oil on canvas, 15 x 35
Denver Art Museum, William Sr. and Dorothy
Harmsen Collection, 2001.1144

called its creator a "sculptor of power."[15] Remington went on to produce several other stellar bronze cowboy figures, including his only equestrian monument, *The Cowboy*, unveiled at Fairmount Park in Philadelphia in 1908.[16]

As time passed, Remington and many of his fellow artists began to employ photography in the creation of their work. In 1877 Eadweard Muybridge (1830–1904) had captured the motion of a running horse in still photographs, enabling artists to depict equine gaits with accuracy for the first time. In the field, artists employed the medium to capture poses and recall details of cowboys and other subjects, usually with greater speed and accuracy than could be accomplished with sketches. Some artists, however,

were criticized for an over-reliance on photography at the expense of the imagination.[17]

After the development of halftone printing in the late 1880s, photographs began to share space in publications with traditional forms of illustration, especially in news magazines. Paintings and drawings, however, remained the preferred medium for illustrating novels and short stories, including those of the cowboy variety, thanks in part to technological advances in color printing.[18]

Nostalgia at the passing of America's frontier era, coupled with the critical and popular success of Owen Wister's cowboy novel, *The Virginian*, in 1902, fueled an almost insatiable demand for illustrated stories of the Old West that would not be satisfied for decades.

Large-format weeklies such as *Collier's*, *Ladies' Home Journal*, and *The Saturday Evening Post* attracted millions of readers with mass-market fiction and high-quality color illustrations printed on slick paper. A new generation of artists was called upon to interpret the cowboy, among other western figures, in ever more romantic terms while maintaining the illusion of reality. Many of the best, such as N. C. Wyeth (1882–1945), W. H. D. Koerner (1878–1938), Frank Schoonover (1877–1972), Harvey Dunn (1884–1952), and Allen Tupper True (1881–1955) were the students of legendary illustrator Howard Pyle (1853–1911), a champion of a theatrical and experiential approach to a medium that was by nature formulaic.[19]

At the other end of the publishing spectrum, western dime novels were

Roy Lichtenstein
The Cowboy (Red), 1951
Oil on canvas, 20 x 16
© Estate of Roy Lichtenstein

William Matthews
January Ransom, 2011
Watercolor on paper, 18½ x 47
Denver Art Museum, Funds from the
Contemporary Realism Group, 2011.260

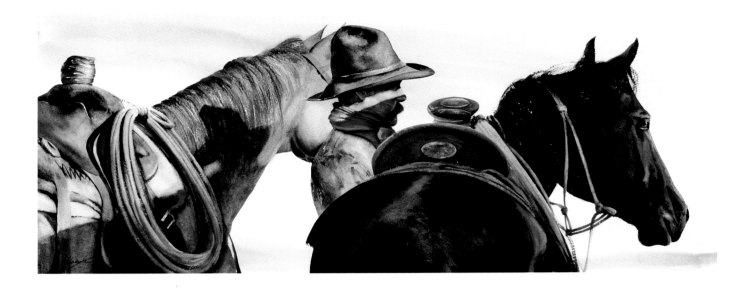

supplanted in the early 1900s by a host of robust pulp magazines with brightly colored, action-packed covers bearing such titles as *Cowboy Stories*, *Ranch Romances*, and *Wild West*. Although the stories inside were usually fiction and illustrated with back-and-white line art of varying quality and quantity, finicky readers were quick to spot and protest the slightest inaccuracy in either pictures or text.[20]

Most of the cowpunchers who rode the pages of the pulps and slicks lived in the past, righted wrongs, engaged in gunplay and romance, and triumphed over evil. Their lives and their looks, however, bore little resemblance to the real cowboys of the era, who used automobiles for transportation, talked on telephones, listened to radios and phonographs, and spent more time on foot doing chores and farm work than on horseback rounding up cattle.[21]

Images of real cowboys were scarce in easel paintings of the era as well, though regionalist artists in the West depicted them from time to time. Working in New Mexico off and on from the 1910s through the early 1930s, William H. "Buck" Dunton (1878–1936), a onetime book illustrator and a founding member of the famed Taos Society of Artists, rendered more cowboy subjects than most. Dunton

dressed like a cowpuncher, wearing hand-made high-heeled boots while he painted en plein air and shading his head from the sun with a tall-crown, "Boss of the Plains" style Stetson hat. Although adept at depicting action, some of his most compelling range works were quiet, carefully composed equestrian portraits that possessed a poetic feeling, strong draftsmanship, and mature palette.[22]

Like many artists, Dunton turned to portraiture and lithography to make ends meet during the Great Depression. Other painters of the era signed on with government-sponsored work relief programs, through which they decorated post offices, schools, and other public buildings with large-scale murals. That cowboys appeared in many such works, especially in the West, is not surprising, given the bedrock values they now embodied and the mythical stature they had attained in American culture. By this time, too, in the mind of the public the cowboy of art and illustration had been conflated with the larger-than-life range-riding heroes portrayed in motion pictures into one iconic figure.[23]

Although cowboys held little attraction for most twentieth-century modernists, their abstracted image had crept into artist Walt Kuhn's (1877– 1949) *An Imaginary History of the West*,

an avant-garde series of western-themed paintings executed between 1918 and 1920. Their simplified forms and flattened figures had also drifted onto the canvases and murals of ranch-raised L. Maynard Dixon (1875–1946) of California and appeared in the engaging images of rodeo cowboys produced by Colorado artist Frank Mechau (1904– 46, page 205), in the 1930s and 1940s.[24]

After World War II, cowboys emerged in the abstract expressionism and pop art of Roy Lichtenstein (1923– 97), whose "Americana" series of 1951 through 1956 included several such images.[25] The artist insisted, however, that subject matter bore "no influence" on his work and that such figures were simply "instruments of amusement, they do not direct one brush stroke I have ever made."[26]

Although the golden age of book and magazine illustration had come to an end in the 1940s and motion pictures and television had become the most influential purveyor of cowboy imagery and myth, cowpunchers in art did not ride off into the sunset. In the 1950s and 1960s, private collectors and local boosters in locales such as Fort Worth, Texas; Tulsa, Oklahoma; Cody, Wyoming; and Great Falls, Montana established museums that sustained and reinvigorated interest in the art of the

American West. At the same time, many former book and magazine illustrators such as Robert Lougheed and Tom Ryan were launching successful new careers as easel painters in the Southwest.[27]

In 1964, a handful of Arizona-based painters and sculptors joined together to form the Cowboy Artists of America, an organization dedicated to creating art in the tradition of Remington and Russell. Although few of its members were, or ever had been, cowboys, the new organization and a handful of similar groups grew and flourished thanks to a generation of patrons thirsty for representational images of the West.[28] Ignoring critics who howled that contemporary cowboy imagery was derivative, illustrative, and commercial, the National Cowboy & Western Heritage Museum, Phoenix Art Museum, and a few other such institutions began to collect contemporary work, mount regular exhibitions, and offer art seminars and other educational programs that boosted its credibility with the public.

Although mocked, parodied, and deconstructed for a post-modern urban audience, the image of the cowboy, both real and mythic, rides on in twenty-first-century art. His larger than life presence persists in the bold colors and simplified forms of maverick artists like William Matthews, Buckeye Blake, and Bill Schenck, and in the realism of the photography of such masters as Jay Dusard, Kurt Markus, and Bank Langmore. "Clearly the cowboy answers a felt need in contemporary society," art historian Sharyn Udall observed in 1985.

> Solid and enduring, he negates the drift toward planned obsolescence and an esthetics based on impermanence. And if the cowboy symbolizes a frontier mentality that distrusts ease, contemplation, and the effete, another part of the cowboy myth embodies raw instinct, exaggeration, and rebellious individuality—qualities any truly original artist must also possess.[29]

Tom Ryan
Night Horse, 1970
Oil on canvas, 23½ x 35½
Denver Art Museum, William Sr. and Dorothy
Harmsen Collection, 2001.1206

President Obama's Oval Office, 2010
Photograph by Bruce White
White House Historical Association: 9466

American political leaders, too, apparently understand the cowboy's powerful visual legacy and symbolic function. What better explains the presence of Frederic Remington's bronze, *The Broncho Buster*, near the president's desk in the Oval Office? [30]

Notes

1 For early images of North American vaqueros/ cowboys see Frederick William Beechey, *Narrative of a Voyage to the Pacific and Beering's Strait . . . in the Years 1825, 26, 27, 28* (London: Henry Colburn & Richard Bentley, 1831); Jeanne Van Nostrand, *The First Hundred Years of Painting in California, 1775–1875* (San Francisco: John Howell-Books, 1980), Plates 11, 15; Charles Christian Nahl, *Mr. Gringo's Experiences as a Ranchero* (San Francisco: Wide West Office, n.d.), copy at the Bancroft Library, University of California, Berkeley, CA; *Frank Leslie's Illustrated Newspaper*, January 15, 1859, cover; Peter H. Hassrick, "William Ranney's *Hunting Wild Horses*," *Southwestern Historical Quarterly* 110 (2007): 348–60; Lonn Taylor, "The Cowboy Hero: An American Myth Examined," in *The American Cowboy*, ed. Lonn Taylor and Ingrid Maar (Washington, DC: Library of Congress, 1983), 63–66.

2 Ibid.

3 Robert Taft, *Artists and Illustrators of the Old West, 1850–1900* (1953; repr., Princeton, NJ: Princeton University Press, 1982), 162–72;

Rufus F. Zogbaum, "Across the Country with a Cavalry Column," *Harper's New Monthly Magazine* 71 (September 1885): 604–10; Peggy and Harold Samuels, *Frederic Remington: A Biography* (1982; repr., Austin: University of Texas Press, 1985), 32–66; G. O. Shields, "Some Facts About Cowboys," *Harper's Weekly* 30 (October 16, 1886): 671.

4 James Ballinger, *Frederic Remington* (New York: Harry N. Abrams, Inc., 1989), 38–39, 71–72, 103–4; "Remington & Russell: Delineators of the American Cowboy," *American West* 14, no. 6 (1977): 16–29; Theodore Roosevelt, *Ranch Life and the Hunting Trail* (New York: The Century Co., 1888); Owen Wister, *The Virginian: A Horseman of the Plains* (New York: Macmillan, 1902).

5 For an excellent biography of the artist see John Taliaferro, *Charles M. Russell: The Life and Legend of America's Cowboy Artist* (Norman: University of Oklahoma Press, 2003).

6 Russell's development as an artist is detailed in Peter H. Hassrick, "Charles Russell, Painter," in *Charles M. Russell: A Catalogue Raisonné*, ed. B. Byron Price (Norman: University of Oklahoma Press, 2007). For a discussion of his illustrated correspondence see Brian W. Dippie, *Charles M. Russell, Word Painter* (Fort Worth, TX: Amon Carter Museum, 1993).

7 Joan Carpenter Troccoli, "Poetry and Motion in Charlie Russell's Art," in *The Masterworks of Charles M. Russell: A Retrospective of Paintings and Sculpture*, ed. Joan Carpenter

Troccoli (Norman: University of Oklahoma Press, 2009), 17–110; Rick Stewart, *Charles M. Russell: Sculptor* (Fort Worth, TX: Amon Carter Museum, 1994), 142–46.

8 An overview of Buffalo Bill's Wild West, its cowboys, and the poster art that advertised them is found in Louis S. Warren, *Buffalo Bill's America: William Cody and the Wild West Show* (New York: Alfred A. Knopf, 2005), 230–41, 233–35.

9 Jack Rennert, comp., *100 Posters of Buffalo Bill's Wild West* (New York: Darien House, 1976).

10 For examples see Remington illustrations accompanying Julian Ralph, "Behind the 'Wild West' Scenes," *Harper's Weekly*, August 18, 1894, 775–76; "Buffalo Bill's Nephew Hurt," *New York Times*, May 1, 1909; Harold G. Davidson, *Edward Borein, Cowboy Artist: The Life and Works of John Edward Borein, 1872–1945* (Garden City, NY: Doubleday & Company, Inc., 1974), 26–33.

11 Frederick [sic] Remington, "How My Models Pose," *Chicago Daily Inter Ocean*, June 19, 1892.

12 After the exposition closed, Proctor's *Cowboy* was relocated to Denver's City Park, where, exposed to the elements, it slowly deteriorated. Alexander Phimister Proctor, *Sculptor in Buckskin*, 2d ed., ed. Katharine C. Ebner (Norman: University of Oklahoma Press, 2009), 107; "About the Studios," *Chicago Daily Inter Ocean*, March 19, 1893; "Objected to the Pose," *Chicago Daily Inter Ocean*, May 26, 1893.

13 L. V. N., "Echoes from the Studios," *Chicago Daily Inter Ocean*, March 15, 1896; Solon Borglum, "Life of Cowboy Sculptor," *Duluth (MN) Sunday News Tribune*, March 30, 1902; "Walter Winans Dies in London," *Baltimore American*, August 13, 1920.

14 "Art Notes," *New York Times*, October 17, 1895.

15 Quoted in "Art and Artists," *Milwaukee Sentinel*, April 5, 1896.

16 See Michael D. Greenbaum, *Icons of the West: Frederic Remington's Sculptures* (Ogdensburg, NY: Frederic Remington Art Museum, 1996); Michael E. Shapiro, "The Sculptor," in *Frederic Remington: The Masterworks*, ed. Michael E. Shapiro and Peter H. Hassrick (New York: Harry N. Abrams, Inc., 1988), 223, 226–27.

Buckeye Blake
Mustang Mesa, 2006
Watercolor and pen & ink on artist board,
23 x 16
Denver Art Museum, Funds from
the Contemporary Realism Group, 2006.28

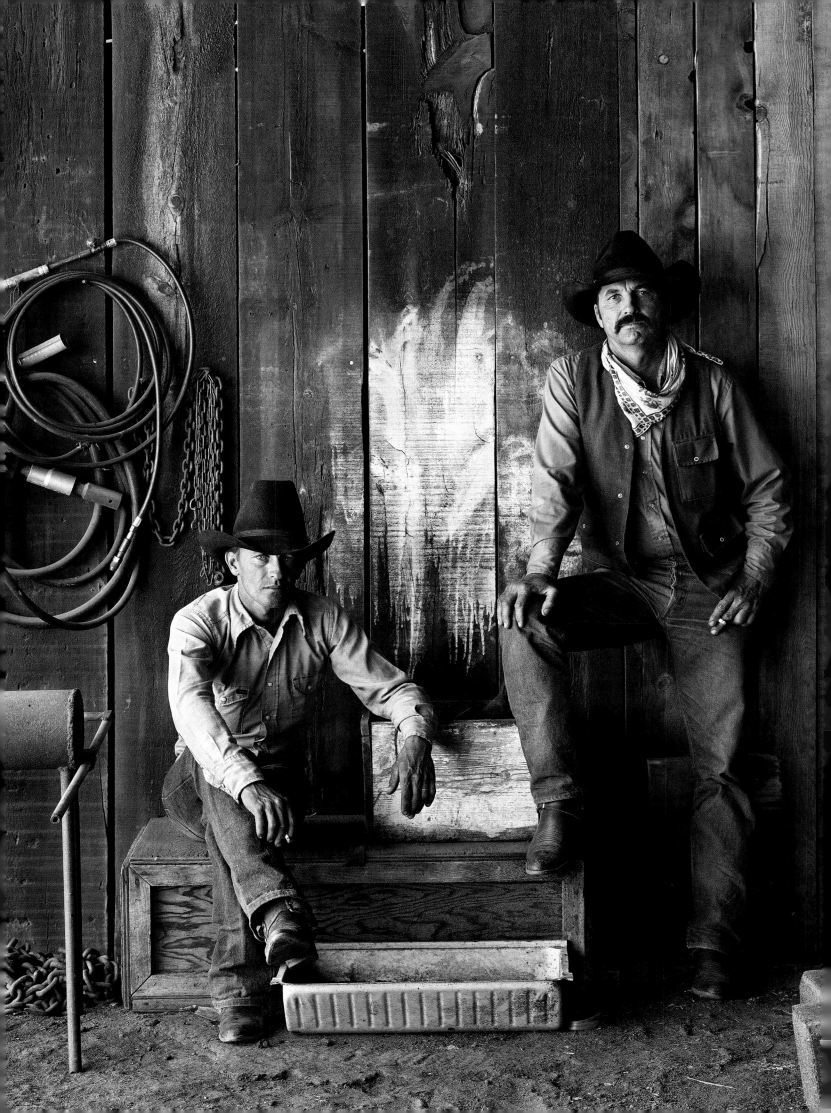

Jay Dusard
Buster Scarbrough and Bob Pulley,
A Bar V Ranch, Arizona, 1981
Photograph, 48 x 38
Denver Art Museum, Funds from the William Sr.
and Dorothy Harmsen Collection, by exchange,
2010.388

Frank Mechau
Rodeo-Pickup Man, about 1930
Oil on canvas, 31¾ x 39
Denver Art Museum,
Gift of Anne Evans, 1935.9

17 Estelle Jussim, *Frederic Remington, the Camera
& the Old West* (Fort Worth: Amon Carter
Museum, 1983); see also Alan C. Braddock,
Thomas Eakins and the Cultures of Modernity
(Berkeley: University of California Press, 2009),
149–53, 156–62, 169–71.

18 Jussim, *Frederic Remington, the Camera & the
Old West*, 48.

19 James K. Ballinger and Susan P. Gordon, "The
Popular West: American Illustrators 1900–
1940," *American West* 19 (July/August 1982):
36–42, 45; Henry C. Pitz, *Howard Pyle: Writer,
Illustrator, Founder of the Brandywine School*
(New York: Bramwell House, 1965); Christine
Bold, *Selling the Wild West: Popular Western
Fiction, 1860 to 1960* (Bloomington: Indiana
University Press, 1987), 78, 119; Norman
Rockwell, "The Decade: 1920–1930," in Walt
Reed, comp. and ed., *The Illustrator in America
1900–1960's* (New York: Reinhold Publishing
Corporation, 1966), 77.

20 John Dinan, "The Pulp Cowboy," *Persimmon
Hill* 15 (Autumn 1987):18–26; B. Byron Price,
"The Pulps and the Slicks: The Golden Age
of Magazine Illustration," *Persimmon Hill*
19 (Winter 1991): 4–10; Walt Reed et. al.,
"Illustrating the Pulps and the Slicks," National
Academy of Western Art Seminar (videotape),
June 7, 1991, National Cowboy & Western
Heritage Museum, Oklahoma City, OK.

21 Cowboy life in the twentieth century is
discussed in P. J. R. MacIntosh, "The Texas
Cowboy Today," *Texas Monthly* 4 (August 1929):
11–27; and "The Motorized American Cowboy,"
The Cattleman 15 (May 1929): 26.

22 Dunton's life and work are discussed in Julie
Schimmel, *The Art and Life of W. Herbert
Dunton, 1878–1936* (Austin: University of
Texas Press, 1984); and Michael R. Grauer, *W.
Herbert Dunton, A Retrospective* (Canyon, TX:
Panhandle-Plains Historical Museum, 1991).

23 Philip Parisi, *The Texas Post Office Murals: Art
for the People* (College Station: Texas A & M
University Press, 2004), 22, 41, 58–60, 64, 68,

74, 108–9, 112–13. For overviews of motion
picture cowboys of the silent era and the1930s
see Andrew B. Smith, *Shooting Cowboys
and Indians: Silent Western Films, American
Culture, and the Birth of Hollywood* (Boulder:
University Press of Colorado, 2003) and Peter
Stanfield, *Horse Opera: The Strange History of
the 1930s Singing Cowboy* (Urbana-Champaign:
University of Illinois Press, 2002).

24 See Walt Kuhn, *An Imaginary History of the
West* (Fort Worth, TX: Amon Carter Museum
of Western Art/ Colorado Springs Fine Arts
Center, 1964); Philip R. Adams, *Walt Kuhn,
Painter: His Life and Work* (Columbus: Ohio
State University Press, 1978); Donald J.
Hagerty, *The Life of Maynard Dixon* (Layton,
UT: Gibbs Smith, 2010); and Cile M. Bach,
Frank Mechau/Artist of Colorado (Aspen, CO:
Aspen Center for the Visual Arts, 1981).

25 Examples of Lichtenstein's cowboys include:
The Cowboy (Red) (1951), *Cowboy on Broncho*
(oil—1953), *Cowboy on Horseback* (1951),
Cowboy and Indian, and woodcuts such as *The
Cattle Rustler* (1953).

26 Quoted in Gail Stavitsky, *Roy Lichtenstein:
American Indian Encounters* (Montclair, NJ:

Montclair Art Museum, 2005), 22.

27 The founding of art museums with significant
collections of cowboy subject matter is covered
in detail in Richard H. Saunders, *Collecting
the West: The C. R. Smith Collection of Western
American Art* (Austin: University of Texas Press,
1988), 50–51.

28 The story of the founding of the Cowboy
Artists of America is found in Don Hedgpeth,
"Sonora, Sedona, and Since," in Michael
Duty, *Cowboy Artists of America* (Shelton, CT:
Greenwich Workshop Press, Inc., 2002), ix–xiv,
and in James K. Howard, *Ten Years with the
Cowboy Artists of America: A Complete History
and Exhibition Record* (Flagstaff, AZ: Northland
Press, 1976). See also B. Byron Price, "Western
Art Comes of Age," *Southwest Art* 25 (May
1996): 46, 48, 50, 52–56.

29 Sharyn Udall, "Into the Neon Sunset," *New
Mexico Magazine* 53 (July 1985): 30.

30 Thomas M. DeFrank, "So much for 'change':
Incoming president Barack Obama won't
makeover Oval Office," *New York Daily News*,
January 19, 2009.

Thomas Eakins: Cowboy Singing

PETER H. HASSRICK

Detail: Thomas Eakins
Home Ranch, 1892
Oil on canvas, 24 x 20
Philadelphia Museum of Art, Gift of
Mrs. Thomas Eakins and Miss Mary Adeline
Williams, 1929-184-12

Facing: Thomas Eakins
Cowboy Singing, ca. 1892
Oil on canvas, 23½ x 19½
Jointly acquired in honor of Peter H. Hassrick by
the Denver Art Museum and American Museum
of Western Art–The Anschutz Collection and
by exchange from funds from 1999 Collectors'
Choice, Sharon Magness, Mr. & Mrs. William D.
Hewit, Carl & Lisa Williams, Estelle Rae Wolf–
Flowe Foundation and the T. Edward and Tullah
Hanley Collection, 2008.491

When the Philadelphia Museum of Art and the Pennsylvania Academy of the Fine Arts set out in 2006 to acquire the Thomas Eakins masterpiece *The Gross Clinic,* the art museum chose to de-accession several Eakins works from its collection, including *Cowboy Singing.* The Denver Art Museum, in collaboration with the Collection, was given an opportunity to purchase this rare western work by Eakins, along with a field sketch of a cattle roundup and a study for Eakins's largest western painting, *Cowboys in the Badlands.*

Eakins was considered the premier painter in America at the end of the nineteenth century. He looked on the people of this nation with a supremely curious and nearly jingoistic eye and was especially interested in celebrating the epic elements of American life.[1] Over the years, he gained renown primarily as a portraitist but also as an artist who relished documenting the world around him.

Aside from being Philadelphia's leading painter in the 1880s, Eakins won praise as a dedicated teacher at the Pennsylvania Academy's School of Art. Despite his lofty status on the faculty, however, he was fired from the Academy at the height of his career in 1887 for disrobing a male model in a life drawing class for women. It was an edgy thing to do, and Eakins knew it. Even so, the dismissal devastated him, causing the artist to become seriously despondent. His doctor prescribed a total change in

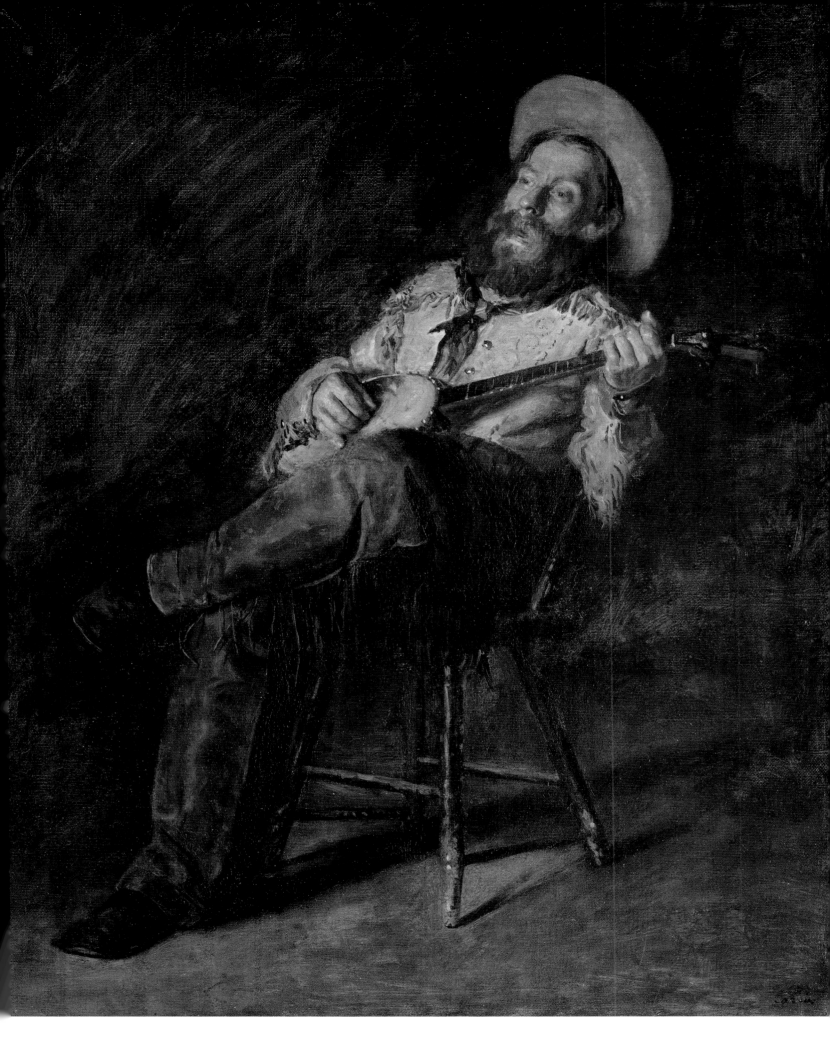

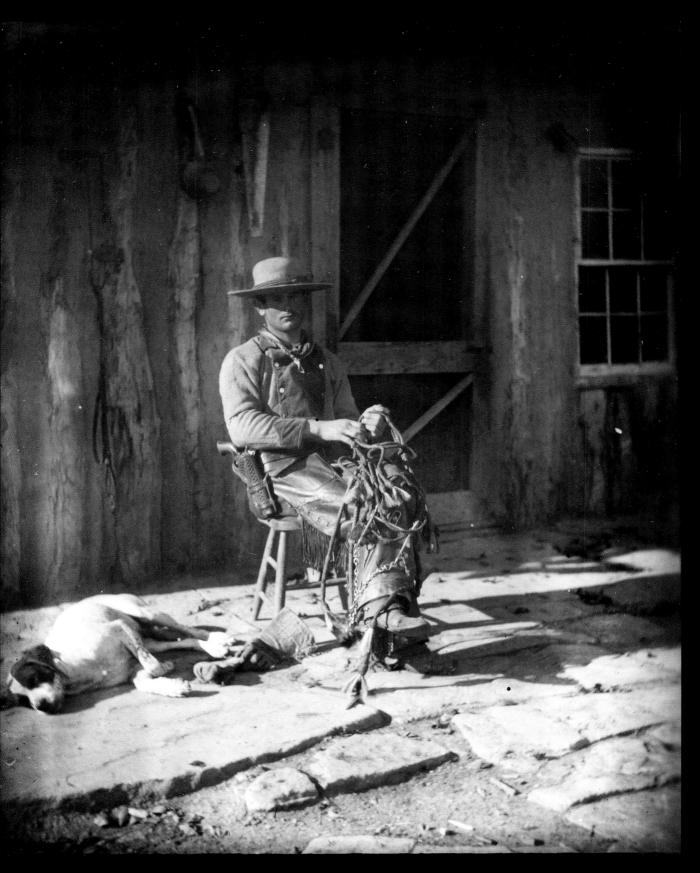

Thomas Eakins
Cowboy sitting in front of BT Ranch building, 1887
Dry-plate negative, 4 x 5
Courtesy of the Pennsylvania Academy of the Fine Arts,
Philadelphia, Charles Bregler's Thomas Eakins Collection,
purchased with the partial support of the Pew Memorial
Trust, 1985.68.2.1074

location, recommending several months' stay on a western ranch.

This was a period in history when a number of eastern artists were exploring the West for solace, adventure, and inspiration. A somewhat younger Frederic Remington, for example, recorded his ranching experiences in animated drawings and paintings that were reproduced in Theodore Roosevelt's landmark book, *Ranch Life and the Hunting Trail* of 1888. The West was ripe for artistic interpretation and exploitation.

Eakins was invited by his friend and patron Dr. Horatio C. Wood to spend several months on the B-T Ranch, which bordered the Dakota Badlands. There, over a ten-week period, his spirits were revived. He reveled in the life of the cowboys and participated enthusiastically and fully in the daily chores and activities of the ranch. His photographs and oil sketches derived from firsthand observations of the ranch work that unfolded around him and in which he avidly partook. He was especially keen about the western horses, so much so in fact that he bought two of the ranch horses and brought them back with him to Philadelphia when he returned east in the fall. He used those same two cowponies as models for his only known major oil to follow his immediate return home, *Cowboys in the Badlands.*[2]

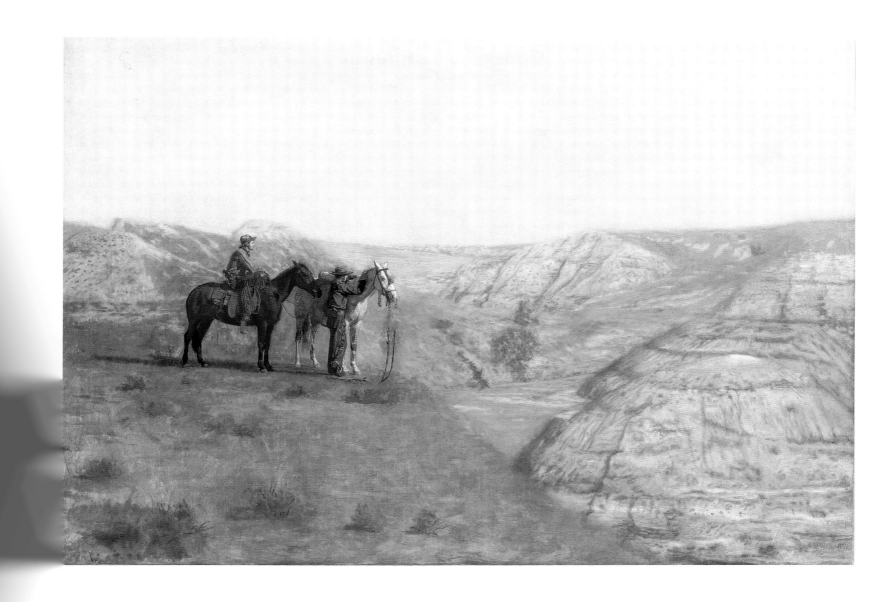

Facing, top: Thomas Eakins
Cowboy: Study for Cowboys in the Badlands,
ca. 1887–88
Oil on canvas, 20 x 24
Denver Art Museum, William Sr. and Dorothy
Harmsen Collection, by exchange, 2008.490

Facing, bottom: Thomas Eakins
Sketch of a Cowboy at Work, ca. 1887
Oil on canvas on Masonite, 10 x 14
Denver Art Museum, William Sr. and Dorothy
Harmsen Collection, by exchange, 2008.489

Thomas Eakins
Cowboys in the Badlands, ca. 1887–88
Oil on canvas, 32¹/₄ x 45
Courtesy of American Museum of Western Art–
The Anschutz Collection

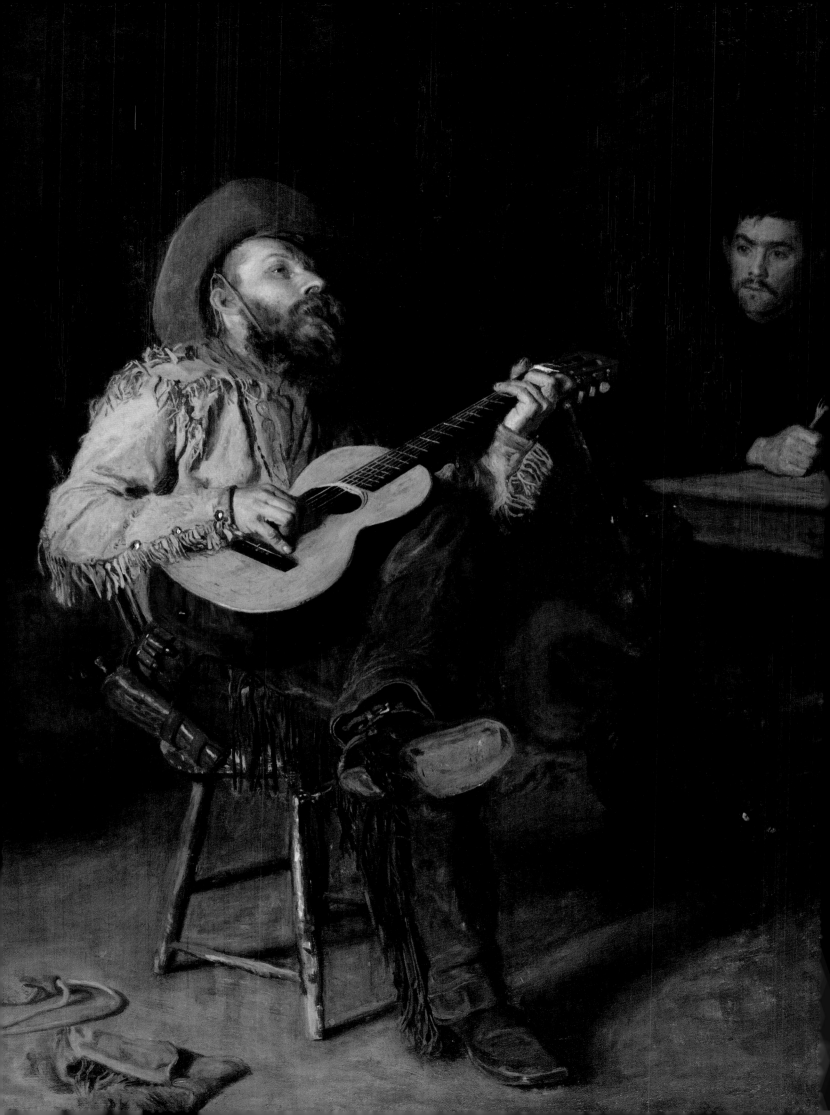

Eakins dressed up eastern models in cowboy gear that he had also carried home with him. Combining his photographs and sketches, and using the two horses and the western clothing and artifacts, he had enough to produce a seminal work that revealed a true spiritual bond with the austere landscape and the men who called that distant, exotic place their home. A sketch for the painting portrays the favorite of his two horses, Billy, and reveals his working methods as a painter: an underlying grid that might suggest the pose was taken from a photograph.

The pleasure of the western experience lingered through the ensuing years in Eakins's mind. About five years after his return from the Dakota Territory, he revisited his B-T Ranch memories. But by this time, his focus had changed. His recollections returned not to the foreboding landscape of the Badlands or the riders who braved the vast, unforgiving terrain. Now, in 1892, his vision instead turned inward to life in the ranch's bunkhouse following the day's work outdoors.

By the early 1890s Eakins had embraced a new theme in his work, American music and musicians. Portraits of opera singers and instrumentalists became signature parts of his oeuvre. The cowboy reentered the scene in an important way. It was at this time that cowboy music was just emerging as a vernacular art form that could be appreciated in both the East and the West. Though based on Irish folk tunes, much of it was, in its lyrics, unique. It concentrated on forlorn, lovesick or homesick tales of lonely wranglers isolated on the range and

well beyond the reach or comforts of civilization. The music also stood as a symbol for the disappearing national icon, the open-range cowboy. The frontier had been declared officially closed early in the decade, and the open-range cowboy was quickly vanishing into the pages of history, displaced by barbed wire, hay hands, and fencing crews.

Eakins retrieved his cowboy clothing from the closet and dressed his favorite model of the day, Franklin Schenck, in the romantic Dakota gear. The re-imagined cowboy was provided with either a banjo or a guitar (both of which Schenck played with some proficiency), seated on an old, painted Windsor chair, and presumably asked to sing one of the popular western tunes of the day like "The Dying Cowboy" or "The Rambling Cowboy."[3] Thus Eakins re-created a wistful scene from his bunkhouse memories.

The Denver Art Museum's version of *Cowboy Singing* is one of three known to exist today. A smaller watercolor of the same title, also picturing Schenck with a banjo, is owned by the Metropolitan Museum of Art, while an oil on canvas, comparable in size to Denver's painting, still belongs to the Philadelphia Museum of Art. This latter work, *Home Ranch*, is comparatively more complex as a composition than the other two. *Home Ranch* features a second cowboy in the composition who appears intent on his next meal but who still looks on as a black cat slithers in between the two men. There is also an array of horse gear strewn on the floor beside the musician. These additional pictorial elements, while appealing, tend to distract from

the central theme of the painting—the melancholy interiority of a cowboy's lament.

Cowboy Singing, on the other hand, is singular in preserving its core message. Light sheds across the cowboy's face and chest, accenting the origins of the song's creation. He rocks back in his chair with his legs crossed in a gesture of self-absorption. The viewer is drawn exclusively to the cowboy's serenade which, though unheard, is poignant, embracing, and, as Eakins would have wanted it, all American.

Notes

1 See Elizabeth Johns, *Thomas Eakins: The Heroism of Modern Life* (Princeton: Princeton University Press, 1983).

2 For a thorough discussion of this work, see *Cowboys in the Badlands: A Masterpiece by Thomas Eakins* (New York: Christie's, 2003).

3 Johns, *Thomas Eakins*, 137.

Thomas Eakins
Home Ranch, 1892
Oil on canvas, 24 x 20
Philadelphia Museum of Art,
Gift of Mrs. Thomas Eakins and
Miss Mary Adeline Williams, 1929-184-12

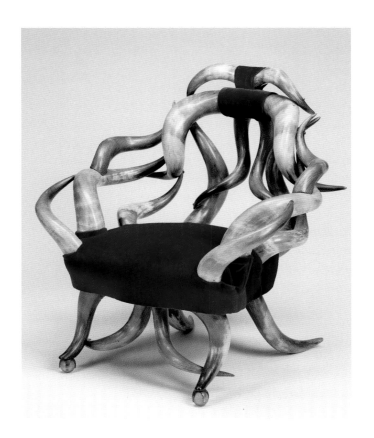

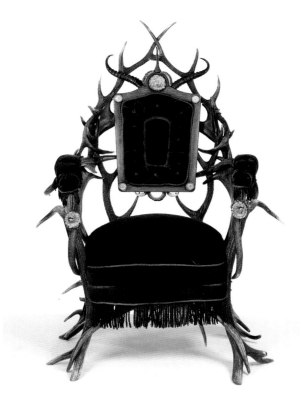

The Horn Chair

DARRIN ALFRED

"The first thing I bought for the Denver Art Museum was this horn chair. I was surprised that a museum in a western city like Denver did not have one. It has become one of our most popular objects."

DAVID PARK CURRY[1]

Former Curator of American Art,

Denver Art Museum

By the 1870s, as frontier life in America began to vanish—when transportation and communication systems connected East and West, when wealth was sufficiently accumulated, and technology and machine production replaced the handwork of pioneer craftspeople—enthusiasm grew for art and artifacts that captured the adventure and romance of western expansion. Stimulated by an outpouring of dime novels and newspaper serials conveying sensational tales mythologizing the untamed West, artists began producing paintings, sculpture, and illustrations that vividly captured the free-spirited nature of the bygone era.[2]

Feeding the imagination of Americans and foreigners alike, furniture makers, professional and amateur, began to fabricate and export their own brand of American exotica—chairs and other types of furniture made from the horns of cattle and antlers of deer and elk. The chairs, sofas, and other furnishings of every kind made specifically from the horns of Texas Longhorn cattle graphically evoked the spirit of the iconic American cowboy and the vast cattle drives of the 1860s and 1870s. This highly romantic vision had more to do with escape than it did with the preservation of any actual frontier. Sitting in a horn chair, one could imagine driving herds of Longhorn along the Chisholm Trail.[3]

The Denver Art Museum's horn armchair was made in the 1880s. While the provenance of the chair is unknown, its feet—four-pronged brass claws

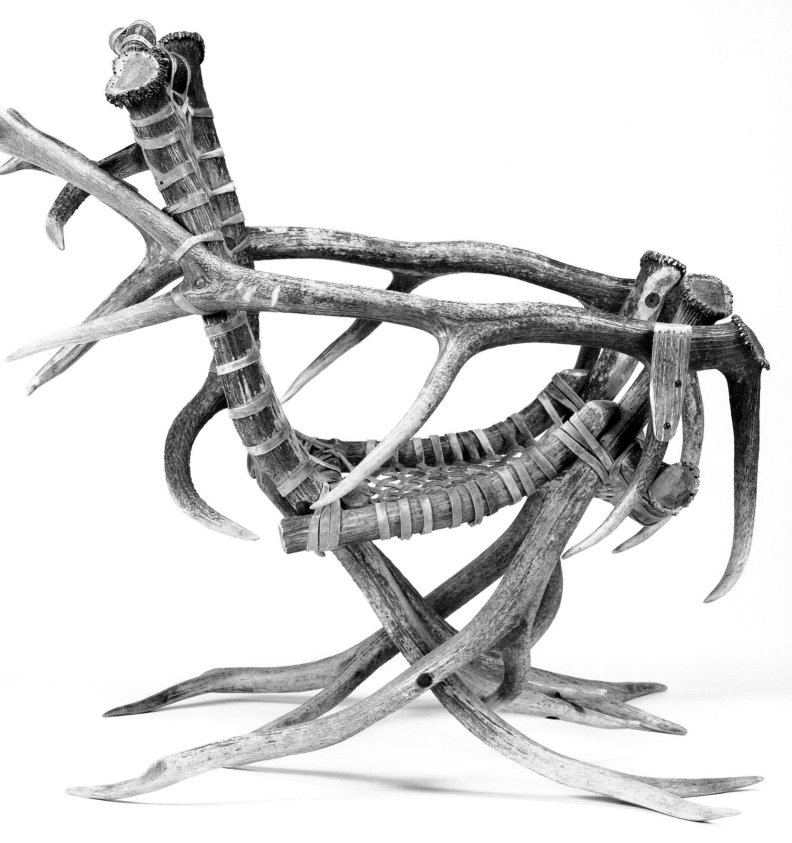

Attributed to Tiffany & Co., New York
Horn Armchair, ca. 1880
Steer horn, velvet, wood, metal, and glass,
35 x 33 x 27
Denver Art Museum, Degan Fund
for Western Art, 1983.59

H. F. C. Rampendahl
Armchair, ca. 1860
Wood, plush, antler, boar tusks, and goat horns
50 x 29 x 32
Victoria and Albert Museum, W.2-1970

Unknown maker
Chair, ca.1910
Elk antler and rawhide, 34½ x 37 x 36
Denver Art Museum, Gift of Mr. and Mrs.
Lloyd Vordenburg, 1984.325

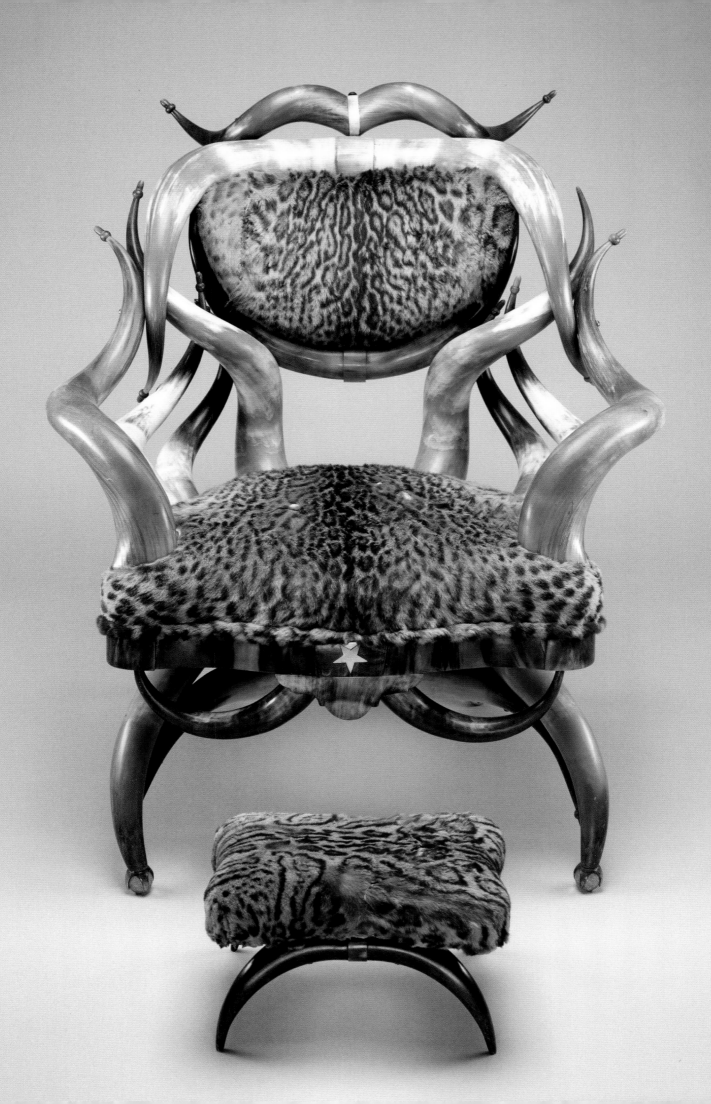

enclosing glass ball casters—are like those used by Louis Comfort Tiffany and the prestigious collaborative of designers known as the Associated Artists. This kind of foot seems to have been a Tiffany trademark, corroborating the chair's attribution to the leading decorator of the day.[4] Such furniture may seem rather gruesome to modern taste. It was extremely fashionable, however, during this period, although it must have been very expensive and thus confined to a small market. Tiffany decorated many of the lavish new homes being built by affluent families, often with smoking dens that would have accommodated such a chair, in addition to animal-skin rugs and walls festooned with trophy animal heads.

The mythology of the American cowboy is not the chair's only source of inspiration. Such pieces had in most cases no discernible style, though they clearly owed much in conception to early nineteenth-century German lodge furniture. Horn furniture was made in Europe as early as the Middle Ages. By the 1800s the taste for antler and horn furniture was especially developed in Germany and appealed to tastes for exoticism and naturalism. Rustic materials were used to suggest a natural world free of the trammels of civilization.

While to the modern eye horn furniture may seem awkward and uncomfortable, it did represent an innovative use of material. Immigrants from Europe brought to America their knowledge of the many uses of horn. Cattle horns have been fashioned into much more than chairs, tables, and sofas. The list includes buttons, combs, knife handles, powder horns, and mirror frames, to name just a few. Horn furniture's popularity grew, and by the end of the 1800s, it was being produced in large numbers in the Midwest using horns from Texas Longhorn cattle. By the mid-1880s, Chicago had become a horn furniture center due to the availability of material from the nearby Union Stock Yards. Some makers, such as Wenzel Friedrich, a German furniture maker in San Antonio, began fabricating horn furniture on a large scale.[5] Pieces were also known to have been made in Kansas, Missouri, Ohio, and along the eastern seaboard in lesser quantities as a hobby. Horn furniture enjoyed a heyday from about 1880 to roughly 1910 when the near extinction of Longhorn cattle, combined with changing tastes, signaled the end of its production.

Notes

1 This was taken from a 1988 Denver Art Museum brochure titled "Chairmanship: The Art of Choosing Chairs," with text primarily in the form of quotes from David Park Curry.

2 Dime novels were a type of inexpensive, usually paperback, melodramatic novel that thrived roughly from the late 1800s to early 1900s in the United States. These short works of fiction typically focused on the American frontier and the dramatic exploits of cowboys, scouts, and Indians.

3 The Chisholm Trail was the major overland route for driving Longhorn cattle out of Texas and north to the railheads of Kansas. The trail was used from approximately 1867 to 1884.

4 Robert Bishop, *Centuries and Styles of the American Chair, 1640–1970* (New York: Dutton, 1972), 413.

5 Wenzel Friedrich was one of many immigrants of German descent who settled in the San Antonio area around 1850. He was already a trained cabinetmaker when he came to America, and he probably saw horn furniture in Germany. Friedrich never signed his pieces but he did do several things to make them distinctively his: he frequently used veneers to cover the frames and other surfaces of his pieces; he would inlay designs like stars into the veneers; he used little acorn finials on the tips of the horn to keep people's clothing from being torn; on some of the joints that were more visible he would actually shape pieces of horn to cover the joint to make it look more finished; and he poured plaster inside the horn and put wooden blocks in it to make it much sturdier than normal horn furniture, which is hollow and bolted or screwed together. Richard St. John, *Longhorn Artist: Wenzel Friedrich* (Wichita, KS: Wichita State University Office of Research and Sponsored Programs, 1982).

Wenzel Friedrich
Platform Rocking Chair, ca. 1880–90
Horn, ivory, and glass with ocelot upholstery,
35¾ x 24 x 20½
Minneapolis Institute of Arts
The Fiduciary Fund, 84.4.1

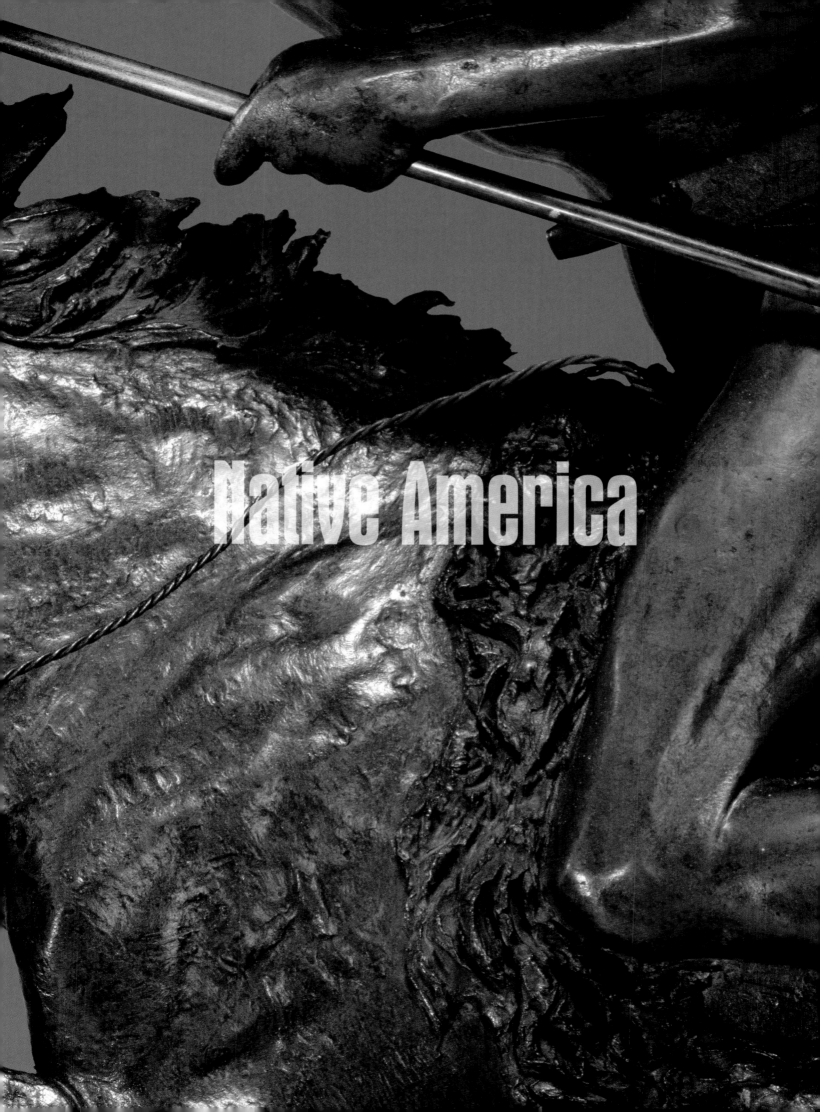

Native America

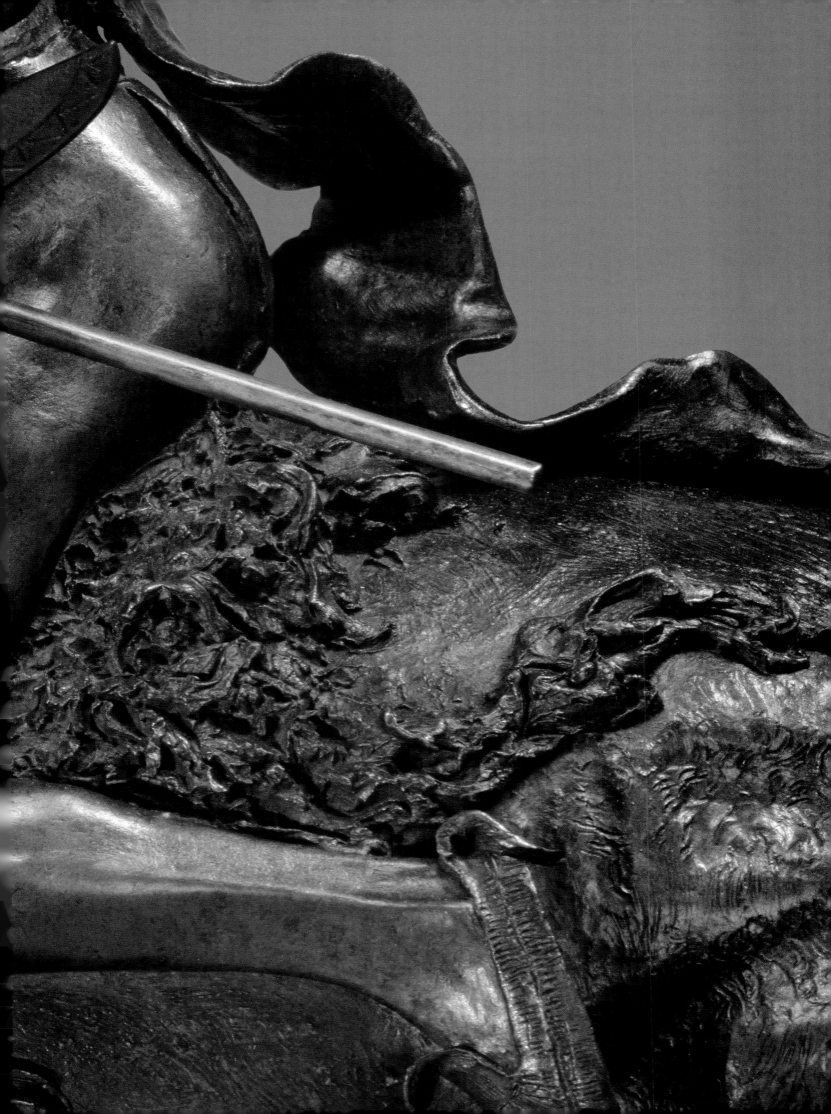

Full view (facing) and detail
Unknown Otoe-Missouria artist
Faw Faw Coat, ca. 1890
Wool, glass beads, and silk, 37 x 39 x 29½
Denver Art Museum, Native Arts acquisition
fund, 1938.79

The Power of Art and Artists in Native America

NANCY J. BLOMBERG

American Indian artists are among the most creative and expressive artists in the world. Their artistic traditions and cultures are continually flowing and changing, with artists playing a vital role in both continuity and change. Over the thousands of years of unbroken artistic creativity, artists in native America have not only created beautiful things but have played a critical role in shaping cultures and traditions. As active agents, artists have power to maintain, sustain—or change—cultures, especially during times of duress. The American Indian art collections at the Denver Art Museum contain hundreds of examples

of artworks that illustrate this point. This brief essay will focus on one brilliantly beaded coat as a case study.

The last half of the nineteenth century was a time of great stress and change for native people in America. After suffering decades of brutal military defeats and forced relocation to newly established reservations, American Indians faced great disruption to their cultures and their artistic traditions. Artists in native America responded in a myriad of ways to these changed circumstances, and much has been written about post-reservation life and culture in native America.[1]

Native religious practices were likewise affected, and new religions began to emerge.[2] One notable example was started by an Otoe-Missouria man named William Faw Faw. He was an ardent and outspoken opponent of the General Allotment Act, passed in 1887

specifically to divide tribally held land by giving small allotments to native individuals and making the remaining lands available for non-Indians to purchase. Faw Faw's failed attempt to stop the law's passage included traveling to Washington, D.C., to convince government officials of the detrimental effect it would have on the cohesion and power of tribes.

Suffering a high fever during an illness, Faw Faw had a dream directing him to start a new ceremony as part of a religious movement in which followers were directed to live exemplary lives and participate in this ceremony, which would mitigate the negative effects of governmental control and white settlement on Indian lands.[3] The ceremony would take place in an earth lodge and feature a cedar tree that was to be pulled up by its roots and transplanted to the center of the earth

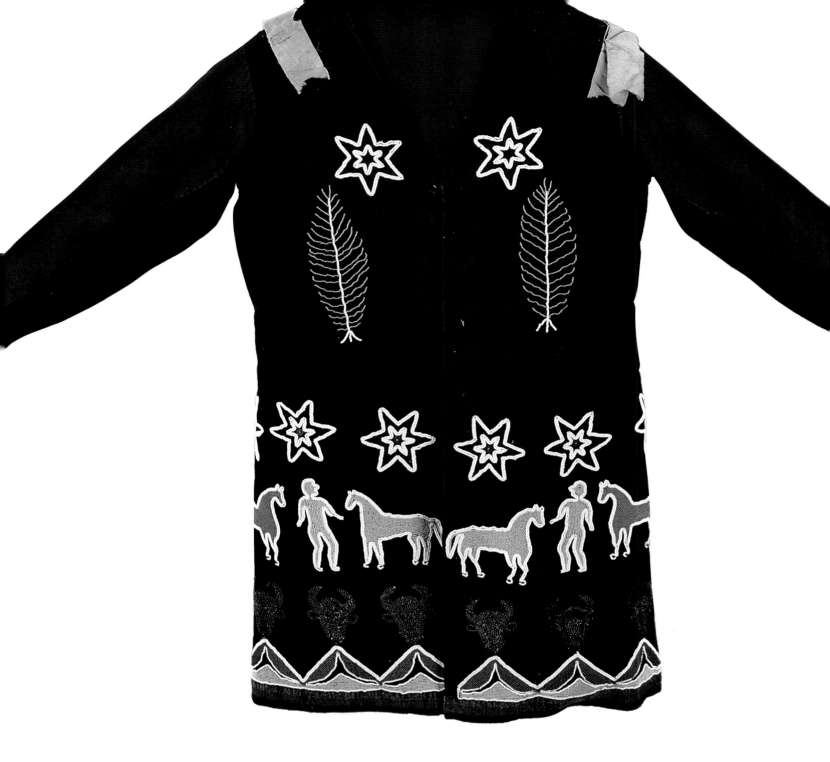

lodge. Men would collect and bring bison skulls and drums to the lodge for the ceremonies. Proper clothing was to be an integral part of this new religion, and Faw Faw prescribed the creation of coats and breechcloths with specific symbolic motifs to enhance the effectiveness and power of the participants. More than a century later, only a handful of these garments survive—including one spectacular example in the collection of the Denver Art Museum.

Starting with a blue wool European-style frock coat, an unknown Otoe-Missouria artist creatively beaded all the motifs that appeared to Faw Faw in his dream.[4] On either side of the front opening are two green and white cedar trees with exposed roots. Beneath the trees are rows of six-pointed stars, colorful horses facing animated male figures, bison heads, and, at the bottom, a row of abstract geometric motifs. The reverse of the jacket features flaring, diagonally striped bands of beadwork—

typically described as "ladders." Each is expertly rendered by a highly skilled bead artist in great detail. Each animal, human, and geometric motif is carefully outlined in either a double or single row of contrasting white beads. Although a century old, the jacket is in remarkable condition, with nearly all features extant with the exception of the beaded bison heads. At some unknown point in time the beads were removed but the stitching deliberately left in the distinct shape of each head.

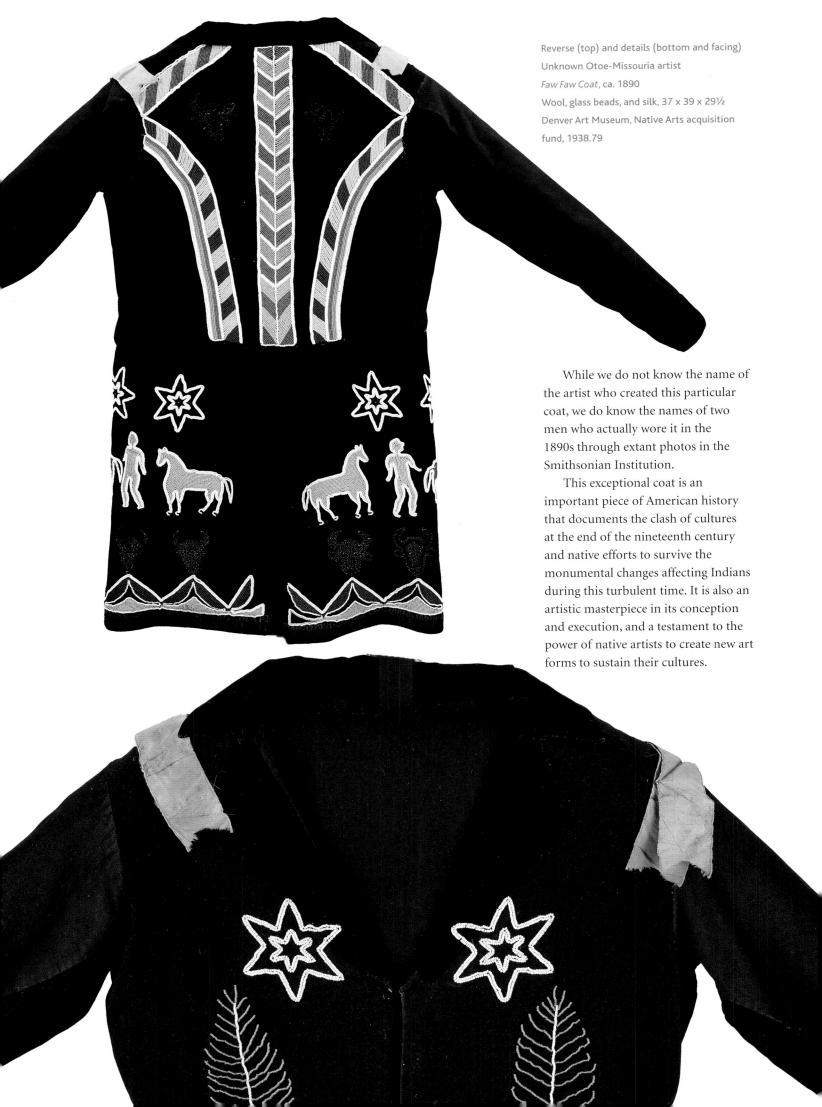

Reverse (top) and details (bottom and facing)
Unknown Otoe-Missouria artist
Faw Faw Coat, ca. 1890
Wool, glass beads, and silk, 37 x 39 x 29½
Denver Art Museum, Native Arts acquisition
fund, 1938.79

While we do not know the name of the artist who created this particular coat, we do know the names of two men who actually wore it in the 1890s through extant photos in the Smithsonian Institution.

This exceptional coat is an important piece of American history that documents the clash of cultures at the end of the nineteenth century and native efforts to survive the monumental changes affecting Indians during this turbulent time. It is also an artistic masterpiece in its conception and execution, and a testament to the power of native artists to create new art forms to sustain their cultures.

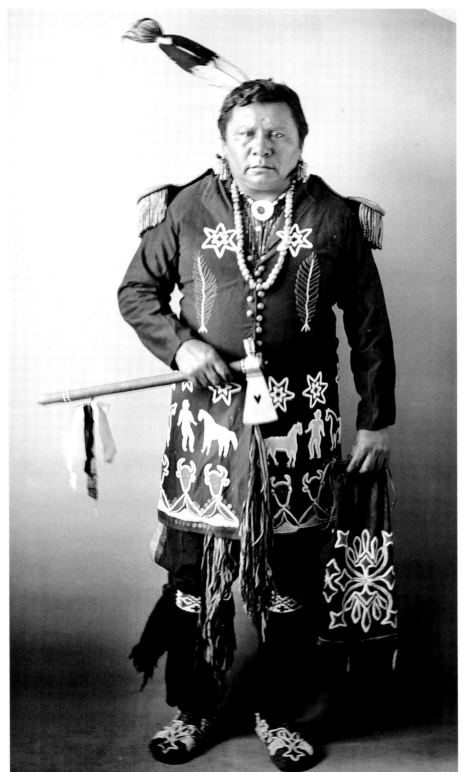

Photograph of Mean-tha-ga-ha (Robert McGlashlin), Otoe-Missouria, wearing this coat in DAM collection, ca. 1890. National Anthropological Archives, Smithsonian Institution (Neg. No. 3828-A)

Notes

1 See, for example, Richard Conn, *A Persistent Vision: Art of the Reservation Days* (Denver: Denver Art Museum, 1986).

2 Alanson Skinner, "Societies of the Iowa, Kansa and Ponca Indians," *Anthropological Papers of the American Museum of Natural History* 11, no. 9 (1914–16): 679–801.

3 Clark Wissler, "General Discussion of Shamanistic and Dancing Societies," *Anthropological Papers of the American Museum of Natural History* 11, no. 12 (1916): 851–76.

4 David Wooley and William T. Waters, "Waw-no-she's Dance," *American Indian Art* 14, no. 1 (Winter 1988): 36–45.

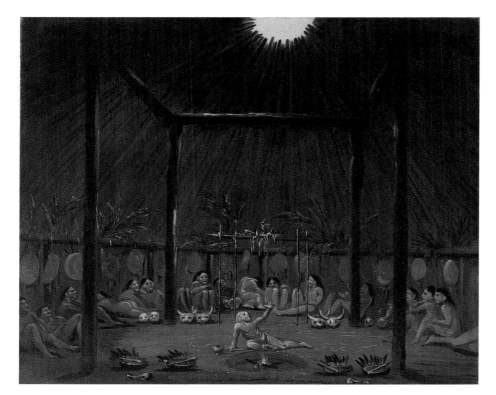

George Catlin
Interior of the Medicine Lodge, Mandan
O-kee-pa Ceremony, 1832
Oil on canvas, 23 x 28
Courtesy of American Museum
of Western Art—The Anschutz Collection

George Catlin
Pohk-hong, The Cutting Scene, Mandan
O-kee-pa Ceremony, 1832
Oil on canvas, 22⅞ x 27½
Denver Art Museum, William Sr. and Dorothy
Harmsen Collection, 2001.456

George Catlin, Pohk-hong, The Cutting Scene

MANDAN O-KEE-PA CEREMONY

JOAN CARPENTER
TROCCOLI

George Catlin (1796–1872) was the first Euro-American artist to devote his career to painting the American West. From 1830 through 1836, Catlin made five tours of the trans-Mississippi West, during which he produced hundreds of Indian portraits, western landscapes, and scenes of native life. These paintings, along with thousands of artifacts, made up Catlin's Indian Gallery, which, taken in its totality, presents a panoramic view of native America during the 1830s. During his tours Catlin dispatched letters about the people and places he visited to a New York newspaper;

they were the foundation of his most important book, *Letters and Notes on the Manners, Customs, and Conditions of the North American Indians,* published in 1841.[1]

Catlin's timing was propitious. Although a number of his subjects had been forced off their ancestral lands in the East and were to varying degrees acculturated to Euro-American civilization, Catlin also visited native communities that had maintained much of their integrity. However, none had escaped contact with Europeans, and, within a decade of Catlin's journeys, they would suffer irreversible change as the United States rapidly expanded to the West.

Catlin had been educated in the law rather than the fine arts, and his lack of formal training constrained him to describe his paintings as "sketches" rather than fully finished works.

However, when his subjects were truly inspirational, Catlin's work transcended the limitations of his technique. Such was the case in 1832, when Catlin traveled by steamer up the Missouri River from St. Louis to Fort Union, an American Fur Company post situated on the border between present-day North Dakota and Montana. He was stunned by the beauty and classic mien of the Crows, Blackfeet, Cheyennes, and other Northern Plains Indians who congregated around the fort to trade. They were, he judged, "models equal to those from which the Grecian sculptors transferred to marble such inimitable grace and beauty."[2]

On his return trip to St. Louis, which he made by canoe, Catlin paused for three weeks at Fort Clark, not far from present-day Bismarck, North Dakota, to make an intensive study of the Mandan Indians, who lived nearby on a tributary

of the Missouri River. Catlin singled out members of the tribe, who earned their livelihood from agriculture and trade as well as the hunt, as epitomes of natural nobility whose values and behavior struck the artist as equal if not superior to those of the most admirable white men. Catlin was so impressed that he accepted the myth that the Mandans were descended from a colony of Welshmen established in the twelfth century and were thus, in fact, partly European.

Catlin was totally mistaken about the origins of the Mandans, but he produced his most important contribution to Native American ethnology while he was among them.

Thanks to Catlin's cordial relationship with Mato-Tope, a popular chief of the tribe, the artist enjoyed access to nearly every aspect of Mandan life. He painted more than a dozen portraits of the town's outstanding citizens and depicted the Mandans' customs and homes in detail; his descriptions of them consume more than a quarter of the two-volume *Letters and Notes*. Most remarkable of all, Catlin was invited to observe and record the tribe's most important religious ceremony, the O-kee-pa. This was an honor not bestowed upon any other white artist.

The O-kee-pa was a four-day religious and historical pageant in which every member of the community—even

the dogs, Catlin thought[3]—was charged with playing a precisely defined role. The elements of the ritual were complex, but its objectives can be boiled down to three: the prevention, by sacrificial and devotional means, of a recurrence of a great flood from which the Mandan people were rescued by their culture hero Lone Man, a figure who can be likened to the biblical Noah; an exhortation to the buffalo to be fertile and to wander close to the Mandans because the tribe lacked enough horses to pursue them at much distance on the prairie; and a test of the strength, endurance, and courage of Mandan males who had recently come of age, which served as a sacrifice to the Great

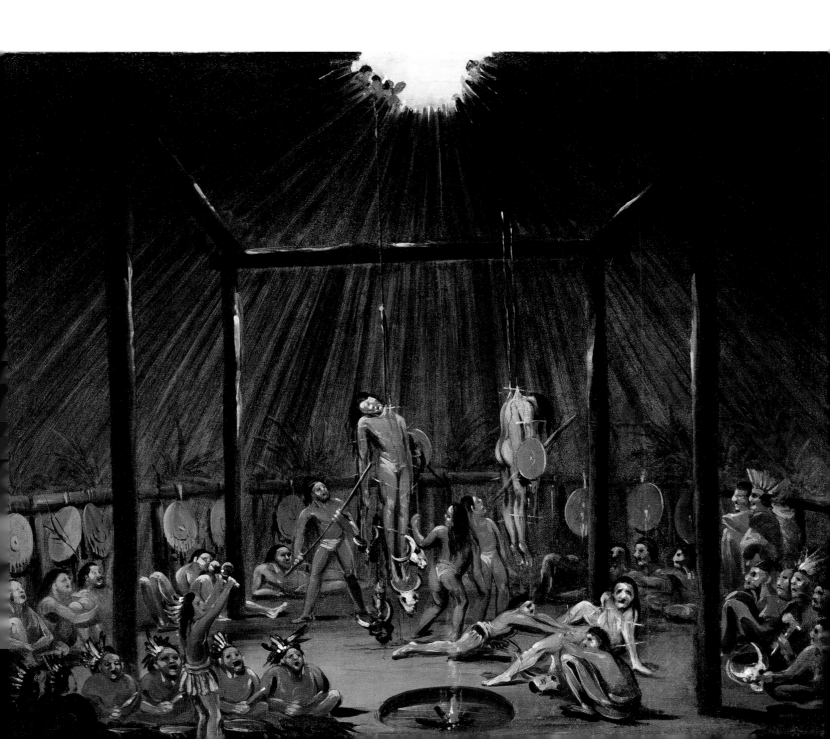

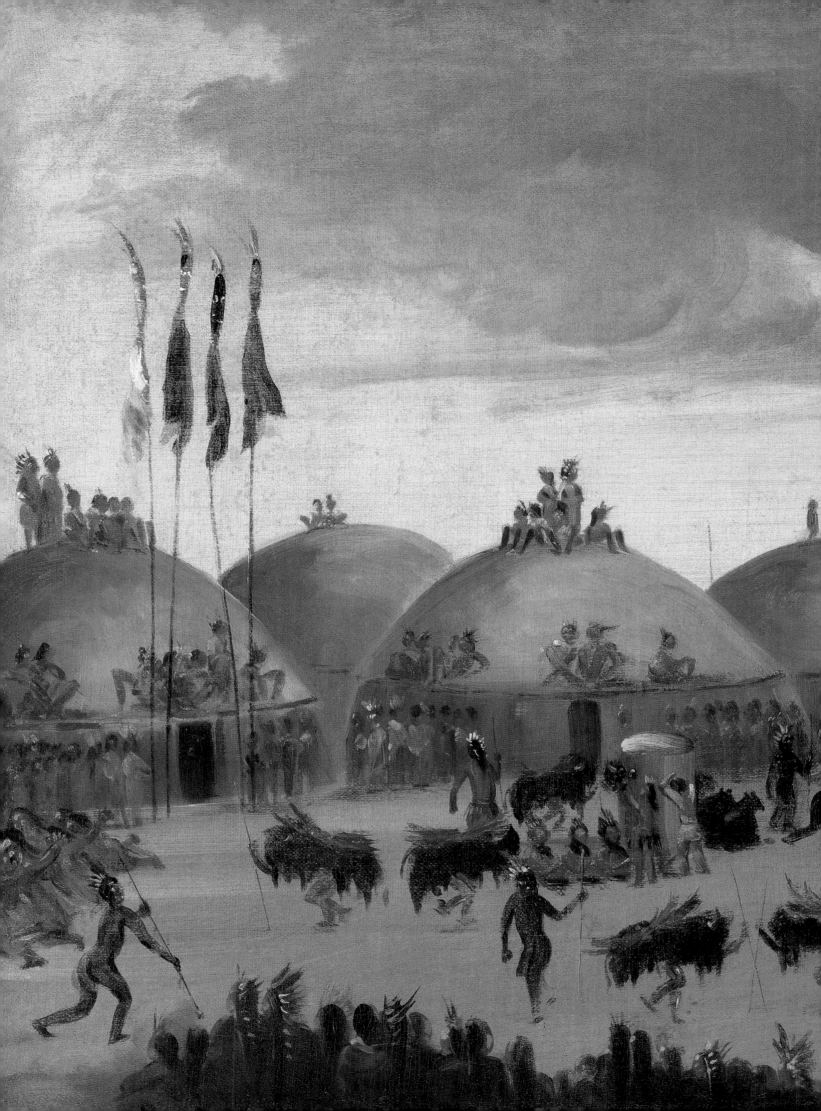

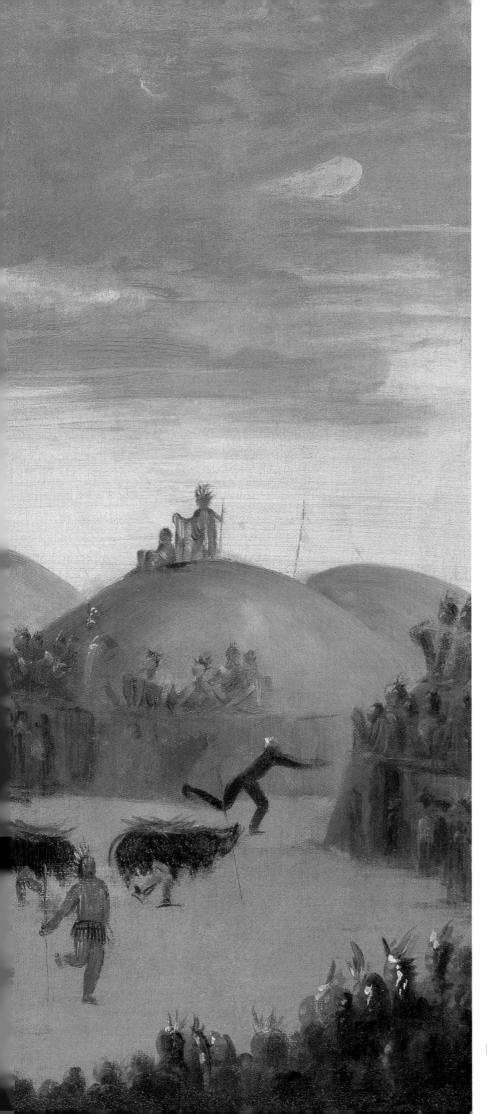

George Catlin
Bull Dance, Mandan O-kee-pa Ceremony, 1832
Oil on canvas, 22$^7$/$_8$ x 27$^7$/$_8$
Courtesy of American Museum
of Western Art—The Anschutz Collection

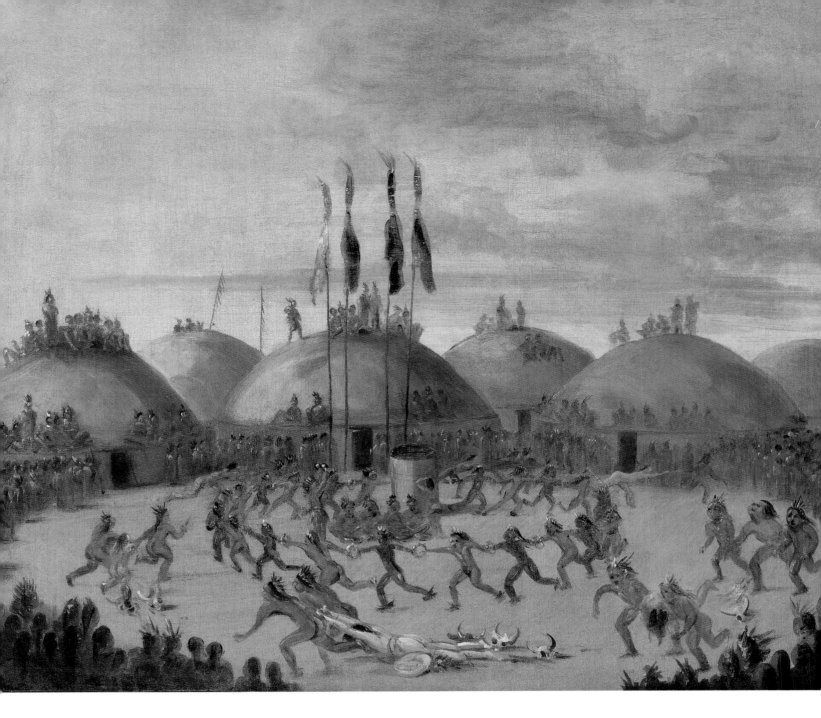

George Catlin
The Last Race, Mandan O-kee-pa Ceremony, 1832
Oil on canvas, 23½ x 28½
Courtesy of American Museum of Western Art—
The Anschutz Collection

Spirit as well as an opportunity for mature warriors to examine the young men's fitness for battle.[4]

Pohk-hong, The Cutting Scene, Mandan O-kee-pa Ceremony is third in a set of four images of the ritual that Catlin painted in the Mandan town or at Fort Clark shortly after he witnessed it. The first in the series, *Interior of the Medicine Lodge, Mandan O-kee-pa Ceremony*, depicts the young men who have been selected to undergo the painful ordeal represented in *The Cutting Scene*. They are gathered in the town's most sacred building, where they will spend up to four days and nights without food, water, or sleep.[5]

The second painting in the group, *Bull Dance, Mandan O-kee-pa Ceremony*, depicts the plaza outside the Medicine Lodge, which centered on an enclosure made of vertically set planks of cottonwood that surrounded an effigy of Lone Man; Catlin called it the "Big Canoe." Men draped in buffalo skins danced around this shrine concurrently with the preparation for

self-sacrifice of the young men within the Medicine Lodge. Strict adherence to the traditional forms of the dance was essential, the Mandans believed, to ensure a plentiful supply of bison.

Pohk-hong, The Cutting Scene, Mandan O-kee-pa Ceremony presents a scene that was, in Catlin's words, a "most extreme and excruciating ordeal."[6] Pairs of vertical cuts were made in the muscles of the young men's backs, breasts, arms, and legs and wooden splints were inserted into them. Men on the roof of the Medicine Lodge, whose faces are visible around the lodge's smoke hole in the painting, lowered cords that were attached to the splints in the young men's upper bodies; once this was done, those on the roof retracted the cords and hoisted the young men off their feet. The splints in the arms and legs of the young men were loaded with weapons and bison skulls, and men disguised as "imps and demons" used poles to spin their bodies at an ever-increasing rate, which heightened their suffering considerably. The candidates remained suspended until they lost consciousness, which, thanks to their state of dehydration and exhaustion, was not long in coming. They were lowered to the floor, and, as soon as they were strong enough to crawl, they presented the little finger of their left hand to be amputated as a further sacrifice; in the lower right corner of the canvas a man brandishing a hatchet above a bison skull, which served as a cutting board, makes ready for them.[7]

Seated in the lower left foreground of *The Cutting Scene* are four musicians who strike sacred drums constructed to resemble turtles, which evoked the Mandan belief that the earth had been created on the backs of four tortoises. The drums, filled with water to simulate the weight of a "spirit buffalo" within, were beaten, and a venerable pair of rattles was shaken to call the buffalo as well as fortify the resolve of the young men undergoing the cutting ceremony.[8]

The final act in this series of trials is depicted in Catlin's *The Last Race,*

Mandan O-kee-pa Ceremony. Each candidate was led out of the Medicine Lodge by a pair of athletic young men who wrapped leather bands around their wrists and, catching hold of him, proceeded to drag him, conscious or not, around the Big Canoe until all the splints and their attachments broke free. When that time finally arrived, each young man slowly rose and staggered home, "where his friends and relatives stood ready to take him into hand and restore him."[9]

Catlin's descriptions of the O-kee-pa were calculated in part to seize the attention of his contemporaries, whose taste for the sensational was as fully developed as that of audiences of our own time. In *Letters and Notes,* Catlin described *The Cutting Scene* in hellish terms:

I entered the *medicine-house . . .* as I would have entered a church, and expected to see something extraordinary and strange, but yet in the form of worship or devotion; but alas! little did I expect to see the interior of their holy temple turned into a *slaughter-house,* and its floor strewed with the blood of its fanatic devotees. Little did I think that I was entering a house of God, where His blind worshippers were to pollute its sacred interior with their blood, and propitiatory suffering and tortures— surpassing, if possible, the cruelty of the rack or the inquisition; but such the scene has been, and as such I will endeavour to describe it.[10]

Catlin was perhaps over-fond of such grisly hyperbole, and that, together with his belief in the spurious Welsh colony and his erroneous proclamation that the Mandans had been totally wiped out by a smallpox epidemic on the Upper Missouri in 1837, led to savage attacks on his credibility by competing western artists and ethnologists.[11] However, modern anthropologists, along with descendants of the Mandans depicted by the artist, have judged

Catlin's accounts of the O-kee-pa to be accurate. Over the next few decades the Mandans who survived the epidemic consolidated themselves with two neighboring tribes, the Hidatsas and the Arikaras, and they continued to perform the O-kee-pa in reduced form until it was suppressed by the federal government in 1890.[12] Certain items central to the performance of the O-kee-pa, including three of the turtle drums, were preserved,[13] and the ceremony was revived, guided in no small part by Catlin's written and pictorial accounts of it, in the mid-1900s.

The Denver Art Museum owns a curious object, a small silver plaque made by John C. Moore and sold by Tiffany, Young, & Ellis[14] (a predecessor of today's Tiffany & Co.), on which a version of *The Cutting Scene* is rendered in repoussé.[15] Catlin produced many variations on the images he took in the field, and the plaque appears to be a reproduction of the more elaborate and highly populated version of *The Cutting Scene* that he painted after his return from the Upper Missouri. This painting, which Catlin exhibited along with the Denver Art Museum's sketchier *Cutting Scene* in his Indian Gallery, went missing sometime after about 1890, when it was described and reproduced in an article in the *New York Times.*[16] The engraving in the *Times,* although very small, as well as cropped on the top and both sides, is virtually identical to the image on the plaque. During the period in which Moore designed and made the plaque (1848–52),[17] Catlin and his Indian Gallery were in London. Deeply disappointed by the U.S. government's refusal to purchase the Indian Gallery, Catlin had expatriated himself in 1839; his Indian paintings had not been seen in New York since that date. Unless Moore had an opportunity to view *The Cutting Scene* in England, his direct source for the image was almost certainly the line engraving of the painting published in Catlin's *Letters and Notes* (vol. I, plate 68).

Tiffany's silversmiths etched, chased,

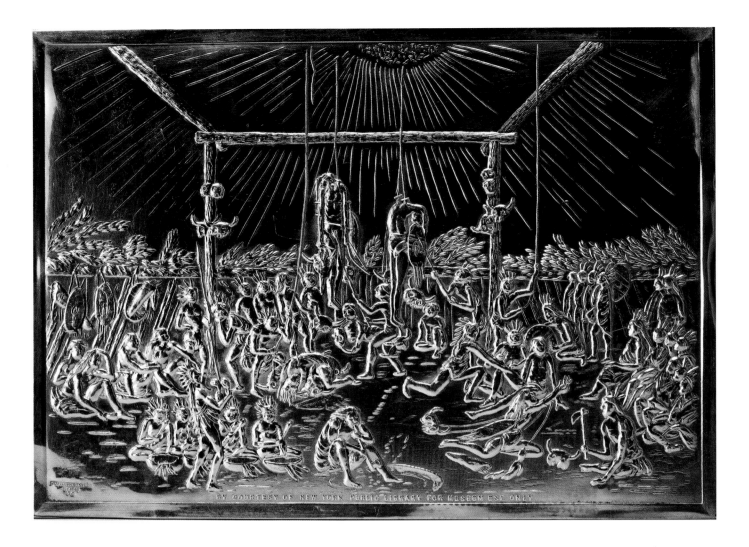

John C. Moore for Tiffany, Young, & Ellis
Pohk-hong, The Cutting Scene,
Mandan O-kee-pa Ceremony, 1848–52
Stamped lower left, "Tiffany, Young,
& Ellis/J. C. M./20"; Stamped bottom center,

Courtesy of New York Public Library, for museum
use only; silver repoussé, 7 x 9½
Denver Art Museum, Funds from William Sr.
and Dorothy Harmsen Collection, by exchange,
2009.2

molded, and modeled figures and genre scenes drawn from Catlin's oeuvre on trophies, loving cups, souvenir spoons, and even entire sets of flatware[18] through the end of the nineteenth century, demonstrating that there was a market for such designs despite the fact that the artist had died in near obscurity more than a decade before most of these items were produced.[19] However, *The Cutting Scene* seems less than an ideal image for a decorative object. The inscription stamped at the bottom of the plaque, "COURTESY OF NEW YORK PUBLIC LIBRARY FOR MUSEUM USE ONLY," suggests that it may have served

an educational function.[20] Whether the plaque was intended from the beginning to be "educational" is a mystery; the New York Public Library did not assume its present form until 1895, nearly fifty years after the plaque was made. Although the plaque's original purpose remains unknown, its very existence attests to the demand in the United States for decorative as well as fine art with distinctively American subject matter. No themes were more closely associated with this country than the wilderness and its native inhabitants, a fact that Tiffany & Co. was clearly aware of early on.

In 1846, Tiffany, Young, & Ellis featured "Indian Goods" (moccasins and other clothing, along with "Pipes, Belts, Pouches, and . . . various fancy articles, made of Birch bark [and] embroidered with Moose hair") in its catalog, noting that such objects would be "suitable for presents to friends on the other side of the water."[21] Tiffany & Co.'s recommendation conforms to Catlin's original motivation for leaving the United States in 1839; he took the Indian Gallery abroad to reap admission fees from exhibiting it in London, and also in hopes of selling it to a British aristocrat. The luxury goods purveyor

presumably had greater success with this strategy than Catlin, who was briefly jailed for debt in England and would return home more than thirty years later penniless and without his precious collection, which had been sold to repay his creditors in 1852.

Notes

1 For Catlin's biography, see Brian W. Dippie, *Catlin and His Contemporaries: The Politics of Patronage* (Lincoln: University of Nebraska Press, 1990) and Dippie, "Green Fields and Red Men," in George Gurney and Therese Thau Heyman, eds., *George Catlin and His Indian Gallery* (Washington, DC: Smithsonian American Art Museum in association with W. W. Norton, 2002), as well as William H. Truettner, *The Natural Man Observed: A Study of George Catlin's Indian Gallery* (Washington, DC: Smithsonian Institution Press, 1979).

2 George Catlin, *Letters and Notes on the Manners, Customs, and Conditions of the North American Indians* (London: By the Author, 1841; repr. New York: Dover Publications, 1973), I:15.

3 Ibid., I:158–59, 166.

4 Ibid., I:157. The most exhaustive study of Catlin's records of the O-kee-pa is Colin F. Taylor, *Catlin's O-kee-pa: Mandan Culture and Ceremonial; The George Catlin O-kee-pa Manuscript in the British Museum* (Wyk auf Foehr, Germany: Verlag fur Amerikanistik, 1996). See also George Catlin, John Ewers, ed., *O-Kee-Pa: A Religious Ceremony; and other Customs of the Mandans. With Thirteen Coloured Illustrations* [1867] (New Haven: Yale University Press, 1967) and Alfred W. Bowers, *Mandan Social and Ceremonial Organization* (Chicago: University of Chicago Press, 1950), chapter 4 and appendix I.

5 George Catlin, *An Account of an Annual Religious Ceremony Practised by the Mandan Tribe of North American Indians* (1865), reprinted in Taylor, *Catlin's O-kee-pa*, 62.

6 George Catlin, *Letters and Notes*, I:156.

7 Ibid., I:170–72.

8 Catlin, Ewers, ed., *O-Kee-Pa*, 53; Taylor, *Catlin's O-kee-pa*, 60–64, 70–73; Catlin, *Letters and Notes*, I:173; Catlin, *An Account of a Religious Ceremony*, reprinted in Taylor, *Catlin's O-kee-pa*, 99.

9 Taylor, *Catlin's O-kee-pa*, 62–63; Catlin, *Letters and Notes*, I:173–74.

10 Catlin, *Letters and Notes*, I:156.

11 The indispensable source on Catlin's relationships with other western painters of his time is Brian Dippie's *Catlin and His Contemporaries: The Politics of Patronage* (see note 1).

12 Taylor, *Catlin's O-kee-pa*, 157–62.

13 Ibid., 70–73.

14 Around 1846, Moore, a leading New York silversmith of the first half of the nineteenth century, began to supply Tiffany, Young, & Ellis with holloware. His son, Edward C. Moore, who took charge of the family firm in 1851, signed an exclusive agreement with the retailer that same year. Moore's company merged with Tiffany's in 1868. See John Loring, *Magnificent Tiffany Silver* (New York: Harry N. Abrams, 2001), 8–9, and Charles H. Carpenter Jr. with Mary Grace Carpenter, *Tiffany Silver* (New York: Dodd, Mead, 1978), 10–11, 96.

15 Two additional copies of the plaque, one in the Tiffany & Co. Archives Collection and the other in the Dallas Museum of Art, are known to exist. I thank Laura Ronner, research coordinator, and Annamarie Sendecki, archivist, Tiffany & Co., for performing the extensive research essential to my discussion of this unusual object. I am also greatly indebted to Medill Higgins Harvey, research associate, Department of American Decorative Arts, the Metropolitan Museum of Art, New York, for her research, expertise, and recommendations regarding the Denver Art Museum's investigation of the plaque. The assistance of Holly Clymore of the Petrie Institute of Western American Art is, as always, critical to my research and writing.

16 Robert Graves, "Dances of Redskins. Interesting Matter to Be Found in the Smithsonian," *New York Times*, undated clipping, Archives of American Art, reel 2707, frames 576–77. In his article, Graves ponders a connection between Catlin's accounts and pictures of the O-kee-pa and the emergence in 1889 of the Ghost Dance religion among the western tribes. Practitioners of the Ghost Dance believed that warriors dressed in "Ghost Shirts" would be protected from soldiers' bullets, a belief proven tragically wrong at the massacre at Wounded Knee in December 1890, which effectively ended the Indian Wars on the Plains. Graves makes no mention of Wounded Knee in his article, leading me to conclude that the article must have appeared prior to December 1890—either earlier that year or possibly in 1889.

17 Amy Dehan, "Tiffany's Buffalo Hunt Loving Cup," *The Magazine Antiques* 169, no. 1 (January 2006): 158 n. 10, incorrectly dates the plaque to 1850. Information from Laura Ronner, June 6, 2011.

18 William Randolph Hearst purchased more than three hundred pieces of Catlin flatware in the 1890s. See Carpenter, *Tiffany Silver*, 208–9.

19 Spoons decorated with motifs adapted from Catlin's images by Tiffany silver designer Charles T. Grosjean (1841–88) in 1884 constitute the majority by far of these objects. See Carpenter, *Tiffany Silver*, 205–10. A Tiffany & Co. catalog, *Indian Spoons, Studied from Catlin's Illustrations of the North American Indians And from Objects in the Museum, Washington, D.C.*, was published in 1893. I thank Laura Ronner for providing me with a number of images from the catalog. The "Museum" referred to in the catalog's title was the Smithsonian Institution, which took possession of Catlin's Indian Gallery in 1879. Catlin's Indian artifacts are today housed in the Smithsonian's National Museum of Natural History; most of the paintings in his Indian Gallery are in the collection of the Smithsonian American Art Museum.

20 According to a researcher in the Manuscripts and Archives Division of the New York Public Library, "We have been unable to turn up [a] context for the creation of John C. Moore's Silver Plaque depiction of Catlin's *The Cutting Scene*." TL to Holly Clymore, May 25, 2011.

21 See *Catalogue of Useful and Fancy Articles, Imported by Tiffany, Young, & Ellis* (New York: Van Norden & Amerman, 1846), 21. In its later catalog, *Indian Spoons, Studied from Catlin's Illustrations of the North American Indians* (see note 19), Tiffany & Co. restated its desire "to present . . . a strictly American product, both in design and work" and notified potential customers that these items could be delivered via its branches in London and Paris.

The Indian Hunter

LEWIS I. SHARP

he Indian Hunter was critically acclaimed when it was first exhibited in bronze in 1862 and established John Quincy Adams Ward as a major American artist.[1] The sixteen-inch-high statuette of a young Native American hunter and his dog was the culmination of the ambition of Ward and his mentor, Henry Kirke Brown, to model American subjects in an objective realist style that revealed the essence of the people and the ideals of the young republic. The beautifully crafted sculpture was also a testament to the evolution of bronze casting in America.[2] Brown had labored unsuccessfully to establish a long-term successful relationship with an

American foundry capable of fine arts casting. Ward's *Indian Hunter* achieved this ambition and ensconced bronze as the principal sculptural medium of the second half of the 1800s.

John Quincy Adams Ward was born to a well-to-do farming family in Urbana, Ohio, in 1830. He showed an early interest in art, but he had limited opportunities to develop his skill. After exploring a career in medicine, he moved to Brooklyn at the age of nineteen, where he lived with his sister and her husband, a successful merchant. She introduced Ward to the sculptor Henry Kirke Brown (1814–86), who had a studio in Brooklyn. Brown initially was not encouraging, but after Ward modeled a figure of the *Venus de Medici*, he was taken into the studio as a paying student and within a year was promoted to a position as a paid assistant.

Ward spent the next seven years in

Brown's studio. In his youth in rural Ohio, far from any knowledge of the aesthetics of neoclassicism, Ward turned to the natural world around him for inspiration. During his apprenticeship, Ward's naturalistic predilection was reinforced by Brown, who had rejected a secure career as a neoclassical sculptor in Italy to devote his artistic energy to the portrayal of American themes in his native country.[3] Ward adopted Brown's credo as his own, employing in his work his mentor's simple, direct naturalism.

Given the opportunity to work in clay, marble, and bronze, Ward learned the basic elements of the sculptor's craft. Brown was a good craftsman, a master stone cutter, and one of the first American sculptors to work in bronze. Ward's frequent use of bronze during his apprenticeship explains his later success in working with the medium. The advantage of bronze is its durability

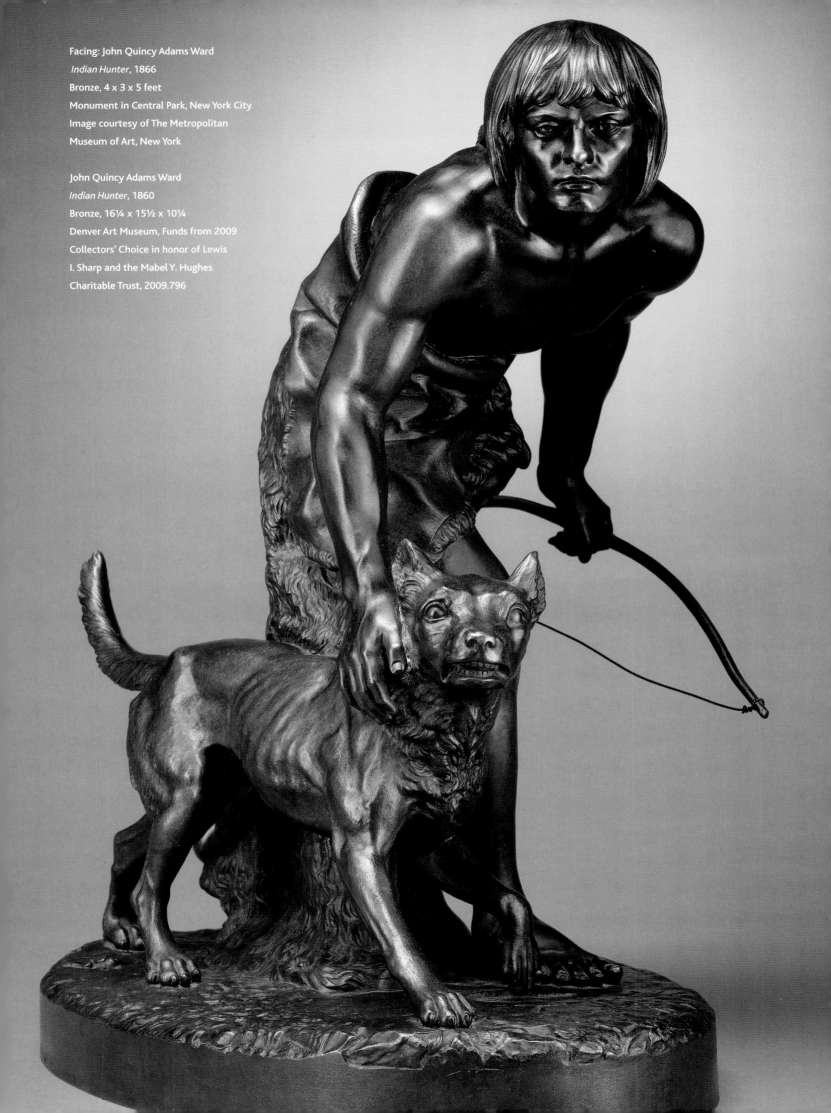

Facing: John Quincy Adams Ward
Indian Hunter, 1866
Bronze, 4 x 3 x 5 feet
Monument in Central Park, New York City
Image courtesy of The Metropolitan
Museum of Art, New York

John Quincy Adams Ward
Indian Hunter, 1860
Bronze, 16¼ x 15½ x 10¼
Denver Art Museum, Funds from 2009
Collectors' Choice in honor of Lewis
I. Sharp and the Mabel Y. Hughes
Charitable Trust, 2009.796

for public monuments erected in North America's harsh climates. The artist could also more faithfully replicate his sculpted model through the bronze casting process than in the hands of stone cutters, and the medium had the potential for multiple castings. But most important were the expressive possibilities of bronze, the facile modeling it allowed, and the rich surface textures and colored patinations—all of this enhanced the realism that sculptors of the later 1800s were seeking.

The years Ward apprenticed with Brown were the most productive and important in the older sculptor's career and set the stage for Ward and his choice of American subjects. In 1848, Brown was commissioned by the American Art-Union, a New York–based art organization, to produce twenty bronze castings of a statuette titled *The Choosing of the Arrow.* The subject of this pivotal work in the history of American sculpture is difficult to explain. After securing the Art-Union commission, in the fall of 1848 Brown traveled to Mackinac Island on Lake Superior, where Indian tribes were gathering for a government payment. During the trip, Brown made numerous pencil sketches and watercolors of Indian subjects. He also made a number of small wax busts, two of which were cast in bronze. To accomplish the bronze casting, Brown set up his own foundry in a "shanty" he constructed near his Brooklyn studio. These small busts were revolutionary for their realism and quality of casting—and are possibly the first sculptures cast in bronze in

America. What is difficult to understand is that when Brown, the following year, cast his twenty-inch-high statuette of *The Choosing of the Arrow*, the slim, attenuated figure was classical in spirit. The only sculptural attribute to nod to Native American subject culture was the quiver and bow. Even the physiognomy, which had been captured so convincingly in the small bust, had been repressed in the statuette, creating a neoclassical image of the *Apollo Belvedere* with a bow and arrow in hand.

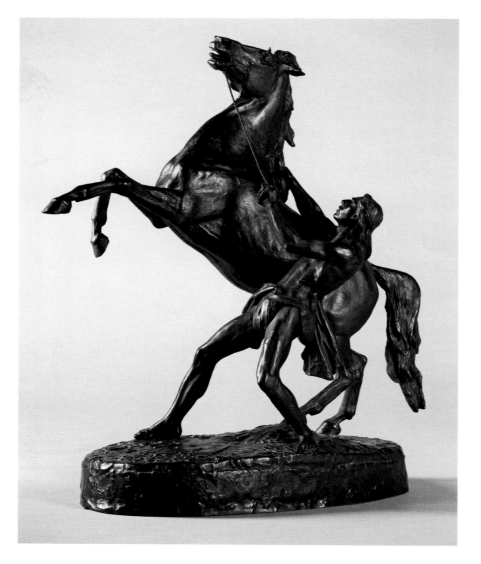

While Brown was not able to capture the realism he advocated, he remained committed to portraying Native American themes. In a letter dated December 1848, he reported that he was working in clay on a "large as life" sketch model for a sculpture titled *Dying Tecumseh*.[4] Unfortunately, there is no visible record of the work. A photograph does exist of a second Indian subject, *Indian and Panther*. In a letter dated January 1850, Brown reported that the sculpture represented "a fine old Indian defending his child against the attack of a panther."[5] The child, as the photograph reveals, was eliminated when the piece was later exhibited in New York City. Several highly naturalistic bronze casts of the panther from the large sculpture exist today. Recently another Indian subject by Brown, *Comanche Indian Breaking a Wild Horse*, has come to light. In all of these works, Brown was unable to go beyond his neoclassical roots. The compositions, even when representing violent actions, are frozen, and the physical characteristics of the figures are more closely related to the antique than the observed realism of his own sketches. The exception seems to occur only when Brown was able to step away from the human figure. The physiognomies of the small bronze busts are compelling and real and the snarling face of the panther reveals the ferocious nature of the big cat. While Brown's human figures lacked the realism that Ward would achieve in *The Indian Hunter*, his mastery of bronze casting was remarkable. All of the sculptures are beautifully cast, chased, and patinated.

In addition to these themes of Native Americans, Ward was able to work closely with Brown on the statue of DeWitt Clinton for Green-Wood Cemetery in Brooklyn and on the equestrian statue of George Washington for Union Square Park in New York City. The latter project was especially important for Ward. Collaborating with Brown, he was involved in the conception, enlargement, and final

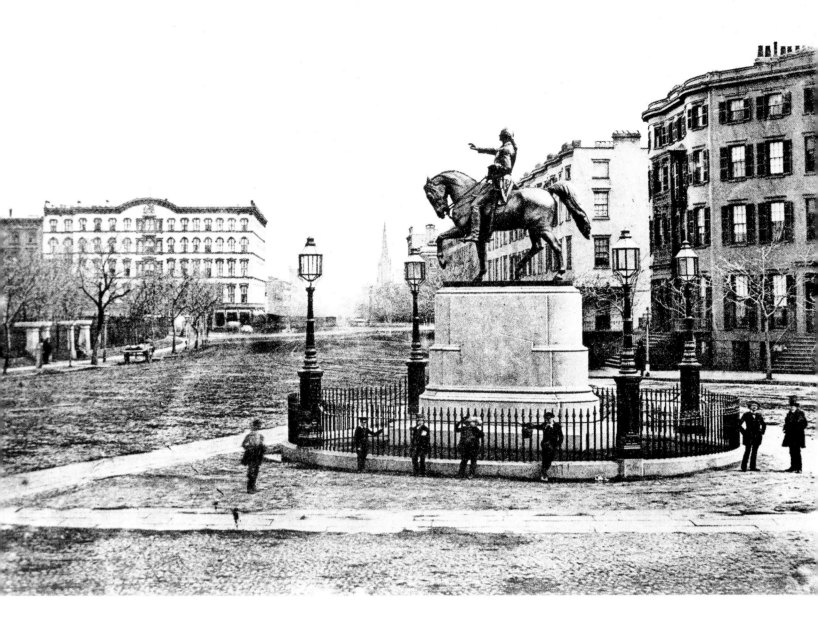

casting of the sculpture. Ward's name was inscribed on the finished sculpture—an unprecedented testament for an assistant. The result of this collaboration was a defining moment in the history of American sculpture. The relationship between the two sculptors was respectful and beneficial to both. The composition of the George Washington sculpture was derived from the famous classical equestrian statue of Marcus Aurelius on the Capitoline Hill in Rome; however, the dominant quality of the piece was its realism. Brown never had, nor would he ever again, successfully wed his classical roots to modern realism. For Ward, it was a chance to see a major commission through from beginning to end, and to set the stage for his future opportunities. Over the past seven years, Brown and his assistant had planted the seeds of realism in American sculpture and had established a proficiency in bronze casting that allowed it to become the principal medium for the future.

The master-student relationship was a lasting friendship. The two became constant companions, hunting and fishing together and spending endless hours in philosophical discussions of life and pursuit of artistic ideals. In addition to his close friendship with Brown,

Ward was introduced to and became part of one of the country's major intellectual and artistic circles, which included the likes of Sanford Gifford, Henry Marquand, Asher B. Durand, and William Cullen Bryant. This influential circle would play a major role in the future casting and placement of *The Indian Hunter* in Central Park.

About the time the George Washington sculpture was completed, Ward's apprenticeship was concluded. With several portrait commissions in hand, he devoted most of his time to two sculptures, *The Indian Hunter* and a statue of Simon Kenton, the Ohio pioneer. In 1859, he exhibited *The Indian Hunter* at the Washington Art Association and later in that year *The Indian Hunter* and *Simon Kenton* at the Pennsylvania Academy of the Fine Arts. Like Brown's sculptures, Ward's two works had compositions derived from influential pieces of antique sculpture. His *Simon Kenton* exhibits the same graceful contrapposto found in the *Apollo Belvedere*. In a like vein, the composition of *The Indian Hunter* is based on the *Borghese Gladiator*—a cast of which was known to be in Brown's, and later in Ward's, studio. The powerful legs of the young Indian, frozen in the midst of a long stride, correspond to those of the fighting gladiator; though the Indian's torso and head turn to the right and the gladiator's to the left, the two figures have the same strong diagonal carried down the back through a disengaged leg. However, like the equestrian statue of George Washington, the classical sources are secondary to Ward's keenly observed naturalism.

Although the two works were well received, the outbreak of the Civil War stalled the projects. To support himself, Ward modeled several portrait busts, small art objects, and presentation pieces for the federal government. He continued to refine *The Indian Hunter* and several other Indian subjects. In bronze he executed a statuette of an Indian chief holding a spear. The

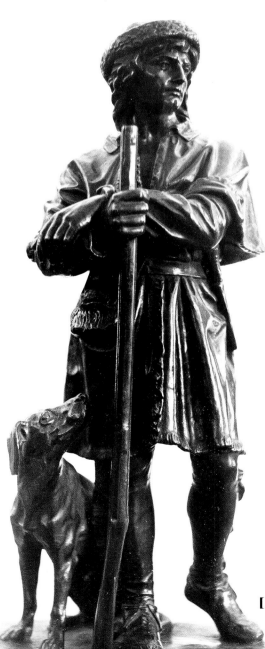

John Quincy Adams Ward
Simon Kenton, 1857
Painted plaster
Collection of Mr. and Mrs. Oliver E. Shipp,
Newburgh, New York
Image courtesy of The Metropolitan
Museum of Art, New York

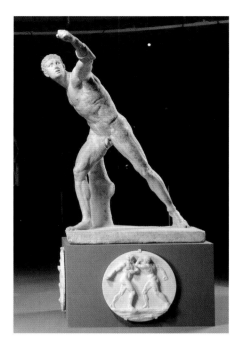

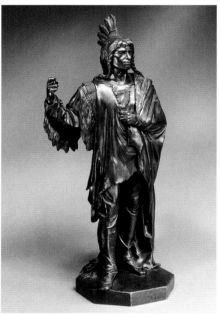

Agasias of Ephesos (1st century BCE)
Borghese Gladiator, Roman copy after a Greek
original (Original 100–75 BCE, copy 200 CE)
Marble, H: 78, Louvre, Paris, France
Photo by Réunion des Musées Nationaux /
Art Resource, New York

John Quincy Adams Ward
Indian Chief, ca. 1860
Bronze, 20 x 8½ x 6¾
Denver Art Museum, Gift from Estelle Rae Wolf
and the Harry I. and Edyth Smookler Memorial
Endowment Fund in honor of Lewis I. Sharp,
2001.634

John Quincy Adams Ward
Head of a Young Indian Girl, date unknown
Bronze, 5 x 5
Mrs. R. Ostrander, Bronx, New York
Image courtesy of The Metropolitan
Museum of Art, New York

Unknown photographer
John Quincy Adams Ward's Studio,
West 49th Street, New York City, ca. 1874
Collection of the American Academy
of Arts and Letters, New York City

lifelike figure is carefully studied and reproduced and the bronze casting is crisp and finely tooled. It was probably at this same time that Ward executed a small, highly naturalistic relief portrait of a young Indian girl (previous page). These two works exemplify the degree to which Ward learned to use the medium of bronze for desired effect and are superb examples of what the young sculptor was able to produce in the 1860s. During this period, Ward worked on two additional Indian subjects, which are unfortunately only known

through sketches in the artist's hand. The first, *Indian Stringing His Bow*, was exhibited in 1860 at the Washington Art Association. The figure can be seen in a photograph of Ward's studio taken in about 1874 (previous page) and in a pencil sketch by Ward. More animated than most of Ward's work, it shows an Indian powerfully exerting pressure on the top of the bow he is stringing. Two other drawings in Ward's sketchbook relate to a work titled *Indian Killing a Buffalo*. An unidentified newspaper article in Ward's scrapbook reported:

J. Q. A. Ward is making a spirited study for a large and characteristically American group—a great, shaggy buffalo rushing desperately to its last charge upon a rearing mustang and the little Indian who has just given the huge creature its death wound. The buffalo is indeed making its last charge on the prairie, and soon would be nothing but a labeled skeleton in a museum were it not for Mr. Ward's valuable work, which it is to be hoped, will not be allowed to remain merely a study.[6]

John Quincy Adams Ward
Indian Stringing His Bow, before 1860
Sketch of statuette
Location unknown
Image courtesy of The Metropolitan
Museum of Art, New York

John Quincy Adams Ward
The Freedman, 1863
Bronze, H: 20
American Academy of Arts and Letters,
New York City

In 1862, he displayed a bronze statuette of *The Indian Hunter* at the National Academy of Design. The sculpture was enthusiastically received, and Ward was elected an associate of the Academy. It was probably at this time that he began work on *The Freedman*, a figure of a semi-nude black man from whose wrists hung the remnants of chains that once bound him—an interpretation in sculptural form of the Emancipation Proclamation issued on January 1, 1863 by President Lincoln. The work reflects not only Ward's abolitionist sentiments, but his desire to sculpt a theme that addressed *the* political and moral issue of the time. Modeled from life, *The Freedman* was one of the first and most accurate sculptural representations of a black American.[7] Again, the composition was based on an antique work—in this instance, the *Belvedere Torso*—however, the essence of the figure is its naturalism. *The Freedman* was praised in the press, and Ward was elected an academician of the National Academy of Design.

Disappointed that none of his efforts to date had been enlarged, Ward set out to model a lifesize plaster cast of *The Indian Hunter*. Before he began work on the statue, he traveled to the Dakotas to study Native American Indians in their tribal habitat. A number of pencil and small wax sketches exist from this trip.[8]

A lifesize plaster cast of *The Indian Hunter* was exhibited in a New York gallery in the fall of 1865. Ward made only a few minor changes in this enlarged version—the oval base was replaced by a rectangular one, the

John Quincy Adams Ward
Study for "The Indian Hunter," 1857–64
Pencil on paper
Albany Institute of History and Art, New York

Henry Kirke Brown
Bust of an American Indian, 1848–49
Bronze, 8 x 3³/₈ x 2³/₈
Collection of John Russell Kaufman, William Tyler
Kaufman, and Meredith Ann Kaufman

native quality of the hair and the facial features was intensified, the bow arm was raised, and the size of the animal skin worn around the figure's waist was reduced. A group of twenty-three private citizens put up the funds to see the work cast in bronze. The actual casting was complicated and the details sketchy at best.[9] The Ames Manufacturing Company of Chicopee, Massachusetts, had worked with Brown and Ward on several projects in the mid nineteenth century. The relationship had always been problematic, but Ward engaged them to cast the enlarged *Indian Hunter.* At some point, Ward became so frustrated, he withdrew the work and gave it to a new partnership that had formed between the New York foundry man, L. A. Amouroux, and a Philadelphia firm, Robert Wood & Company. The actual work was done by the Philadelphia branch of the company, but the New York branch's name was inscribed on the finished bronze. Ward continued to work with Robert Wood & Company over the next six years—an extremely busy time for him, as he completed six major public monuments during this period. The finished sculpture and *The Freedman* were exhibited in the Paris Exposition of 1867. The following year, *The Indian Hunter* was presented by its subscribers to the city of New York for placement in the newly created Central Park—the first work by an American sculptor to be erected there (see page xx). It has been one of most admired and popular works in the park ever since. Three additional casts of *The Indian Hunter* were later commissioned. In 1897 a life cast was created for Cooperstown, New York, and following Ward's death in 1910, a recast was commissioned to mark his grave in Oakdale Cemetery, Urbana, Ohio; a third recast was made in 1926 for Delaware Park Meadow, Buffalo, New York.

THE EFFECT *The Indian Hunter* had on American sculpture cannot be overemphasized. Augustus Saint-Gaudens wrote of Ward: "His work and career, his virility and sincerity, have been a great incentive to me, from the day when he exhibited his *Indian Hunter* in an art store on the east side of Broadway. It was a revelation, and I know of nothing that had so powerful an influence on those early years."[10]

The Denver Art Museum's statuette is one of twelve known life casts.[11] All of these casts derive from the original pin model that breaks into four parts for the purpose of casting and is preserved today at the American Academy of Arts and Letters in New York City. The museum's cast descended in Ward's family. At some point, it was painted gold. This was successfully removed and it was repatinated in a color and tonal quality characteristic of Ward's sculpture. None of the early castings have foundry marks, making it impossible to assign any one of them to the Ames Manufacturing Company or the Robert Wood foundry. The Denver Art Museum's sculpture is one of two documented works cast by the Henry-Bonnard Bronze Company in 1885. The firm was led by the difficult but talented Eugene Aucaigne, a former newspaper editor, who developed a close working relationship with Ward.[12] Over a period of a quarter century, from 1883 through the end of Ward's active career in 1906, the firm cast all of Ward's work. The crisp and richly detailed surface of the bronze represents the high standard of craftsmanship set by Ward and Aucaigne. The uniquely American vision in bronze that Brown and Ward had worked so hard to establish was finally realized.

Notes

1 The primary source for this essay is Lewis I. Sharp, *John Quincy Adams Ward: Dean of American Sculpture* (Cranbury, NJ.: Associated University Presses, 1985), 26–48; see the separate catalog entries for each of Ward's sculptures discussed in the essay.

2 For a comprehensive history of bronze casting in America see Michael E. Shapiro, *Bronze Casting and American Sculpture, 1850–1900* (Cranbury, NJ: Associated University Presses, 1985).

3 Wayne Craven, "Henry Kirke Brown: His Search for an American Art in the 1840s," *American Art Journal*, November 1972, 44–58.

4 Letter from H. K. Brown to E. P. Prentice, 27 December 1848, H. K. Brown Papers, Library of Congress, Washington, DC, Manuscript Division. Reproduced in Craven, "Henry Kirke Brown," 53.

5 Letter from H. K. Brown to E. P. Prentice, 21 January 1850, H. K. Brown Papers, Library of Congress, Washington, DC, Manuscript Division. Reproduced in Craven, "Henry Kirke Brown," 54.

6 Sharp, *John Quincy Adams Ward*, 151. Unidentified newspaper article in John Quincy Adams Ward Scrapbook, Albany Institute of History and Art, Albany, NY.

7 An interesting footnote to this important sculpture is a finely modeled, small relief portrait of a young black boy (above right) that was a companion piece to his relief of a young Indian girl (page 239). Sharp, *John Quincy Adams Ward*, 279. The two reliefs decorated a court cupboard that belonged to Ward's stepdaughter-in-law, Mrs. R. Ostrander Smith. Their present location is unknown.

8 The wax sketches in the Ward material at the American Academy of Arts and Letters have striking similarities to Brown's small bronze busts cast in 1848 and to Ward's Indian subjects from the 1860s. This raises the question of whether Brown's wax sketches might have been handed down and used by Ward, or they might have been the wax sketches Ward reportedly made on his trip to the Dakotas in 1865.

9 Shapiro, *Bronze Casting*, 64–65, 167, 176.

10 Sharp, *John Quincy Adams Ward*, 47. Augustus Saint-Gaudens, *The Reminiscences of Augustus Saint-Gaudens*, ed. Homer Saint-Gaudens, vol. 2 (New York: The Century Co., 1913), 52.

11 Sharp, *John Quincy Adams Ward*, 146–50. The Denver Art Museum's cast is catalog #12.14.

12 Shapiro, *Bronze Casting*, 63, 71–76, 171–72.

John Quincy Adams Ward
Head of a Young Black Boy, date unknown
Bronze, 5 x 5
Mrs. R. Ostrander Smith, Bronx, New York
Image courtesy of The Metropolitan Museum of Art, New York

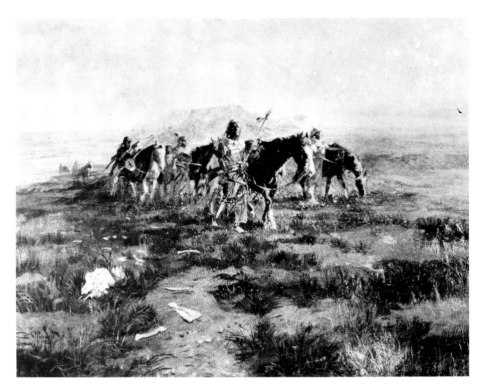

Charles M. Russell's In the Enemy's Country

BRIAN W. DIPPIE

n 1921, nearly thirty years after he quit the Montana range to take up art full time, Charles M. Russell (1864–1926) finished a vibrantly colored oil he titled *In the Enemy's Country*, which shows a party of dismounted Indians walking on grassy hills above a sunlit river valley. The catalog for its exhibition in Santa Barbara in 1923 explained:

Kootenai Indians crossing the Blackfeet country. There were no buffalo west of the mountains. The Kootenai and other tribes who lived west of the range crossed to hunt buffalo. The Blackfeet were enemies of most of these western tribes, so that they were always in danger while in the buffalo country. That is why they chose dark horses and threw their robes over them with the fur side up and walked at the shoulders of their mounts. At a distance they resembled a small band of buffalo. Old bulls traveled in small bands, and no Indian cared for bull meat. Therefore they were not molested.[1]

The basic facts outlined here were entrenched in the historical literature. Ross Cox, in his classic account of his experiences as a fur trader in the Pacific Northwest from 1812 to 1817, *The Columbia River; or, Scenes and Adventures during a Residence of Six Years on the Western Side of the Rocky Mountains*, commented on Flathead and Upper Kootenai incursions into Blackfeet country in search of buffalo as the cause of "dreadful," wasting conflicts. The Flatheads, he wrote, referring to the Salish of Montana, had seen their numbers "greatly diminished" due to "their love of buffalo," while the Kootenai "were perpetually engaged in war with the Blackfeet for the right of hunting on the buffalo grounds."[2]

The Flathead and the Kootenai have been described by one ethnographer as "Plateau tribes, with strong Plains affinities."[3] Speculation holds that both tribes once lived east of the continental divide but were pushed westward after the more numerous Blackfeet acquired guns. Today they share a common reservation in western Montana, the Flathead Indian Reservation south of Flathead Lake below Glacier National Park, where Russell had a summer home. He would come to know the Flathead area and its people well. Catholic converts, they were traditionalists when it came to appearance. "I belive there is mor old

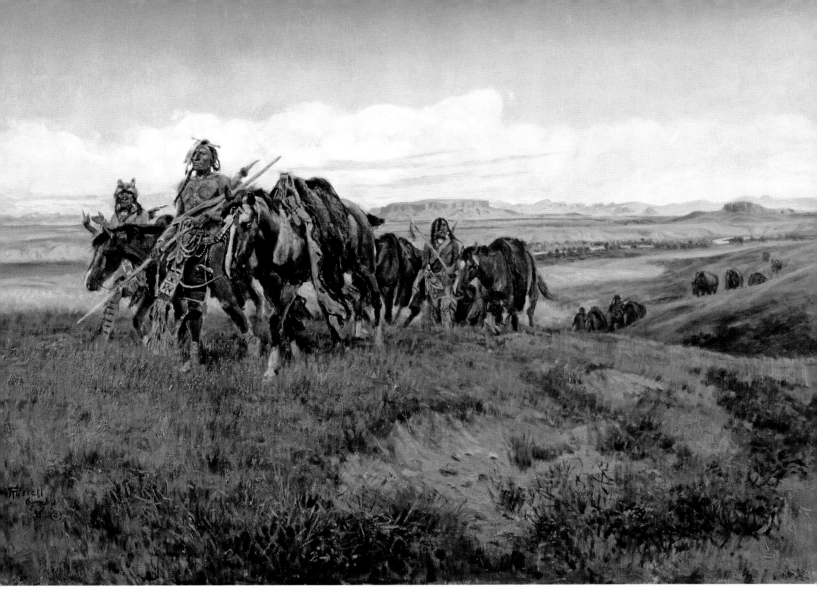

time dressed indians in that reservation than aney of them," he wrote in his characteristic prose, misspellings and all, in 1916. "I never saw a short haired Flat head the Indian was the mos picture esque man in the world"—and the Flathead and Kootenai, to his artist's eye, were the most picturesque of all.[4]

Russell returned to favorite subjects throughout his career—roping scenes, buffalo hunts, Indians on the move. Some subjects he explored in one period and then abandoned—white pioneers making a desperate stand against circling Indians, for example, and Indian camp life with domestic scenes set inside the tipi. Occasionally he essayed a theme and then returned to it years later. *In the Enemy's Country* is a case in point. The subject belongs within the broad category of parties of

Indians on the move, but like Russell's scenes of horse thieves making off with their plunder, constitutes a distinct variation on the theme. He first tackled it in 1901 in an oil painting, twenty-four by thirty inches, titled *Traveling in the Enemy's Country*. This canvas shows dismounted Indians moving from left to right across an open stretch of plains. Otherwise the composition closely anticipates the 1921 oil. As an artist, Russell required something that would visually encapsulate a historical moment. He settled on the stratagem employed by the Kootenai hunters to make themselves resemble a band of buffalo seen from a distance. In effect, the hunters became the hunted, masquerading as the very game that drew them on their risky venture. The men walk beside their horses; the spear

carried by the foremost figure points to the ground to prevent the sun flashing off its metal head. A buffalo skull and scattered bones in the foreground serve a narrative purpose by establishing the hunting party's reason for traveling in their enemy's country—the lure of buffalo.

Russell returned to the same theme in a small 1902 watercolor titled *Dangerous Ground*. Compositionally, it closely resembles the oil painted the previous year, but Russell has reversed the flow of action as the party proceeds from right to left. Again the central figure carries a spear pointed down, but no tell-tale bison bones appear in the foreground. Instead the story line is implicit in the wary advance of men and horses alert to an unspecified danger. In a remarkable letter that accompanied

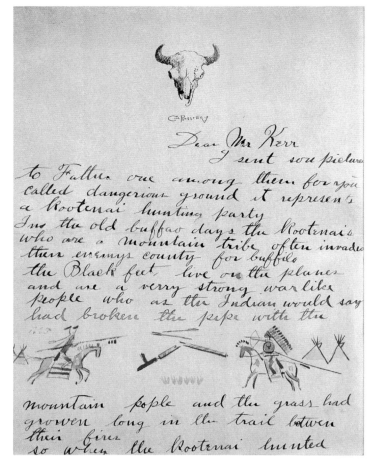

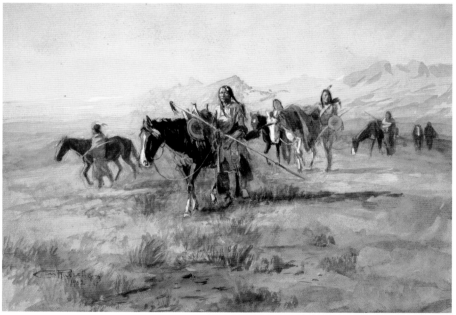

Top: Charles Marion Russell
Letter to George W. Kerr [March 21 1902]
Four-page letter, with pen and ink and
watercolor vignettes on each page
Joseph & Miriam Sample Collection
Image courtesy of Amon Carter Museum of
American Art, Fort Worth, Texas

Bottom: Charles Marion Russell
Dangerous Ground, 1902
Watercolor, 10³/₈ x 14½
Buffalo Bill Historical Center, Cody, Wyoming;
Gift of William E. Weiss, 22.70

the painting, Russell made that danger
explicit. "It represents a Kootenai
hunting party," he wrote his patron:

> In the old buffao days the Kootenais
> who are a mountain tribe often
> invaded their enemys country for
> buffilo the Black feet live on the
> planes and are a very strong war
> like people who as the Indian would
> say had broken the pipe with the
> mountain pople and the grass had
> grown long in the trail betwen their
> fires so when the Kootenai hunted
> in the Blackfoot county cautiously
> dismounting and walking beside his
> pony when in high or open country
> on these occasions they went in small
> partys generly using dark Poneys if
> white the owner threw his robe over
> him they traveled verry slow allowing
> there animels to grase now and then
> imitating as nere as possible the
> movments of a heard of old bulles all
> glittring orniments were hidden even
> the lance was carred point down for
> fere its frash [flash] in the sun might
> betray them in old times when buffilo
> were plenty old bulls were not hunted
> as nether there meat or hide was good
> as soon as a bull looses his fighting
> quality he is whiped out of the heard
> by the younger set and as misiry loves
> coumpiny these old fellows gether in
> small bunches away from the main
> heard.

Blackfeet scouts scrutinizing the
country from some distant promontory
would mistake the Kootenai party for a
small band of old bulls, not recognizing
them as trespassers on their land and
ignoring them as undesirable game.[5]

When Russell returned to the same
theme for a third time in 1921, he gave
full play to his later, brighter palette
and to the effects of light playing over
an undulating landscape beneath a
brilliant blue sky. The impression
created by buffalo robes thrown over
the horses and the men walking in
step beside them is expertly rendered.
Russell's advance in technical skill is

evident as the eye trails to the rear of the procession where horses and men blend into clumps of buffalo-like dark brown, requiring no bison bones to establish the stratagem or to advance the narrative line. The warm, rich hues are typical of Russell's work in oils in the last decade of his life as he applied color freely—pink and mauve, yellow and green, russet and turquoise. Liberated by the example of artists and illustrators he admired such as Maxfield Parrish, he shook off his thralldom to the "stouter" colors he had favored in the past. The ice cream scoops of cloud on the horizon have been described as "too sweet," but they do have a prominence that strikes me as intentional. These humpbacked puffs of white, like the robe-covered horses receding into the distance, resemble a herd of buffalo on the move, echoing the painting's theme.[6]

It would be stretching matters to say that *In the Enemy's Country* constitutes an allegory, but Russell was not the only western artist to link the fate of the Indians and the buffalo on which they subsisted. At the time Russell signed his painting with his buffalo skull insignia in 1921, James Earle Fraser's allegorical sculpture *End of the Trail*—showing a mounted Indian, head bowed in dejection, his buffalo robe tossed by the wind—was a popular sensation, while Fraser's elegant Indian head/buffalo nickel had been in circulation for eight years.[7] It was a time in America's development to commemorate what Russell called "the West that has passed." A year before his death, he made the case for buffalo as a better symbol than turkey for a western Thanksgiving. "The west owes nothing to that bird," he said, "but it owes much to the humped backed beef . . . thair is no day set aside where he is an emblem the nickle wares his picture dam small money for so much meat he was one of natures bigest gift and this country owes him thanks."[8] Those Kootenai hunters, risking everything to "go to buffalo," would have agreed.[9]

Notes

1 *Special Exhibition: Paintings and Bronze by Charles M. Russell, Great Falls, Montana* (Santa Barbara: [The School of the Arts Gallery, 1923]), #7. *In the Enemy's Country* was apparently first exhibited in Denver at the Brown Palace Hotel, November 26–December 17, 1921. *Rocky Mountain News*, December 4, 1921. This essay adopts the spellings used by the Salish Kootenai College, Pablo, Montana.

2 Ross Cox, *The Columbia River; or, Scenes and Adventures during a Residence of Six Years on the Western Side of the Rocky Mountains*, 3rd ed. (London: Henry Colburn and Richard Bentley, 1832), 2 vols., 1:216–17; 2:133. Whether Russell was familiar with Cox's book, he likely had access to another published in 1890 that summarized Cox's main points, Peter Ronan's *Historical Sketch of the Flathead Indian Nation from the Year 1813 to 1890*. Of the four Salish-speaking tribes on the Flathead Indian Reservation the designation "Flathead" refers specifically to the Bitterroot Salish. See Bon I. Whealdon, et al., *"I Will Be Meat for My Salish": The Buffalo and the Montana Writers Project Interviews on the Flathead Indian Reservation*, ed. Robert Bigart (Pablo, MT: Salish Kootenai College Press, with the Montana Historical Society Press, Helena, 2001), 1–8; and the standard history, John Fahey, *The Flathead Indians* (Norman: University of Oklahoma Press, 1974).

3 Harry Holbert Turney-High, *The Flathead Indians of Montana*, Memoirs of the American Anthropological Association 48 (Menasha, WI: American Anthropological Association, 1937), 11; and his *Ethnography of the Kutenai*, Memoirs of the American Anthropological Association 56 (Menasha, WI: American Anthropological Association, 1941), 13–14.

4 C. M. Russell to Joe De Yong, undated note [ca. 1916], Flood Collection, C. M. Russell Museum, Great Falls, MT; and for missionary activity in the area see L. B. Palladino, *Indian and White in the Northwest: A History of Catholicity in Montana 1831 to 1891* (Lancaster, PA: Wickersham Publishing Company, rev. ed. 1922); John J. Killoren, *"Come, Blackrobe": De Smet and the Indian Tragedy* (Norman: University of Oklahoma Press, 1994); and Jacqueline Peterson with Laura Peers, *Sacred Encounters: Father De Smet and the Indians of the Rocky Mountain West* (Norman: University

of Oklahoma Press, 1993). The tortuous history of the Kootenai portion of the Flathead Reservation is recounted in William L. Davis, *A History of St. Ignatius Mission* (Spokane: C. W. Hill Printing Co., 1954), chapter 10.

5 C. M. Russell to George W. Kerr [21 March 1902], in Brian W. Dippie, ed., *The 100 Best Illustrated Letters of Charles M. Russell* (Fort Worth: Amon Carter Museum, 2008), 22–23. Harry Holbert Turney-High, who wrote ethnographies of the Flathead and the Kootenai based on field work conducted in the 1930s, contradicted Russell's account. "When mid-June arrived the Upper Kutenai would go over the mountains on the summer bison hunt," he said. "Unlike the Flathead, they . . . claim to have felt no fear in crossing the mountains into Blackfoot territory . . . [They] never went east in the summer with less than eighty lodges, so they had no fear of Piegan or Blood." Turney-High, *Ethnography of the Kutenai*, 54–55.

6 For elaboration on Russell's artistry in *In the Enemy's Country*, see Brian W. Dippie, "In the Enemy's Country: Western Art's Uneasy Status," *Redrawing Boundaries: Perspectives on Western American Art* (Denver: Institute of Western American Art, Denver Art Museum [Western Passages], 2007), 14–16.

7 See Brian W. Dippie, *The Vanishing American: White Attitudes and U.S. Indian Policy* (Lawrence: University Press of Kansas, 1982), 215–20; and David W. Lange, *The Complete Guide to Buffalo Nickels: Second Edition* (Virginia Beach: DLRC Press, 2000).

8 C. M. Russell to Ralph Budd, 26 November 1925, in Dippie, *100 Best Illustrated Letters of Charles M. Russell*, 195.

9 Frank B. Linderman, *Kootenai Why Stories* (New York: Charles Scribner's Sons, 1926), x. For a fine historical overview, see William E. Farr, "Going to Buffalo: Indian Hunting Migrations across the Rocky Mountains," *Montana The Magazine of Western History* 53 (Winter 2003): 2–21; (Spring 2004): 26–43.

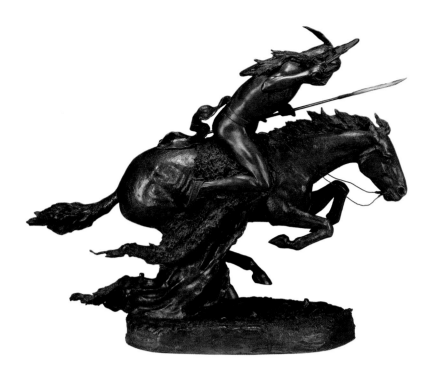

Frederic Remington's The Cheyenne

LEWIS I. SHARP

The Denver Art Museum's cast number three of Frederic Remington's *The Cheyenne* is a masterpiece in the field of American sculpture.[1] The revolutionary work attests to Remington's meteoric rise as one of the most daring and successful artists at the turn of the nineteenth century. The pony, with all four hooves off the ground, carries a Cheyenne warrior across the plains. The concept of the sculpture was brilliant, its realism unprecedented, and its experimental use of *cire perdue* (lost wax casting) expanded the potential of bronze as an artistic medium.

Born in Canton, New York, in 1861, Remington showed an early predilection for art, though it was not necessarily encouraged. He attend the Yale School of Fine Arts for a year and a half, but the sudden death of his father in 1880 cut short his formal art training, with the exception of a short stint at the Art Students League. Throughout his life, Remington would portray himself as solely self taught; however, the lessons learned from drawing and studying from plaster casts at the art school exerted a profound influence on him. Over the next five years he toiled at a number of jobs—all proving futile. Married and with a small inheritance, Remington traveled west with his new wife, living for a short time in Missouri and wandering through New Mexico and Arizona. The romance of the West was immediate. He was caught up in the vast spaces of the plains, the rugged mountains, the herds of wild animals, the nomadic cowboy, and the nobility of the Native American people. He returned with a few sketches that were published in the widely distributed magazine *Harper's Weekly*. The popularity of Remington's illustrations was instant. While crudely conceived and executed in relation to works by skilled illustrators of the day, they were keenly observed and had a direct honesty that was appealing. Over the next five years, Remington became the foremost illustrator of the American West. The astonishing thing about this recognition was the short period of time in which Remington found his subject, completely mastered it, and showed the technical proficiency necessary to be recognized as one of the most highly regarded illustrators of the day. The speed and confidence in which he mastered a new medium was an extraordinary skill, and one that he would demonstrate again as a painter and then as a sculptor.

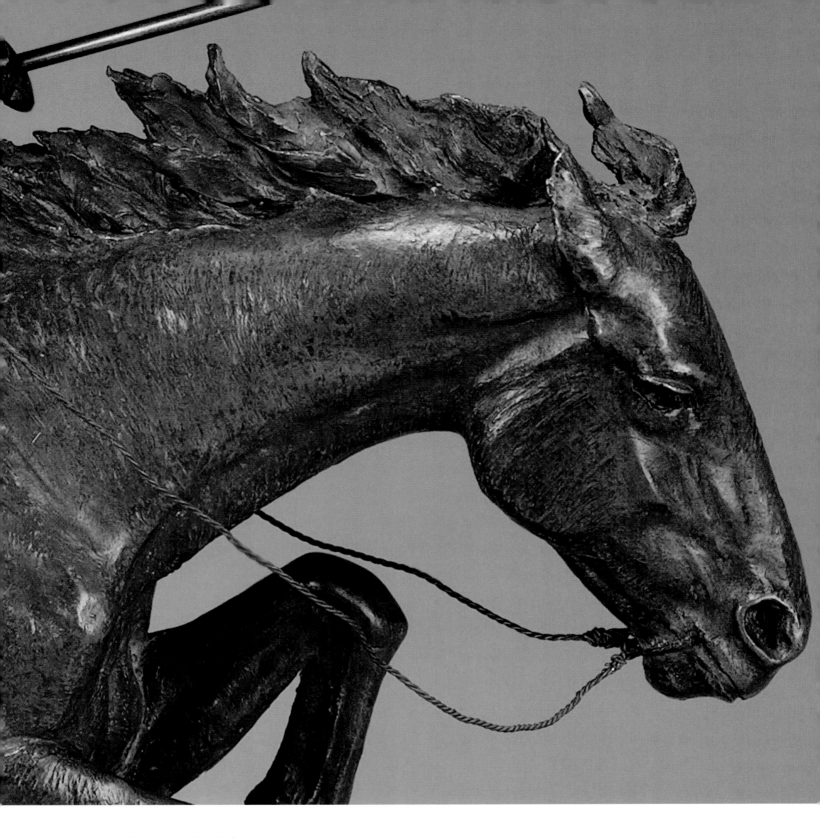

Facing and details this page and overleaf:

Frederic Remington

The Cheyenne, ca. 1901–04

Roman Bronze Works casting #3

Bronze, 21 x 24½ x 7½

Denver Art Museum, Funds from the William D.

Hewit Charitable Annuity Trust, 1981.14

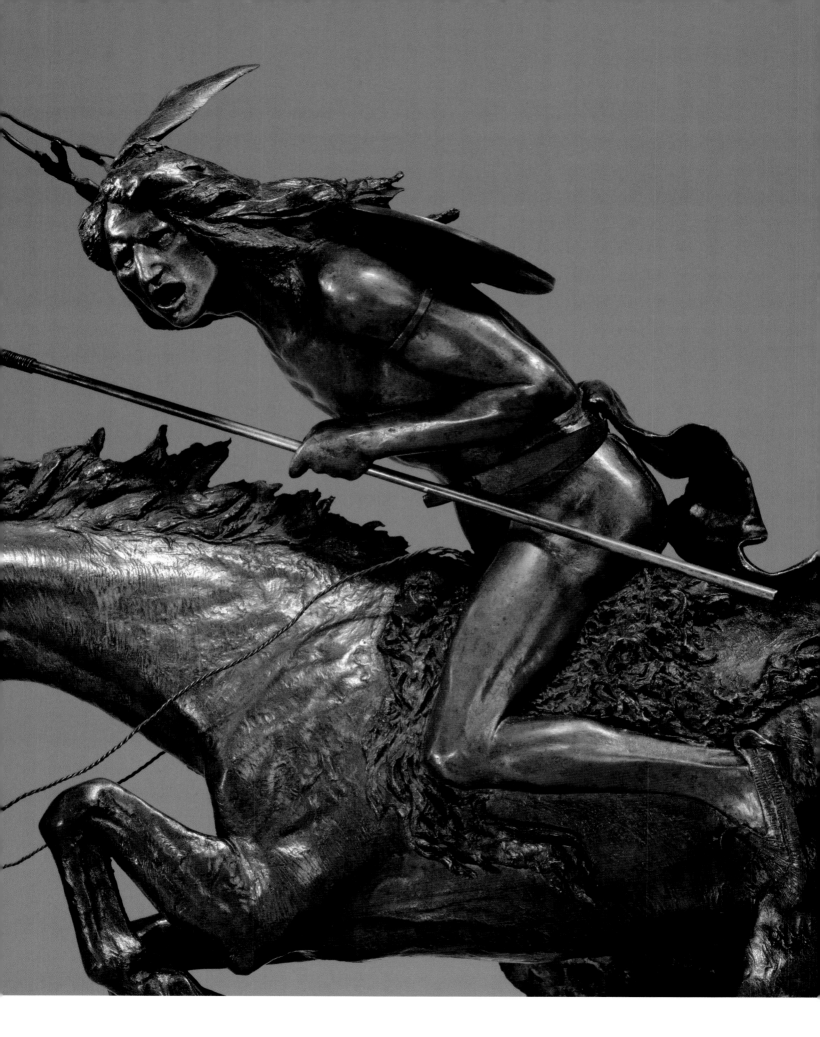

Financially comfortable from his success as an illustrator, Remington turned his ambitions to painting. He experimented in watercolors and took classes at the Art Students League to better understand the mixing and application of paint. Again it was Remington's power of observation, coupled with artistic brilliance, that propelled him forward. Living in New York, the intellectual capital of the country, he was familiar with the major painters working at home and abroad. He absorbed and combined current art trends with his eye as an illustrator. Like his contemporary Winslow Homer, also an illustrator early in his career, he was later able in his paintings to portray compelling narratives that captured the essence of a time, a place, or an event.

With supreme confidence Remington submitted a selection of drawings and a painting, *The Last Lull in the Fight,* to the 1889 Paris Universal Exposition.[2] With this sudden recognition he created the following year an enormous canvas, *A Dash for the Timber,* for the National Academy of Design's annual exhibition. The sheer ambition of the painting is daunting. Eight cowboys, pursued by a band of Indians, explode from the picture plane. The dynamic action is coupled with the observed realism of an illustrator. The smell of gunpowder, dust, and sweat are in the air. The cowboys and their horses are well drawn, and his use of light and color are convincing. *A Dash for the Timber* is a masterpiece, and while parochial critics might continue to label him an illustrator, the painting justifiably established Remington as a major painter. Over the next twenty years he created a body of work that equaled that of any of his peers.

In 1895, the final chapter of Remington's artistic life unfolded as he turned his interest to sculpture.

Again it was with immediate and total preoccupation. His artistic ambition was especially amazing because of the challenges the new medium presented to a fledgling practitioner. Rarely in the history of art have painters turned to sculpture as an end in itself. It requires a unique skill to be able to visualize objects in three dimensions. A limited number of painters utilized sculpture to help them realize the human form in space. Degas and Matisse are prime examples of two artists who created an important body of sculpture, yet it was a tool to help them with their painting and not an end in itself. Remington is unique in that without any training he embraced the art form, and it became a very important part of his oeuvre. From the outset, he successfully realized complex images in space. It is also important to note that like Henry Kirke Brown, John Quincy Adams Ward, and Augustus Saint-Gaudens, Remington

Frederic Remington
A Dash for the Timber, 1889
Oil on canvas, 48¼ x 84⅛
Amon Carter Museum of American Art,
Fort Worth, Texas, 1961.381

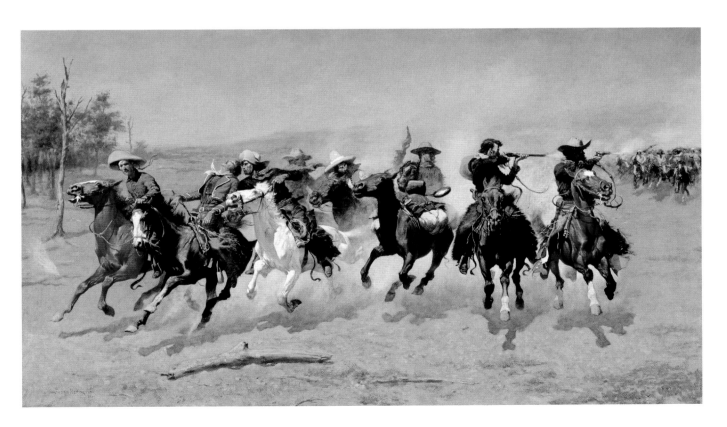

challenged foundry practices and pushed foundries and the medium to new artistic heights. From 1895 until his death in 1909 Remington would create twenty sculptures with approximately 265 life casts—an extraordinary output for an artist who did not execute his first sculpture until he was thirty-four, and whose life would be cut short at the age of forty-eight.

Remington's chance encounter with sculpture came in 1894, when Frederick Wellington Ruckstull, a competent but pedestrian sculptor, modeled an equestrian statue in a neighbor's backyard of General John Hartranft, for Harrisburg, Pennsylvania. Enthralled with the work and the process, Remington mined Ruckstull for the three months that the sculptor worked on the model. With his usual confidence and ambition Remington threw himself into modeling a cowboy on a bucking bronco. He wrote to his friend, the novelist Owen Wister: "My oils will all get old . . . my watercolors will fade—but I am to endure in bronze . . . I am modeling—I find I do well—I am doing a cow boy on a bucking broncho and I am going to rattle down through all the ages."[3] In eight to ten months the model of *The Broncho Buster* was completed and sent to the Henry-Bonnard Foundry to be cast in bronze. The statuette was an overnight sensation and became an icon in the field of American art. Over the next twelve years, approximately 150 casts of the sculpture were produced, sixty-four initially at the Henry-Bonnard Foundry and approximately ninety after 1900 at the Roman Bronze Works.[4]

The switching of foundries was significant in the realization of *The Cheyenne*. Prior to 1900 the Henry-Bonnard Foundry was regarded as the finest foundry in the country.[5] Led by the talented but difficult Eugene Aucaigne, their castings, finishing, and patinations were outstanding; however, there was little room for collaboration or experimentation. Between 1895 and 1900 the foundry produced four separate works for Remington. As was the custom of the day they were sand cast. The sculptures are all of the highest quality. Yet Remington was never close to Aucaigne and after a fire at the foundry, in which inventory was lost, Remington terminated the relationship. About the same time a young Italian, Ricardo Bertelli, was trying to establish a new foundry, the Roman Bronze Works in Brooklyn, using lost-wax casting. While lost-wax casting was an ancient and well-known process that had been revived and creatively used in the Italian Renaissance, it had no tradition in the Americas.

The Roman Bronze Works offered two equally important things to Remington. First was Bertelli's

willingness to collaborate. The two men developed a close personal and professional friendship. An astute businessman, Bertelli offered the sculptor a new business arrangement. In casting Remington's sculptures, he did not require the artists to pay for the foundry work until the sculpture was sold.[6] This was a significant advantage to the financially savvy sculptor. The potential of casting in lost wax was also promising. The sculpture could be conceived and cast in a single mold, with the added potential for deep undercutting in the bronze. The sculptor also could model directly on the wax surface, with unlimited freedom for making changes. It allowed for a more painterly surface—giving the work an invigorated spontaneity and a heightened realism. The two men also began experimenting with chemically applied patinations. They moved beyond a uniform brown patination to a varied range of colors—creating almost a polychrome appearance. The original beauty of Remington's patinations may have been compromised over the years by repeated waxing.[7] While waxing enhances the sheen, it can distort the

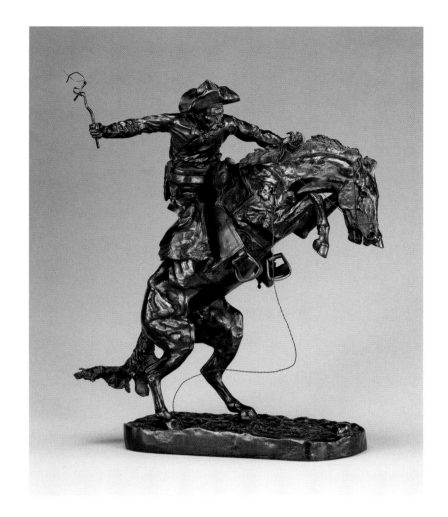

Frederic Remington
Sketches among the Papagos of San Xavier
Harper's Weekly, April 2, 1887
Sheet of twelve drawings
Denver Public Library

Frederic Remington
The Bronco Buster, 1895
Bonnard casting #59
Bronze, 24 x 17½ x 14
Private collection, Denver, Colorado

Frederic Remington
The Norther, 1900
Roman Bronze Works
Bronze, 22 x 8¾ x 20
Gilcrease Museum, Tulsa, Oklahoma, 0827.39

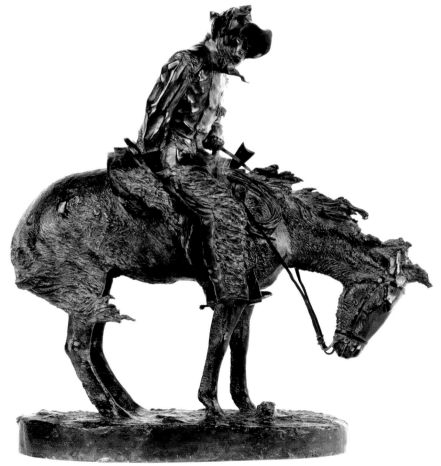

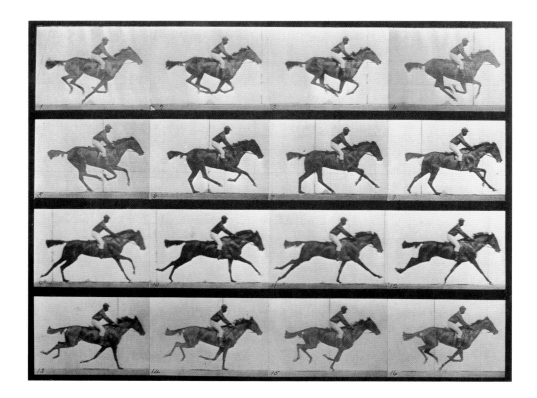

Eadweard Muybridge
Animal Locomotion. Plate No. 626, 1881
Collotype, 10 x 12
University of Pennsylvania Archives
[ID 20050616002]

Frederic Remington
The Wounded Bunkie, 1896
Henry-Bonnard Bronze Company
Bronze, 20¼ x 13
Gilcrease Museum, Tulsa, Oklahoma, 0826.35

original color—and possibly the subtle effect the artist may have desired. It is interesting that impressionist painters did not varnish their paintings as they sought a matte, more naturalistic look. There is no documentation of the waxing of bronzes, and a number of sculptures that have not gone through the art market have no evidence of being waxed. *The Cheyenne*, flying across the dry plains, would have an added realism if it possessed an unwaxed, matte finish.

The first sculpture that Remington and Bertelli collaborated on was *The Norther*, an image of a cowboy leaning forward on his horse with a biting cold wind at their backs.[8] The work was a tour de force. Impressionistic in spirit, it captured a fleeting moment of time. Remington and Bertelli exploited the expressive qualities of the lost-wax process. The undercutting of the bronze is extreme, the contrast of surface treatment unprecedented, and

the olive-colored patination captures the impression of ice and snow. *The Norther* demonstrated the potential of the new relationship; however, the sculpture lacked the spirited action of his earlier works and did not have a wide commercial appeal with only three known casts being realized.

Ebullient about the lost-wax process, Remington turned his attention to the creation of *The Cheyenne*. Remington was an experienced horseman and was aware of Eadweard Muybridge's pioneering stop-action photographs of a horse in mid-stride, in which its four legs off the ground are folded under its body.[9] Remington had experimented with this image earlier in *The Wounded Bunkie*, but the Henry-Bonnard Foundry had not been able to devise a way to keep all four of the horse's hooves off the ground. Remington implored Bertelli in a letter that he "wanted to preserve the effect of the action,"

possibly supporting the figure with a finely textured buffalo robe.[10] The result was brilliant. Everything Remington and Bertelli had aspired to was realized. The kinetic sculpture floats over the ground; the finely polished surface of the Indian's flesh is in stark contrast to the richly textured surfaces of the base, the buffalo robe, and the horse hide. The variegated golden-brown patination is breathtaking. In this bold experiment, artist and artisan elevated each other to a new level of artistic excellence.

The Denver Art Museum's cast number three is not dated in the Roman Bronze Works' ledger.[11] In 1904, after eight figures were cast, Remington made a number of changes to the statuette. The shield was lowered on the warrior's back, feathers were attached to the shield, and earrings were added to the warrior. Probably to simplify the casting of the sculpture, the size and complexity of the base were reduced and simplified

and the horse's right rear fetlock was straightened. After cast twenty-one, both rear fetlocks were straightened. Without the intensity of their collaborative involvement, the quality of the casting deteriorated over time. In 1907, when the Metropolitan Museum of Art acquired four works by Remington for its permanent collection, the sculptor was so distressed by the quality of cast number nineteen of *The Cheyenne* that he ordered the model to be destroyed. A close inspection of comparative photography of cast number three and number twenty, the last located life cast, illuminates the quality of Remington's life cast and sheer beauty of the Denver Art Museum's cast.

Notes

1 For the pioneering work on Remington's sculp-
 ture see Michael E. Shapiro, *Cast and Recast:
 The Sculpture of Frederic Remington* (Washing-
 ton, DC: Smithsonian Institution Press, 1981).
 Portions of this book were republished with
 invaluable additional information on bronze
 casting in America, see Michael E. Shapiro,
 *Bronze Casting and American Sculpture,
 1850–1900* (Cranbury, NJ: Associated Univer-
 sity Presses, 1985). Also see Shapiro's work on
 Remington expanded on in the comprehen-
 sive book on Remington's sculpture, Michael
 D. Greenbaum, *Icons of the American West:
 Frederic Remington's Sculpture* (Ogdensburg,
 NY: Frederic Remington Art Museum, 1996).
 For an insightful overview of Remington's art
 see Michael E. Shapiro and Peter H. Hassrick,
 Frederic Remington: The Masterworks (New

York: Harry H. Abrams Inc., in association with
the Saint Louis Art Museum, 1988).

2 Shapiro and Hassrick, *Frederic Remington: The
 Masterworks*, 69.

3 Frederic Remington to Owen Wister, January
 1895. Owen Wister Papers, Library of Con-
 gress, Washington, DC.

4 Greenbaum, *Icons of the American West*, 27–30.

5 Ibid. See also Shapiro, *Bronze Casting and
 American Sculpture*, 132–36.

6 bid., 36–38.

7 Ibid., 29 n. 8.

8 Ibid., 84–87.

9 Ibid., 88–93.

10 Ibid., 89.

11 Ibid., 184.

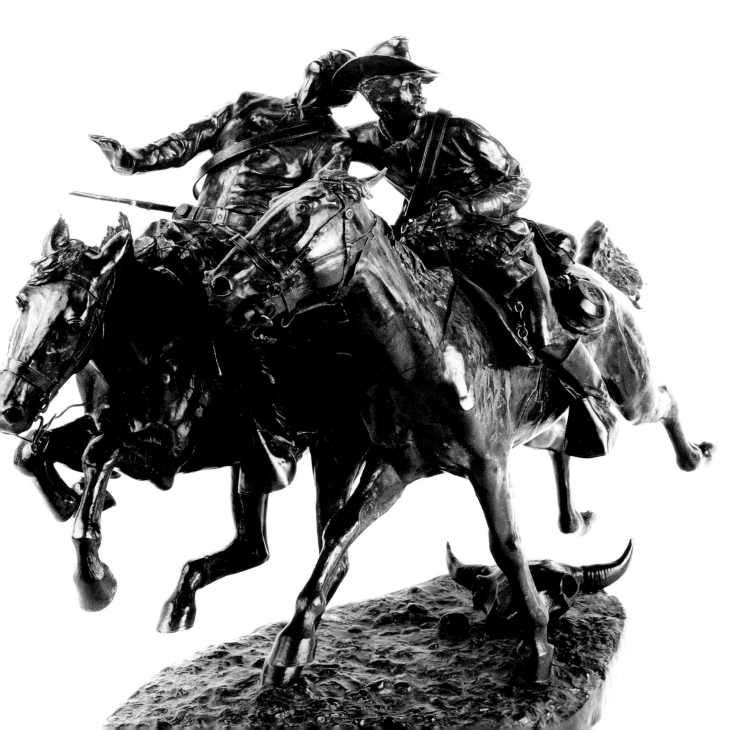

Andy Warhol
The American Indian (Russell Means), 1976
Synthetic polymer paint and silkscreen
ink on canvas, 84 x 70
Denver Art Museum, Charles Francis Hendrie
Memorial Collection by exchange, 1993.107
©2011 The Andy Warhol Foundation for the
Visual Arts, Inc. / Artists Rights Society (ARS),
New York

Andy Warhol's The American Indian
(RUSSELL MEANS)

"I didn't volunteer to have my portrait done; certainly not. Andy Warhol had asked me. And I accepted, since his gallery, Ace, had donated $5,000 to the American Indian Movement— and that was it. When the money went to the cause, I gave my consent."

RUSSELL MEANS[1]

CHRISTOPH HEINRICH

Unlike most of the portraits that Andy Warhol made after 1970, *The American Indian (Russell Means)* is less about immortalizing a celebrity or endowing a well-paying client with the glamour of Liz, Marilyn, and Elvis; part of a series, the painting belongs to Warhol's theme of "big American topics." In fact, it's quite unlikely that Warhol himself chose Means as a portrait subject. Given his famous question to friends and dealers—"Gee, what should I paint?"—and his tendency to readily follow their suggestions, it's more probable that someone at Ace Gallery, Warhol's West Coast representation in Venice, California, conceived the idea. Means theorized that someone at Ace conducted a brief survey among American Indians in California and Canada asking who they thought should represent their culture today, and Means was their choice.[2]

It was a brilliant and timely choice. *The American Indian* series would offer an important counterpart to Warhol's earlier tinsel-town cowboys—Elvis (1964) and Dennis Hopper (1971). It was also great timing; 1976 was the year of the United States Bicentennial, celebrating two hundred years as an independent republic since the adoption of the Declaration of Independence. Means was a logical selection, as he was the most prominent member of the American Indian Movement (AIM), which was formed to promote the freedom of Native Americans to follow their traditional ways and to call national attention to their oppressed

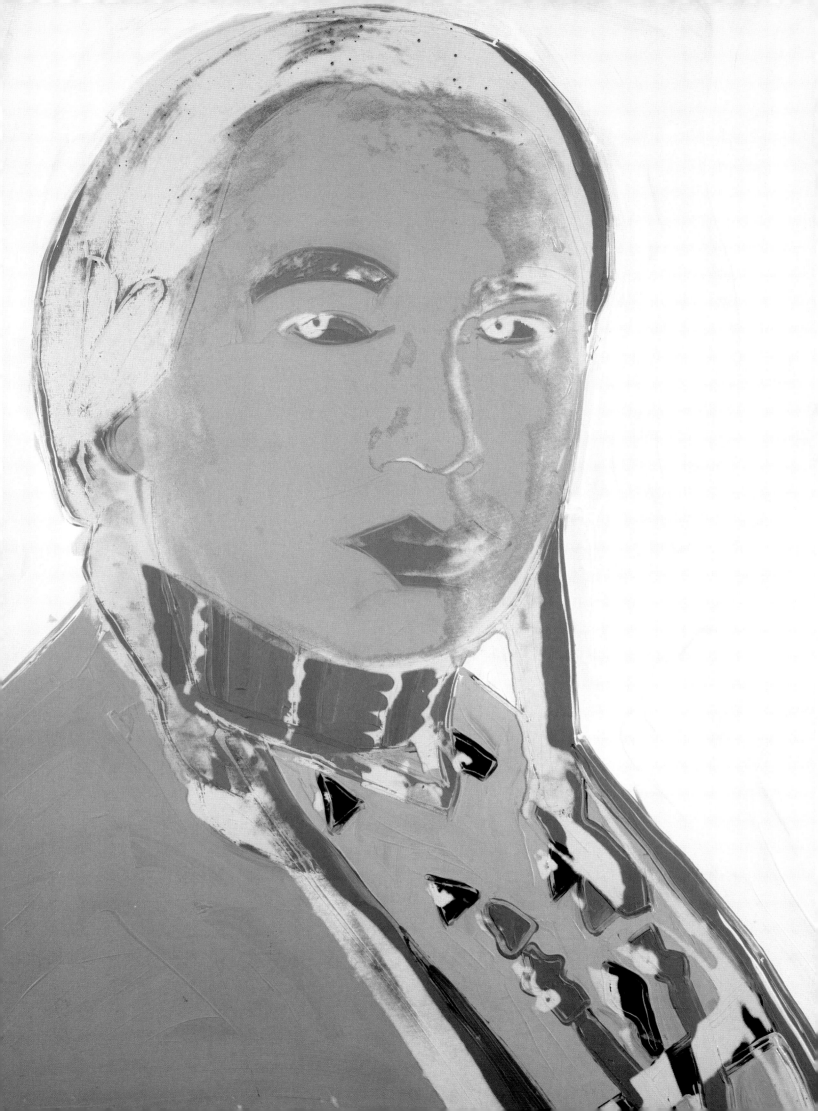

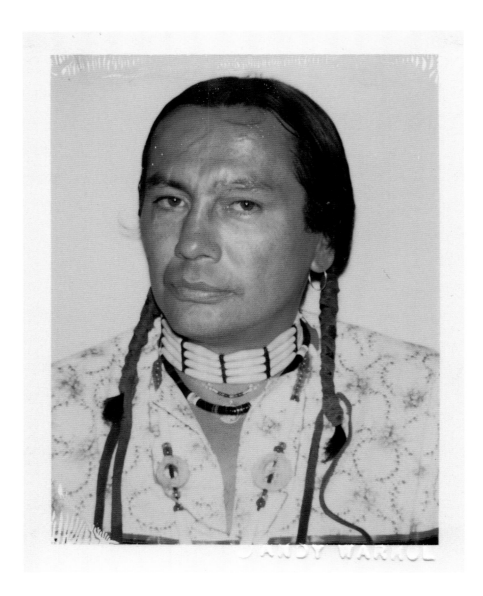

Andy Warhol
American Indian (Russell Means), 1976
Photograph, Polacolor Type 108®
Courtesy University Museums, University of
Delaware, Gift of The Andy Warhol Foundation
for the Visual Arts, Inc.
© 2011 The Andy Warhol Foundation for the
Visual Arts, Inc. / Artists Rights Society (ARS),
New York

state. Born in 1939 into the Oglala/ Lakota Sioux tribe, Means ignited American Indians to actively protest their second-class status. He attracted plenty of attention from the media (and the government) and was tried numerous times for marches and other unauthorized activities. Most notorious was the Wounded Knee affair at the South Dakota site of the final massacre of the Indian Wars in 1890, where the Seventh Calvary attacked three hundred-fifty unarmed Indians. Eighty-three years later, Means and several hundred AIM sympathizers occupied the small hamlet of Wounded Knee for seventy-one days in an armed standoff with the Federal Bureau of Investigation and state law enforcement agents. His trial took place in 1974 (he was acquitted). Means's fearless participation in AIM is controversial among American Indians; however, he was certainly one of their most charismatic spokespeople. Such was his talent as an inspiring public figure that by the 1990s, he'd become a movie actor and used his fame to further his cause more peaceably, appearing in films including *The Last of the Mohicans* and *Natural Born Killers,* and as the voice of Chief Powhatan in Disney's *Pocahontas.*

Andy Warhol spent his entire career portraying the symbols and metaphors of the American way of life: bottles of Coke and cans of Campbell's soup, the dollar bill, movie stars, most-wanted criminals, fatal car accidents, the electric chair. In addition to the cowboy-themed paintings of Elvis and Dennis Hopper, a 1986 series of ten screen prints further elaborated the cowboys and Indians theme, featuring John Wayne and Annie Oakley, Sitting Bull as well as General Custer, and Geronimo, katsina dolls, and an Indian head nickel. Warhol loved the punch of stereotypes.

Invariably, his images were based on photographs—some from the print media, some he and his assistants took— and produced in series. For Means's portrait, which was made in Warhol's New York studio, the Factory, the artist would have taken a series of photos; thirty-eight shots were found in the artist's estate.[3] His

camera of choice was the Polaroid SX 70, a.k.a. "The Big Shot," which instantly produced and developed a four-by-three-inch image. Sometimes, the model had a word in the selection of the image; in the case of *The American Indian* it's not likely. All Warhol's Polaroid shots show the model in a close-up, mostly frontal or three-quarter profile—the conventional format of the portrait bust, with small differences in the direction the model is looking. The Polaroid made it quick and easy for Warhol to create photos as the basis for his portrait series; it was like a portable "photo-booth" (which he used for his early portraits in the early 1960s), capable of producing sharp photos at very little cost and no special expertise required. Just like the photo-booth strips, the Polaroid evened out the facial features, thereby making the models for his silk screens appear timeless and iconic. Thus, all the requirements were met for a business model that combined everything that mattered to Warhol: the reproductive potential of photography and its ability to produce an accurate and authentic replication of reality; Warhol's affinity for success and glamour; and his reputation as a prolific artist.[4] As critic Robert Rosenblum points out, by the 1970s Warhol had become a "celebrity amongst celebrities." He was an ideal court painter for the international modern aristocracy in which all different levels of wealth, elegance, style, and intelligence were included.[5] This efficient production formula also embodied Warhol's statement: "Art is business." Under these circumstances it's no surprise that Means vehemently denied (too vehemently?) that he had volunteered to pose for the "court painter" of the international jet set: "Certainly not"!

Warhol's series, *The American Indian (Russell Means)*, includes about forty acrylic on canvas paintings, and among them are twelve in the large format like the one in the Denver Art Museum. In addition there are at least eighteen large-format pencil drawings.[6] The majority of the paintings in the series are rendered in electric pastel colors, typical for Warhol's portraits of the mid-1970s, and in most of the versions, Warhol plays off the stereotype of the "red skin" and traditional dress adorned with some patches of color. However, the Denver painting is different.[7] The face is grayish, with lavender hues that dissolve into the zinc-white of the ground. The portrait deals with a subtle visual idea of disappearance and death, also seen in Warhol's *Shadows* series, his black and gray Marilyn print, and some of the later self-portraits that he painted and printed white on white.

Warhol's intentions to combine timeless glamour with the transitory nature of being become most obvious in his photo-mechanically reproduced silk screens. He became interested in Marilyn Monroe *after* her suicide and portrayed Jackie Kennedy at JFK's assassination and at the funeral. So too can Denver's portrait of Russell Means be seen as a painting about disappearance. As a charismatic speaker and prominent (even notorious) American media figure, Means embodied the qualities the artist sought. But at the same time he represents, as an AIM activist, the last defiant struggle of a culture that was already perceived as doomed and had been relegated by many Americans to a place in history and folklore. Yes, Warhol shows Means in a traditional outfit: a leather shirt with a horn necklace, and braids bound with leather strips. But in the Denver painting these details are not emphasized; they are all part of the gray and white palette. Scratched on the surface with the end of the paintbrush, they seem to sink into the background—a radiant afterglow, comparable to the negative of a photograph, or the photosensitive gelatin of the acetate, which Warhol knew from the critical step between the source photo and the silk screens for his painting production. In this mysterious transformation lies a power and seriousness that separates itself from the easy glamour of the portrait production of these years. Warhol was certainly not an artist with a strong political agenda, nor was he an advocate for the rights of minorities. But his art was always intuitive—and as such it serves as a mirror of the current moment, a mirror of his times. In this case, a man and his people are disappearing.

My thanks to Neil Prinz, editor, and Mary Keefe, editorial assistant, who are preparing the catalogue raisonné at the Andy Warhol Foundation, for their valuable information.

Notes

1 Interview with Russell Means, Geneva, September 22, 1977, published in *Andy Warhol: The American Indian*, exh. cat. (Geneva: Musée d'art et d'histoire, 1977), 26.

2 Ibid.

3 According to the catalogue raisonné the Polaroid that was used for the acetate is still in the photography collection of the Andy Warhol Foundation (inv. #FA09.01456).

4 See Christoph Heinrich, "Andy Warhol. Art Director—Amateur—Artist," in *Andy Warhol: Photography*, exh. cat. (Hamburg: Hamburger Kunsthalle; Pittsburgh: Andy Warhol Museum [Edition Stemmle], 1999), 9–17.

5 Robert Rosenblum, "Andy Warhol: The Court Painter of the Seventies," in *Andy Warhol: Portraits of the Seventies and Eighties* (London: Anthony d'Offay Gallery in association with Thames and Hudson, 1993), 146.

6 The catalogue raisonné has documented thirty-eight paintings to date: twelve in large format (eighty-four by seventy inches) and twenty-six small (fifty by forty-two inches). Among the thirty-eight paintings documented, four remained in the studio until Warhol's death, three in the smaller size and one larger. This last one is the painting from Denver.

7 The catalogue raisonné has documented two other canvases somewhat related to the one in Denver: one (fifty by forty-two inches) belonging to the Robert Rauschenberg Foundation; the other (eighty-four by seventy inches) in a private collection. Both are *grisailles*, in a sense, with a white screen impression on a black background.

Portraits by James Bama

PLAINS INDIANS DURING AN ERA OF MOVEMENT

James Bama

A Young Oglala Sioux, 1975

Oil on board, 24 x 18

Buffalo Bill Historical Center, Cody, Wyoming

Gift of an anonymous donor, 26.97

THOMAS BRENT SMITH

In 1968, New York City native James Bama left a successful illustration career for the solitude of the Absaroka Mountains of Wyoming and the hopes of building a career as a fine artist. He discovered a West filled with rugged yet romantic contemporary people, which became the subject of his art. Among the vanguard of American photorealists, he painted his most successful works, a series of portraits of young Native Americans, in the 1970s.

Bama's migration westward coincided with the rise of the American Indian Movement (AIM) in the heated political atmosphere of the 1960s. Founded in Minneapolis in 1968, the militant organization grew out of the civil rights struggles of the era. Originally formed to protect the rights of native people faced with poverty and police oppression in urban areas, the movement quickly developed into a national vehicle for social and cultural protest. In the late 1960s and 1970s, AIM participated in several high-profile protests, including the 1969 occupation of Alcatraz Island and a 1972 march on Washington to protest treaty violations. The Washington demonstration culminated in the takeover of the Bureau of Indian Affairs headquarters. On February 27, 1973, in the village of Wounded Knee on the Pine Ridge Reservation in South Dakota, approximately two hundred Sioux led by AIM activists occupied the town for seventy-one days. Near the gravesite of Lakotas killed by U.S. troops in the 1890 Wounded Knee Massacre, AIM members waged what became known as

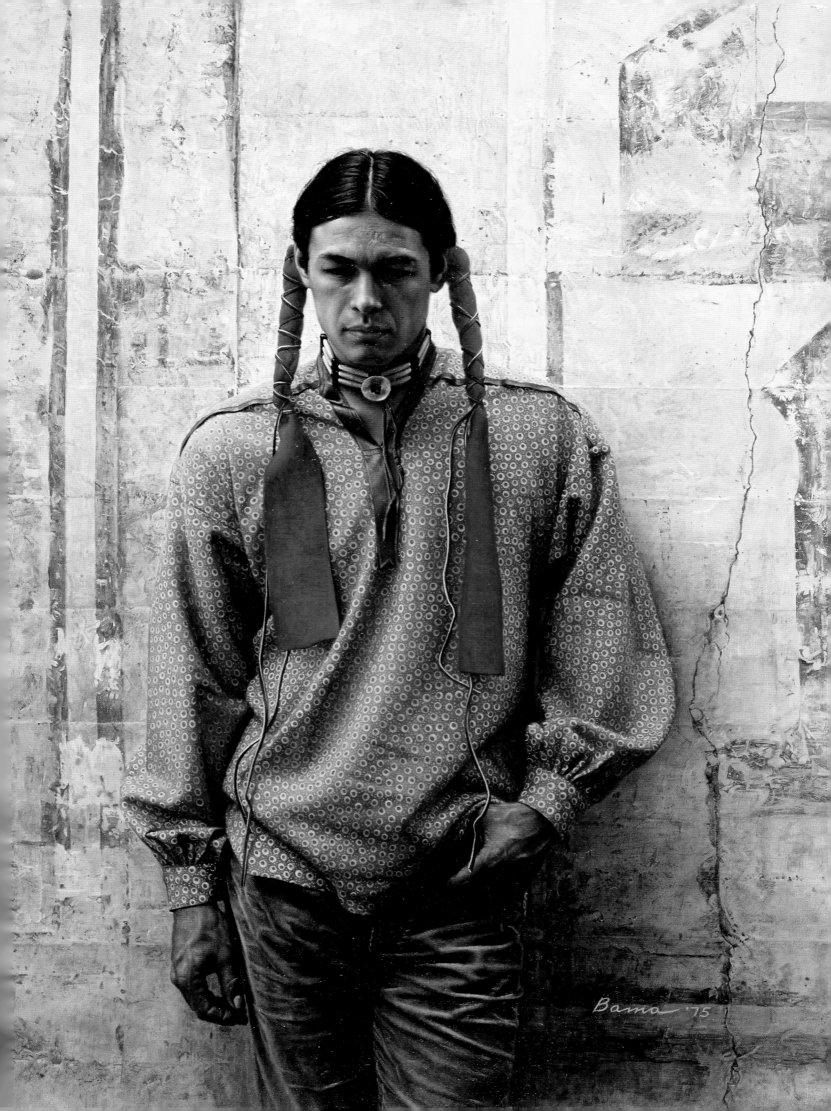

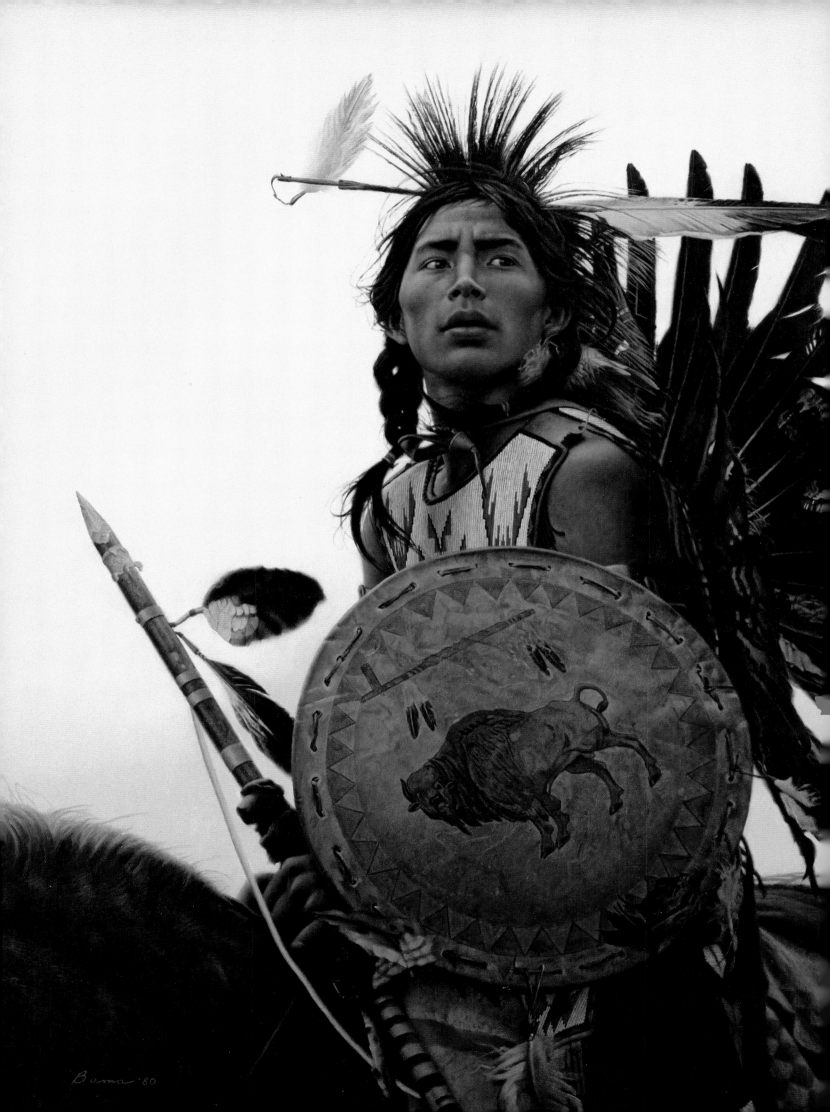

the "Second Battle of Wounded Knee." The dissidents captured the attention of the world and gained public awareness for their plight. Wounded Knee II also encouraged a new generation of Native Americans to renew traditional connections to their ancient cultures.[1]

Around the time of Wounded Knee II, Bama found a group of young Indians he met at a sporting tournament in Denver to be complex subjects worthy of his artistic efforts. Although none of the fourteen Native Americans Bama photographed in Denver were, to his knowledge, directly related to the events at Wounded Knee, he saw them as symbolic representations of militant tribesmen. "The young contemporary Indians, the Wounded Knee types," said Bama, "are more arrogant and defiant, and I paint them that way. I paint contemporary Indians as being of two worlds, part modern mainstream culture and part reservation Indian."[2]

In subsequent years, Bama painted a series of portraits of the young subjects. These works marked the pinnacle of his artistic development and became his greatest and most successful artistic statement. Bama painted the

James Bama
Young Plains Indian, 1980
Oil on Masonite, 23½ x 23½
Denver Art Museum, Funds from the
Contemporary Realism Group, 1998.215

James Bama
Untitled (Crow Fair), 1979
Image scanned from an orginal negative
Buffalo Bill Historical Center, Cody, Wyoming;
P. 243.crowfair1979

James Bama
Untitled (Wall), date unknown
Image scanned from original negative
Buffalo Bill Historical Center, Cody, Wyoming;
Gift of Lynn and James Bama, P.243.2M.1.20d.5

Aaron Siskind
Jerome, Arizona 21, 1949
Photograph, 24 x 20
©Aaron Siskind Foundation, New York, courtesy
of Bruce Silverstein Gallery, New York

young men he photographed in Denver against a modern backdrop, thereby avoiding stereotypical motifs. "I was uninhibited by what other people had done with the traditional Indian," Bama recalled. "I saw this as an opportunity to place them in a contemporary setting."[3]

Although Bama gravitated toward realism early on, he never alienated himself from abstraction or other art movements or ideas. Bama often painted his subjects against nonspecific present-day backgrounds. As the artist once explained, "Rather than doing them with a teepee or a robe behind them, I thought I would put them in a completely abstract contemporary setting."[4]

The artist's integration of realist portraiture with his interest in the abstract beauty of surfaces set him apart from many of his realist peers. Bama does not paint in the abstract

expressionist sense of Jackson Pollock or Clyfford Still, but instead searches for abstraction as it appears in life. While traveling around Wyoming and Montana, Bama noticed the abstract beauty of old walls, which he photographed. Although he gathered such material for years with no specific use in mind, he found such backdrops perfect for his portraits of contemporary Native Americans.

The abstract background used in *A Young Oglala Sioux*, for example, belonged to a building in Fromberg, Montana, an almost deserted town between Cody, Wyoming, and Billings, Montana. This was Bama's first significant integration of abstraction and realism. The confluence of the detailed subject and an abstract background makes for great contrast.

Although Bama was always influenced by painters, it was the

photographers Edward S. Curtis, who photographed Native Americans, and Aaron Siskind, who often directed his camera at peeling walls, who were more direct inspirations. Siskind was a key member of the abstract expressionist movement in New York and the sole photographer in the group. In the early 1940s after Siskind befriended abstract expressionists such as Franz Kline, Barnett Newman, Adolph Gottlieb, and Mark Rothko, his work shifted to abstraction.[5] During the fifties, Siskind's primary subjects were urban facades containing partial signs, graffiti, and peeling posters; isolated figures; and stone walls in Martha's Vineyard. His primary interests were in the flat graphic messages they contained and in exploring problems of space, line, and planarity. When photographing abstract façades, both Bama and Siskind deviated from mere documentation. As Siskind

observed, "For the first time in my life, subject matter, as such, had ceased to be of primary importance. Instead, I found myself involved in the relationships of these objects, so much so that these pictures turned out to be deeply moving and personal experiences."[6] For Bama, abstract façades provided a flat, contemporary background that contrasted with his three-dimensional human subjects.

Bama's 1975 painting titled *A Young Oglala Sioux* depicts Rick Williams and is Bama's first portrait of an Indian youth. Williams was later pictured in *Time* magazine in connection with his involvement in a Mohawk Indian protest in upper New York State. The artist effectively captured Williams's personal attitude with a natural pose. The subject's casual, yet reflective gestures show not only his youthful vitality, but also his wariness.

Williams's attire suggests he straddles the contemporary world and his traditional culture. His ordinary rugged jeans bespeak working class values, while his braids, choker, and ribbon shirt represent his Indian heritage. A recent tradition, ribbon shirts were commonly worn on reservations in the 1970s. Bama continued to paint his series, which totaled more than half a dozen during the decade, while the attention remained on AIM. These portraits mark a significant moment in the history of the contemporary American West and portray individuals who, even if not active participants in the protest movement, were notably representative of their time.

During the 1980s, after much of the volatile climate surrounding the AIM movement subsided, Bama returned to Native American subjects, but this time the works were more centered on the continuation of traditions. Many of his works in the following decade were of people he met in Hardin, Montana, at the annual Crow Fair.

One important way the ancient culture of Plains Indians is currently manifested is in traditional gatherings known as powwows. Native Americans have been gathering for such ceremonies and social fellowship for centuries. During the second half of the 1800s, however, the United States government banned Native American dance traditions and religious practices, forcing Indians to perform these rituals in secret until 1933, when the restrictions were lifted. Beginning in the 1950s, the Sioux, Crow, and Blackfeet tribes began to sponsor intertribal powwows. Today, powwows are held on reservations and in cities across the country and are attended by Indians and non-Indians alike.[7]

Bama photographed some of his most compelling subjects at Crow Fair, an annual intertribal social event attended by thousands, which began as an agricultural and livestock showcase for inhabitants of the Crow Reservation. Held annually east of Crow Agency near Hardin, Crow Fair events typically include a rodeo, dances, horse races, and a parade.

In 1980, Bama converted his photo of the young Indian horseman into a painting titled *Young Plains Indian*. Clad in traditional accoutrements and riding bareback, the horseman reminded Bama of Native Americans that Curtis captured on film nearly a century earlier. "I caught him in an attitude," Bama recalled. "It is something you could never get in a pose. He just had this look in his eye. He could have been living in 1879, not 1979."[8]

Bama strangely leaves the references to time ambiguous. This ambiguity, even awkwardness, in this portrait is not dissimilar to the awkward gap between ancient Native American tradition and mainstream American culture in which the subjects live.

James Bama's portraits are the summation of his goal to capture Native Americans as they maintain their native culture in balance with life in contemporary society. Unlike many artists working in the American West today, he steadfastly refused to paint the Old West but instead dedicated his career to painting real people of the modern West. His detailed portraits capture the ethnic and cultural complexity of the American West through people who live simultaneously in two worlds.

Notes

1 Dennis Banks with Richard Erdoes, *Ojibwa Warrior: Dennis Banks and the Rise of the American Indian Movement* (Norman: University of Oklahoma Press, 2004).

2 James Bama, interviewed by author, July 27, 2005, Wapiti, WY. Tape recording, Buffalo Bill Historical Center, Cody, WY.

3 Ibid.

4 Ibid.

5 Thomas B. Hess, introduction to *Places: Aaron Siskind Photographs* (New York: Light Gallery: Farrar, Straus and Giroux, 1976). In the 1930s Siskind was primarily a documentary photographer. His important body of work, *Harlem Document,* captured daily life in that part of New York City at the end of the Harlem Renaissance.

6 Aaron Siskind, "The Drama of Objects" [1945], in *Aaron Siskind: Toward a Personal Vision, 1935–1955,* ed. Deborah Martin Kao and Charles A. Meyer (Boston: Boston College Museum of Art, 1994), 51.

7 For a good resource on pow wows see Tara Browner, *Heartbeat of the People: Music and Dance of the Northern Pow-Wow* (Urbana: University of Illinois Press, 2002).

8 Quoted in Elmer Kelton, *The Art of James Bama* (Trumbull, CT: Greenwich Workshop, 1993), 145.

The Southwest

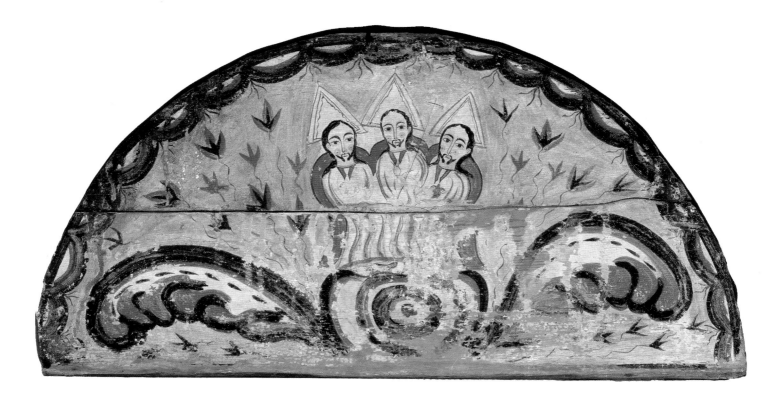

Art History Mystery: A New Mexican Lunette

DONNA PIERCE

The Denver Art Museum has in its Spanish colonial collection a stunning lunette panel from an altar screen formerly in a church in New Mexico. An in-depth look at the object and its history highlights the unique cultural encounters and strong sense of independence typical of the American West. The northernmost frontier of the Spanish empire in the Americas, New Mexico was colonized by Spain in 1598. The artists or *santeros* (makers of saints) in colonial and nineteenth-century New Mexico left a visual legacy in the form of several thousand images of saints.[1] Known as *santos*, these images exist either as wooden sculptures (*bultos*), painted panels (*retablos*), or a combination thereof that forms a large altar screen (also now known as *retablos*). Primed with natural gesso and painted with water-based paints, the Denver Art Museum panel depicting the Holy Trinity is composed of two large pieces of hand-adzed pine joined together horizontally and cut into a semi-circular shape to grace the top of a large altar screen. Known as *remates*, these upper portions of altar screens were usually cut in semicircular or scalloped shapes and installed as single pieces or in groupings of two or three.

The subject represented is the Holy Trinity (Father, Son, and Holy Ghost) as three identical men.[2] Of approximately forty images of the Trinity extant from colonial and early nineteenth-century New Mexico, thirty are in this form. The origin of what is called the Three Person Trinity type is controversial, but its popularity in European art reached

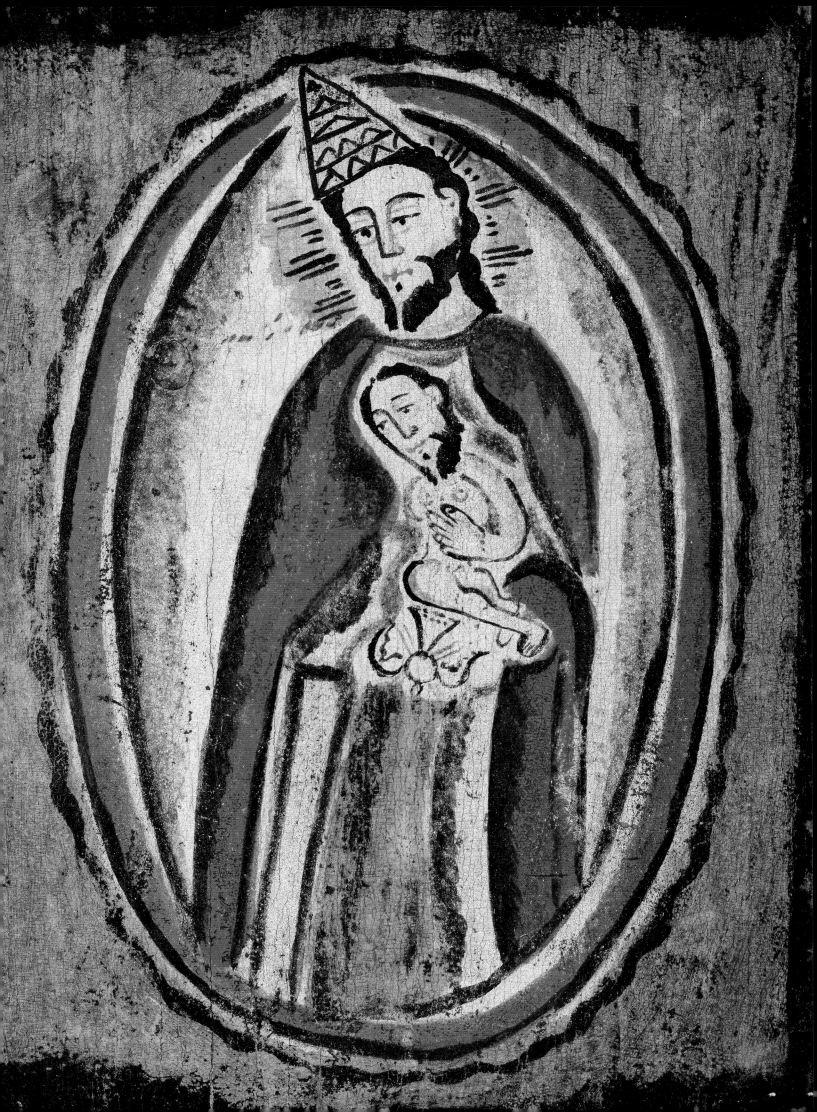

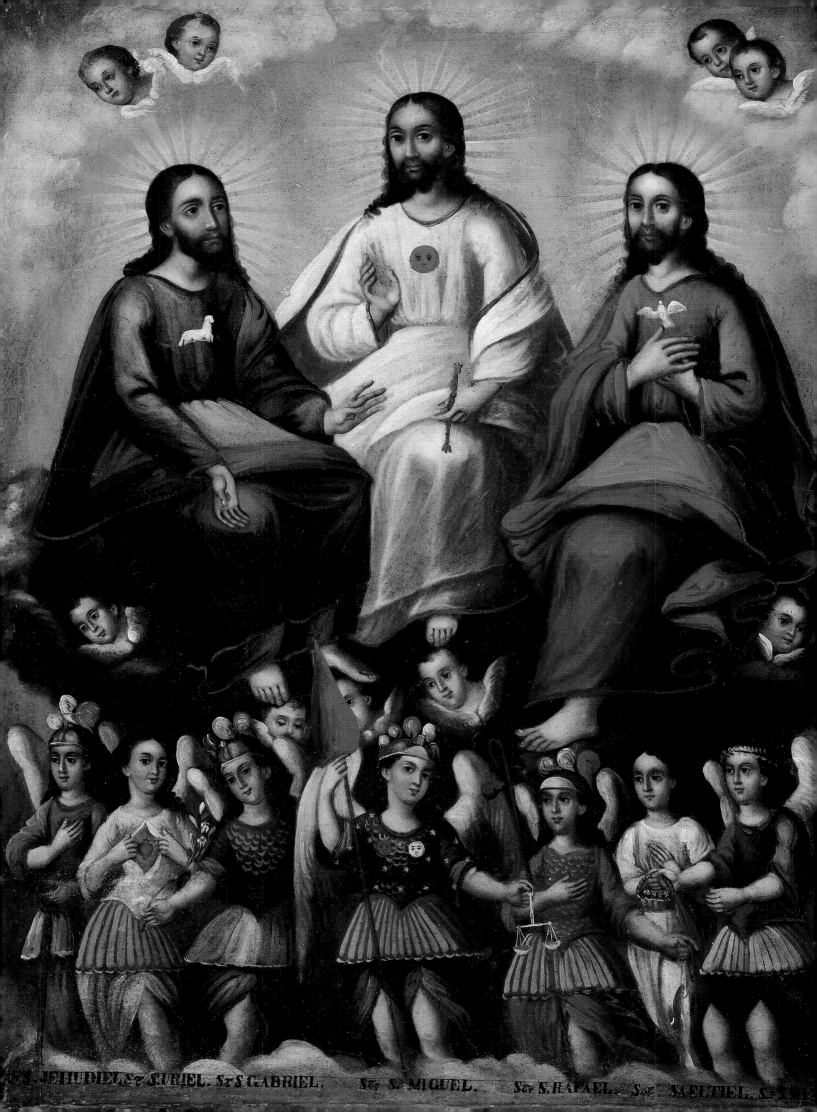

JEHUDIEL. S. URIEL. S. S. GABRIEL. S. S. MIGUEL. S. S. RAFAEL. S. SAELTIEL. S.

a peak in the 1400s. The image aroused theological controversy and was finally banned by Pope Benedict XIV in 1745. It was replaced by officially sanctioned images of the Trinity as two persons, no longer identical, with the Holy Spirit represented by a dove flying above or between them. In some cases, this two-person Trinity with dove appears in the form of a Pietá, as seen in an example from the Denver Art Museum collection. Although rarely seen in Europe after the ban, the Three Person Trinity continues to be used in Latin America up to the present.

In colonial Mexico and New Mexico, certain iconographic details of the Three Person Trinity are unique. In Europe, the triangular halo was reserved for God the Father, but in Mexico and New Mexico it is applied to all three members of the Trinity. Distinctively Mexican and New Mexican are symbols on the chests of the men to differentiate them: a sun for the Father, a dove for the Holy Ghost, and a lamb or a cross for Christ. In European art, the dove and lamb are traditional symbols, but they usually appear in the absence of the Holy Ghost and Christ rather than accompanying them as attributes. The use of a sun to distinguish the Father from the other Trinity members seems to have been a New World invention.

The Three Person Trinity, by nature, emphasizes the plurality of the Trinity at the expense of its unity. To compensate for this, artists in medieval Europe often represented the figures under a single crown, draped in a single mantle, and/or encompassed by a huge belt or rope to express their oneness. Frequently in New

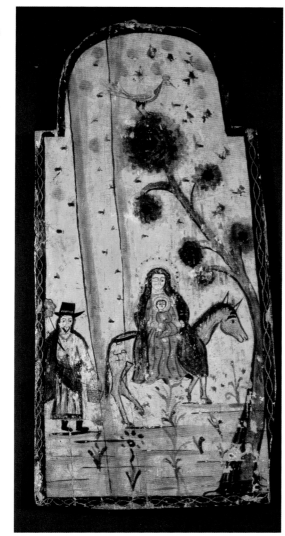

Mexico, the belt motif is replaced by a large horizontal rod or scepter. Although the Trinity members sometimes carry individual scepters, all three persons holding onto a single horizontal scepter is apparently unique to New Mexico and creates an iconographic emphasis on the unity of the Trinity similar to that of the encircling belt. Although partially lost in the seam between the two panels, a large horizontal scepter is held by the three figures in the Denver lunette. In both Europe and the Americas, the three persons are seated together upon a single large orb, an iconographic element that expresses their unified rule over the earth. In the Denver example, this orb has been elaborated with large flanking wings or leaves, a motif not seen in other images. The lunette would have served as the central or singular *remate* over the middle section of the altar screen since traditional Catholic iconography always located the most important figures, particularly images of God the Father, Christ, the Trinity, or the Virgin Mary, in the central section.

Not only does the horizontal scepter, unique to New Mexico, appear in the Denver Art Museum lunette, but other mysterious iconographic motifs are present as well. In addition, determining the identity of the artist and the original location of the lunette have required piecing together parts of an art historical puzzle.

Denver's lunette is executed in the style of native New Mexican artist Pedro Antonio Fresquis (1749–1831). The artist of the body of work now attributed to Fresquis was previously referred to as the "Calligraphic Santero"

William Henry Jackson
Mission, San Juan Pueblo, ca. 1881
Courtesy Palace of the Governors
Photo archives (DCA/NMHM), 003337

for the quality of drawing and linear details, and was later known as the "Truchas Master" after altar screens in the church at Truchas, New Mexico. Scholarship eventually associated the style with Fresquis—documented as the maker of artwork in various New Mexico churches—through the inclusion of the initials "PF" in several *retablos,* such as those seen on the rump of the donkey in a *Flight into Egypt.*[3] Some scholars doubted the attribution since Fresquis was documented to have worked at Santa Cruz church, but the artwork found there didn't match his style. However, in 1985 during conservation treatment at Santa Cruz an example of his painting style was discovered underneath a layer of later overpainting on an altar screen, finally verifying the association of Fresquis with the body of work assigned to the "Calligraphic Santero" or "Truchas Master." In addition, tree-ring cutting dates of *retablos* in this style span the documented life dates of Fresquis, the earliest native-born New Mexican artist to be identified by name. Like all New Mexicans named Fresquis or Frésquez, he was a direct descendant of a Flemish miner named Jan Frishz who first came to New Mexico in 1617.[4] Artists in New Mexico were of different ethnicities and backgrounds: some were Spaniards born in Spain, such as Bernardo Miera y Pacheco; some were of European descent born in the Americas, such as Fresquis; and recent research has indicated that some were probably

Native American or of mixed ancestry.[5]

Fresquís's artistic style is unique within the repertoire of New Mexican *santeros* and heralds a break from the baroque tradition and a shift to the lighter, newer rococo style, probably inspired by imported prints.[6] Internationally, one of the major changes from the baroque to the rococo was a reliance on Asian textile patterns, resulting in light, delicate motifs spread across a shallow space. In keeping with the rococo aesthetic, decorative motifs in Fresquís's art often appear to float through the space and seem superfluous to the central image. The Denver lunette is a quintessential example of Fresquís's implementation of this new convention: the space surrounding the Trinity is shallow and ill-defined, and it is sprinkled with strange three-pronged motifs that seem to have no meaning. Following the new rococo tradition, pastel colors, particularly pale pinks and blues, replace the dark, saturated hues and dramatically obscure backgrounds of baroque art. The softer palette appears in most of Fresquís's *retablos*, including this lunette with its unusual peach-colored background. Another characteristic of Fresquís's style is an illogical sense of scale with plants sometimes towering over figures; this may account for the huge leaves or wings that flank the orb.

Fresquís's personal style is characterized by free-form, impressionistic drawing executed with fine lines, hence the "calligraphic" moniker. Wavy lines, which appear to have been executed with a pen rather than a brush, outline forms such as the three haloes and the folds in the garments. The wavy lines are also used to delineate the three-pronged motifs—reminiscent of tracks made by wild turkeys native to northern New Mexico—seen in the lunette as well as in many of Fresquís's *retablos*, and that serve as a leitmotif of his style. The wavy lines alternate with very heavy black and blue lines that define the scalloped border, the orb, and its flanking wings or leaves. Faces are created in a distinctive manner with long, narrow noses delineated by one or two straight lines descending directly from the eyebrows, and oval eyes with large pupils that give the impression of being slightly dilated.

Known for using unusual iconography, Fresquís may have invented the horizontal scepter motif. He used it in at least six other instances, including in a side altar screen at Truchas church dated 1821; known examples by other artists probably postdate the ones by Fresquís.[7] In addition, the traditional New World symbols on the chests of the figures have been slightly altered by Fresquís in the Denver lunette: the circular sun symbol on the chest of God has been embellished with the addition of faint wings and a head, making it appear to be a large diving bird. Although all Three Person Trinity images by Fresquís include symbols, none are consistent. Fresquís appears to have misunderstood the symbols or chosen to alter them either of his own accord or at the request of his patrons.

The altar screen lunette came into the Denver Art Museum collection in 1971 as part of an exchange with Charles and Nina Collier of New York and New Mexico, founders of the International Institute of Iberian Colonial Art. Among the earliest people from the United States to recognize and collect Spanish colonial art from all over Latin America as well as from the southwestern United States, the Colliers amassed an extensive collection. Previously housed in their home near Alcalde, New Mexico, most of the IIICA collection is now in the Palace of the Governors, part of the New Mexico History Museum in Santa Fe. When former Denver Art Museum curator Robert Stroessner made the exchange with the Colliers, Nina Collier told him that they had acquired the panel in the late 1940s or early 1950s from the priest at San Juan Pueblo, north of Santa Fe and not far from the Colliers' home near Alcalde.

San Juan Pueblo has a unique history within the colonial period of New Mexico since it was the first pueblo to have intensive contact with Spaniards. When the original Spanish settlers under the command of Juan de Oñate arrived in New Mexico in 1598, they took up residence within San Juan Pueblo, and the first church ever built in New Mexico was consecrated there on September 8 of that year.[8] That church—like many churches built in the Indian pueblos of New Mexico during the early colonial period—was destroyed in the Pueblo Revolt of 1680, the most successful Native American rebellion in North American history. Ironically, the revolt was led by a native of San Juan Pueblo. When the Spanish settlers returned to New Mexico thirteen years later, they began the slow process of rebuilding churches in both Spanish villages and Indian pueblos. At San Juan, a temporary church was built shortly after the Spanish return, but it had fallen into disrepair by mid-century. A new church was constructed sometime between 1746 and 1763 during the tenure of Fray Juan José Pérez de Mirabal. It was long and narrow, approximately one hundred ten feet long and twenty-two feet wide.

An altar screen was commissioned in 1762 for San Juan at the expense of the Spanish governor of New Mexico, but seems to have been considered unattractive by Spaniards and Indians alike. A new one was commissioned and paid for by the Indians of the pueblo in 1782. Since no early photograph of the interior of San Juan survives, it is impossible to know if this altar screen was executed by Fresquís or another local artist. Documentation indicates that the San Juan altar screen remained in situ until 1880 when the summer rains nearly washed out the rear wall of the church. When United States Army Lieutenant John Bourke visited in 1881 he described the repairs and noted that "It has . . . been restored quite recently, whitewashed and provided with a new altarpiece." Bourke himself purchased a "wooden 'santo,' or holy figure, painted

Pedro Antonio Fresquis
Altar Screen at Chapel of San Pedro
and San Pablo in Chamita
New Mexico, late 18th–early 19th century
Overpainted late 19th–early 20th century
Photo by Robin Farwell Gavin

in archaic fashion," that may have come from the old altar screen.[9]

It is possible that Denver's lunette graced the top of the altar screen commissioned by the Indians of San Juan in 1782 and that it was salvaged in the late summer of 1880 when the summer rains threatened, but did not destroy, the back wall of the church. It may have remained stored until a subsequent priest pulled it from a storage area to sell to the Colliers in the late 1940s or early 1950s. In spite of the Colliers' statement that they acquired the lunette from San Juan, it has been associated with the altar screen by Fresquis in the church in the adjacent Hispanic settlement of San Pedro and San Pablo de Chamita.[10]

The small, predominantly Hispanic village of Chamita is just across the road from San Juan and was administered by the priest assigned to San Juan Pueblo. Chamita has a small adobe church built in 1875 with an altar screen recently attributed to Fresquis. Unfortunately, the entire screen has been overpainted, with the exception of the interior of the central niche, following the outlines of the original imagery. There are two small, semicircular *remates* each depicting a cherub, on the outside top corners of the screen. Although at least partially overpainted, these small *remate* panels are in the same color scheme as the Denver lunette with its soft, peach-colored ground. The cherubs' faces are flanked by large wings with dark outlines reminiscent of those on the sides of the orb under the Denver Trinity. The space between the cherub panels—above the central aisle of the screen—is now empty and probably originally held the lunette.

However, Fresquis died in 1831 and the church at Chamita was not built until 1875. Consequently, the altar screen could not have been made for this location; rather it must have been transferred there from another, older church. So, although it seems clear that the lunette comes from the altar screen now at Chamita, the question remains:

Where did the Chamita screen come from? In view of the close association between San Juan and Chamita, it is likely that the former altar screen from San Juan, originally commissioned and paid for by the Indians of San Juan in 1782, may have been moved to Chamita in 1880, after the rain damage to the back wall of the San Juan church. The altar screen is too large for the small apse at Chamita and the small angel *remates* are tilted forward and downward in order to fit beneath the roof beams. The taller lunette would not have been able to fit into the confined space. As a result, most likely the lunette was never installed at Chamita and remained in storage at San Juan until the Colliers acquired it in the late 1940s or early 1950s. In addition, its representation of the Three Person Trinity had been banned for well over a century by this period, a further incentive for removing it from the screen.

Although this scenario is probable, it is still impossible to definitively prove that the altar screen at Chamita originally came from the San Juan Pueblo church. If it did, it would be the earliest surviving altar screen by Fresquis. Future research may yield conclusive documentation. Since it was spared overpainting, the lunette provides an idea of the original style and color scheme of the Fresquis screen. Regardless of its exact history, it is clear that the lunette reflects the unique cultural mixture occurring in the American West during the late 1700s and early 1800s. Whether it comes from the main altar at San Juan Pueblo, or the small chapel of the nearby village of Chamita, or both, it was executed by a native-born New Mexican of Flemish-Spanish ancestry whose descendants still live in the Southwest today. The artist was the first in New Mexico to take selective inspiration from the international rococo style, but he inserted numerous distinctive elements to relate to the local southwestern clientele and environment. The lunette

depicts one of the earliest uses of the horizontal scepter, an iconographic convention invented in New Mexico, and possibly by Fresquis. And, finally, the lunette depicts a unique American take on an old European version of the Trinity. One that, in defiance of the official papal ban of 1745, continues to be used in churches in New Mexico up to the present—a very independent and western American thing to do.

Notes

1 The seminal work on *santos* remains E. Boyd, *Popular Arts of Spanish New Mexico* (Santa Fe: Museum of New Mexico Press, 1974). Also see José E. Espinosa, *Saints in the Valley: Christian Sacred Images in the History, Life and Folk Art of Spanish New Mexico*, rev. ed. (Albuquerque: University of New Mexico Press, 1967); Thomas J. Steele, *Santos and Saints: The Religious Folk Art of Hispanic New Mexico*, rev. ed. (Santa Fe: Ancient City Press, 1994); William Wroth, *Christian Images in Hispanic New Mexico: The Taylor Museum Collection of "Santos"* (Colorado Springs: Taylor Museum of the Colorado Springs Fine Arts Center, 1982); Larry Frank, *New Kingdom of Saints: Religious Art of New Mexico, 1780–1907* (Santa Fe: Red Crane Press, 1992). More recent publications include Robin Farwell Gavin, *Traditional Arts of Spanish New Mexico* (Santa Fe: Museum of New Mexico Press, 1994); Donna Pierce and Marta Weigle, eds., *Spanish New Mexico: The Spanish Colonial Arts Society Collection* (Santa Fe: Museum of New Mexico Press, 1996); Marie Romero Cash, *Santos: Enduring Images of Northern New Mexico Churches* (Niwot: University Press of Colorado, 1999); Larry Frank, *A Land So Remote: Religious Art of New Mexico, 1780–1907*, 2 vols. (Santa Fe: Red Crane Books, 2001). Two recent publications look at the multicultural aspect of *santo* production: Claire Farago and Donna Pierce, eds., *Transforming Images: New Mexican Santos In-Between Worlds* (University Park: Pennsylvania State University Press, 2006) and Robin Farwell Gavin and William Wroth, eds., *Converging Streams: Art of the Hispanic and Native American Southwest* (Santa Fe: Museum of Spanish Colonial Art, 2010).

2 Donna Pierce, "The Holy Trinity in the Art of Rafael Aragón: An Iconographic Study," *New Mexico Studies in the Fine Arts* (University of New Mexico) 3 (1978): 29–33.

3 The term "Calligraphic Santero" was first published in Mitchell A. Wilder and Edgar Breitenbach, *Santos: The Religious Art of New Mexico* (Colorado Springs: Taylor Museum of the Colorado Springs Fine Arts Center, 1943). William Wroth coined the term "Truchas Master" (*Christian Images in Hispanic New Mexico*, 171–84). E. Boyd made the connection between documents citing Fresquis and the body of work through the "PF" initials (*Popular Arts of Spanish New Mexico*, 329–30).

4 Fray Angélico Chávez, *Origins of New Mexico Families: A Genealogy of the Spanish Colonial Period*, rev. ed. (Santa Fe: Museum of New Mexico, 1992), 30, 177, 356. Also see Boyd, *Popular Arts of Spanish New Mexico*, 327–35.

5 For discussions of the ethnicity of New Mexicans, including *santeros*, see Farago and Pierce, *Transforming Images*, and Gavin and Wroth, *Converging Streams*.

6 Much of this discussion of style is based on Donna Pierce, "The Active Reception of International Sources in New Mexico," in Farago and Pierce, *Transforming Images*, 44–57, and Pierce, "Saints in New Mexico," in Pierce and Weigle, *Spanish New Mexico*, 30–59.

7 The Truchas screen is reproduced in Frank, *New Kingdom of Saints*, 25. Other Fresquis examples with horizontal scepters include two in the Taylor Museum in Colorado Springs (one is reproduced in Wroth, *Christian Images in Hispanic New Mexico*, fig. 163); two in the Museum of International Folk Art in Santa Fe; and one in the Frank collection at the Palace of the Governors, Museum of New Mexico, Santa Fe (reproduced in Frank, *New Kingdom of Saints*, plate 15).

8 See John L. Kessell, *The Missions of New Mexico Since 1776* (Albuquerque: University of New Mexico Press, 1980), 90–96.

9 Kessell, *The Missions of New Mexico*, 92–93.

10 Although long discussed among experts in the field, the first to publish the association of the Denver lunette with the Chamita altar screen is Cash, *Santos*, 75. I am grateful to Robin Farwell Gavin for her assistance with information on Chamita based on her unpublished research there in 1990 and for use of the photograph reproduced here on the facing page.

Bert G. Phillips
Camp at Red Rocks, 1898
Oil on board, 6 x 17
Denver Art Museum, Gift of Ralph J. Phillips,
1979.267

E. Irving Couse
War Dance at Glorietta, 1903
Oil on canvas, 35 x 46
Denver Art Museum, William Sr. and Dorothy
Harmsen Collection, 2001.1149

Bound for Taos: In Search of American Art

MARIE WATKINS

Although stalwart Anglo artists accompanying exploratory expeditions preceded Joseph Henry Sharp to Taos, the legendary founding of the Taos art colony begins with the deaf Cincinnati artist's first trip to Taos in the summer of 1893. A year later in Paris at the Académie Julian, Sharp amused fellow students Bert Geer Phillips and Ernest L. Blumenschein with his discovery of the painting opportunities that awaited artists—penetrating sunlight, breathtaking landscapes, and the rich traditions of Indian and Hispanic cultures. Four years later, in 1898, the two younger artists inadvertently followed Sharp's advice.

Phillips and Blumenschein left their shared studio in New York City, traveling by train to Denver. From there, the two greenhorns, who did not know how to saddle a horse, much less harness and drive the wagon team they purchased, precariously embarked on what they believed to be a painting trip to Mexico. Fate, however, had something else in store for them and for American art. Slowly making their way south, they camped along the Front Range of the Rockies that summer. Phillips documented their early campsite about fifteen miles west of Denver in *Camp at Red Rocks*. For the easterners, where all seemed magnified in the West, the dramatic 300-foot sandstone monoliths dwarfed them and their meager man-made campsite. On September 3, their wagon broke down about twenty miles outside Taos, just south of the Hispanic village of Questa. They flipped a three-dollar gold piece to see who would carry the broken wheel to Taos for repair. Two days later, Blumenschein returned with the wagon wheel and the artists made their way to Taos. Phillips never left.

In November, Blumenschein returned to New York. He continued to correspond with Phillips to determine how to get people to come to Taos "like the group of Barbizon painters & writers"—as Phillips expressed.[1] With mounting frustration, Phillips exploded to Blumenschein: "For heavens sake tell people what we have found! Send some artists out here! There is a lifetime's work for 20 men. Anyhow, I'm lonesome."[2] Phillips's plea would be answered many times over as Taos in due course fell into the rhythms of a cosmopolitan community.

Through another serendipitous encounter Blumenschein met Eanger Irving Couse on the New York City streets in 1902. Couse

told Blumenschein of his ongoing desire to paint Native Americans and his difficulty in finding models. Blumenschein easily solved his fellow artist's problem. That summer Couse traveled with his wife, Virginia, to Taos, returning each summer (except for 1904), and the couple eventually purchased their first home there in 1906. *War Dance at Glorietta*, painted during his second summer visit, showcases his academic training as master of the heroic male nude. For Sharp, too, Taos was a seasonal journey that eventually became a permanent residence. In 1906, Sharp excitedly wrote: "Bert Phillips is here the year around. Couse has just bought a little place fitted up with a studio & is at work, & likely for many summers. Young Berninghaus of St. Louis just left, and Curtis, Sauerwein,

& others are coming, so there may be a Taos colony a la Barbizon yet!"[3] Evoking the hallowed French site of "Barbizon," this nucleus group was intent on creating a similar site in Taos for artists who sought to transform American art. The painters responded to Taos in a myriad of ways, ranging from detailed, figurative renderings of the sacred and secular to abstract explorations of light, color, and shape.

On July 15, 1915, the Taos Society of Artists (TSA), which came to include twenty-one active, associate, and honorary members, became official. The group lasted twelve tumultuous years.[4] The Society splintered into the short-lived (1923–27) modernist art organization the New Mexico Painters,[5] which included members from the developing Santa Fe art colony seventy

miles south. Other artists chose to work solo. The artists who passed through or settled in Taos after the core group were not unlike them in their artistic practices. They, too responded to the southwestern environment in a multiplicity of ways, with traditional and innovative styles coexisting.

At the heart of their subject matter were the millennium-old cultures of the Pueblo peoples, from religious ceremonies to genre scenes. Most, if not all, artists who journeyed to Taos painted Taos Pueblo or used it as a backdrop. Charles Graham, a popular illustrator for *Harper's Weekly*, matter-of-factly depicted the multilevel blocks of adobe dwellings. Two Indian figures in the foreground seemingly block our entrance to the bridge across Red Willow Creek that leads to their home

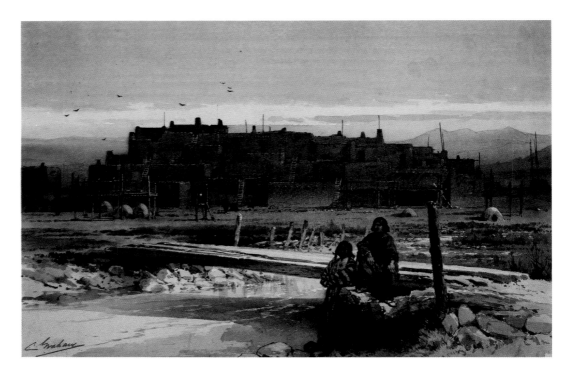

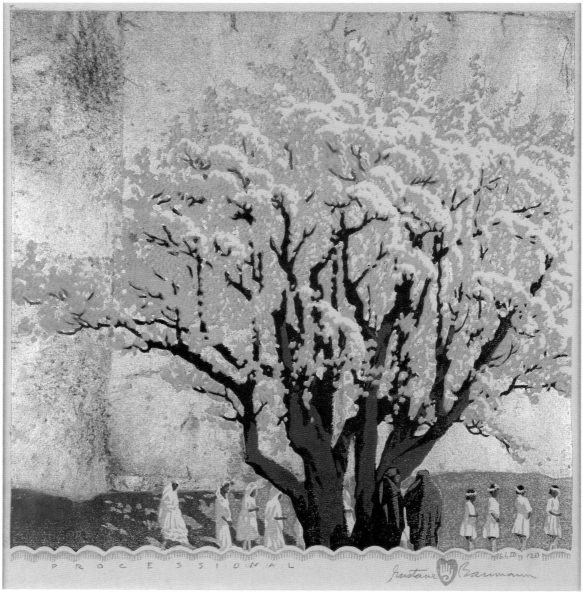

in the background. In contrast to this traditional image of the pueblo frozen in time, Gustave Baumann, working in his preferred woodcut-print medium, relished contemporary Pueblo life and its ceremonies as portrayed in stylized "snapshot" scenes like *Processional*. Expressive rather than literal shapes of simplified pure color lend a decorative quality to this representation of centuries-old Pueblo traditions. Unlike Baumann, who was a member of the TSA and resided in Santa Fe because he found Taos too crowded and too social, Juan Mirabal (Tapaiu or Red Dancer) was an artist from Taos Pueblo. He, too, painted in a modernist vernacular, exemplified in his interpretation of a Pueblo ceremony reduced to cubes, spheres, and cones in an ambiguous space in a mural at Harwood Museum

of Art in Taos that is eight feet across. Other pueblos, such as Santo Domingo, attracted artists to their observances. Russian-born, second-wave Taos resident Leon Gaspard's expressive brushstrokes in *Indian Fiesta Santo Domingo* (overleaf) mirror the lively festivities, creating a vibrant immediacy. Framed by simplified adobe walls, loosely brushed Indian riders in brightly colored clothing block the view of the dance plaza.

As iconic a subject as the architecture of the pueblos are pictures of Pueblo women coupled with pottery, traditionally a woman's art among the Pueblo peoples. Catherine Critcher, the lone woman in the TSA, honored the generations of women artists in *Indian Women Making Pottery*. For TSA members Sharp, Julius Rolshoven,

and Robert Henri, the ubiquitous pot served as a prop, if not metaphor, for their female models. Placed against the adobe wall in his studio where he worked for more than thirty-five years, Sharp painted two of his favorite models, Crucita (in the meditative *The Red Olla*) and her daughter Leaf Down (in the softly glowing, firelit *Taos Indian Girl*). Rolshoven, an urbane expatriate who resided in Italy and temporarily migrated to Taos and Santa Fe with the outbreak of World War I, also painted graceful seated Pueblo models. The bold geometric-patterned Indian blankets that structure *Taos Beauty in Pink* give the composition a distinctly modern flair, much in the manner of Henri's southwestern portraits that transcend a simple description of a girl with dashing strokes of color.

Facing, top: Charles Graham
Taos Pueblo, 1855
Gouache, pen, and ink on paper, 10 x 14
Denver Art Museum, by museum exchange, 1967.12

Facing, bottom: Gustave Baumann
Processional, 20th century
Woodblock print, 14 x 13¼
Denver Art Museum, William Sr. and Dorothy Harmsen Collection, by exchange, 2006.226

Juan Mirabal
Untitled, ca. 1930
Oil mural, 46½ x 97
Collection of the Harwood Museum of Art of the University of New Mexico

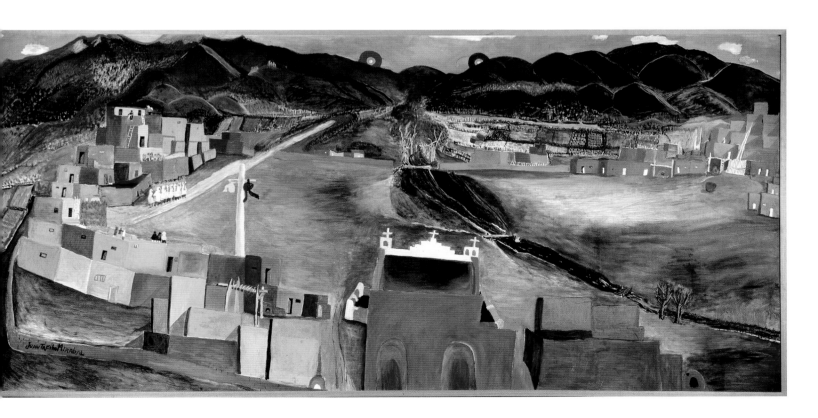

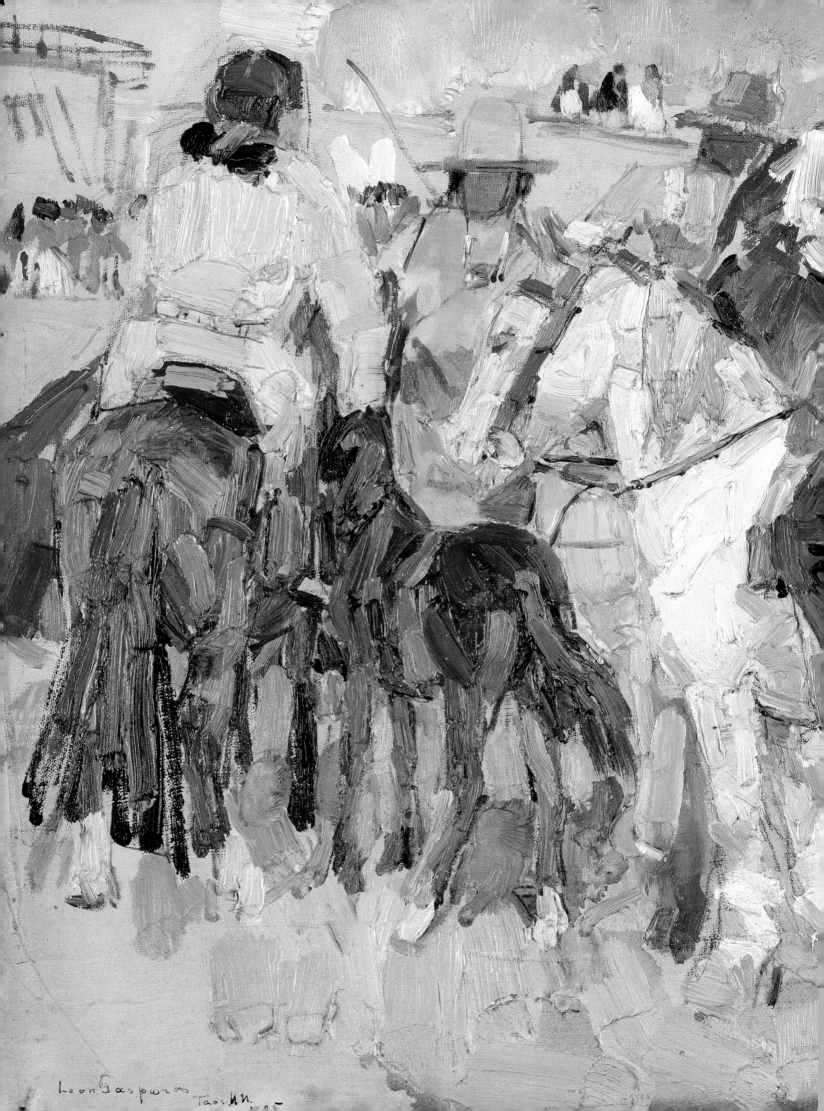

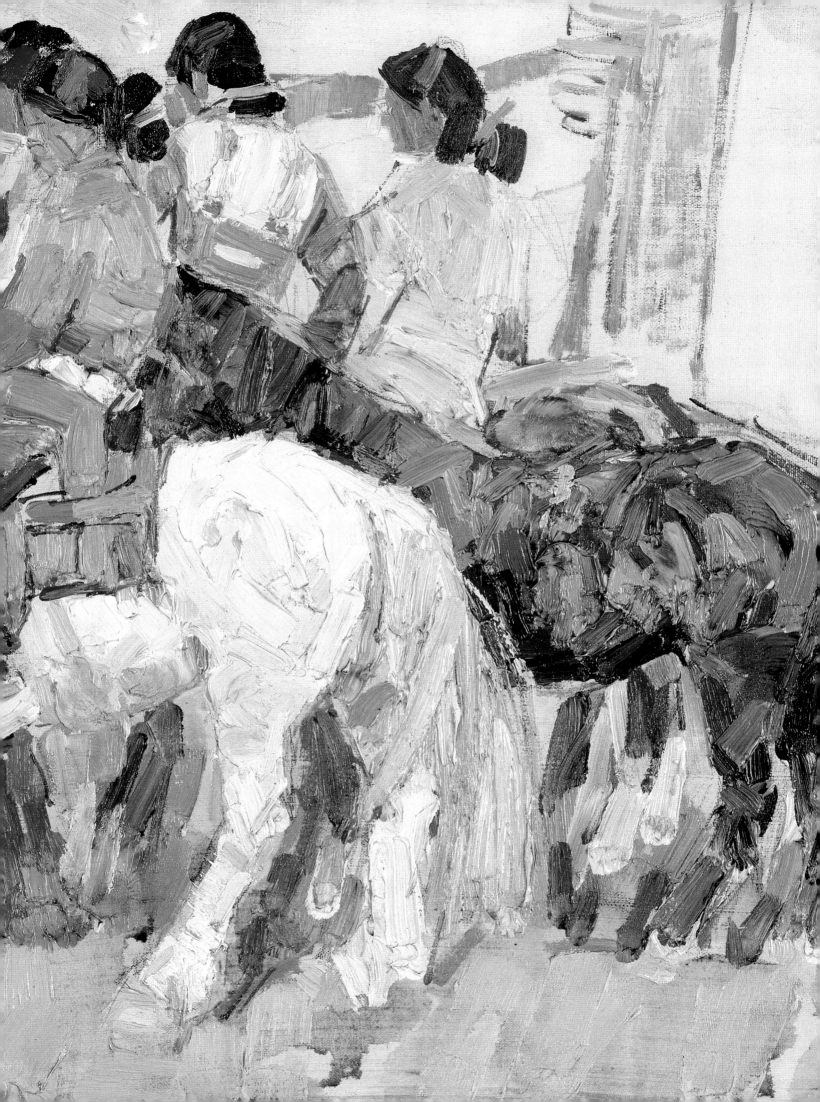

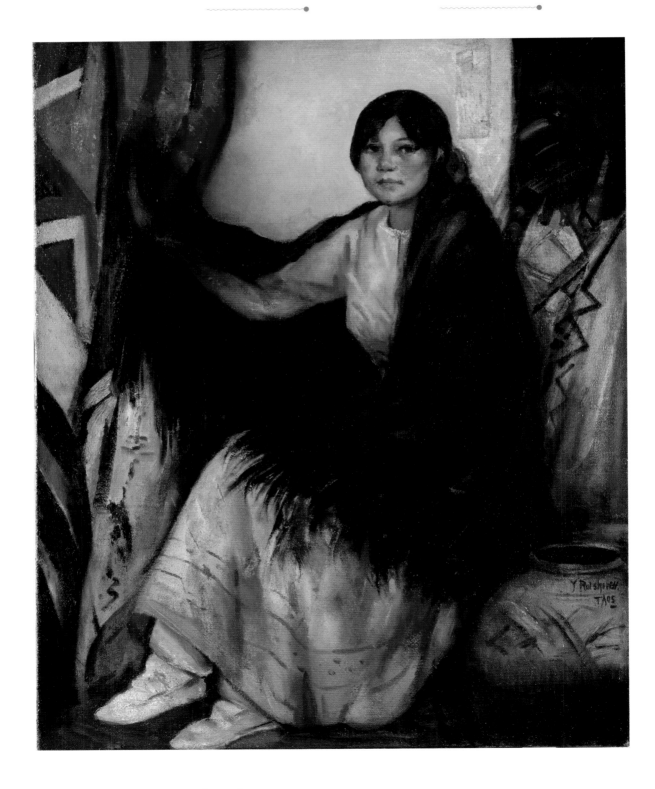

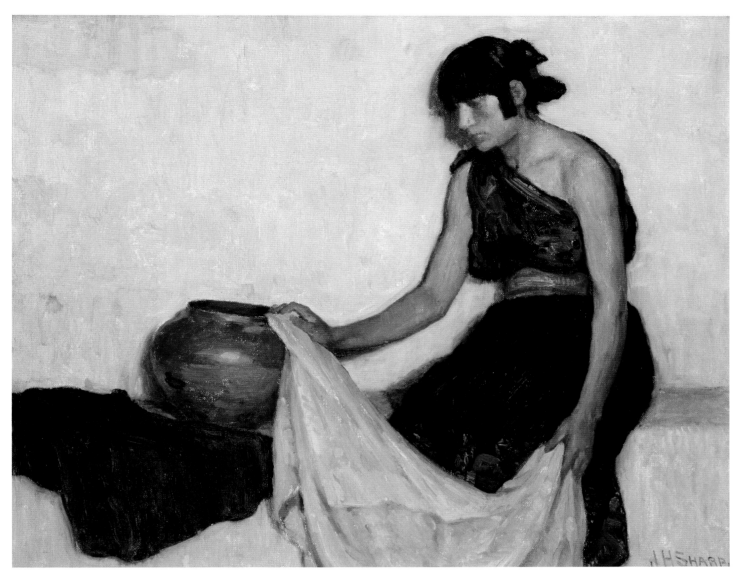

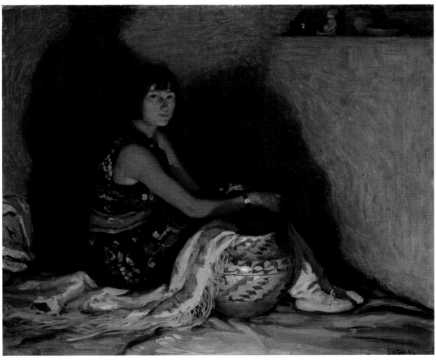

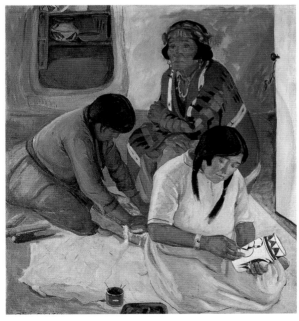

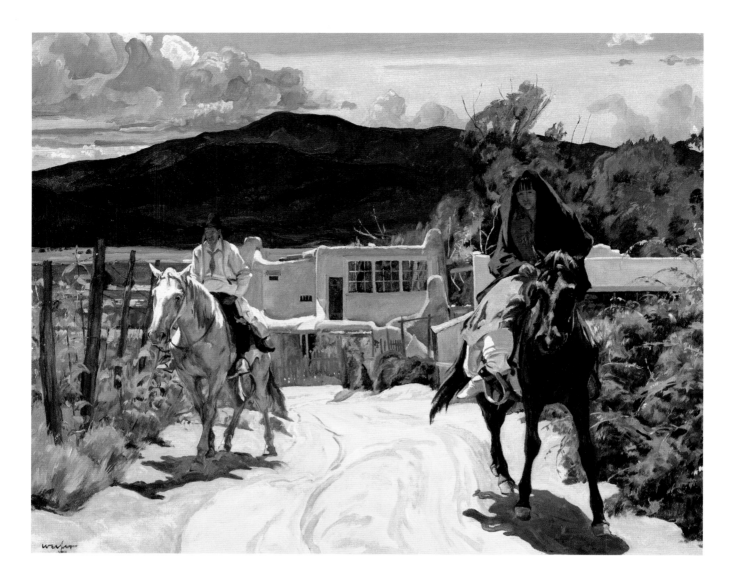

Walter Ufer
The Kissel Studio, after 1929
Oil on canvas, 20 x 25
Denver Art Museum, Funds from 1989
Collectors' Choice, 1990.5

Oscar E. Berninghaus
The Indian Call, 1921
Oil on canvas, 31¹/₄ x 25
Denver Art Museum, William Sr. and Dorothy
Harmsen Collection, by exchange, 2009.384

Many of the artists looked closely at the people around them and painted unsentimentally what they saw. Set against the ageless presence of the Sangre de Cristo Mountains, Oscar E. Berninghaus, who first rode into Taos on the Chili Line in 1899, understatedly rendered the coexistence of multiple ways of life. *The Indian Call* portrays a group of Indians on horseback, recently passed by a barely discernible automobile in the distance, as they unhurriedly make their way down a dirt road in companionable silence to

Lucero Peak, a favorite landmark of the artist. Irascible TSA artist Walter Ufer, who primarily painted outdoors, captured the everyday activities of the Pueblo Indians he came to know with raw realism. Most likely returning from a modeling session with artist Eleanora Kissel, an Indian couple in dynamic symmetry ride indifferently into the viewer's space, generating tension, in the sun-drenched *The Kissel Studio.* Ufer again created a monumental composition out of the mundane in the brilliantly sunlit *Trailing Homeward.*

Painting the straightforward, closely observed contemporary reality of a mounted Indian trailing one of his horses home, Ufer provided a new motif for ranching, a part of the iconography of the West. Gaspard also painted Taos ranch imagery with the conventional subject *Ranch Corral.* With an impressionist's brush he recorded the optical effects of the northern New Mexico sky with clear bright colors. An avid outdoorsman who had once worked as a cowpuncher, William Herbert ("Buck") Dunton, on his first

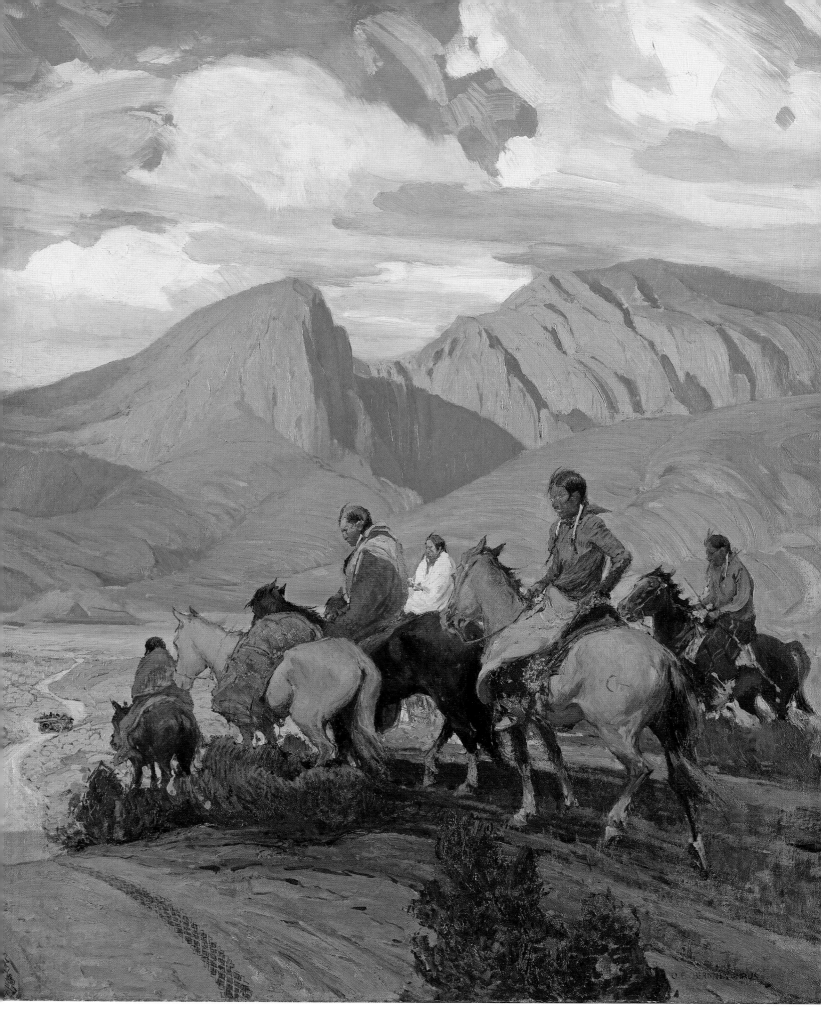

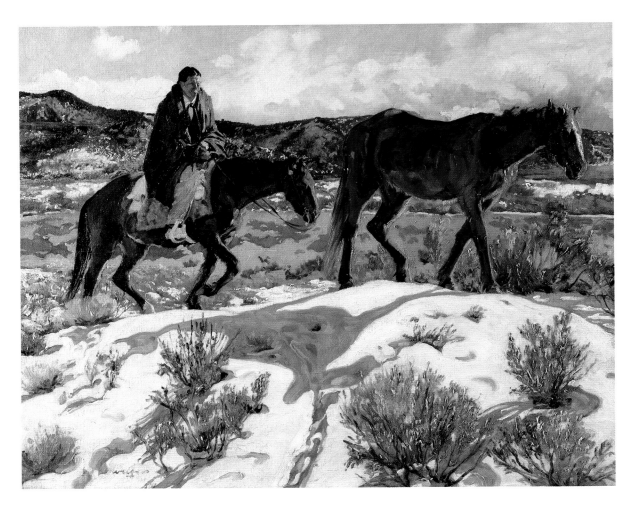

visit to Taos in 1912 at the invitation of Blumenschein, contributed to ranch iconography with his portrayal of Anglo cowboys riding across the desert floor under a vast sky in the painterly *Open Range*, a subject that became his signature.

The landscape not only served as backdrop for many of the artists' compositions, but also became their inspiration. Victor Higgins's *Game Hunter/Snow* is as much a genre painting as it is a landscape. Receptive to modern approaches, the academically trained TSA artist, using heavy brushstrokes of thick paint, absorbed the Indian hunter into an environment of geometric forms that is devoid of detail, presenting a new interpretation of the banal hunting composition.

Although E. Martin Hennings, who first traveled to Taos at the behest of his patron, Chicago mayor Carter Harrison II, thought of himself as figure painter, he painted poetic Taos landscapes such as the warmly glowing *Flight*, evocative of Japanese woodblock prints. He employed a signature screen of silhouetted wild sunflowers to emphasize the two-dimensional quality of the canvas and post-impressionist abstract forms of the land, animals, and vegetation to create harmonious surface patterns. Blumenschein's landscapes are also modern in treatment but he, like Hennings, never abandoned figuration. With *Mountain Lake*, a favorite fishing hole, he interlocked distinctive northern New Mexico vegetation and land formations in abstract forms. *Fantasy* is even more abstract. He reduces the sunlit snow-covered forested mountains to essential forms. A harmonious color pattern of cool blues and whites is balanced with splashes of warm yellows and reds. But within this modern landscape Blumenschein succumbed to include a diminutive, stylized genre figure of an Indian hunter with bow and arrow taking aim at deer in flying gallop on the ridge.

Top: E. Martin Hennings
Flight, ca. 1947
Oil on canvas, 25 x 30
Denver Art Museum, Gift of Mr. and Mrs.
David MacKenzie, 1984.328

Bottom: Ernest Blumenschein
Mountain Lake (Eagle Nest), 1935
Oil on canvas, 29 x 39½
Denver Art Museum, William Sr. and Dorothy
Harmsen Collection, 2001.458

Ernest Blumenschein
Fantasy, 1940s
Oil on canvas, 16 x 20
Denver Art Museum, Gift of
Mrs. George D. Volk, 1983.228

William Herbert "Buck" Dunton
Open Range, 1912
Oil on canvas, 26 x 39
Private collection

Theodore Van Soelen
The Road to Santa Fe, 1948
Oil on canvas, 44 x 54
Denver Art Museum, William Sr. and Dorothy
Harmsen Collection, 2001.1143

Gustave Baumann
Summer Clouds, 1956
Color woodblock print, 12 x 10¾
Denver Art Museum, Gift of Anne Gilsdorf Bliss,
2006.80

The Anglo artists also shared an intense interest, if not romance, in the more-than-four-hundred-year-old Hispanic culture in the Southwest. Hispanic subject matter, however, did not match the prodigious output of Pueblo imagery. Theodore Van Soelen, who moved to New Mexico for his health in 1916, carefully chronicled everyday life with unsentimental realism, as exemplified in *The Road to Santa Fe.* Painted with strong contrasts of light, a *leñador* (woodcutter) with hunched shoulders follows his two burros laden with large loads of wood, quietly leaving behind a woman who would need the wood for cooking and keeping warm. A more picturesque moment is depicted in Baumann's *Summer Clouds.* A woman leans over the wooden fence in a neighborly way and watches her friend at work in a garden of pink hollyhocks. The open gate bids the viewer welcome to the low adobe casita. A champion of Hispanic cultural preservation, William Penhallow Henderson, who moved to Santa Fe in 1916 because of his wife's health, painted in an expressive post-impressionist style of simplified,

SUMMER CLOUDS

Gustave Baumann '56

outlined forms and high-keyed color. *The Chaperone* presents a quizzical image of the Hispanic custom of chaperoning an unmarried couple, with a scene of a closely attached threesome walking down a lane under a romantic full moon. An enticing young woman in red turns away from her suitor to stare at the viewer; perhaps courtship is not what it should be for her. Her chaperone, a conservatively dressed woman (likely an aunt), links her right arm through the somber suitor's left, seemingly the focus of his attention. A lone young mother with her child, who looks on from the background, perhaps portends the future.

Andrew Dasburg's arrival in Taos in 1918 at Mabel Dodge Luhan's request marked the passing of the artistic torch.

The work of the first generation of artists became passé and was supplanted by the more modernist style of Dasburg, one of the most progressive American painters of his time. Landscape was not the focus of his composition, but a conceptual departure for his personalized cubist approach.

Dasburg's student Kenneth Adams followed him to Taos in 1924 and became the last, and youngest, artist to join the TSA before it disbanded—a link between past and present, conservative and avant-garde. Adams's dignified portrait of the laborer Juan Duran was painted from life while Duran was on a cigarette break. Duran's large workingman's hands, resting on his knees, reflect Adams's respect and empathy for the Hispanics he came

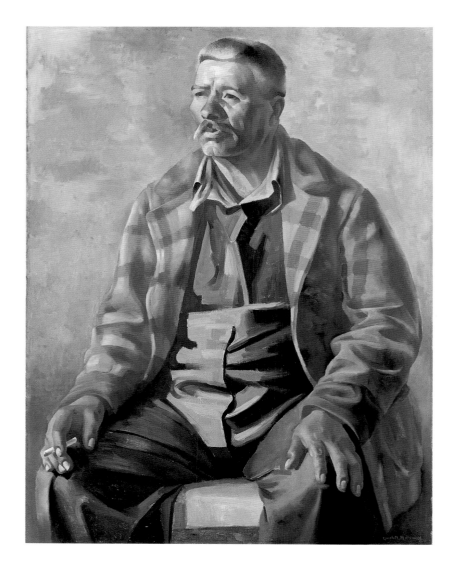

Kenneth M. Adams

Juan Duran, 1933–34

Oil on canvas, 40 x 30

Smithsonian American Art Museum, Transfer

from the U.S. Department of Labor, 1964.1.148

William Penhallow Henderson

The Chaperone, ca. 1916

Oil on canvas, 23½ x 29½

Denver Art Museum, Gift of Mrs. Edgar Rossin,

1974.16

to know. The simplified forms, thick strokes of vivid color, and the faceted lines and angles of the plaid jacket speak the language of modernism.

Cady Wells and Barbara Latham, among many young artists who came to Taos and worked with Dasburg, also practiced a contemporary sensibility. Wells, an ardent collector of *santos* and other Hispanic religious objects, responded to the Penitente practices as seen in the calligraphically rendered *Penitente Morada*. The dynamic, moody work offers a glimmer of hope and comfort, if not redemption, as the sun rises on the edgy indigenous landscape and buildings. In contrast, Latham,

who left behind a successful career in commercial art in New York, is more lighthearted in approach with her careful observations of Hispanic life. *Decoration Day*, with its splashes of color, playful angles of the fence, and simplified forms, resonates as a festive Memorial Day as families come to place flowers on the graves of their loved ones at Talpa Cemetery. Stylistically this work reflects Latham's study of Diego Rivera's murals in Mexico.

The Taos art colony that thrived in the first half of the 1900s embodied and promoted a popular American art movement in search of a pure American art form, with Taos as the muse. Sharing

this spirit of place, an eccentric mix of artists answered her call with individual styles and aesthetic values.

Notes

1 Robert R. White, "The Taos Art Colony and the Taos Society of Artists, 1911–1927," in *Bert Geer Phillips and The Taos Art Colony* (Albuquerque: University of New Mexico Press, 1998), 65.

2 Ibid. Twenty-five Anglos lived in Taos at the time of Phillips's and Blumenschein's arrival.

3 Joseph Henry Sharp, Taos, NM, to J. H. Gest, 15 June 1906, Cincinnati Art Museum Archive, Cincinnati, OH.

4 The charter members of the Taos Society of Artists were Ernest L. Blumenschein, Oscar E.

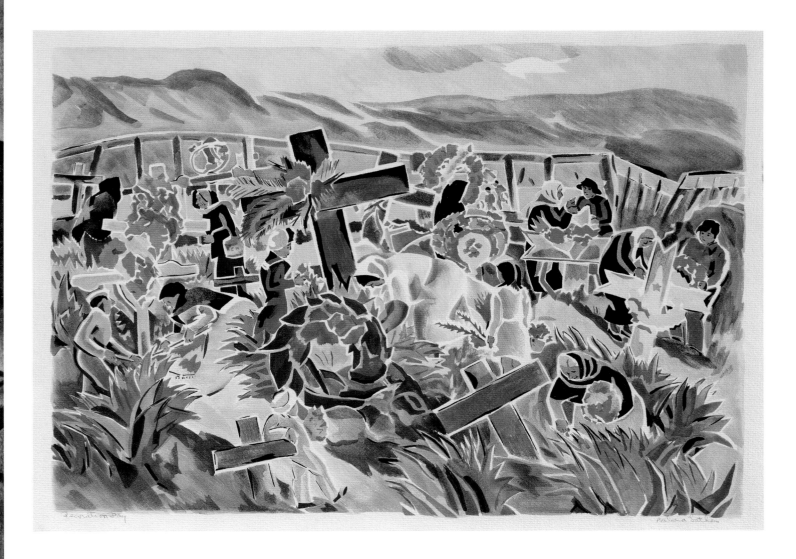

Cady Wells
Penitente Morada, ca. 1935
Watercolor on paper, 14 x 21
Collection of the Harwood Museum of Art
of the University of New Mexico

Barbara Latham
Decoration Day, 1940s
Watercolor on paper, 14¹/₁₆ x 16 x 20¼
Denver Art Museum, Funds from the William D.
Hewit Charitable Annuity Trust, 1986.40

Berninghaus, Eanger Irving Couse, Herbert "Buck" Dunton, Bert Geer Phillips, and Joseph Henry Sharp. Active members added between 1917 and 1926 were Kenneth Adams, Catherine C. Critcher, E. Martin Hennings, Victor Higgins, Julius Rolshoven, and Walter Ufer. Associate members were Gustave Baumann, Randall Davey, Albert L. Groll, Robert Henri, John Sloan, B. J. O. Nordfeldt, and Birger Sandzén. Honorary members were Edgar L. Hewett and Frank Springer.

5 The New Mexico Painters were together for a brief time from 1923 to 1927. The eight founding members included Taos artists Ernest Blumenschein, Victor Higgins, and Walter Ufer, and Santa Fe artists Frank Applegate, Jozef Bakos, Gustave Baumann, William P. Henderson, and B. J. O. Nordfeldt. Later members included John Sloan, Andrew Dasburg, Theodore van Soelen, Randall Davey, Walter Mruk, and Olive Rush.

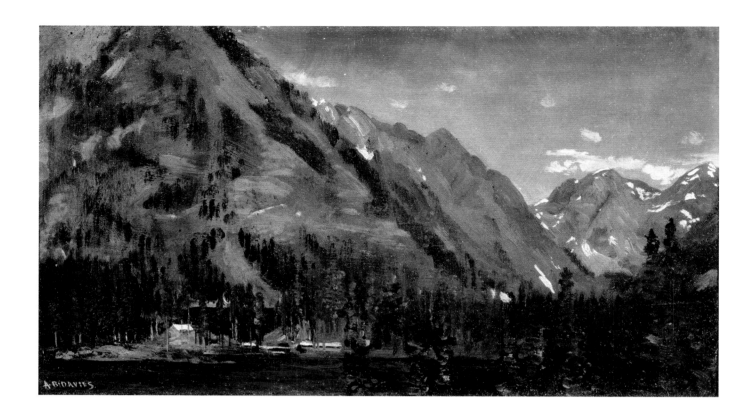

Robert Henri and the Changing Face of Modern

THOMAS BRENT SMITH

Arthur B. Davies
Emerald Lake, 1905
Oil on canvas, 6 x 10¼
Denver Art Museum, D.A.M. Yankees and funds
from the Acquisition Challenge Grant, 1987.16

n the first decade of the 1900s, painter Robert Henri (1865–1929) was an eminent teacher and promoter of a modern American art style. His pupils and followers were many, and his voice was as strong as that of any American painter. Henri had studied in Paris before returning to Philadelphia to teach, and by 1892 he attracted a solid following of young illustrators, including William Glackens, George Luks, Everett Shinn, and John Sloan.[1] Henri had begun to build a circle of faithful followers. In 1902, Henri began teaching at the New York School of Art, where he widened his influence by instructing artists like George Bellows, Edward Hopper, Rockwell Kent, Randall Davey, Stuart Davis, and others.

During the first decade of the century, Henri was equally successful as a painter and instructor. The artist was elected into the prestigious National Academy of Design in 1906. However, only a year after his election, Henri withdrew his already accepted works from the 1907 exhibition in protest after three of his pupils were denied inclusion. A natural maverick, Henri criticized the conservative Academy and resolved to organize an exhibition of his own.

He partnered with another weighty American painter, John Sloan, and the art dealer William Macbeth. They organized an exhibition titled *The Eight,* which challenged the ideas of the Academy and set a new standard for American painting.[2] The exhibition's success cemented Henri as the leading figure in modern American painting—for the moment.

In 1911, Henri and most of his followers joined forces with younger talents to form the Association of American Painters and Sculptors. This short-lived association proved to be laudable in the evolution of American modernism as well as poisonous to Henri's stature. Inconspicuously, the Association elected Arthur B. Davies as its president rather than Henri. Davies wished to introduce American audiences to progressive European modern art and set out to organize the Armory Show of 1913. In contrast Henri believed that an exhibition exalting the European avant garde would make American artists more provincial, and thus Henri quickly found himself without power and at odds with Davies.[3]

The Armory Show had a lasting effect on American artists and encouraging many of his followers to discover the beauty and power of the American Southwest, he managed to remain relevant to modern American painting in the first quarter of the 1900s.

In the summer of 1914, he accepted an invitation from a former student, Alice Klauber, to visit La Jolla, California.[4] "It's a new experience for us," stated Henri, "this West and summering in America is not usual—what star of luck led us Westward!"[5]

Klauber introduced Henri to Dr. Edgar Hewett, director of the Museum of New Mexico, who was in charge of the ethnological and art exhibition at the upcoming Panama-California Exposition to be held in San Diego the following year. Hewett successfully secured Henri's assistance with an exhibition of modern American art and Europe with "Indians, Mexicans [and] Chinese." However, the artist's palette comes alive and forgotten are the dark, brooding backgrounds of his earlier works. "The color is fine, wrote Henri, "its [sic] not like Spain—they all think it is but it isn't—not so invigorating—not so silver and gold in light. There is a hot brilliant sun but the mists both close and open the days."[8]

Among the portraits Henri completed that summer in La Jolla was *Romancita*, a painting of a Tewa artist who was visiting San Diego. The "hot brilliant" yellows, blues, and pinks mixed with a white in a nondescript background are particular to the place. Henri gives much attention to the woman's attire: her squash blossom necklace, silver bracelets, and traditional Tewa clothing (unlike the New Mexico

American Painting: Portraits of Westerners

introduced the New York public, used to the conservative Academy, to modern art. Both Henri and Davies had fought the Academy, but Davies brought on a tidal wave of modernism and forever changed the Academy and art in America. Although the majority of works in the exhibition were by American artists, it was the European work that garnered the most attention. The exhibition introduced Americans to pointillism, fauvism, and cubism. Marcel Duchamp's futurist painting *Nude Descending a Staircase* became a national scandal. Overnight American art had changed forever, and Henri had lost his position as orator of modern American painting.

As a result of this setback, Henri turned his attention to the American West and found new subjects that fit his painting philosophies. By organizing an exhibition in San Diego, helping to form policies at the Museum of New Mexico, for the exposition and gained what proved to be a timely cohort.[6] Henri possibly saw organizing the exposition's art exhibition as a platform for his comeback as the leader in American painting—a sequence of events that ultimately didn't come to pass, as the exhibition was overshadowed by the larger Panama-Pacific International Exposition in San Francisco and relatively unknown to eastern audiences. However, it did allow him to remain influential and active.

Primarily known as a portrait painter, Henri found subjects in southern California that he believed worthy of his efforts. "Have painted a good many Indians, Mexicans, Chinese & found it all mighty interesting," Henri wrote a friend.[7] Henri's dedication to painting the undistinguished or social outcast did not waver in the West. He replaced the gypsies and Irish immigrants he had painted in the East subjects Henri would later paint, Romancita was from Arizona).

In 1916, Henri returned to the West, this time to Santa Fe, New Mexico, at the invitation of Hewett, who gave the artist a studio in the old Palace of the Governors. Hewett again asked for Henri's advice, in developing the art portion of the Museum of New Mexico. Henri's stance toward an open door policy for artists would become an important characteristic of the museum's art program and attract many artists, including those in Henri's circle.[9]

Henri ultimately worked only three summers in New Mexico: 1916, 1917, and 1922. However, it was a productive period for the artist, particularly his first two visits. By 1922, Henri's New Mexico paintings had become more subdued, and he routinely employed less impasto and a smooth application to the paint surface. The brushwork is more exact and refined, as is evident in the

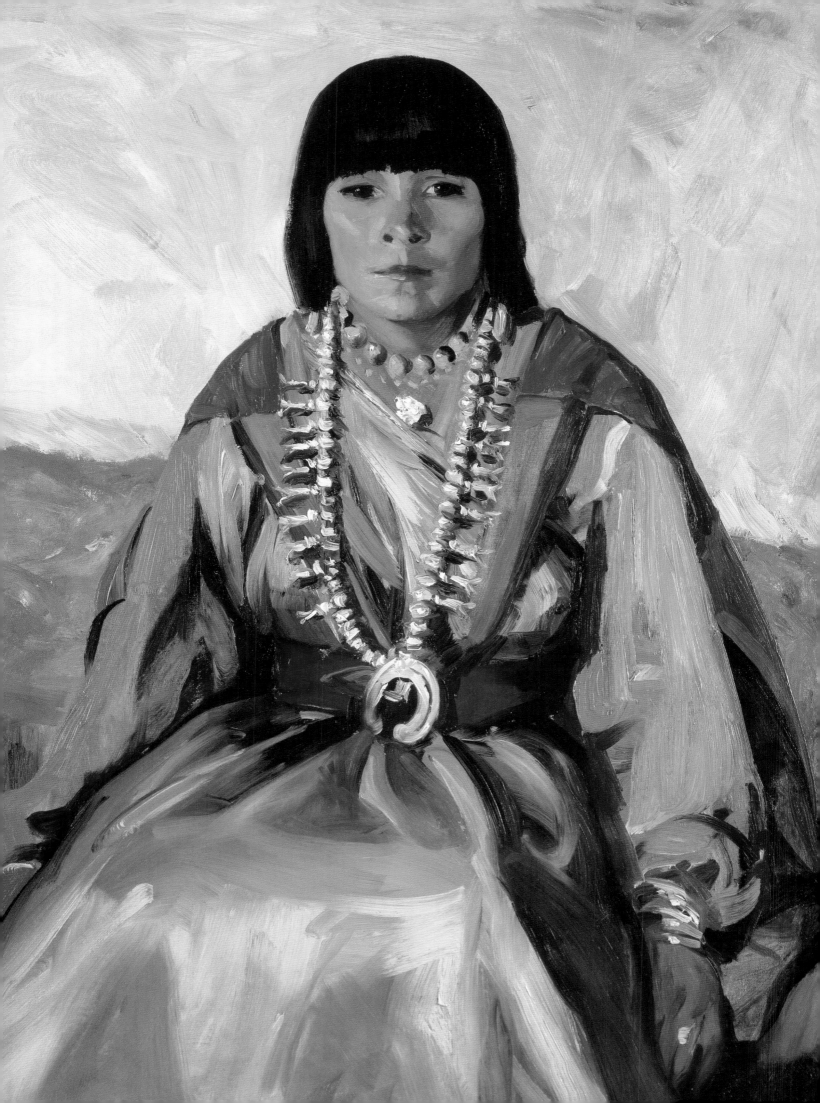

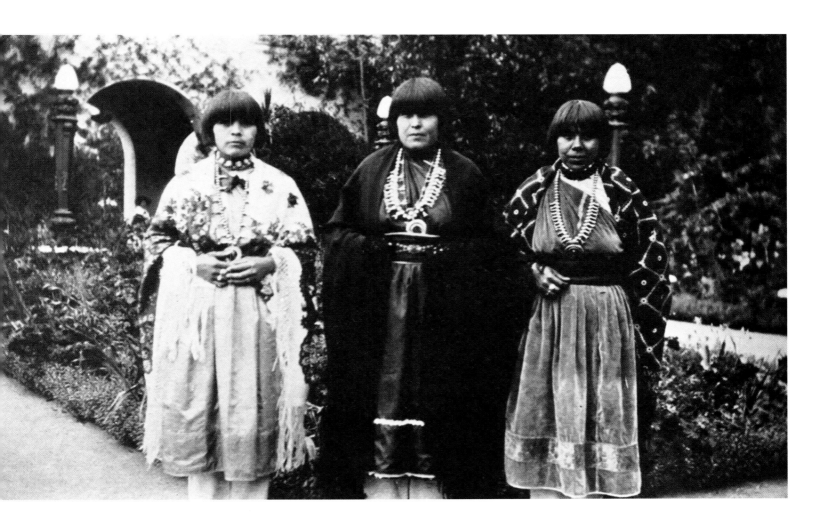

Detail, Robert Henri
Tom Po Qui (Water of Antelope Lake/Indian Girl/ Romancita), 1914
Oil on canvas, 40½ x 32½
Denver Art Museum, William Sr. and Dorothy
Harmsen Collection, 2001.461

Romancita, Maria, Ramona, *Tewa Artists at the San Diego Exposition. From Art and Archaeology: [the Arts Throughout the Ages]: An Illustrated Monthly Magazine,* vol. 16, no. 1–2. Washington, July–August 1923. Image courtesy Ryerson and Burnham Libraries, Art Institute of Chicago (705 A78ana)

portrait of *Lola*, a favorite subject, and there is dramatically less ferocity than is apparent in the earlier works.

Beyond his own paintings of New Mexico Henri played a key role in encouraging other artists to visit the region. The first of Henri's New York friends to visit Santa Fe was Leon Kroll. Although Kroll's visit only lasted approximately two weeks, he quickly adapted to the southwestern landscape, and his works display the clarity of light that is characteristic of New Mexico.

George Bellows, another of Henri's close associates, arrived in Santa Fe just after Kroll.[10] Although both artists were highly influenced by Henri and were accomplished portrait painters, curiously neither painted portraits while in New Mexico.

Although Henri was not in New Mexico in the summer of 1919, two of his close associates visited Santa Fe, John Sloan and Randall Davey.[11] Both would go on to buy homes there and make major contributions to the local

art scene. Sloan spent his summers in Santa Fe for nearly thirty years, and his subjects are as diverse as one might expect over such a period of time. The painting *Gateway to Cerrillos* shows a typical scene of the artist painting the landscape from his automobile, which he used to visit the surrounding areas near Santa Fe. The desert Southwest was a place of rejuvenation for the artist, but the environment, style, and aesthetics seeped into his New York life, too. The portrait of art patron Ruth Martin is

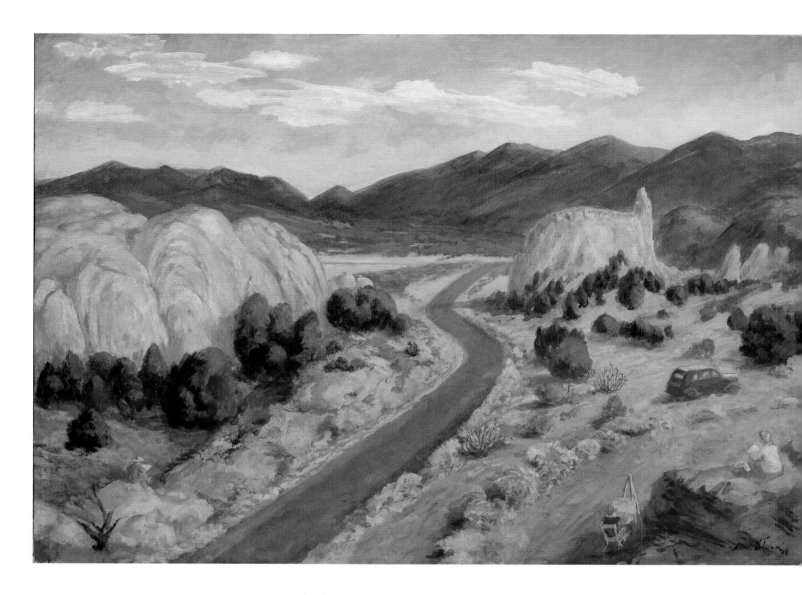

John Sloan
Gateway to Cerrillos, 1946
Mixed media, 25½ x 18
Denver Art Museum, William Sr. and Dorothy
Harmsen Collection, by exchange, 2006.73

Leon Kroll
Santa Fe Landscape, ca. 1917
Oil on canvas, 26 x 32
Collection of Lanny and Sharon Martin

evidence of the power the Southwest had on easterners. Martin, a society woman, chooses to wear a squash blossom necklace in her portrait. One can only guess if the necklace is a tribute to her interest in the West or solely Sloan's idea.

Davey's work also spanned the expected variety of subjects; however, formal portraits were few. One of the most successful portraits he painted

in New Mexico was *Western Man*. The subject appears to be a Hispanic man of mature years. His withered hands speak to a working-class life, yet the vest and pink kerchief add an obvious elegance as he politely holds what ambiguously appears to be his hat. The viewer is curious about the man's thoughts and life. This intrigue, and the choice to depict a working-class subject, is undeniably indebted to Henri.

Several artists could have been indirectly encouraged to visit the Southwest by Henri's presence there, including his former students Stuart Davis and Edward Hopper. A less obvious associate of Henri's to visit New Mexico was Homer Boss. A student of Henri's at the New York School of Art in 1902, Boss took over teaching at Henri's own independent school (Henri School of Art) when Henri left for Europe in

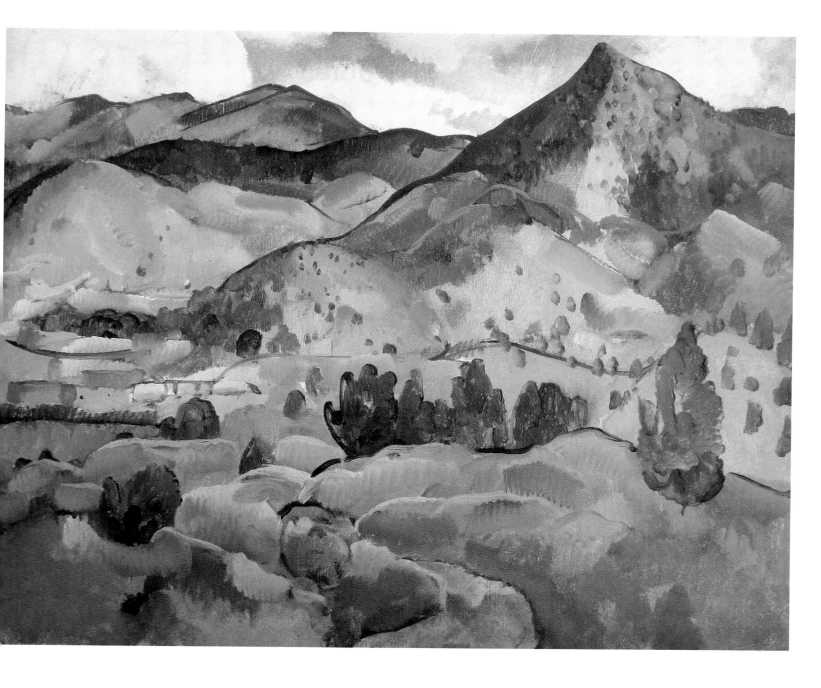

1910. Boss frequently exhibited with Henri and his circle in the first decade of the twentieth century and was known as a proponent for the rebellion against the National Academy.[12] Starting in 1925 the artist began visiting New Mexico and continued this pattern until his death in 1956.[13] Boss's portraits owe as much to Henri as any New Mexico portraits by his associates. In the painting of Encarnacion Montoya titled *Koh-tseh (Yellow Buffalo)*, Boss incorporates a textile in the background, a design element regularly employed by Henri. The flat brushwork, distinct realism, and portrayal of one of society's outsiders evident in this work are all fundamentals of Henri's ideas about modern American painting.

Although the actual amount of time Henri spent in the Southwest was not very long, both the works he created there and the artists he encouraged to visit contributed to a much greater legacy.

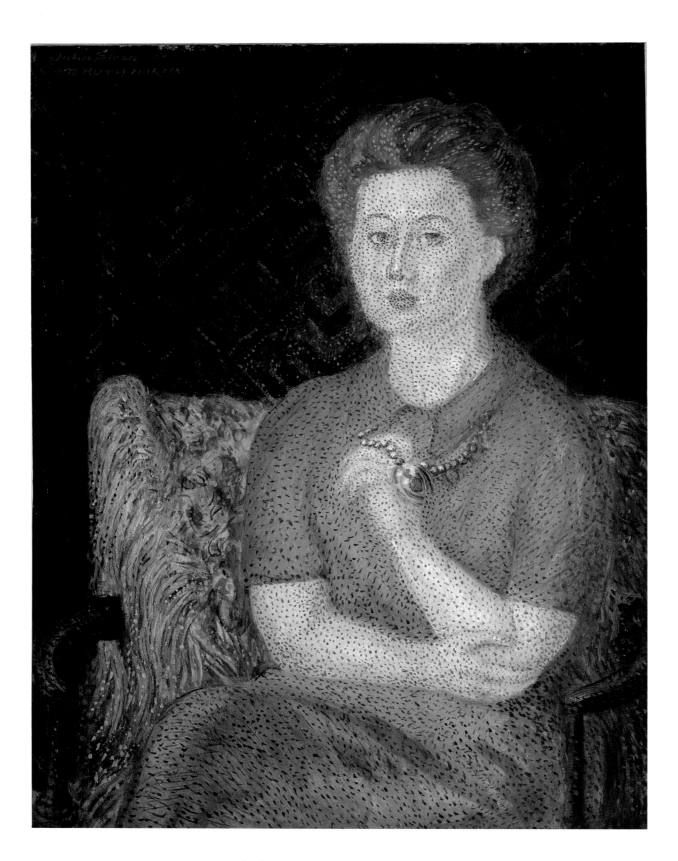

John Sloan
Ruth Martin (Navajo Necklace), 1950
Oil on canvas, 26 x 20
Collection of Chuck and Barb Griffith
©2011 Delaware Art Museum / Artists Rights
Society (ARS), New York

Robert Henri
Lola of Santa Fe, 1922
Oil on canvas, 23 x 19½
Denver Art Museum, T. Edward and Tullah Hanley
Collection, by exchange, 1993.20

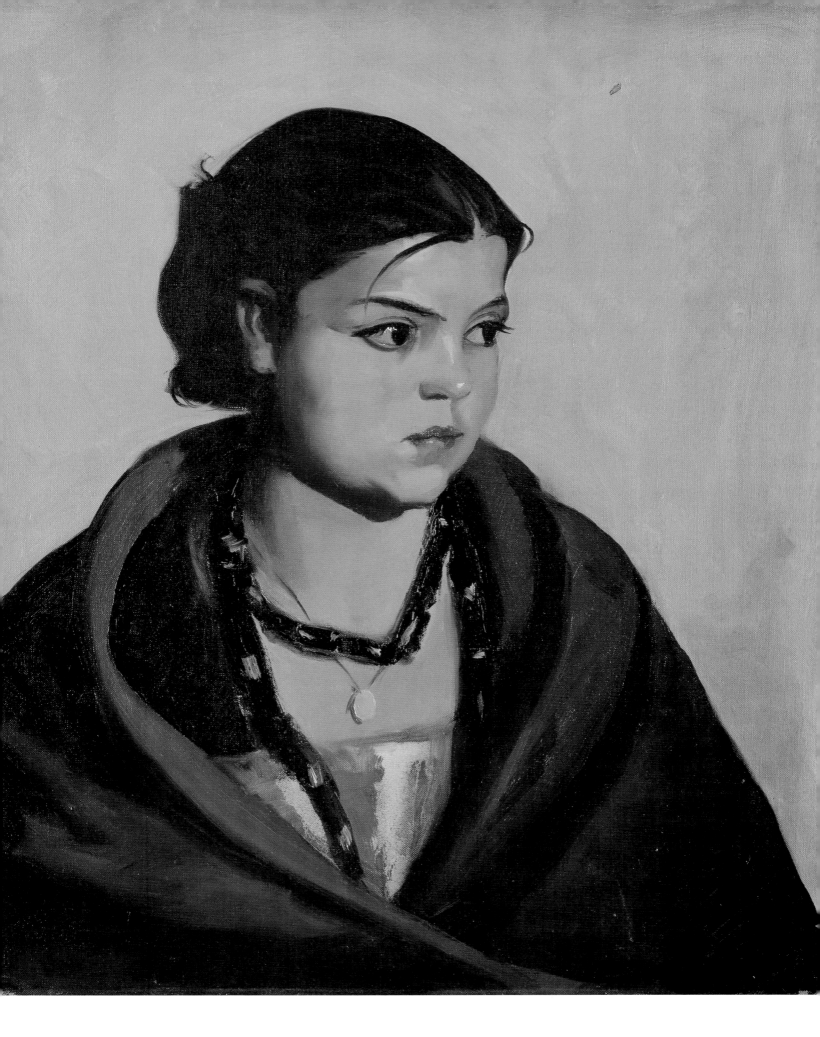

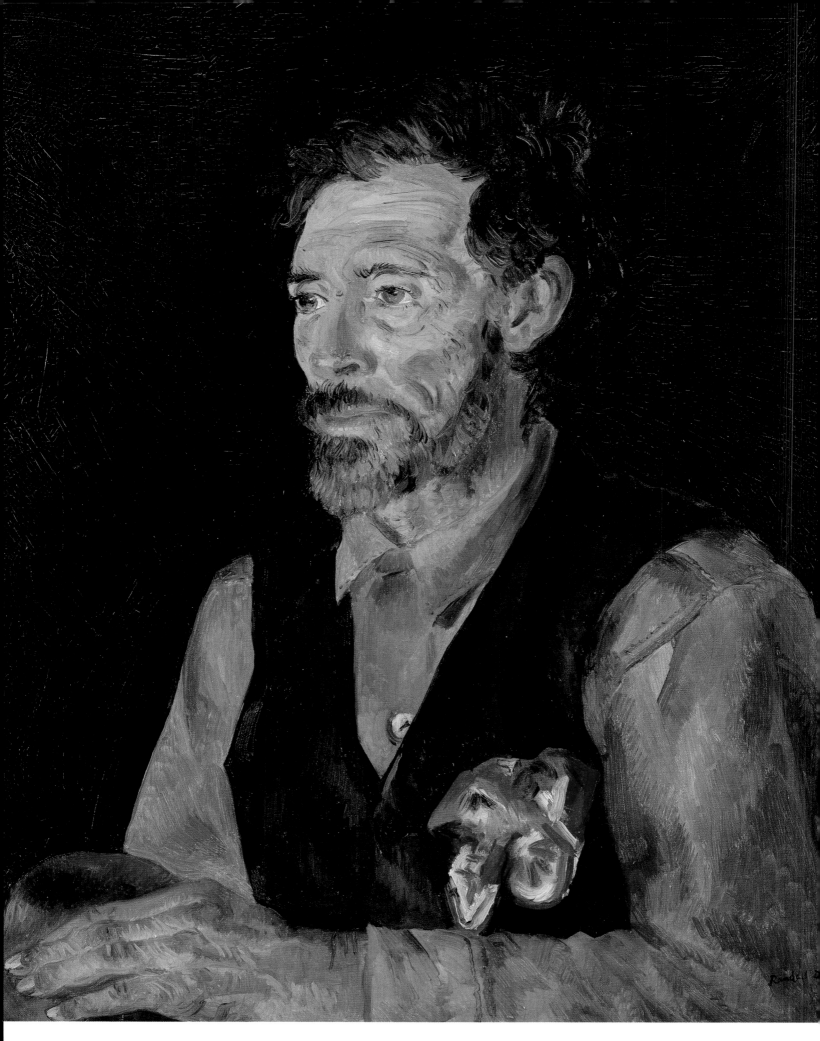

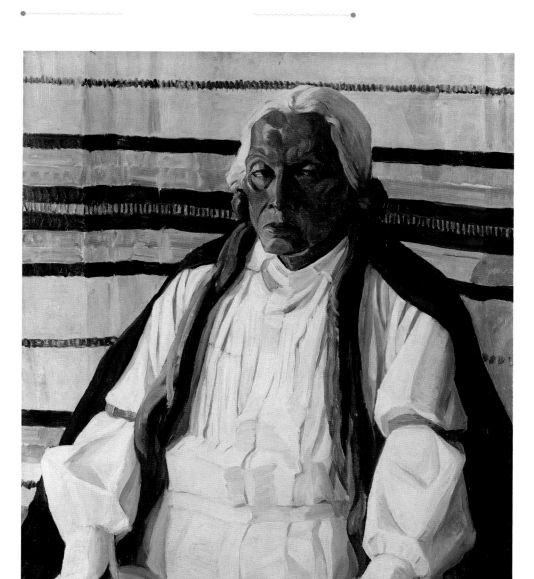

Notes

1 Milton W. Brown, *American Painting: From the Armory Show to the Depression* (Princeton, NJ: Princeton University Press, 1955), 9.

2 For a biography of Henri see William Inness Homer and Violet Organ, *Robert Henri and His Circle* (Ithaca, NY: Cornell University Press, 1955), 9, 49.

3 Brown, *American Painting: From the Armory Show to the Depression,* 47–48.

4 For more on Henri and the exposition, see Jean Stern, "Robert Henri and the 1915 San Diego Exposition," *American Art Review* 2 (September/October 1975): 108–17.

5 Quoted in Valerie Ann Leeds, *Robert Henri in Santa Fe: His Work and Influence* (Santa Fe: Gerald Peters Gallery, 1998), 9.

6 Stern, "Robert Henri and the 1915 San Diego Exposition," 109.

7 Quoted in Leeds, *Robert Henri in Santa Fe,* 10.

8 Ibid., 9.

9 Ibid., 12.

10 Ibid., 31.

11 Ibid., 33.

12 Susan S. Udell, *Homer Boss: The Figure and the Land* (Madison, WI: Elvehjem Museum of Art, University of Wisconsin-Madison, 1994), 6–12.

13 Ibid., 26–31.

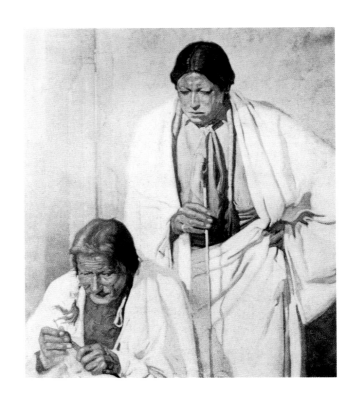

E. Martin Hennings, Rabbit Hunt

PETER H. HASSRICK

<p style="float: left"></p>

By about 1925, when E. Martin Hennings is thought to have painted this imposing oil, the artist was living in Taos, New Mexico. A bachelor, he resided in an apartment near the town's famous plaza. He had been unanimously elected as a member in the prestigious Taos Society of Artists the year before, after satisfying the prerequisite that he spend at least a part of three contiguous years residing and painting in the celebrated artists' colony. And he had recently distinguished himself nationally by winning awards at the National Academy of Design in New York, the

Pennsylvania Academy of the Fine Arts in Philadelphia, and in his hometown at the Art Institute of Chicago.

Hennings was a traditionalist as a painter. He trained for five years at the School of the Art Institute of Chicago, mostly under the tutelage of one of America's most renowned academic figure instructors, John H. Vanderpoel.[1] After completing his schooling in Chicago and exploring commercial work as an illustrator and muralist, Hennings embarked in 1912 on a course of study at the Royal Academy in Munich. His parents had emigrated from Germany when Hennings was two years old, so a return there was both natural and exhilarating. After considerable effort, Hennings was accepted as a student by Franz von Stuck, the exalted master of Jungendstil, the German version of art nouveau. Heretofore, Hennings had been painting in the classical, academic

manner embraced by the American Renaissance. It was with Stuck that Hennings learned to paint in a more modern mood, adopting a style that combined bold figural work with an affectionate rendering of landscape all intertwined with brilliant color, elegant line, and a firm commitment to controlled yet lively design.

The First World War interrupted Hennings's foreign interlude. He escaped Europe for Chicago in 1915 and resumed his commercial career. Two years later, at the behest of Chicago's long-term mayor, Carter H. Harrison Jr., Hennings was able to visit New Mexico. Several of his fellow Chicago artists, including Walter Ufer and Victor Higgins, whom he had met and befriended at the American Artists Club in Munich and the Palette and Chisel Club in Chicago, had visited Taos under identical circumstances a few

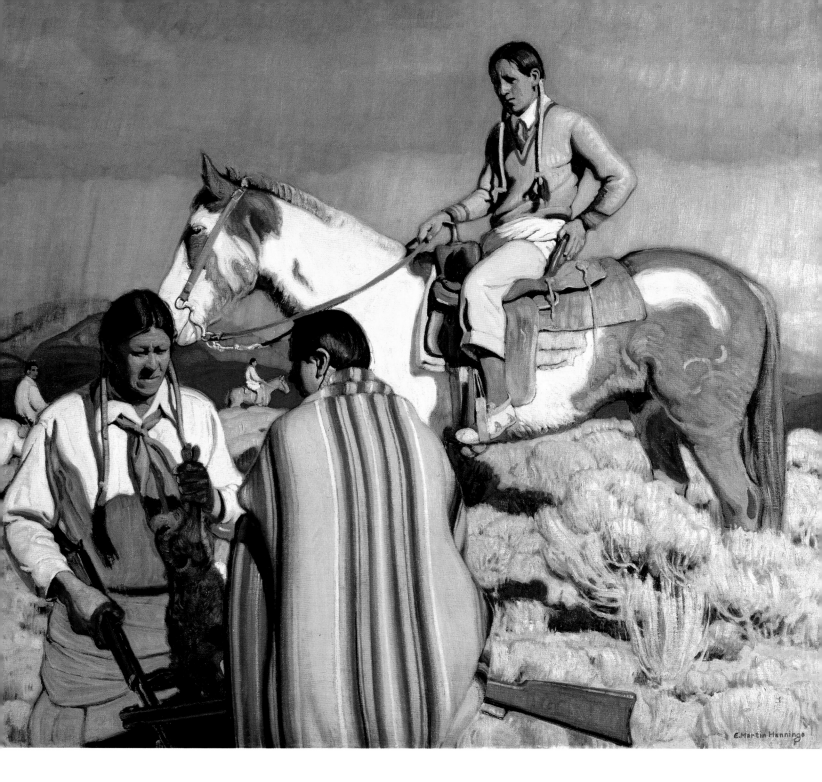

E. Martin Hennings
Stringing the Bow, 1918
Featured on cover of the *Bulletin of the Los Angeles Museum of History, Science and Art*,
April 1921, Ryerson and Burnham Libraries, Art Institute of Chicago (Falk records: AIC 1918)

E. Martin Hennings
Rabbit Hunt, ca. 1935
Oil on canvas, 35½ x 39½
Denver Art Museum, William Sr. and Dorothy Harmsen Collection, 2001.449

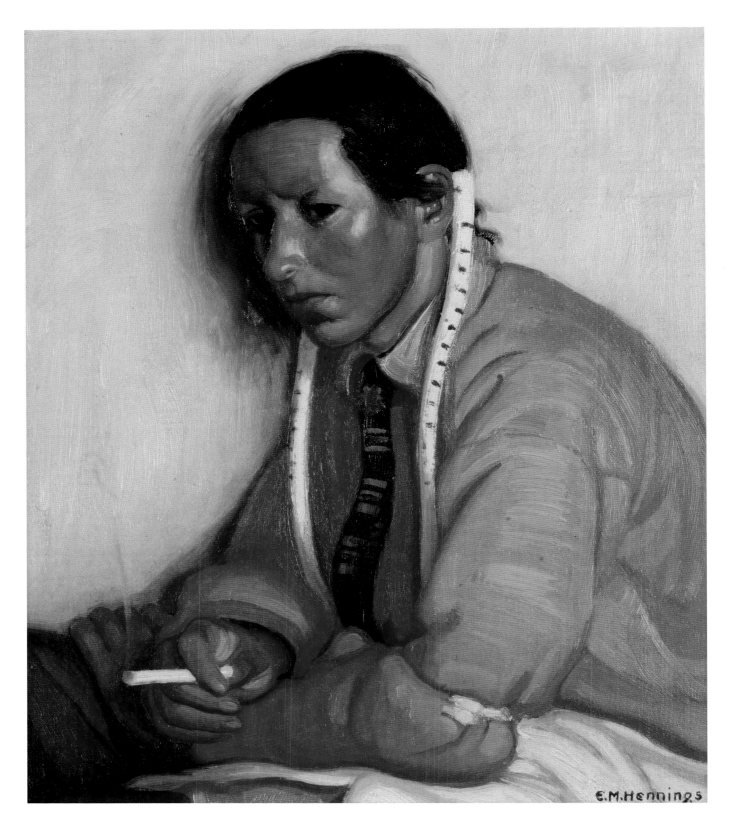

E. Martin Hennings
At Leisure, ca. 1925
Oil on canvas, 14 x 12
Stark Museum of Art, Orange, Texas

years earlier. Ufer and Higgins became annual residents in Taos following their first trips. It took Hennings a bit longer to extricate himself from his commercial bonds. Not until 1921 did he return to spend the better part of each year painting the Hispanic and Pueblo peoples as well as New Mexico's magnificent landscape.

Once Hennings made the commitment to Taos, the region began to transform him, enlivening his art and inspiring him to seek new ways of seeing and interpreting the Southwest. In the spring of 1922 he mounted a major exhibition of current work at the galleries of Marshall Field & Co. in Chicago. All at once his paintings were "creating a sensation," according to the *Chicago Evening Post*. "The Taos Society of Artists can count another significant member, who has a new message of the lands of sunshine and desert."[2]

The next year Chicago embraced not one but two comprehensive shows of Hennings's Taos work, one at Marshall Field & Co. in April and a second at the Art Institute of Chicago in September. The mayor's wife, Edith Ogden Harrison, did the honor of writing an introduction for the first exhibition brochure. Published verbatim in the *Chicago Evening Post*, the essay summarized his achievement.

> With his strong feeling for the decorative, with his keen sense and love of the contrast between the deep blue of the skies, or of the cloud-shadowed mountains and of the foreground bathed in a flood of golden sunshine, Mr. Hennings has painted his bit of the Great West in a most individual manner.[3]

When his exhibition opened at the Art Institute, the *Chicago Daily Tribune* proclaimed it "one of the best one-man shows the museum has had in a long time." The reviewer even remarked that Hennings's cohorts, Ufer and Higgins, had better "look to their laurels," as an extraordinary new talent was emerging in their ranks. "A sure touch, a confidence in color, a harmony in composition, a sincerity in representation, mark every canvas," she concluded.[4]

By the time Hennings was formally admitted to the ranks of the Taos Society of Artists, in 1924, his star had risen and his fame was far-reaching. It was shortly following this ascendant moment, a true high point of his artistic career, that it is thought that he painted *Rabbit Hunt*. Hennings rarely dated any of his works, and his palette and style remain fairly consistent until the last decade of his life, the late 1940s and early 1950s. Thus ascribing a date to a work, especially one like *Rabbit Hunt* that has no exhibition history or provenance record before 1967, is conjectural. There are a few hints, however, that reside in the portraits of two of the primary figures. The man on the left of the composition was his favorite model, Frank Samora, whom Hennings had begun using as early as 1917. In this rendition, Samora is still quite youthful, appearing only slightly more mature than he had in a painting of 1918 titled *Stringing the Bow*. The other prominent figure, the boy on the horse, is even more revealing. In 1925 Hennings produced a series of small oils, probably intended for the tourist trade, of a Pueblo boy whose name has not come down in the records. This boy, generally posed seated on an outdoor *banco*, is mentioned only once, in a letter accompanying one of these portrait studies that Hennings donated to the Vanderpoel Art Association in 1928 in memory of his late mentor. The artist wrote parenthetically that "(The model did considerable posing for me, standing out under the hot sun, while I made myself comfortable under a sketching umbrella.)"[5] The portrait that most resembles the boy on the horse is a small oil titled *At Leisure*, owned by the Stark Museum of Art (Orange, Texas), which dates from this period.[6] Here the model sits smoking a cigarette, wearing braids and a necktie and staring somewhat petulantly into space.

Whether completed in 1925 or somewhat later, *Rabbit Hunt* represents something of an anomaly in Hennings's oeuvre. Generally, Hennings combined his figures with strong landscape elements as seen here. And, following a mandate from Harrison that went back to the teens, he almost always pictures his figures in common, everyday activities, thus avoiding idealization and stereotyping that is found in works by fellow Taos painters like Joseph Henry Sharp and E. Irving Couse. But rarely (unlike Ufer and Ernest Blumenschein) did he offer a symbolic or political gesture with his art. *Rabbit Hunt* is an exception on that count.

The three primary figures are scaled to present an imposing presence in the scene. The boy and his horse rise conspicuously above the horizon line, filling the picture plane and dominating even the mountain crests that are silhouetted against a gray sky in the distance. There appear to be two stories here. One is the conversation that takes place between the two men in the foreground. They each hold modern weapons—Winchester rifles—but wear traditional Pueblo garb, a colorful striped serape on the one and the white cotton blanket sometimes referred to as a *manta* wrapped around the waist of the other. The boy, whose role was probably to flush the rabbit from its hiding place, rests outside the space of his elders. In a sartorial juxtaposition, he is also separated from the cultural norms of the tribe that they represent. He is dressed in moccasins but also khakis, tennis sweater, white shirt, and tie. Astride his pinto pony, he has found an identity apart from the older generation.

In the work of more radical painters like Blumenschein, this separation could make for a deliberate political statement. In his 1920 painting *Star Road and White Sun*, Blumenschein pushed the matter of generational identity to the point of confrontation. He strove to recognize traditional Pueblo culture, under threat from drastic

Ernest Blumenschein
Star Road and White Sun, 1920
Oil on canvas, 42 x 51
Courtesy of the Albuquerque Museum of Art
and History, museum purchase, 1985 general
obligation bonds. Albuquerque High School
Collection, 1985.50.3, gift of the classes of 1943,
1944, and 1945. Photo by David Nufer

measures being exercised at the time by the Bureau of Indian Affairs, and to champion modern Indian life as well. He wanted Indians of both generations to be recognized as a living part of the American cultural fabric. Hennings evidently shared this aspiration.

Apparently such a potent representation of the modern Indian did not resonate with American art patrons. Blumenschein's painting, though broadly exhibited and critically acclaimed, never sold. He was eventually forced, in the last years of his life, to part with it at cost to the Albuquerque High School. Interestingly, though much milder in its presentation of an identical theme, Hennings's rendition did not find a buyer either. It appears to have remained in his studio until after his death, when it was sold in 1967 by his widow to Bill and Dorothy Harmsen, who eventually donated it to the Denver Art Museum.

If Blumenschein and Hennings shared a vision of Indian self-identity, they also had much in common with regard to their fundamental expectations of painting as art. In what Blumenschein considered to be his "religion," he applied four basic criteria to art: color needed to "sing," design must be "vigorous," rhythms should enliven each work, and line needed to convey a sense of "dignity."[7] In an interview with the *Christian Science Monitor* in 1928, Hennings said that in good art, "I expect the fundamentals to be observed." It must "embody all the elements of art which I term draftsmanship (line), design, form, rhythm and color."[8]

Hennings's color was generally bold and, like Blumenschein, he often used it to define form. For him, line and rhythm worked in tandem. The elegance and grace of his contours, reflecting his art nouveau training, offered a pictorial mood and cadence that was at once musical and poetic. And his design mastery, as evidenced in *Rabbit Hunt*, was controlled, balanced, and well considered. It was works like this, perhaps, that led Blumenschein to

purportedly conclude that Hennings was the finest of the Taos artists.[9]

In the 1800s and early 1900s, the standard artistic paradigm for portraying Indians was either to idealize them as noble symbols of America or to memorialize them as disappearing. Hennings and a few of his Taos compatriots succumbed to neither approach. They preferred to show the people of Taos Pueblo as survivors, as individuals with personal integrity and shared cultural identities. If in the process his Indian subjects were decoratively composed and elegantly delineated, it was because at the core of Hennings's creative being he felt they were one with his art. His respect and admiration for them as people was uncompromising. He wanted his art to be ascendant and his beloved subjects, enhanced with his "own ideas" of aesthetic creation, to be testaments to the best union of art, mankind, and nature.

Notes

1 In a letter commemorating Vanderpoel's life and teaching career written by Hennings in 1928, he claims that Vanderpoel "exercised the greatest influence on me during the impressionable and formative period of my life." See "Selections from Gallery of Vanderpoel Art Assn.," *Chicago Weekly Review*, July 20, 1928. Vanderpoel's definitive treatise, *The Human Figure: Life Drawing for Artists*, published in 1926, is still available as a standard text in a Dover Publications' 1958 reprint.

2 "The Art Dealers," *Chicago Evening Post*, May 9, 1922.

3 Edith Ogden Harrison, "E. Martin Hennings," *Chicago Evening Post*, April 10, 1923.

4 Probably Inez Cunningham, from an incomplete clipping from the *Chicago Daily Tribune*, September 9, 1923, Hennings Papers, Archives of American Art, Smithsonian Institution, Washington, DC.

5 "Selections from Gallery of Vanderpoel Art Assn."

6 The Vanderpoel version, titled *Examining His Arrows*, resides in the John H. Vanderpoel Art Association in Chicago today, and a third piece, *Drummer Boy*, can be seen in the Fred Jones

Jr. Museum of Art, University of Oklahoma, Norman.

7 Quoted in and discussed in Peter H. Hassrick and Elizabeth T. Cunningham, *In Contemporary Rhythm: The Art of Ernest L. Blumenschein* (Norman: University of Oklahoma Press, 2008), 187.

8 J. K., "E. Martin Hennings," *Christian Science Monitor*, April 23, 1928.

9 Sherry Clayton Taggett and Ted Schwarz, *Paintbrushes and Pistols: How the Taos Artists Sold the West* (Santa Fe: John Muir Publications, 1990), 215.

West Point Points West

Sweet on the West
HOW CANDY BUILT
A COLORADO TREASURE

Redrawing Boundaries

COLORADO
THE Artist's Muse

IN CONTEMPORARY RHYTHM
THE ART OF ERNEST L. BLUMENSCHEIN

PETER H. HASSRICK AND
ELIZABETH J. CUNNINGHAM

THE MASTERWORKS OF
CHARLES M. RUSSELL
A Retrospective of Paintings and Sculpture

Heart of the West

Charlie Russell
& Friends

SHAPING the WEST
AMERICAN SCULPTORS OF THE 19TH CENTURY

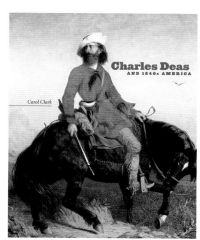

Charles Deas
AND 1840s AMERICA

Carol Clark

Elevating
Western
American Art

DEVELOPING an INSTITUTE
in the CULTURAL CAPITAL
of the ROCKIES

EDITED BY
THOMAS BRENT SMITH
INTRODUCTION BY
BARBARA CHAMBERS

West Point/Points West
Western Passages vol. 1, 2002

Sweet on the West: How Candy Built a Colorado Treasure
Western Passages vol. 2, 2003

Contemporary Realism Collection
Vol. 2, 2006

Redrawing Boundaries: Perspectives on Western American Art
Western Passages vol. 3, 2007

Heart of the West: New Painting and Sculpture of the American West
Western Passages vol. 4, 2007

Colorado: The Artist's Muse
Western Passages vol. 5, 2008

In Contemporary Rhythm: The Art of Ernest L. Blumenschein, 2008

The Masterworks of Charles M. Russell: A Retrospective of Paintings and Sculpture, 2009

Charles Deas and 1840s America, 2009

Charlie Russell and Friends
Western Passages vol. 6, 2010

Shaping the West: American Sculptors of the 19th Century
Western Passages vol. 7, 2010

Elevating Western American Art: Developing an Institute in the Cultural Capital of the Rockies
Western Passages vol. 8, 2012

"REDRAWING BOUNDARIES: PERSPECTIVES ON WESTERN AMERICAN ART," MARCH 7, 2007

 Brian W. Dippie, *University of British Columbia*

 Erika Doss, *University of Colorado*

 Angela Miller, *Washington University*

 Martha Sandweiss, *Amherst College*

 William Truettner, *Smithsonian American Art Museum*

 Moderated by Peter H. Hassrick, *Denver Art Museum*

 and Patricia Limerick, *Center of the American West, University of Colorado*

"HEART OF THE WEST: NEW ART/NEW THINKING," JANUARY 5, 2008

 Emily Neff, *Museum of Fine Arts, Houston*

 B. Byron Price, *Charles M. Russell Center, University of Oklahoma*

 James K. Ballinger, *Phoenix Art Museum*

 Gordon McConnell, *noted painter*

 Moderated by Peter H. Hassrick, *Denver Art Museum*

 and Ann S. Daley, *Denver Art Museum*

"TAOS TRADITIONS: ARTISTS IN AN ENCHANTED LAND," JANUARY 6, 2009

 Peter H. Hassrick, *Denver Art Museum*

 Marie Watkins, *Furman University*

 Judith Barter, *Art Institute of Chicago*

 Peter Stremmel, *Coeur d'Alene Art Auction*

 Moderated by Patricia Limerick, *Center of the American West, University of Colorado*

"SHAPING THE WEST: AMERICAN SCULPTORS OF THE 19TH CENTURY," JANUARY 5, 2010

 Andrew J. Walker, *St. Louis Art Museum*

 Thayer Tolles, *Metropolitan Museum of Art*

 Peter H. Hassrick, *Denver Art Museum*

 Sarah Boehme, *Stark Museum of Art*

 Moderated by Alice Levi Duncan, *Gerald Peters Gallery*

 amd Patricia Limerick, *Center of the American West, University of Colorado*

"A DISTANT VIEW: EUROPEAN PERSPECTIVES ON WESTERN AMERICAN ART," JANUARY 6, 2011

 Peter Bolz, *Ethnologisches Museum Berlin, Germany*

 Laurent Salomé, *Musées de Rouen, France*

 Sam Smiles, *University of Plymouth, England*

 Moderated by Joan Carpenter Troccoli, *Denver Art Museum*

"LEST WE FORGET CALIFORNIA: ARTISTS IN THE GOLDEN WEST," JANUARY 5, 2012

 William Gerdts, *Graduate School of the City University of New York*

 Scott Shields, *Crocker Art Museum*

 Will South, *Columbia Museum of Art*

 Thomas Brent Smith, *Denver Art Museum*

 Moderated by Peter H. Hassrick, *Denver Art Museum*

DARRIN ALFRED

Darrin Alfred is associate curator of architecture, design, and graphics at the Denver Art Museum. Alfred curated the museum's 2009 exhibition *The Psychedelic Experience: Rock Posters from the San Francisco Bay Area, 1965–71.* He previously served as assistant curator of architecture and design at the San Francisco Museum of Modern Art and, more recently, contributed to Brazilian designers Fernando and Humberto Campana's catalogue raisonné, *Campana Brothers: Complete Works (So Far)* (Rizzoli, 2010).

NANCY J. BLOMBERG

Nancy J. Blomberg is chief curator and head of the Native Arts Department at the Denver Art Museum. She has received numerous grants for research, exhibitions, conservation, and collections management from the National Endowment for the Arts (NEA), National Endowment for the Humanities (NEH), the National Science Foundation (NSF), the Luce Foundation, and the National Park Service. Very active in the field, she has served as a panelist and reviewer for organizations including the NEA, NEH, NSF, the Institute of Museum Services, the John D. and Catherine T. MacArthur Foundation, and the Council for Museum Anthropology. Her research specialties include North American Indian art and culture, specifically Navajo textiles.

KAREN E. BROOKS

Karen E. Brooks holds a master's degree in art history from the University of Colorado at Boulder, where she focused on the art of the American West and museum studies. Since graduating in May 2010, Brooks has worked at the Denver Art Museum in a variety of capacities in the Petrie Institute of Western American Art, the Native Arts Department, and the Education Department. She currently serves as the department assistant for the Petrie Institute of Western American Art.

MARLENE CHAMBERS

Marlene Chambers was director of publications at the Denver Art Museum for thirty years. In that role, she edited (and often wrote) everything from exhibition catalogs to brochures and gallery labels. With undergraduate majors in education and English and M.A. degrees in English and art history, it is not surprising that she is keenly interested in the "writing on the wall" and that she considers the John Cotton Dana Award for Leadership given by the American Association of Museums Education Committee in 1996 the capstone of her career. Her occasional essays on museum-related topics have appeared in *Museum News, The Exhibitionist,* and *Curator: The Museum Journal.*

GWEN CHANZIT

Dr. Gwen Chanzit is curator of modern and contemporary art and the Herbert Bayer Collection & Archive at the Denver Art Museum. Among her exhibitions are *Matisse from the Baltimore Museum of Art, Bonnard, Overthrown: Clay Without Limits,* and many on Herbert Bayer. She has authored three books on Herbert Bayer and contributed to other publications including *RADAR: Selections from the Collection of Vicki and Kent Logan; Ahoi, Herbert!: Bayer und die moderne; The View From Denver; Embrace!;* and *Overthrown: Clay Without Limits.* Chanzit holds a Ph.D. in art history and is director of the graduate program in museum studies at the University of Denver's School of Art and Art History.

CAROL CLARK

Carol Clark is the William McCall Vickery 1957 Professor of the History of Art and American Studies at Amherst College, where she has taught since 1987. From 1984 until 1987 she was Prendergast Executive Fellow at the Williams College Museum of Art, and she served as curator of paintings at the Amon Carter Museum of American Art from 1977 until 1984. Professor Clark writes on nineteenth- and early-twentieth-century American art and culture. Her most recent book, published in conjunction with a 2010 exhibition she organized for the Denver Art Museum, is *Charles Deas and 1840s America* (University of Oklahoma Press, 2009).

ANN SCARLET DALEY

Ann Scarlett Daley, former curator of American art at the Denver Art Museum, joined the Petrie Institute of Western American Art at the Denver Art Museum at its founding in 2001. While at the institute, she was responsible for the collection of contemporary Western art and organized a retrospective of the work of George Carlson. Curator of a private Denver collection since 1985, she was also the inaugural curator of the Coors Western Art Exhibit and Sale at Denver's National Western Stock Show. She has written extensively on western American art and is co-author of *Landscapes of Colorado* (Fresco Fine Art Publications, 2007). Daley earned her B.A. in American studies from the University of Wyoming and a master's degree in art history from the University of Denver.

JILL DESMOND

Jill Desmond is associate director of exhibitions at the Denver Art Museum. She started at the museum as an intern in the Department of Modern and Contemporary Art in 2005 and worked with the Herbert Bayer Collection. In 2006, she was hired as a research assistant and was named curatorial assistant the next year. Tapping into her passion for electronic art, Desmond recently curated the museum's first large-scale exhibition devoted entirely to electronic and time-based media—*Blink! Light, Sound & the Moving Image*. Desmond holds an M.A. in art history and museum studies from the University of Denver.

BRIAN W. DIPPIE

Brian W. Dippie retired in 2009 after thirty-nine years as a professor of history at the University of Victoria, British Columbia. Among his books are *Custer's Last Stand: The Anatomy of an American Myth* (1976; new ed., 1994), *The Vanishing American: White Attitudes and U.S. Indian Policy* (1982; new ed., 1991), *West-Fever* (1998), and *Crossroads: Desert Caballeros Western Museum* (2010). A specialist in the history of western American art, he has published extensively on George Catlin, Frederic Remington, and Charles M. Russell and is currently advisor to a Russell exhibition at the Glenbow Museum in Calgary, Alberta, that will mark the centennial of the Calgary Stampede in 2012. Dippie served as president of the Western History Association in 2002–3.

HUGH GRANT

Hugh Grant is the founding director and curator of the Kirkland Museum of Fine & Decorative Art in Denver and adjunct curator of the Kirkland Collection at the Denver Art Museum. Grant established the Kirkland Foundation in 1996 to document, collect, exhibit, and publish Colorado artists, primarily from 1820 to about 1980. The foundation now exhibits work by more than 170 Colorado artists in addition to painter Vance Kirkland. He also built the majority of Kirkland Museum's international decorative art collection, of which there are more than 3,300 objects on view. Grant and Kirkland Museum have loaned artworks to nearly one hundred institutions in eighteen states and eleven countries. Grant received an honorary doctor of fine arts degree from the University of Denver in 2003 and the 2009 Bonfils-Stanton Foundation Award.

PETER H. HASSRICK

Peter Hassrick is director emeritus of the Petrie Institute of Western American Art at the Denver Art Museum, having retired from the directorship in May 2009. He is the founding director emeritus of the Charles M. Russell Center for the Study of Art of the American West at the University of Oklahoma in Norman, where he worked from 1998 to 2001. Before that, he was the founding director of the Georgia O'Keeffe Museum in Santa Fe. For the previous twenty years, Hassrick served as the director of the Buffalo Bill Historical Center in Cody (and now carries the title of director emeritus and senior scholar for that institution). He has taught and lectured widely in both university and public venues and has published many books and articles on western American art.

CHRISTOPH HEINRICH

Dr. Christoph Heinrich, the Frederick and Jan Mayer Director of the Denver Art Museum, came to the museum in 2007 as curator of modern and contemporary art. Before then, Heinrich was at the Hamburg Kunsthalle, where he organized more than fifty exhibitions, eighteen of which were major loan exhibitions, during his thirteen-year tenure. Some of his most notable exhibitions include *Andy Warhol: Photography*, which traveled to the Andy Warhol Museum in Pittsburgh and the International Center for Photography in New York; *Francis Bacon: The Portraits; Mahjong: Contemporary Chinese Art from the Sigg Collection;* and *Daniel Richter: A Major Survey.* Born in Frankfurt/ Main, Germany, Heinrich attended the University of Vienna, where he studied art history and dramatics. He earned his M.A. and Ph.D. at the Ludwig Maximilian University of Munich.

HEATHER HOLE

Heather Hole is tauthor of *Marsden Hartley and the West: The Search for an American Modernism* (Yale University Press, 2007) and curator of the traveling exhibition of the same name. She holds a Ph.D. in the history of art from Princeton University and teaches at Simmons College in Boston. In her previous position as curator at the Museum of Fine Arts, Boston, she played a key role in planning and installing the new Art of the Americas Wing, which opened in November 2010. Her current research examines Mexican and American cultural nationalism in the 1920s and 1930s.

MICAH MESSENHEIMER

Micah Messenheimer is curatorial assistant in the Photography and Textile Art departments at the Denver Art Museum. He holds an M.A. in art history from the University of Denver and an M.F.A. in photography and conceptual and information art from San Francisco State University. The current focus of his research concerns the correlation between humans and the landscape in photography.

EMILY BALLEW NEFF

Emily Ballew Neff is curator of American painting and sculpture at the Museum of Fine Arts, Houston. She organized the major traveling exhibition *The Modern West: American Landscapes, 1890–1950* and wrote the accompanying catalog (Yale University Press, 2006). She also authored the museum's permanent collection catalog *Frederic Remington: The Hogg Brothers Collection of the Museum of Fine Arts, Houston* (Princeton University Press, 2000).

RONALD Y. OTSUKA

Ronald Y. Otsuka, Dr. Joseph de Heer Curator of Asian Art, has been with the Denver Art Museum since 1973. He did his graduate work at the Institute of Fine Arts, New York University. In addition to his other publications, Otsuka developed special issues on the Denver Art Museum's collections for the journals *Orientations* and *Arts of Asia*, and he has organized and administered more than sixty-five Asian art exhibitions for the Denver Art Museum, Colorado State University, and Japan Pavilion (Epcot Center). He is the recipient of research grants from the Asian Cultural Council, Bunkacho (Agency of Cultural Affairs, Japan), and the National Endowment for the Arts.

NICOLE A. PARKS

Nicole A. Parks serves as the curatorial assistant for the Petrie Institute of Western American Art at the Denver Art Museum. She holds two B.A. degrees from the University of Colorado in art history and anthropology and a master's degree from the University of Denver in art history. She contributed an essay, "Albert Bierstadt's Colorado," to a previous Western Passages publication, *Colorado: The Artist's Muse*, and has worked on various institute projects including the exhibition and catalog for *Charles Deas and 1840s America* and *The Masterworks of Charles M. Russell: A Retrospective of Paintings and Sculpture*, among others.

DONNA PIERCE

Dr. Donna Pierce is Frederick and Jan Mayer Curator of Spanish Colonial Art at the Denver Art Museum and head of the New World Department. She holds a master's degree from Tulane University and a Ph.D. from the University of New Mexico. She curated the 2004 exhibition *Painting a New World: Mexican Art and Life, 1521–1821* at the Denver Art Museum and edited and co-authored the companion publication of the same title. She has collaborated on exhibitions at the Metropolitan Museum of Art, the Brooklyn Museum, the Minneapolis Institute of Arts, and the Santa Barbara Museum of Art, and has published extensively in the field.

B. BRYON PRICE

B. Byron Price is Director of the Charles M. Russell Center for the Study of Art of the American West and the University of Oklahoma Press. He also holds the Charles Marion Russell Memorial Chair and has written or edited several books including *The Charles M. Russell Catalogue Raisonné* (2007) *Fine Art of the West* (2004); *Erwin E. Smith: Cowboy Photographer* (1997); *Cowboys of the American West* (1996); and *The National Cowboy Hall of Fame Chuck Wagon Cook Book* (1995).

LEWIS INHAM SHARP

Dr. Lewis Inman Sharp is director emeritus of the Denver Art Museum. He received a master's degree in the Winterthur Program in Early American Culture and a Ph.D. in art history from the University of Delaware. Before coming to Denver, he was a Chester Dale Fellow at the Metropolitan Museum of Art and a member of the curatorial staff of the American Painting and Sculpture Department as well as the administrator overseeing the building of the Met's American Wing. In 1989, Sharp was appointed director of the Denver Art Museum and served in that capacity until his retirement in 2009.

THOMAS BRENT SMITH

Thomas Brent Smith is director of the Petrie Institute of Western American Art at the Denver Art Museum. He previously served as curator of art of the American West at the Tucson Museum of Art, where he curated the exhibition *A Place of Refuge: Maynard Dixon's Arizona* and authored the eponymous publication. Smith was a Robert S. and Grace B. Kerr Foundation graduate fellow at the University of Oklahoma's Charles M. Russell Center for the Study of Art of the American West.

DEAN SOBEL

As director of the Clyfford Still Museum, Dean Sobel has spearheaded the efforts to create a permanent home for the 2,400 works of art by Still bequeathed to the City of Denver in 2004. Previously, Sobel was director of the Aspen Art Museum and chief curator at the Milwaukee Art Museum, where he held the joint position of curator of contemporary art. A specialist in twentieth-century art, Sobel has organized more than sixty exhibitions of international modern and contemporary art, ranging from one-artist retrospectives to small projects of new work.

TIMOTHY J. STANDRING

Dr. Timothy J. Standring is the Gates Foundation Curator of Painting and Sculpture at the Denver Art Museum. Since 1989, Standring has served the museum in many capacities, including deputy director, chief curator, and curator of the Berger Collection. In addition to his upcoming Becoming Van Gogh exhibition, he has curated ten other shows at the Denver Art Museum, including Inspiring Impressionism, Sargent and Italy, and El Greco to Picasso from the Phillips Collection. Standring spent much of his early career in academia and received fellowships from, among others, the Clark Art Institute, the Getty, and the Center for Advanced Study in the Visual Arts at the National Gallery. He has published widely on a broad variety of subjects.

DON STINSON

Don Stinson is known for painting vistas that explore the physical and cultural landscapes of the West. Late twentieth-century practices of cultural geography, land-use planning, and topographic photography shape his artwork. He received an M.F.A. in painting from the School of the Museum of Fine Arts, Boston. He was the recipient of a Colorado Council on the Arts Director's Grant, and his work is in the collections of the Denver Art Museum and the Art in Embassies Program in Riyadh, Saudi Arabia. He has been featured in solo and group exhibitions in Colorado and Texas, with prominent showings at the Museum of Contemporary Art, Denver; the Nicolaysen Art Museum, Casper, Wyoming; the Coors Western Art Exhibit, Denver; and Artist Space, New York

KATHLEEN STUART

Kathleen Stuart is the curator of the Berger Collection at the Denver Art Museum. Before joining the museum in 2007, she was a curator of drawings at the Morgan Library & Museum in New York City, where she organized the exhibition and wrote the catalog for *Tales and Travels: Drawings Recently Acquired on the Sunny Crawford von Bülow Fund.* Stuart was a special curatorial fellow at the Yale Center for British Art in summer 2009. She is currently writing catalogs for two upcoming exhibitions, *Treasures from the Berger Collection: British Art 1400–2000* and *Master Drawings from the Collection of Esmond Bradley Martin, Jr.*

JOAN TROCCOLI

While earning her Ph.D. from the Institute of Fine Arts, New York University, Joan Carpenter Troccoli published a groundbreaking article, "The Infra-Iconography of Jasper Johns" in the *College Art Journal.* Following her move to Oklahoma in the early 1980s, Dr. Troccoli reoriented her scholarship to the art of the American West, becoming curator of exhibitions and later director of the Gilcrease Museum in Tulsa, where she organized traveling exhibitions of the western watercolors of Alfred Jacob Miller and the paintings and watercolors of George Catlin. She was appointed deputy director of the Denver Art Museum in 1996 and became founding director and curator of the Petrie Institute of Western American Art in 2001. Her most recent exhibition, which was accompanied by a major publication, was *The Masterworks of Charles M. Russell: A Retrospective of Paintings and Sculpture* (2009). Since 2005, she has served as senior scholar of the Petrie Institute.

MARIE WATKINS

Marie Watkins, associate professor of art history at Furman University in Greenville, South Carolina, is a specialist in American and European art of the nineteenth and early twentieth centuries with a particular interest in the Taos Society of Artists. Her professional activities cross an array of disciplines and include teaching in the United States, Berlin, and London; curating exhibitions in the humanities and the sciences; managing a renal pathology laboratory; and serving as a college administrator. Among her recent publications are a chapter on Frederic Remington for *Icons of the American West* (Greenwood Press, 2008) and an essay on Joseph Henry Sharp's *Indian Hunters* for the *Kresge Art Museum Bulletin.* Forthcoming works include a monograph on Sharp for the University of Oklahoma Press.